cat. 49.3

cat. 113

VOGUE PARIS

Edited by
Sylvie Lécallier

100 YEARS

Since its creation in 1920, *Vogue Paris* has helped make Paris the capital of fashion and an international symbol of elegance.

The editors that have guided it over its one hundred years have all shared the same ambition: To promote Parisian fashion design and expertise, and to illuminate the city of Paris and its architecture. Throughout its history, the magazine has acutely observed changes in society and translated readers' aspirations by challenging how the body and beauty are represented.

But beyond fashion, *Vogue Paris* has always acted as an account of the effervescent quality of Parisian culture. Within visual arts, literature, and music, the magazine has never hesitated to look toward other horizons and to submit itself to the words of others, notably Simone de Beauvoir, Françoise Giroud, and Jean Genet.

I am delighted that the Palais Galliera, Paris's museum of fashion of Paris, will be able, with this exhibition, to highlight *Vogue Paris*'s contribution to the history of Parisian fashion and culture—something that we have especially missed so much during recent times, and that we now have the joy of rediscovering. A reminder of the vital human need for culture.

Anne Hidalgo
Mayor of Paris

4

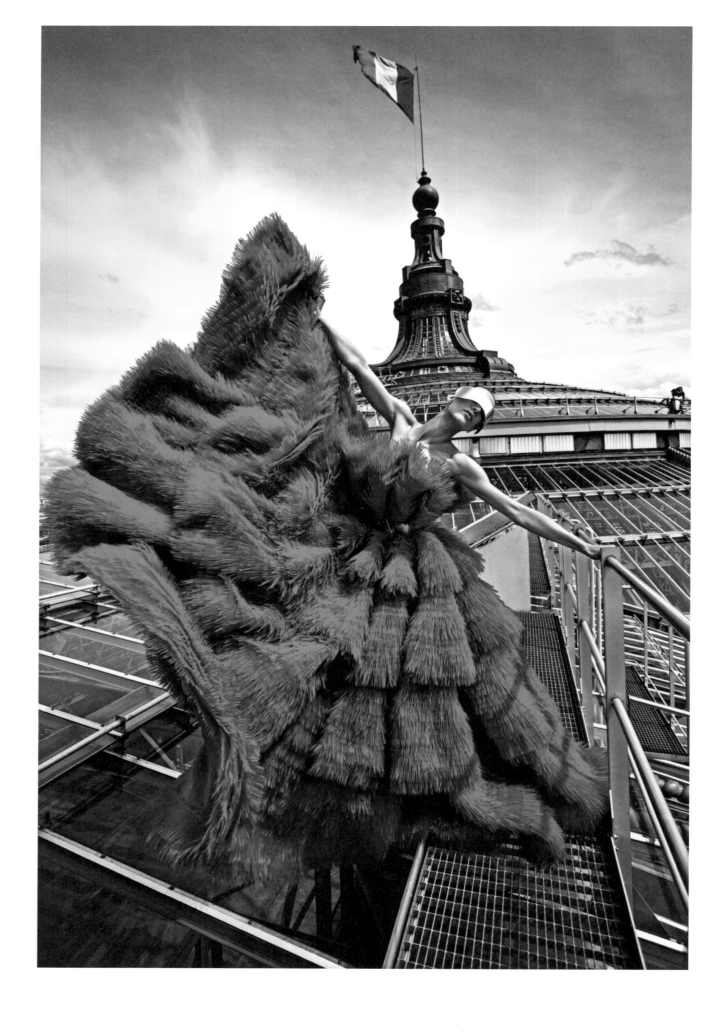

cat. 384 Mario Sorrenti. "Paris mon amour." Aymeline Valade. Alexander McQueen dress.
Grand Palais, Paris. Directed by Emmanuelle Alt. *Vogue Paris*, August 2012, p. 193

Vogue Paris celebrated its one hundredth anniversary in 2020. For its long-standing history, this iconic magazine has earned recognition by the Palais Galliera, the museum of fashion of the city of Paris. The magazine's undeniable impact on the fashion and beauty industries has led it to be far more than a mere spectator in its field, but a true stakeholder, disseminator, and influencer of fashion and lifestyle trends through each era of its publication. Through its assertive editorial choices, the magazine launched and supported the careers of many designers and photographers, consequently writing the most beautiful pages in the history of fashion.

The magazine as object itself—through the evolution of its content and form by embracing changes in arts and techniques, and by recognizing both illustration and fashion photography as art—constitutes a particularly rich field for study, even when considering the rarity and fragility of its first paper issues. Thanks to privileged access to Condé Nast's archives in both Paris and New York, the anniversary exhibition at the Palais Galliera will present many unpublished works and documents covering the magazine's history. Exhibition designer Adrien Rovero honors the role of the magazine's original copies and their importance to national heritage.

Since 2014, while continuing its regular publication schedule and editorial mission, the magazine has recognized its formal induction into the history of fashion by supporting the Palais Galliera through the Vogue Paris Foundation. Each year they've provided the museum with the ability to acquire several preeminent silhouettes of contemporary fashion. In doing so, *Vogue Paris,* dedicated to its longtime commitment to design, has become an active participant in safeguarding, for future generations, the fashion heritage of which it is part.

Miren Arzalluz
Director of the Palais Galliera

For this book, it was decided to use the name "*Vogue Paris*" to refer to the French edition of the magazine no matter the era.

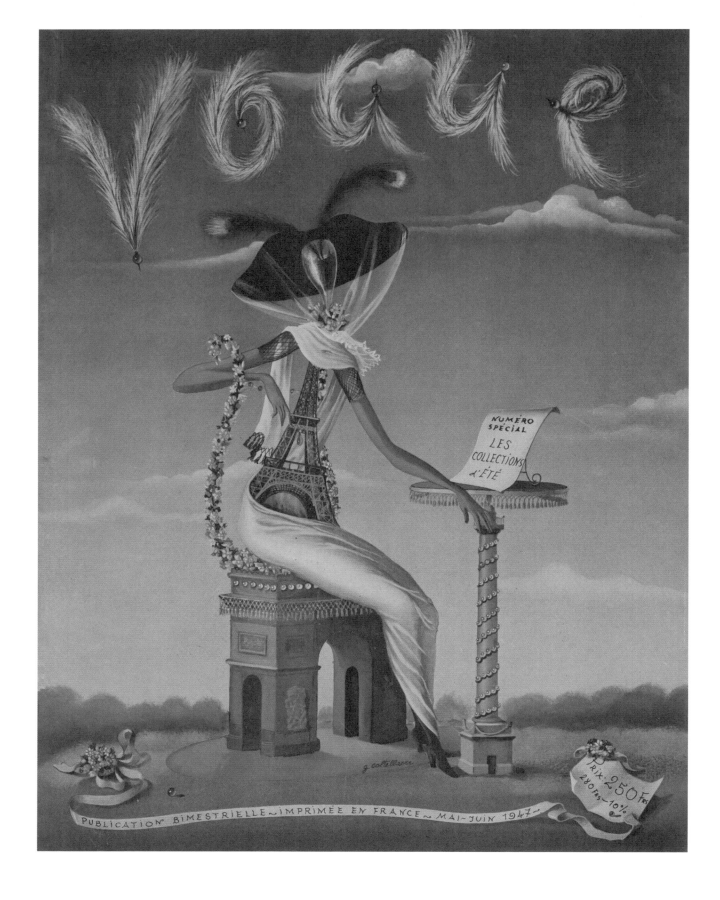

cat. 128 Giulio Coltellacci. *Vogue Paris*, May/June 1947, cover

Vogue Paris is one hundred years old. Launched on June 15, 1920, it is the oldest French fashion magazine still in publication,[1] having lasted a century with only one break during the German occupation of France.[2] Although the magazine has celebrated many of its anniversaries in its own pages,[3] and several books and exhibitions have focused on its iconic covers and its "Beauty" pages, there has never been a major exhibition and publication devoted exclusively to the magazine's history.

Nonetheless, *Vogue Paris* remains a living magazine, in the midst of creating its next issue as these lines are written. The editors in chief over the last century and up to today are the common threads of this exhibition and its accompanying catalogue. The magazine's identity is owed to these women and men who have not just guided it but become its embodiment. Their personalities, lasting collaborations, and commitment have made the distinctiveness and coherence of *Vogue Paris* what it is today. The editors in chief are the ones who bring together a team, attract talent, and choose creators and personalities to interview and promote. It is around them that "a family"[4] forms—a concept which has been explicitly promoted by the magazine in multiple articles throughout its history and which is also implicit in the loyalty of its collaborators and stylistic relationships that have emerged over time; it is an extended family that reaches beyond its offices and pages to encompass the readers who await the release of the latest issue every month.

We have chosen to focus on the "core," or "heart," of the magazine, the term used to describe the photo shoots that *Vogue Paris* commissions to fill its pages, separate from the advertising that fits into dedicated spaces of its own. Telling the story of a fashion magazine means diving into the heart of its production processes (image creation, content writing, printing, distribution, and more) and its inherent constraints: material, economic, and editorial. It means trying to understand a space that is open yet unpredictable because of its periodic renewal, a space that grants the right to take risks, shake up conventions, and suggest daring new ways of examining things. Just as *Vogue Paris* is a witness to—and a mirror of—its time, it is also, above all, a player. From the beginning and throughout the past century, it has taken on many roles through its editorial choices[5] such as questioning notions of taste, beauty, celebrity, and elegance; publicizing culture and the arts; proposing new ways of living to its readers and new ways of viewing their femininity and their daily lives; and being at the intersection of fashion, Paris, and creativity.

"*Vogue* Means Fashion"[6]

Because of its place at the creative heart of an industry, the magazine follows a set of rules imposed over the decades by the fashion system. Many of its organizational constraints are related to the haute couture and ready-to-wear calendars, the seasonal revival of particular themes, and the influence advertisers may exercise over editorial content.

Since it is said that the history of fashion is written in the pages of magazines, it is worth remembering how quickly *Vogue Paris* gained power within the industry. As Roland Barthes wrote, a magazine is "a machine that creates fashion."[7] *Vogue Paris* launched and supported the careers of couturiers, including Elsa Schiaparelli in 1927, Christian Dior and Yves Saint Laurent, who were championed

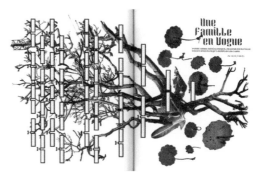

ill. 1 M/M (Paris). "Une famille en *Vogue*." *Vogue Paris*, December 2002/ January 2003, pp. 260–261

cat. 238 Kammermann-Dalmas. Yves Saint Laurent succeeds Christian Dior. *Vogue Paris*, March 1958, p. 117

by Michel de Brunhoff, and Tom Ford, a protégé of Carine Roitfeld, influencing others with what it chose to publish. Its status means that its opinions on fashion have authority to those involved in the field and those who wish to be part of it. *Vogue Paris* acts as a mediator between fashion designers and their clientele.

Since its inception, the magazine has always been closely integrated into the fashion industry, and its prescriptive power gives it economic clout. This is reflected in its commitment to haute couture: protecting it against the threat of forgeries in the 1920s, publishing extensive portfolios of French couturiers during the 1930s ("The Portfolio of *Vogue*"), which heralded the great contemporary tradition of photo shoots, and then, after the Second World War, in Michel de Brunhoff's support for French design in the face of competition from the American fashion industry. Throughout its history, *Vogue Paris* has focused on couturiers and the creative process, promoting young and new designers and publishing increasing coverage of the Paris collections, right up to the advent of the couture superstars. In the early 2000s, when the fashion industry was undergoing major changes due to production and distribution speeding up and growing increasingly global, *Vogue Paris* adapted and repositioned itself. Its Parisian roots and promotion of fashion in all its forms continue to go hand in hand.

"A True Parisian Magazine"[8]

The national identity of the magazine—which belongs to an American publishing group—is evident in the heading of its first editorial: "We speak French" (ill. 2 p. 15).[9] At the same time, its Parisian distinctness was highlighted. In its first issue, *Vogue Paris* claimed to be "the mirror of the best and surest taste in Paris: It is this city that *Vogue* has always drawn on as its source of inspiration. Such is the greatest secret of its success."[10] Thus, the chosen base of the French edition of *Vogue* was not only a new place of production but also the source of the news and images that the magazine used. A useful tool in the magazine's growing independence from the directors in New York, Paris itself became the subject of numerous articles and columns. Similarly, picture choices strongly affirmed the French capital as synonymous with elegance. Covers, illustrations, photographs, and editorial articles presented Paris as the ideal setting for fashion, placing the city at the heart of the magazine.

Beyond its status as a fashion capital, Paris was always presented in the magazine as a cultural and artistic capital: a center that shines. This has been reflected for more than a century in the publication of numerous articles dedicated to Parisian life. The magazine promoted this Parisian identity to the point of incorporating it into its logo in different forms starting in the 1950s.[11] Today, *Vogue Paris* is the only magazine from the Condé Nast group to bear the name of a city and not of a country. Even when it experienced periods of strong international influence, especially in the 1990s, it still always returned to Paris as its home base.

"A city is a woman,"[12] Violette Leduc wrote in 1965, speaking of Paris as a capital of creativity. At *Vogue Paris*, editors, designers, readers, models, and other figures represented in the pages of the magazine have created a very Parisian vision of womanhood, whether through her relationships, her culture, or her elegance. Marie-Laure de Noailles, Catherine Deneuve,

Charlotte Gainsbourg, as well as editors Carine Roitfeld and Emmanuelle Alt, both Parisians by birth, have all been embodiments of the *Vogue* woman. The magazine has very skillfully exploited the image of Paris as a geographical anchor and symbolic site, as well as that of the Parisienne who, like the city, is both a fantasy and a reality.

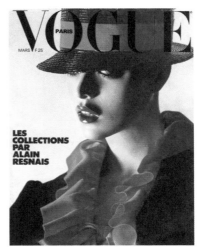

cat. 253 Helmut Newton. *Vogue Paris*, March 1978, cover

"Everyone Knows That *Vogue* Is Synonymous with Art"[13]

The deliberately elitist positioning of the magazine was established from its inception. For Condé Nast, it was a question of targeting a social class with plenty of purchasing power that was likely to be attracted by high-end advertising. *Vogue Paris* was aimed at the cultured woman who moves in social and artistic circles where clients, models, and readers meet. From its beginnings, the magazine employed the services of the Duchess d'Ayen and Princess Bibesco. *Vogue Paris* was obviously a luxury magazine, as much because of those who created it and read it as because of its high-quality content and printing. Since its launch, literature and the arts have been woven through its pages in the form of reviews of artistic events, interviews with artists, and collaborations with painters, illustrators, photographers, and writers. After the Second World War, editor Edmonde Charles-Roux made room for literature and music, opening *Vogue Paris* to unconventional and engaging writers. The fashion magazine expanded to include a culture section while the editorial sections became increasingly elaborate.[14] This became most strongly apparent in the 1990s.

Vogue Paris positioned itself at the creative heart of fashion by discovering young talent and offering support to artists, sometimes in the form of genuine patronage. In the 1930s, the commissions that artist Christian Bérard received from Michel de Brunhoff became an unexpected source of financial security. Being published in *Vogue Paris* could also propel photographers such as Helmut Newton to fame.[15] Over the last century, many exceptional photographers and illustrators have made the double-page spread of *Vogue Paris* their preferred medium. The sections "Beauty," "Accessories," and "Youth," which were less subject to editorial constraints, were also spaces of visual freedom where young talent always found an opportunity to experiment. The creativity on display in the pages of the magazine is often elevated by the layout design, as well as by the interaction between different artistic fields—including fashion, painting, and photography (Schiaparelli, Dalí, and Beaton, for example [cat. 71])—or, later, between still and moving images (such as illustration, photography, film, television, and videos). *Vogue Paris*, over time, has always struck a balance between the quality of the content it promoted with the style in which it was presented.

While for a long time, the magazine combined illustrations and photographs in a complementary and sometimes competitive way, it is photography that most closely reflects the story of *Vogue Paris*. It is both an individual and a collective process that has changed considerably over the years. The number of photographers has increased while the technology has moved from analog to digital, from gelatin silver prints mounted on paper, retouched and annotated by hand, to image files sent electronically to the printer.[16] In addition, fashion photography has risen in status, evolving to become an artistic and autonomous genre to which the doors of museums have now been opened. *Vogue Paris*, as a demanding medium of communication, has played a large part in this process.

"Fashion Moves. And So Does *Vogue*."[17]

The history of a fashion magazine offers opportunities for analysis that may be of interest to multiple fields of study including publishing, illustration, photography, graphic design, fashion, society, and gender. The multidisciplinary and complementary approaches featured in this book tell the tale of a century of *Vogue Paris* for the first time. They emphasize the fact that this magazine is a collective adventure with an ever-changing yet enduring identity.

The early years are explored through rarely seen primary sources: the Condé Nast papers and the Edna Woolman Chase papers, which cover two fundamental periods of the magazine's history as well as the material circumstances of its creation. By examining the media before the Second World War, Marlène Van de Casteele looks at the era when a fertile relationship grew between the American Condé Nast group and the Parisian team and involved a constant demand for creativity. Sophie Kurkdjian immerses us in the conflict of war, discussing in detail how Michel de Brunhoff strove in the face of adversity and practical constraints to revive the magazine and promote the city of Paris after its liberation. At the end of 1954, Edmonde Charles-Roux became the first woman to head *Vogue Paris.* Alexis Romano offers a semiotic perspective on the fashion images of the 1950s and 1960s, and analyzes the representations of women in motion that heralded the advent of ready-to-wear and reflected the urban, artistic, and intellectual modernity of the time. The 1970s and 1980s are presented by Alice Morin as the golden age of photographers. Francine Crescent, editor in chief for eighteen years, acted as a bridge between these two decades, deploying an approach to fashion photography that found the pages of the magazine to be an ideal medium. This period has remained in the collective memory as the magazine's creative peak. By comparison, the 1990s brought a *Vogue Paris* with less fashion and more editorial content, led by journalists with a global perspective. Interacting with other disciplines, fashion was now part of a social, creative, and cultural environment that cried out for individual involvement. Finally, the modern era, showcasing the power of stylists Carine Roitfeld and Emmanuelle Alt, is examined by Shonagh Marshall, who looks at its relationship to the real world—the dream of fashion versus the reality. She looks at the future of the magazine in both form and content, its shift to digital, and how it has survived recent major upheavals in the world.

These chronological sections are accompanied by shorter examinations of themes specific to the history of *Vogue Paris*, helping to connect the eras. Jérôme Gautier presents a lively overview of the women who have appeared on the cover, a unique blend of figures, faces, elegance, and fame.

All of these sections bear witness to the fact that, while remaining true to itself, *Vogue Paris* has spent a century demonstrating its capacity for creativity, adaptation, rebirth, and excitement.

1 The first issue of *L'Officiel de la couture, de la mode et de la confection* appeared in July 1921.
2 No issue appeared between June 1940 and December 1944.
3 See p. 281 in this book.
4 "Une famille en *Vogue*," *Vogue Paris* (December 2002/January 2003): 260–261. For this Christmas issue on the theme of family, the M/M (Paris) agency designed an empty family tree, intended to be filled in by the readers.
5 "Où l'on expose le rôle de *Vogue*," *Vogue Paris* (March 1, 1923): 33.
6 Editorial, *Vogue Paris*, (July 1, 1920): IV. In American *Vogue*, printed January 1, 1923 (p. 75), an excerpt from the dictionary was printed showing the definition of *vogue*: ("Vogue: fashion"), accompanied by this comment: "In 1892, *vogue* was only a word in the dictionary—today all the world knows it as a magazine."
7 Roland Barthes, *Système de la mode*, Paris, éditions du Seuil (1967): 9.
8 Lucien Vogel quoted by Edmonde Charles-Roux, interview with Susan Train, *Vogue Paris* (December 1995/January 1996): 26.
9 *Vogue Paris* (June 15, 1920): 3.
10 Ibid.
11 From September 1951 to August 1956, French *Vogue* had the subtitle "Paris Edition." From September 1956 to December 1958 (except for the March 1958 issue), the subtitle became "The Fashion and Life

of Paris." For the October 1963, August 1964, December 1964, and February 1965 issues, the word *Paris* was integrated into the word *Vogue* (first following it, then in the bar of the *E*). Since the July/August 1968 issue, the word *Paris* has been printed inside the o of the word *Vogue*.
12 *Vogue Paris* (March 1965): 152.
13 Editorial, *Vogue Paris* (April 1, 1921): VI.
14 "In 1954, among seventy pages devoted to fashion, thirty were dedicated to culture, transforming the image of the magazine and its readership." (Sophie Kurkdjian, *Lucien Vogel et Michel de Brunhoff, parcours croisés de deux éditeurs de presse illustrée au XXᵉ siècle*, Bayonne, Institut Universitaire Varenne, Theses Collection (2014): 810, note 3776.
15 "My work began to have a certain influence on the field, which shows the importance of getting published in magazines and being credited." (Helmut Newton, *Autoportrait*, Paris, Robert Laffont (2004): 180.
16 However, as a sign of the high production quality that is demanded, *Vogue Paris* has Epson inkjet prints made of all the photographs in the magazine sent to repro to ensure the closest possible match to the original images. (The author thanks Francis Dufour, head of production for Condé Nast Publications, for these technical details.)
17 Editorial, *Vogue Paris* (February 1989): 143.

I

1920—1938

FROG, A TRANSATLANTIC MAGAZINE

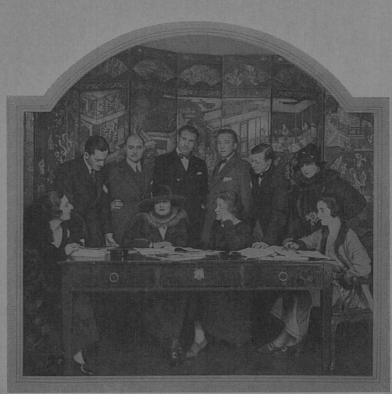

ill. 1 Anonymous. *Vogue Paris* team. Seated: Madame Calvé,
Mademoiselle Marjorie Howard, Madame Vogel, Mademoiselle
Godebska. Standing: Monsieur Horton, Monsieur Laporte,
Monsieur Philippe Ortiz, Count Wladimir Rehbinder, Monsieur
Lucien Vogel, Madame Fernandez. American *Vogue,* January 1,
1923, p. 77

"American *Vogue* compared with *Frog*" is the title of a memorandum sent by Dr. Agha[1] to Edna Woolman Chase[2] on February 26, 1930, with the intention of conducting a comparative study of two issues of American *Vogue* and French *Vogue*. The abbreviation "Frog" can be found noted in several of the magazine's administrative papers and is a combination of the words *French* and *Vogue*, acting as a code name[3] used by the various collaborators of the New York office to communicate more efficiently within its transnational organization. It was also a nod to the nickname the British gave to the "Frenchies," as they called them, who had the reputation for eating frogs' legs; and, thus, reflects the cultural differences intrinsically linked to the expansion of the Condé Nast publishing empire. Such expressions crystallize the aesthetic, commercial, and organizational power struggles between these two publishing offices. Equally, this may reveal the result of a more demanding and efficient American style of work meeting a more relaxed French approach. Review of the Condé Nast Papers and the Edna Woolman Chase Papers[4]—direct sources recording thousands of professional and private correspondences between the publisher and editor in chief with their various collaborators in Paris, New York, and London—testify to the creative tensions resulting from these power struggles, which influenced the content of French *Vogue* in its development as a luxury magazine that was still taking shape.

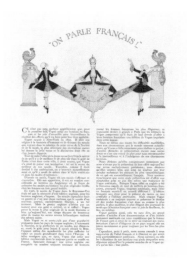

ill. 2 "On parle français!" Editorial. *Vogue Paris*, June 15, 1920, p. 3

In Search of an Identity

"It is not without some apprehension that, for the first time, *Vogue* greets its readers in French and asks them to look kindly upon the result of the efforts it will make to please them."[5] These few words marked the beginning of a publication that has endured for a century. In June 1920, eleven years after the purchase of the *Vogue* social gazette, French *Vogue* was born, a beginning justified by the commercial success of British *Vogue,* which was founded in 1916, and whose success spurred in 1917 the idea of a European edition whose main target was the French-speaking market.[6] The launch of a French version of American *Vogue*[7] may have simply been the product of Condé Nast's global aspirations, an economic response to the presence of an ample consumer market for luxury goods and a niche female readership in Paris. This would justify the desire to launch a duplicate version of American *Vogue* translated into French,[8] as announced in the editorial of the first issue.[9] But this would also ignore the strong symbolic value French *Vogue* would gradually attain and underestimate the appeal of Paris as an epicenter of creativity. At its inception, *Vogue Paris* was primarily thought of as an artistic and cultural outpost and less as a source for profit.[10] This new edition thus forged fruitful relationships with Parisian fashion designers, artists, and writers whose talents would feed the content of the publishing group's other magazines, such as *Vanity Fair* and *House & Garden*. Although in 1920 Condé Nast had already welcomed illustrators Georges Lepape, André Édouard Marty, and Benito to his pool of talent—due to his relationship with Lucien Vogel and his financial involvement in the *Gazette du bon ton*,[11]—he planned to become closer to other artists based in Paris, such as Jean Pagès, Pierre Mourgue, and Christian Bérard. The launch of a French *Vogue* was also, for Nast, a way to have more control from New York over the somewhat free spirits of these artists, which were difficult to manage from

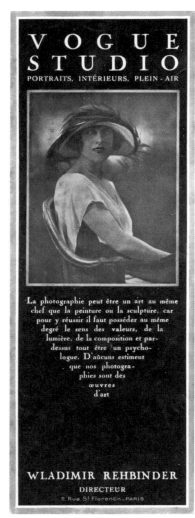

ill. 3 Ad for Vogue Studio.
 Vogue Paris,
 October 1922, p. 64

a distance. As a result, the first few years brought together American and Parisian artists such as Bernard Boutet de Monvel and Charles Martin, who interacted with the American illustrator Irma Campbell and rubbed shoulders with the cosmopolitan Baron de Meyer. This new edition aimed to take advantage of the world's fascination with the French capital. As noted in the first issue's editorial, the young magazine, aimed at the French and international social and cultural elite, would be "the mirror of the best and surest taste in Paris." This intended to convey that, even though the city was bruised on its surface at the end of the Second World War, the myth of Paris—the capital of haute couture, arts, and culture—still served as a powerful aphrodisiac in the eyes of the American public.[12]

Based on this, we may well ask questions about the identity of French *Vogue* and its gradual shift from an American magazine to a French publication. As the editorial of the first issue announced, French *Vogue* aimed to "get closer to the French ideal and eliminate what would be too specifically American."[13] Although initially the illustrated covers were based on those of American *Vogue,* but with a two-week delay, and therefore reflected an identical production process. And most articles published in the American edition were simply translated word for word for the French version, although some columns were personalized. For example, the article "L'élégance pour les bourses modestes," though a direct translation of the American title "Dressing on a Limited Income,"[14] had a modified introduction to meet the expectations of French readers. The table of contents, society and news sections, and advertisements were also adapted for the French edition, as were the headlines,[15] demonstrating how the choice of words was already targeting a particular audience. On the other hand, articles aimed specifically at Americans vacationing in Paris[16] mirrored an internationalization of journalistic practices and were indicative of artistic and commercial exchanges between France and the United States; one example was the story published in the July 1, 1923 issue, which traced the "ideal" daily routine of an American woman just arriving in Paris in order to offer a tourist's experience to the reader.[17]

Although *Vogue Paris* remained an American magazine that looked French, over the years its focus turned more and more toward the Parisian capital. This dependence on Paris as an arbiter of elegance and good taste for everything related to the arts, high society, and fashion also had a direct impact on the organization of the publishing group and on the modes of communication instituted by the parent company.

Producing a Transnational Magazine

Fully controlled from the New York office, the first issues of French *Vogue* required the work of many people and posed logistical and strategic challenges. Although the magazine was printed in London for the first six months of its life,[18] it was E. W. Chase who supervised it from her New York office. In the same way that she ran British *Vogue,* she chose the content of French *Vogue* and guided the choice of topics, providing instruction to the various teams during her regular trips to Paris. It was a challenge to produce a new fashion and cultural magazine that could position itself to compete with other publications such as *Femina* or *L'Officiel de la couture et la mode de Paris*.[19] Because

of this Condé Nast appointed the American Philippe Ortiz[20] as the magazine's administrative, financial, and editorial director, and offered the French fashion journalist Cosette Vogel, wife of publisher Lucien Vogel and daughter of publisher Maurice de Brunhoff, the responsibility of editor in 1922. This first attempt to establish in the French capital, on rue Édouard-VII,[21] a Franco-American duo allowed Nast to remotely control the business and its direction, with the pair responding to orders imposed from New York while also taking advantage of important Parisian contacts and local expertise. Moving in the cultural and artistic circles of Parisian high society and endowed with a solid knowledge of the press and haute couture,[22] Vogel refined the content of the magazine by adding a letters page and a shopping service,[23] which addressed the readers more directly. Following the departure of Vogel in 1927, fashion editor Carmel Snow took an interim role—while Chase relinquished her position as editor in chief of French *Vogue* to become general director of all *Vogue* editions— until 1928, when American fashion editor and illustrator Main Rousseau Bocher, known as Mainbocher, would take over until the arrival of Michel de Brunhoff.

ill. 4 George Hoyningen-Huene. Horst P. Horst (left). Vogue Paris Studio, 65, avenue des Champs-Élysées. *Vogue Paris*, July 1930, p. 29

Toward a More Independent French *Vogue*

It was not until Brunhoff's appointment in December 1929 that the French edition became more autonomous. Armed with his experience as a close collaborator of Lucien Vogel on the *Gazette du bon ton* and *Le Jardin des modes*, and having served as interim editor of British *Vogue* in 1926, Brunhoff was chosen for his knowledge of the world of couture and his immersion in Parisian artistic and literary circles—and likely because of his connection with Cosette Vogel. Even though he was not part of the aristocratic world and had little interest in high society, he could nevertheless rely on the network of the Duchess d'Ayen.[24] An important haute couture client, the duchess brought to the organization an aristocratic but intellectual influence that was invaluable to the prestige of *Vogue,* as did Count Rehbinder[25] and Baron de Meyer, both having been hired by Nast not only for their talent as photographers, but also for their titles and connections within the beau monde. Therefore, the pages on the cultural and artistic life of Paris occupied an increasingly prominent place at the heart of the magazine, helping to establish its identity. From texts by renowned French authors and writers such as Colette,[26] Jean Giono,[27] Louise de Vilmorin,[28] and Max Jacob[29] to portraits of celebrities of the day including Vicomtesse de Noailles (cat. 42) and Marie-Berthe Aurenche, wife of Max Ernst (cat. 44), as well as the collaborations with Emilio Terry and Man Ray and the support of Jean Cocteau,[30] the intermingling of Parisian artistic effervescence and contemporary high society reflects a carefully managed editorial strategy and carefully woven relationships.

While American correspondents stationed in France—such as Bettina Wilson Ballard, who arrived in Paris in September 1935—were responsible for generating fashion content for American publications and winning the loyalty of professional buyers in Europe, thus linking the two editions, the ongoing emancipation of French *Vogue* continued to occur beneath the surface. Lucien Vogel played an essential role in this regard, first as an intermediary, or "agent," to Parisian artists and an advisor to Condé Nast on administrative matters, then officially as art director between October 1924 and September 1927

Frog,
A Transatlantic Magazine

(the overall artistic direction of Condé Nast publications was still supervised by Heyworth Campbell until Agha replaced him in 1929.) As art director of French *Vogue,* Lucien Vogel chose to transform the design of the magazine, focusing on the legibility of the headlines, the brightening of the page layout using broad white margins, and a typeface modeled on the design of the *Gazette du bon ton.* Although Vogel's position was never fully formalized at the magazine after 1927, he was involved in multiple editorial projects and acted as an intermediary between Brunhoff and Nast, providing opinions on layout, printing techniques, sales impacts, and staff management. Memos addressed by Vogel to Nast and Agha reveal his positive opinion on photographer André Durst,[31] who had recently been recruited, and his recommendation of Constantin Joffé[32] after passing along a selection of his photographs. Vogel also had a role as a discoverer of young talent in the same way as Brunhoff.[33] In 1926 he hired photographer George Hoyningen-Huene, who became chief photographer of the *Vogue Paris* studio until 1935, when he left *Vogue* to join *Harper's Bazaar* following a disagreement with Agha. He was replaced by his protégé and assistant Horst P. Horst, who in turn was replaced by Durst when he was called back to the New York office in 1939. In operation from 1922 to 1939, the Parisian studio[34] was not equipped with the advanced technology found in the Graybar Building in New York where Condé Nast was headquartered, but it nevertheless functioned as a laboratory of experimentation and creative freedom for photographers who came to prove themselves and learn before leaving to complete their training in the United States. Thus, starting with the arrival of Hoyningen-Huene, the initial transatlantic setup gave way to illustrators and photographers trained specifically in Paris.

A Divergence of Editorial Approaches

Since French *Vogue* was produced locally, it was free from American control not only on matters of content but also on aspects of managerial organization and the recruitment of artists. Brunhoff's desire was to employ high-quality artists chosen "exclusively for their purely artistic and intellectual abilities,"[35] "even if their work is sometimes far from *Vogue*'s fashion objectives,"[36] as Vogel explained to Nast in 1941 after analyzing the last ten years of French *Vogue.* The American approach was particularly focused on presenting garments clearly in order to provide as much detail as possible to the reader. In this respect, photography, as well as being a showcase of modernity, was, in Nast's eyes, a vital outlet for disseminating information within the world of fashion promotion. Brunhoff adopted an editorial style of his own, having become sensitive to matters of graphic design, typography, and layout. Starting in 1925, the year in which the covers of French *Vogue* first became autonomous—made possible by a more established Parisian logistical network—Brunhoff advocated for high-quality visuals based on covers by credited artists. Although the role of photography was far from negligible within the pages of French *Vogue,* in Brunhoff's opinion, illustrations made it possible to reflect an artist's creative realm and transport the reader into a world of fantasy. This topic was a recurring point of disagreement between Nast and Brunhoff, as evidenced by a memorandum by Chase and Agha addressed to Brunhoff that focused on the critical review of the March and April 1938 issues: "Perhaps, for the French

public, your attack on makeup may be more acceptable than ours but, since we are giving you our frank opinion, we must say that we cannot like it."[37] The criticisms were aimed both at editorial presentation—an April issue that was too extensive and teeming with fashion looks (232 in all) at the expense of graphic effectiveness—as well as Christian Bérard's illustrations "that should tend toward greater realism," and the color pages whose decorative beauty and informative content were not enough to justify them. This led to a radical conclusion: From the American point of view, the approach taken by French *Vogue* was "more or less outdated" and did not reflect in any way the latest graphic, advertising, and typographical trends coming from Europe and France.[38]

Another area of disagreement was the relationship between French *Vogue* and Parisian couture. Although the publication was created to forge direct links with French fashion designers, Nast accused Brunhoff of openly publishing promotional albums for Parisian haute couture, as evidenced by the "Le Portfolio de *Vogue*"[39] section, rather than providing an actual service to readers. This ran counter to the American strategy, since he believed French *Vogue* should act as a showcase to attract upscale readers and therefore ought to offer this kind of commercial service.

Lastly, the final points of disagreement rested on personalities and on Nast and Brunhoff's diametrically opposed approaches to work. While Nast relied on statistics, market research, and memorandums to pass along instructions, Brunhoff worked instinctively and made few notes with his team. The New York office thus reproached Brunhoff for his muddled ways, love of improvisation, lack of organization, and late morning arrivals[40] (the time difference between the two offices allowed the French office to avoid New York's demands and tighter controls). Despite these differences, transatlantic cooperation between Nast and Brunhoff continued until the late 1930s with an exchange of good ideas and mutual admiration, as evidenced by the expressions of economic and emotional support Brunhoff and Duchess d'Ayen received when France's entry into the Second World War became imminent, as well as throughout the war years.

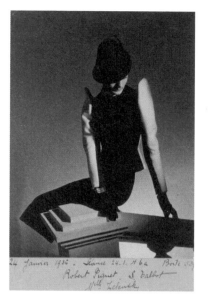

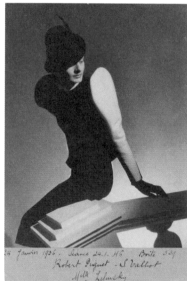

cat. 46 and 47 Horst P. Horst. Doris Lyla Zelensky. Robert Piguet ensemble, Suzanne Talbot hat. *Vogue Paris*, March 1936, p. 54 and American *Vogue,* March 1, 1936, p. 67

1 Mehemed Fehmy Agha was art director of Condé Nast Publications from 1929 to 1943.

2 Edna Woolman Chase was editor in chief of American *Vogue* from 1914 to 1952.

3 Just as we find the shortened form *Brogue*, a combination of *British* and *Vogue*, on some memorandums mentioning British *Vogue*.

4 Grouped under the name Condé Nast Papers and Edna Woolman Chase Papers, these documents are stored in the Condé Nast Archives in New York. They group missives, surveys, exclusive contracts, statistics, and accounting lists sent to the various employees of the group.

5 Editorial in the first issue of French *Vogue* (June 15, 1920).

6 In English, *Continental Vogue* is similar to British *Vogue*, but has the price in francs on the cover.

7 The publisher Condé Nast (1873–1942) acquired in 1909 a confidential gazette of New York high society, *Vogue* magazine, founded in 1892 by Arthur Baldwin Turnure. When it was purchased, the magazine had been losing money and readers, and the circulation amounted to 14,000 copies per month alone. Nast decided to apply the formula he used to create his own success: He set out to address a social class with strong purchasing power, likely to be seduced by high-end advertising.

8 When British *Vogue* was launched in 1916, it had the same content as American *Vogue*, only the advertisements were tailored for its specific market. The same was true for Spanish *Vogue* in 1918.

9 Editorial of June 15, 1920: "We frankly admit that our only claim is to offer an adaptation, if not even a translation, of American *Vogue*."

10 At least until the economic crisis of 1929. A biweekly magazine until its switch to a monthly publication in June 1922, *Vogue Paris* was initially printed at 20,000 copies and sold for 4 francs.

11 The artists of *Gazette du bon ton* collaborated with American *Vogue* and European *Vogue* before the creation of French *Vogue*. Condé Nast took a stake in the *Gazette* to gain access to these French artists, and Vogel played the role as intermediary before working for French *Vogue*.

12 See also the editorial of July 1, 1920: "This is why *Vogue* has imposed on itself the task of presenting twice a month, the fashions, high society, arts, and elegance that constitute American *Vogue* in the language of the courts and capitals, the language of beauty and originality, the language that characterizes the cultured woman—in short the French language."

13 Editorial of June 15, 1920.

14 See the issues of July 15, 1920, and October 15, 1922.

15 See "À la recherche de l'âme française," *Vogue Paris* (December 1, 1922): 25.

16 See "L'Amérique envoie les épices de la vie à l'Europe," *Vogue Paris* (June 1, 1923), and "Cécile Sorel acclamée par les Américains," *Vogue Paris* (December 1, 1923).

17 See "La journée d'une Américaine à Paris," *Vogue Paris* (July 1, 1923): 3–5 and 54: "This American discovering Paris begins her day in the Bois de Boulogne, has lunch at the Ritz, meets in the afternoon at the Cercle Interallié (the former hotel of Henri de Rothschild) to finish her evening until the early morning hours in a jazz club, as the Jardin de ma soeur located in central Paris."

18 From April 1, 1921, French *Vogue* was printed in Paris, at G. de Malherbe et Cie. See the announcement in the April 1, 1921 issue of "*Vogue* derrière la rampe," 36: "We were going to London to organize the publication of French *Vogue*, which was prevented by circumstances from printing in Paris. . . . It is in France from now on that we will continue our essentially French work."

19 *Femina* was founded in February 1901 by Pierre Lafitte. Following the example of *Gazette du bon ton*, in the 1920s, he employed illustrators Pierre Brissaud, Georges Lepape, Paul Iribe, Benito, André Édouard Marty, and Georges Barbier. *L'Officiel de la couture et de la mode de Paris* was created in 1921 by Max Brunhes.

20 Mexican-born and naturalized American Philippe Ortiz had already been appointed head of Europe for the Condé Nast group before the creation of French *Vogue*. It was probably more for his connections with the world of couture that Nast hired him. He was replaced by Albert Lee in 1928, Iva S. V. Patcévitch in 1932, then successively Francesca van der Kley and Thomas Kernan from 1937 to 1940.

21 In 1928 the offices of French *Vogue* moved to 65, avenue des Champs-Élysées. The magazine's premises were located on two floors, each consisting of four offices and a long hallway leading to the mailroom and delivery room. In addition to the three offices reserved for the French editor in chief and the editors, the fourth was occupied by the representative of Condé Nast and administrative director of the Paris office. See Susan Train's interview with Léone Friedrich (December 1995), Condé Nast Archives, quoted by Sophie Kurkdjian in *Lucien Vogel et Michel de Brunhoff, parcours croisés de deux éditeurs de presse illustrée au xxᵉ siècle*, Bayonne, Institut Universitaire Varenne, Theses Collection (2014).

22 See Edna Woolman Chase, Ilka Chase, *Always in Vogue*, London, Victor Gollancz Ltd., (1954): 294.

23 After the arrival of Cosette Vogel, readers could write to the magazine or go directly to the offices of *Vogue*. On March 15, 1922, French *Vogue* established an information office and, at the end of 1923, a shopping and travel service accessible to all readers. Each month this service responded to mail requests and provided more information on new fashion. See *Vogue Paris* (July 1, 1922).

24 Solange d'Ayen joined *Vogue* in 1928 before being officially hired by Condé Nast in October 1929. See the Duchess Solange d'Ayen file (Edna Woolman Chase Papers, Condé Nast Archives, New York).

25 As evidenced by an advertisement in the August 1922 issue, the *Vogue Paris* studio was initially placed under the direction of Wladimir Rehbinder. Also known as the "art photography atelier," it was located at 11, rue Saint-Florentin in December 1923. "If you want a beautiful portrait in which a consummate talent is combined with the science from the most expert technician, order it from VOGUE-STUDIO, and you'll finally know what can result from beautiful photographic art." ("10 raisons pour lesquelles vous devez lire" *Vogue*, *Vogue Paris* (December 1923): 74.

26 Colette wrote the editorial of French *Vogue* from December 1, 1924 to the end of 1925 while writing other articles in the magazine, including "Le printemps de demain (February 1925): 31, and "Élégance ?. . . Économie ?. . ." (May 1925): 31. This was a productive collaboration and lasted for many years.

27 Jean Giono, "Hiver," *Vogue Paris* (January 1934): 37.

28 Louise de Vilmorin, "Beau temps," *Vogue Paris* (March 1935): 51.

29 Max Jacob, "La jeune fille dans la commode," *Vogue Paris* (April 1932): 51.

30 "Quelques dessins de Cocteau," *Vogue Paris* (January 1, 1926): 32–33.

31 Memo from Lucien Vogel to Agha, "Private no. 120. DURST" (December 18, 1936), Condé Nast Papers, Condé Nast Archives, New York.

32 Lucien Vogel's letter to Condé Nast, "Joffé the photographer" (January 19, 1942), Condé Nast Papers, Condé Nast Archives, New York.

33 Letter from Lucien Vogel to Agha, "Private no. 120. DURST" (December 18, 1936), Condé Nast: "Notwithstanding all this, we are not satisfied that we have solved the photographic problem and Brunhoff is constantly on the search for new and better photographers. All of the editors are most ready to give talent a chance."

34 In 1928, after the relocation of *Vogue Paris*, the studio was moved to the sixth floor of the new premises on the Champs-Élysées. It was then headed by Mademoiselle Dilé. "According to the studio's first manager, Simone Eyrard, recalling the detail, the photo shoots in the 1930s looked like a real mess where nothing seemed really organized. She recalls being dismayed in the early days by the disorder that reigned on the premises of French *Vogue* during the photo shoots." (Quoted by Sophie Kurkdjian in *Lucien Vogel et Michel de Brunhoff, parcours croisés de deux éditeurs de presse illustrée au xxᵉ siècle, op.cit.)* The studio closed just before the war.

35 Agha's memorandum of August 25, 1930, addressed to "Mr. Nast, Mrs. Chase, Mrs. Snow," Edna Woolman Chase Papers, Condé Nast Archives, New York: "I think that De Brunhoff's efforts must be directed toward discovering artists who can produce material of an artistic and brilliant kind which we need so badly and I think we must make it quite clear to him."

36 Letter from Lucien Vogel to Condé Nast (September 30, 1941), Condé Nast Papers, Condé Nast Archives, New York.

37 Letter from E. W. Chase written in collaboration with Dr. Agha and sent to Brunhoff on April 13, 1938, Edna Woolman Chase Papers, Condé Nast Archives, New York.

38 Ibid., "The fact is that the whole present trend, both in magazine making and in advertising, which calls for great effects—bleed pages, striking presentation of pictures, etc.—is really of French or European origin, and there are many pieces of printed matter designed in France which are the supreme expression of this trend. Somehow, however, the fashion magazines in France, do not respond to this new influence as quickly as American magazines, and we can't help feeling that, from our point of view and perhaps even from the point of view of more advanced French typographer, the French *Vogue* attack is more-or-less old-fashioned."

39 This section, which appears in the March 1933 issue, features eight photographs each promoting an outfit created by a fashion house (Patou, Lanvin, Piguet, Chanel, Heim, etc.). Initially, these photographs are collectively credited with "VOGUE-STUDIO." From 1938 the portfolio was credited in the magazine's table of contents and expanded to some twenty pages, resembling a fashion editorial series. It showcased either an artist (portfolio of creators by Eric in April 1939) or the star photographer of the studio (portfolio of Erwin Blumenfeld in October 1938, portfolio of André Durst in November 1938 and March 1940).

40 As Sophie Kurkdjian explains in *Lucien Vogel et Michel de Brunhoff, parcours croisés de deux éditeurs de presse illustrée au xxᵉ siècle, op.cit.*, 286–290.

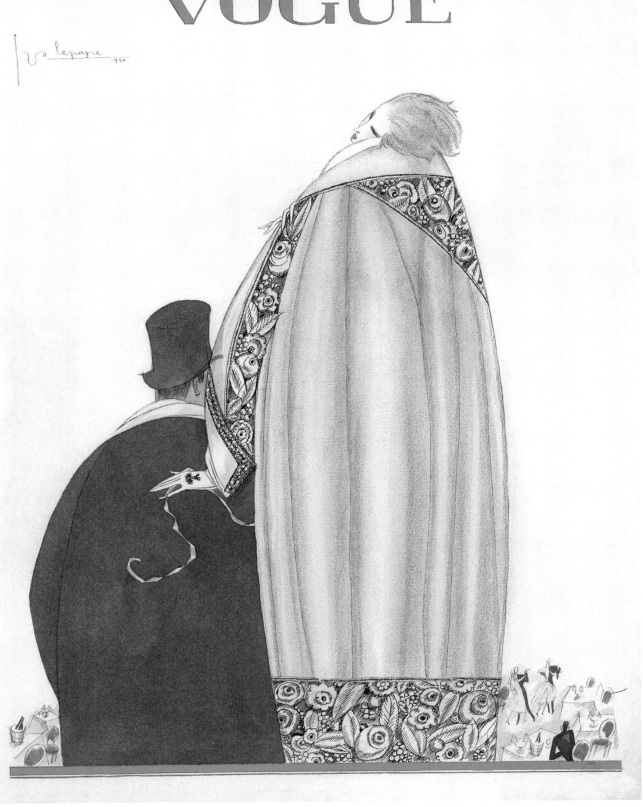

cat. 7 Georges Lepape. Evening coat. American *Vogue*, October 15, 1920, cover and *Vogue Paris*,
 November 1, 1920, cover

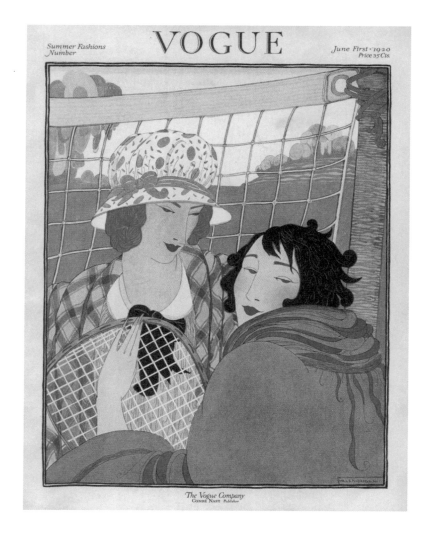

cat. 60 Helen Dryden. American *Vogue,* June 1, 1920, cover

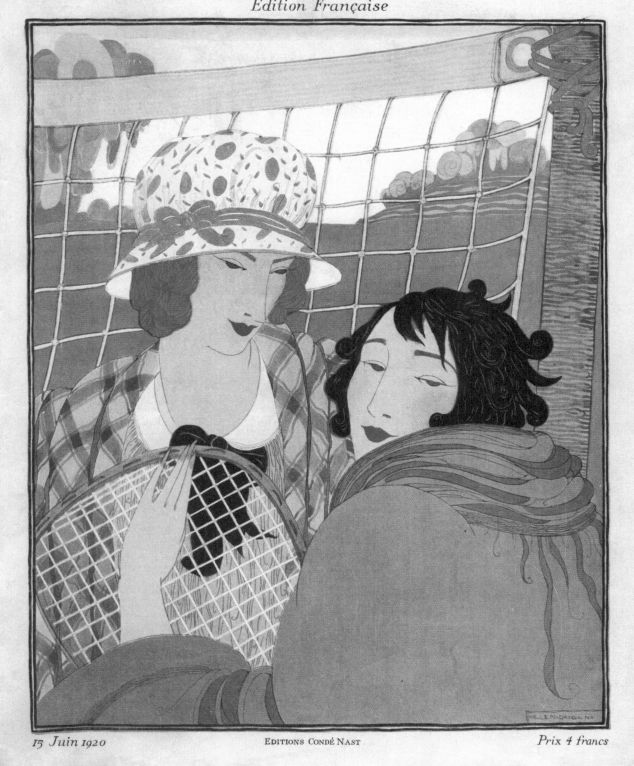

cat. 61 Helen Dryden. *Vogue Paris*, June 15, 1920, cover

cat. 9 Georges Lepape. "La loge de Françoise." Chéruit dress. *Vogue Paris*, November 1922, p. 16
and American *Vogue,* January 1, 1923, p. 82

cat. 2 Wladimir Rehbinder. Jane Renouardt in *Une sacrée petite blonde* by Pierre Wolff
and André Birabeau. Jeanne Lanvin dress. *Vogue Paris*, February 1, 1922, p. 17

cat. 4 Adolphe de Meyer. Elsie Ferguson. Callot Sœurs dress. American *Vogue,* February 1, 1921, p. 40 and *Vogue Paris,* February 15, 1921, p. 16

(En bas) Ravissante petite
robe en charmeuse d'un ton
corail très vif. La jupe est
formée par une tunique en
forme et le corsage est très
ouvert et fait valoir les bras

(En haut) Chéruit avait une
généreuse la jour où il
composa cette robe en crêpe
Georgette noir, car elle lui
donna six traînes et il
orna la jupe de perles

Cape du soir, en tissue d'or très fin, sur tulle orange, orné d'une
ruche de plumes d'autruche orange. Ceci nous indique quelles plumes
d'autruche vont continuer d'orner les manteaux d'été de leur souplesse

Cette robe inspirerait une sérénade sous le
soleil d'Andalousie, avec sa jupe en dentelle
noire émigrare et son corsage en crêpe orange
qui se termine par une ceinture. Celle-ci orné
ée d'une rose magnifique et prolongé en traîne

QUELLE ROBE DU SOIR

NE SERAIT EMBELLIE PAR

LE NUAGE LÉGER D'UNE

TRAÎNE DE MOUSSELINE

DE SOIE QUI ONDULE

Une baguette magique a métamorphosé un
arc-en-ciel de mousselines de soie rouge,
mauve et rose en une robe du soir légère aux
panneaux flottants, dont la ceinture est
composée de coraux et de perles d'argent

Tombant de la ceinture lâche d'une robe de
mousseline de soie couleur corail, flotte une
traîne de mousseline de soie assortie. Des
fleurs de soie tendue flamme l'épanouis-
sent sur le corsage. Les couleurs sont d'argent

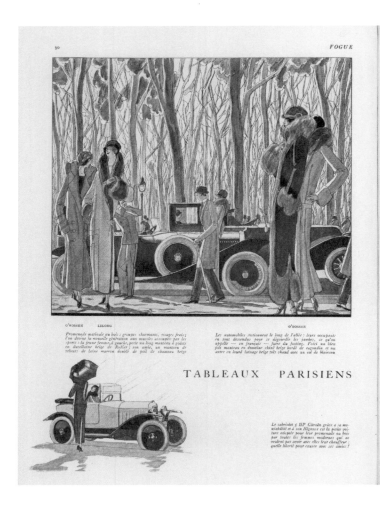

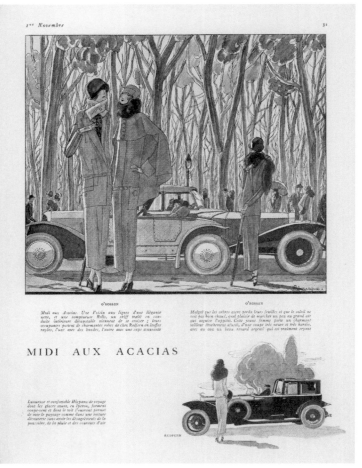

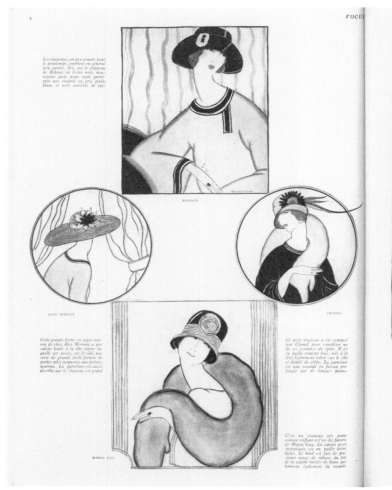

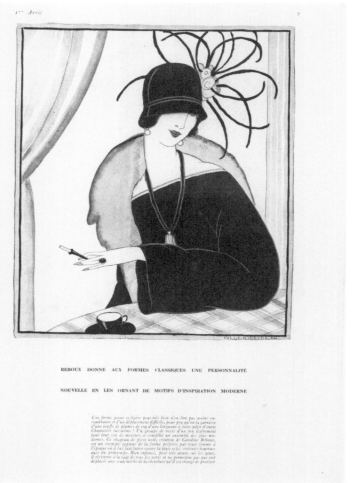

ill. 5 Pierre Mourgue. *Vogue Paris*, November 1923, pp. 30–31

1920–1938 ill. 6 Helen Dryden. *Vogue Paris*, April 1, 1922, pp. 6–7

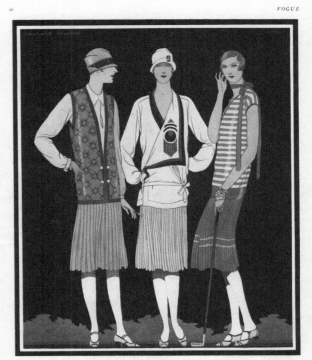

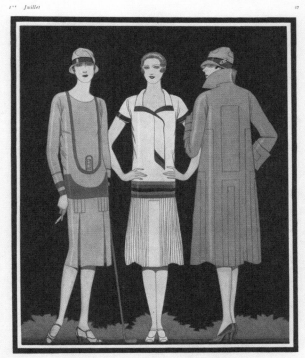

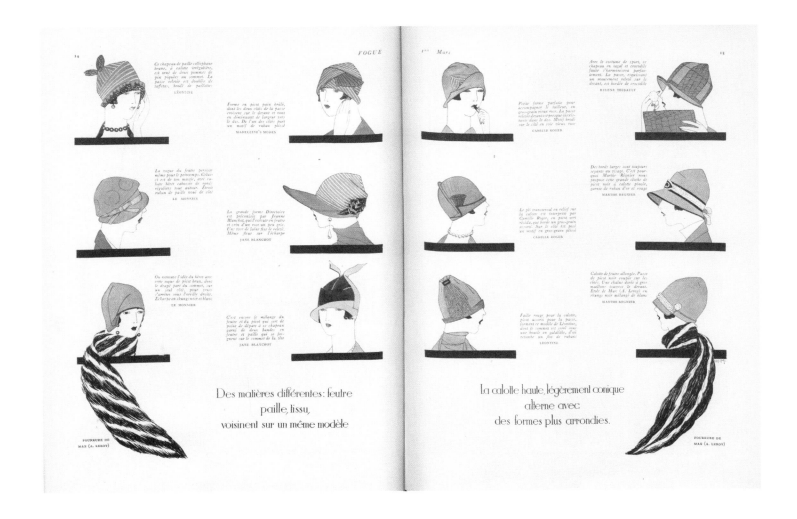

44 VOGUE JANVIER 1931 45

MADELEINE VIONNET
CE MANTEAU À TAILLE HAUTE EST EN HERMINE ET
VELOURS BOURGOGNE DENTELÉ DANS LE BAS. LES
BIJOUX ET CEUX DE L'AUTRE PAGE SONT DE CARTIER

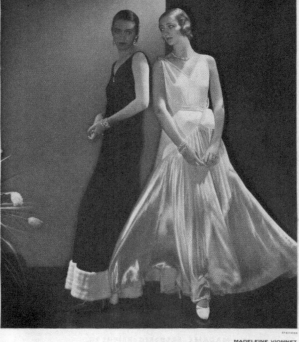

MADELEINE VIONNET
UN LOURD VELOURS NOIR AMPLEMENT BORDÉ D'HERMINE
TOMBE D'UNE SEULE LIGNE JUSQU'EN BAS. L'AUTRE
ROBE COMBINE CRÊPE ET PANNE BLANCHE BRILLANTE

1920–1938 cat. 11 Edward Steichen. Marion Morehouse (left and center). Madeleine Vionnet coat, Cartier jewelry (left page). *Vogue Paris*, January 1931, pp. 44–45

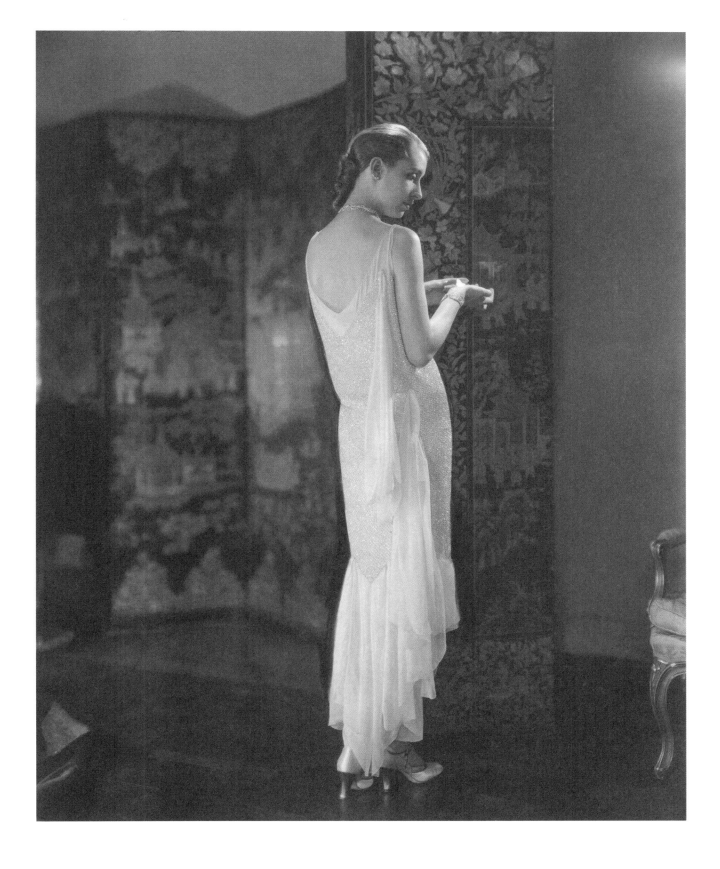

ill. 8 Edward Steichen. Marion Morehouse. Chanel dress. Apartment of Condé Nast, New York. *Vogue Paris*, December 1927, p. 16

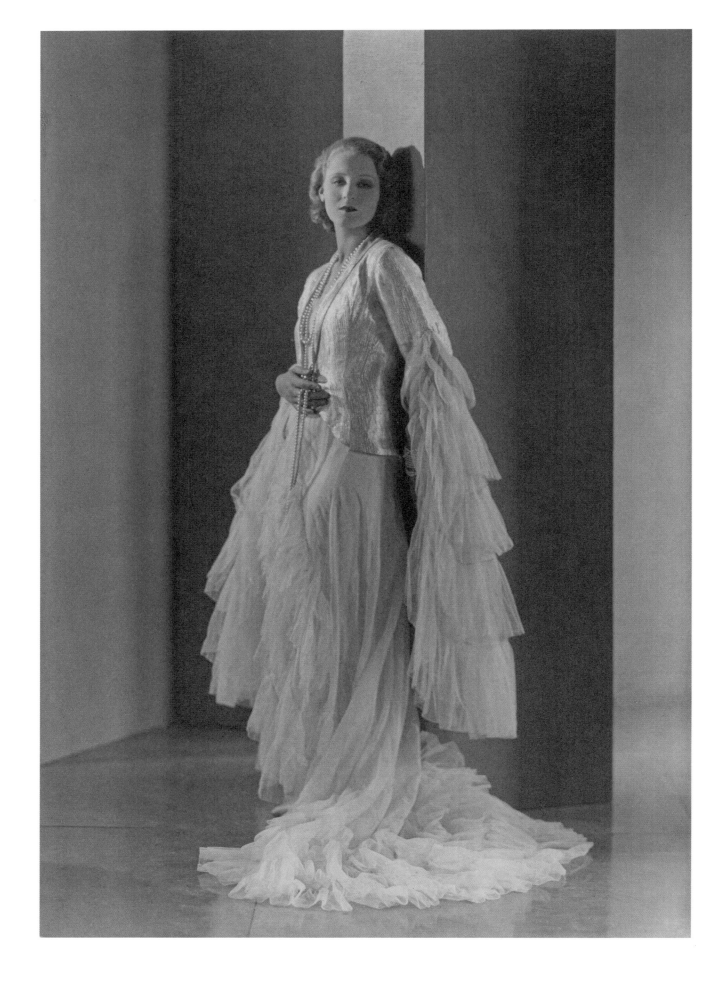

cat. 12 George Hoyningen-Huene. Brigitte Helm in *L'Argent* by Marcel L'Herbier (1928).
Louise Boulanger dress. *Vogue Paris*, October 1928, p. 39 and American *Vogue,*
February 16, 1929, p. 70

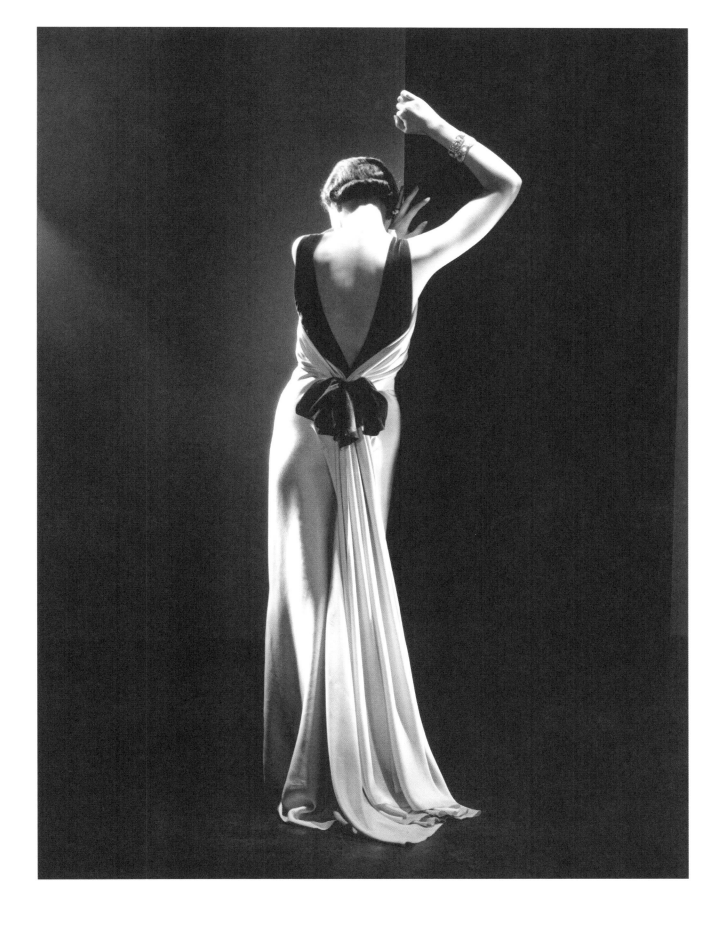

cat. 13 George Hoyningen-Huene. Toto Koopman. Augustabernard dress. American *Vogue*, September 15, 1933, p. 31 and *Vogue Paris*, October 1933, p. 22

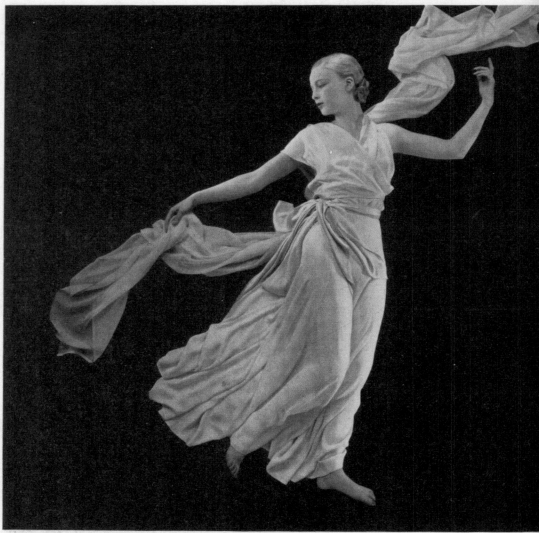

MADELEINE VIONNET

BAS-RELIEF

de Hoyningen-Huene

Texte de Jean-Louis Vaudoyer

Devant la double image de cette jeune mort comment ne pas songer à ses sœurs divin aux Victoires sans ailes qui dansèrent pendant siècles sur la frise du petit temple grec, posé con en vedette à l'extrême pointe de l'Acropole ?... marbres sont maintenant montrés dans un m un peu triste, où ils sont, hélas, à jamais privé ce que leur donnaient d'imprévisiblement vivant jeux de la lumière et les caprices du ciel.

Il serait maladroit et imprudent de deman aux couturiers d'habiller nos contemporaines

cat. 15 and 16 George Hoyningen-Huene. Sonia Colmer. Madeleine Vionnet dress.
Vogue Paris, November 1931, pp. 24–25

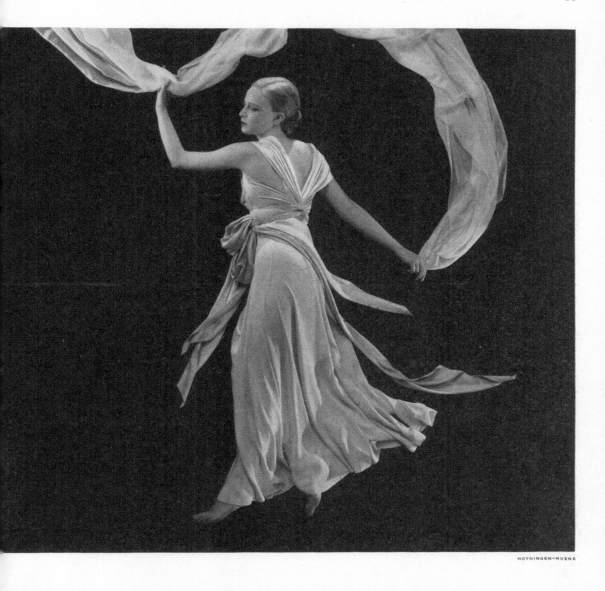

HOYNINGEN-HUENE

l'idée d'en faire des déesses. Mais cette robe de Vionnet n'a-t-elle pas le mérite exceptionnel (que la grâce du modèle rend peut-être miraculeux) de suggérer sans imiter ; d'être une allusion sans être une copie ?

L'une des lois fondamentales de la représentation plastique de la forme en mouvement est d'associer, jusqu'à les confondre, le corps et le vêtement. La tunique d'une nymphe grecque, la robe d'une princesse gothique ont pour rôle de préciser les proportions, de caractériser l'attitude, d'accompagner le geste. La robe que voici, sans cesser d'être la robe d'une femme d'aujourd'hui, a le pouvoir peu commun de donner à la réalité directe les prolongements de la réalité imaginée. Elle nous offre à la fois un spectacle et une évocation. Cette svelte, harmonieuse et agile élégante, que les voiles et les écharpes enveloppent d'un halo de poésie, nous rappelle l'inconnue que P.-J. Toulet rencontra un jour, qu'il ne nomme pas, mais dont il dit beaucoup en disant seulement : " Elle était belle comme les choses qu'on regarde avec la mémoire. "

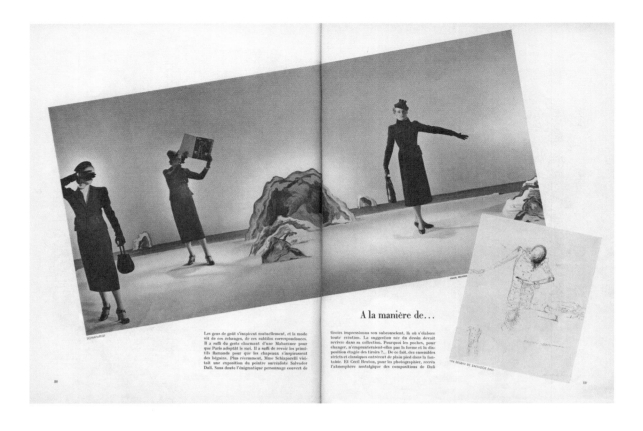

cat. 71 Cecil Beaton. Schiaparelli ensembles. Drawing by Salvador Dalí. *Vogue Paris*, December 1936, pp. 58–59

cat. 18 Horst P. Horst. "Le point de vue de *Vogue*." Décor by Emilio Terry. American *Vogue*, March 15, 1936, p. 66 and *Vogue Paris*, April 1936, p. 31

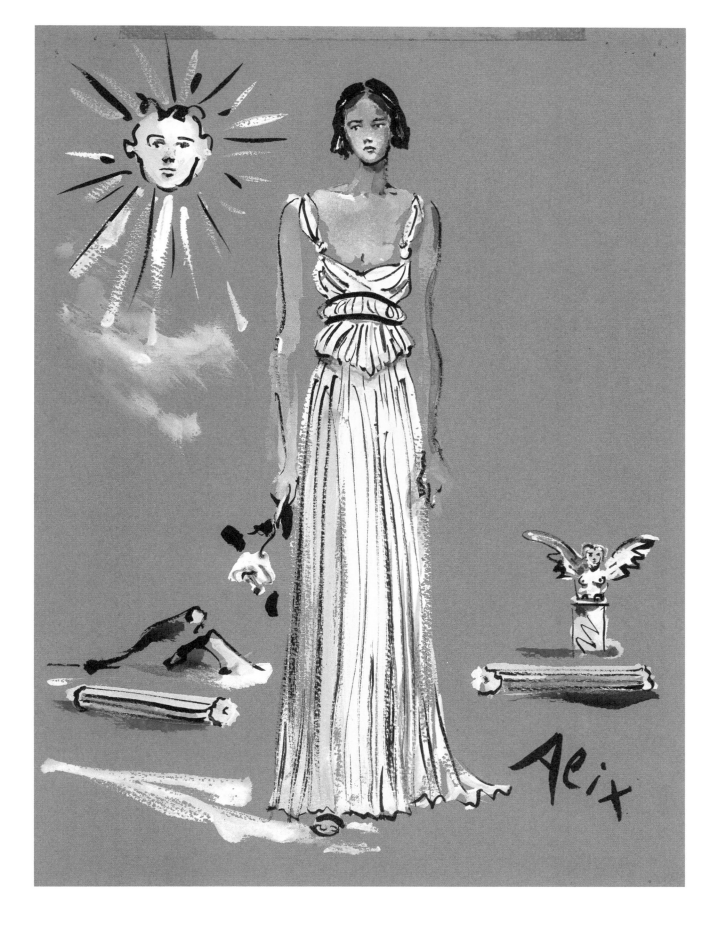

cat. 17 Christian Bérard. Alix dress. *Vogue Paris,* October 1937, p. 113

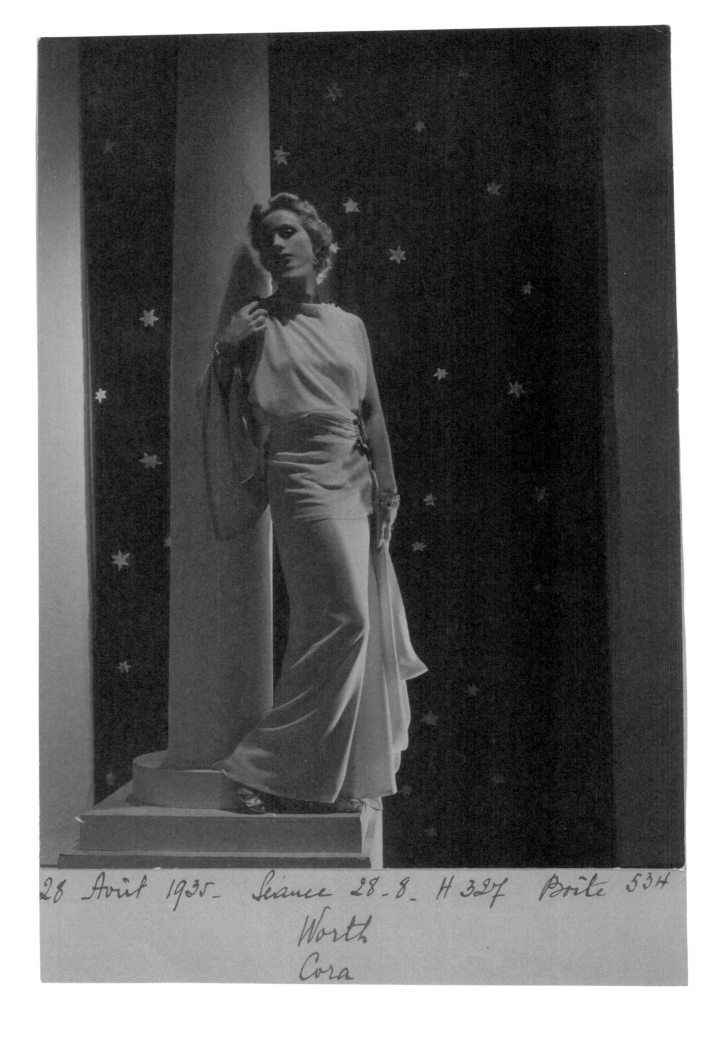

28 Avril 1935. Séance 28-8. H 327 Boite 534
Worth
Cora

cat. 20 Horst P. Horst. Cora Hemmet. Worth dress. *Vogue Paris*, October 1935, p. 32

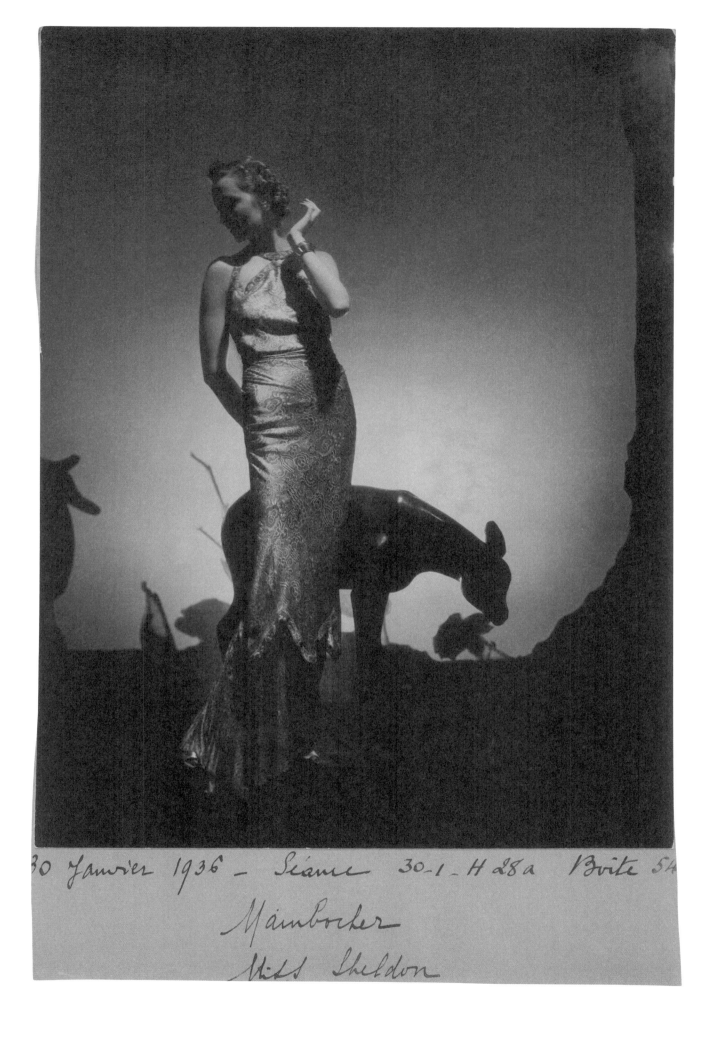

30 Janvier 1936 – Séance 30-1 – H 28a – Boîte 54

Mainbocher

Miss Sheldon

cat. 21 Horst P. Horst. Louise Sheldon. Mainbocher dress. *Vogue Paris*, March 1936, p. 46
and American *Vogue,* March 1, 1936, p. 55

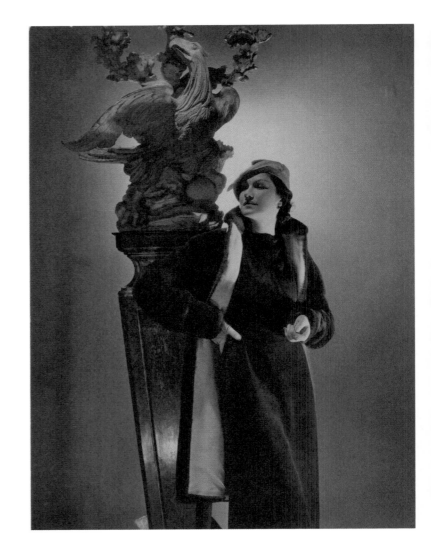

cat. 22 Horst P. Horst. Comtesse de la Falaise. Creed suit, Reboux hat. *Vogue Paris*, August 1934, p. 20
cat. 23 Horst P. Horst. Worth dress and coat, bronze statue by Baguès. *Vogue Paris*, August 1934, p. 44

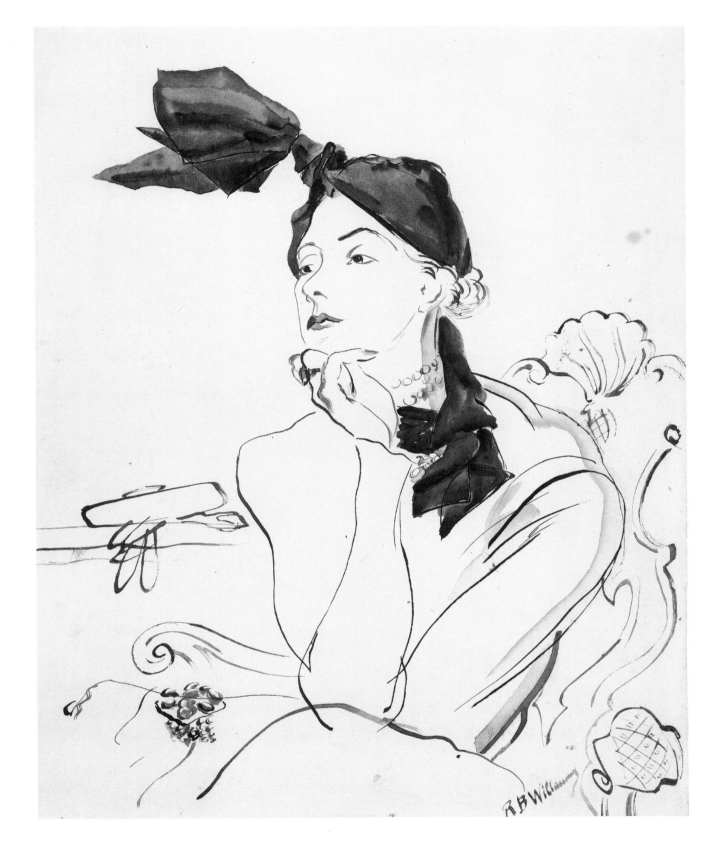

cat. 24 René Bouët-Willaumez. Suzanne Talbot scarf and hat. *Vogue Paris*, February 1935, p. 39

Frog,
A Transatlantic Magazine

cat. 27 Carl Erickson, known as Eric. Maria Guy hat, Worth scarf (left). Agnès hat, Schiaparelli scarf
 (right). *Vogue Paris*, March 1932, p. 27 and American *Vogue,* March 15, 1932, p. 59
cat. 67 George Hoyningen-Huene. Schiaparelli ensembles (left page). Léda and Rivolia trench
 coats (right page). *Vogue Paris*, May 1928, pp. 24–25

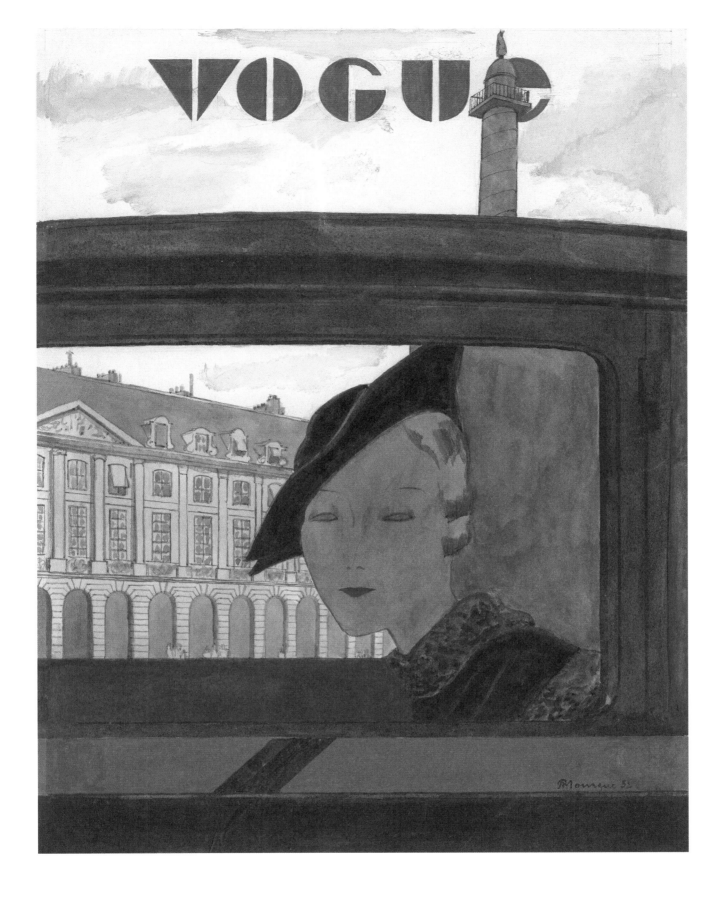

cat. 25 Pierre Mourgue. "L'automne à Paris." *Vogue Paris*, November 1932, cover and American
Vogue, November 1, 1932, cover

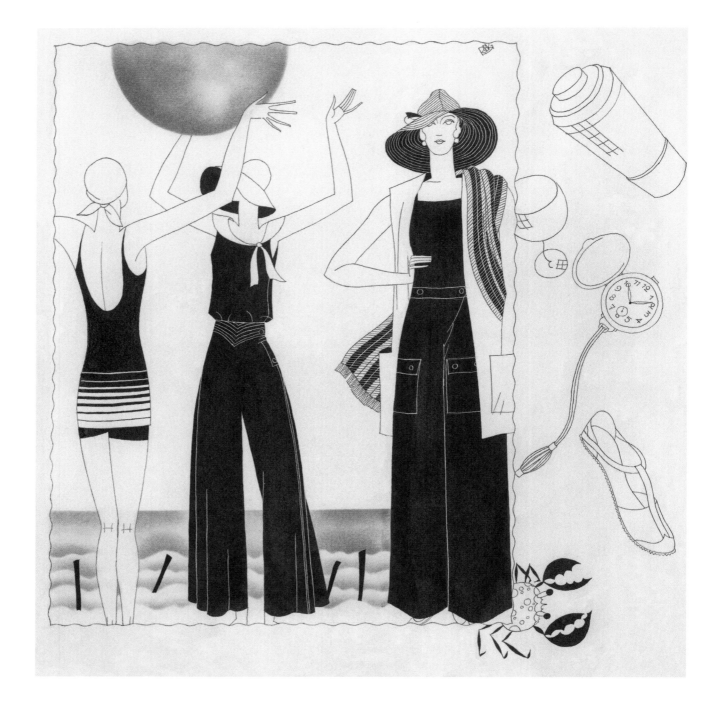

cat. 32 Raymond Bret-Koch. Au Grand Frédéric swimwear, Irande beach pajamas, Schiaparelli ensemble, Hermès accessories. *Vogue Paris*, July 1929, p. 54 and American *Vogue,* July 6, 1929, p. 45

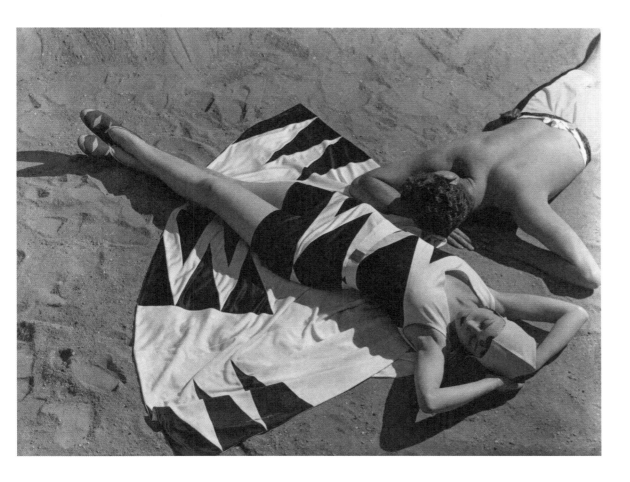

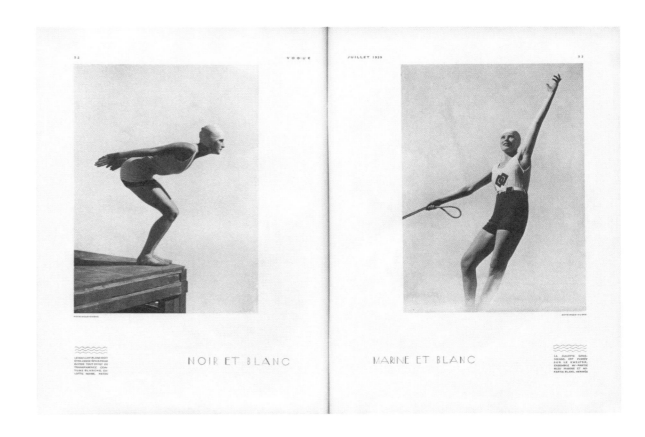

cat. 29 George Hoyningen-Huene. Beer beach ensemble. *Vogue Paris*, July 1928, p. 17
and American *Vogue,* July 1, 1928, p. 41

cat. 30 and 31 George Hoyningen-Huene. Jean Patou swimwear (left page) and Hermès swimwear
(right page). *Vogue Paris*, July 1929, pp. 52–53

cat. 34 George Hoyningen-Huene. Marguerite Jay slip. American *Vogue*, November 15, 1931, p. 74, and *Vogue Paris*, January 1932, p. 46

cat. 69 Edward Steichen. *Vogue Paris*, July 1934, pp. 16–17

cat. 35 George Hoyningen-Huene. Siégel mannequin, Marie Alphonsine beret, Jean Patou coat.
Vogue Paris, September 1928, p. 11, and American *Vogue,* September 15, 1928, p. 73

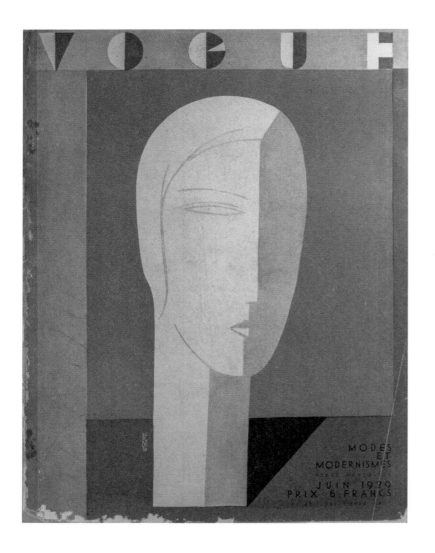
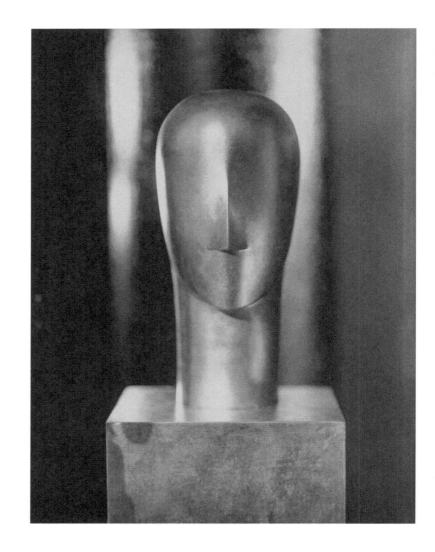

ill. 9 Benito. *Vogue Paris*, June 1929, cover
ill. 10 George Hoyningen-Huene. Siégel model head. *Vogue Paris*, June 1928, p. 1

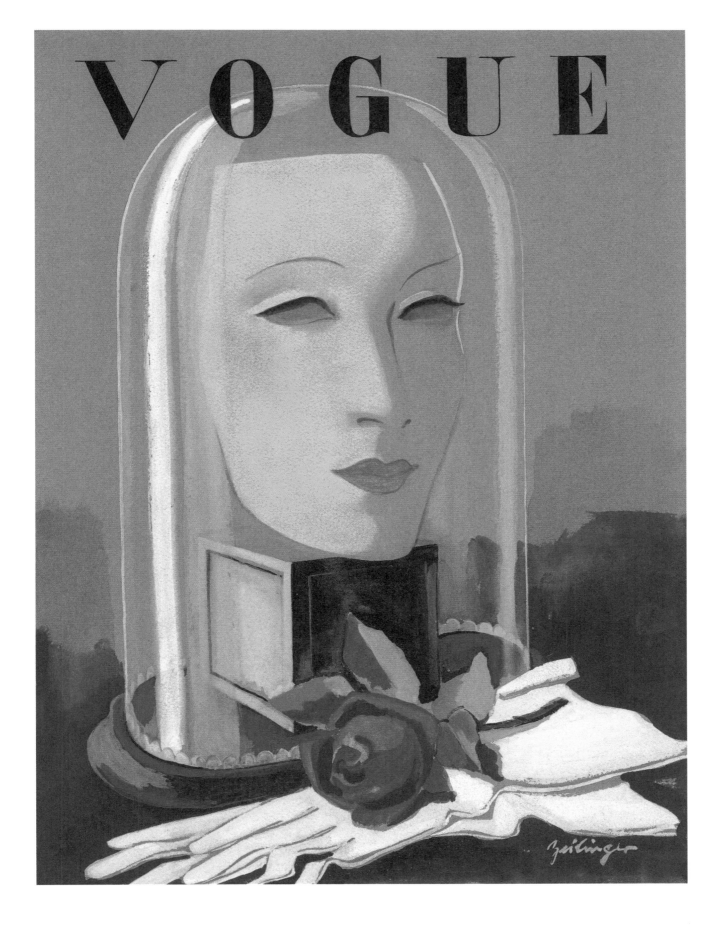

cat. 36 Léopold "Alix" Zeilinger. American *Vogue*, November 1, 1934, cover and *Vogue Paris*,
January 1935, cover

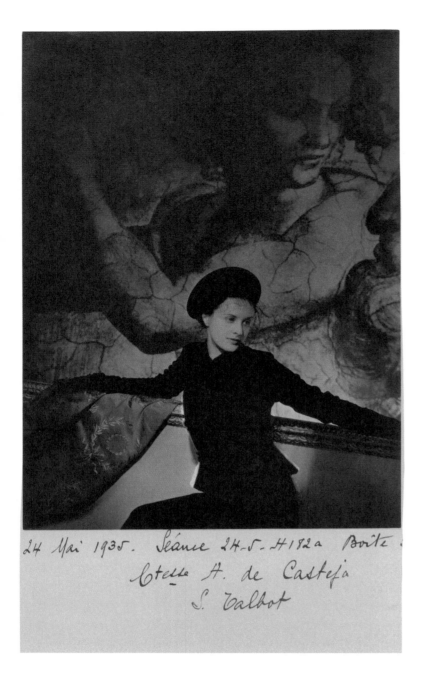

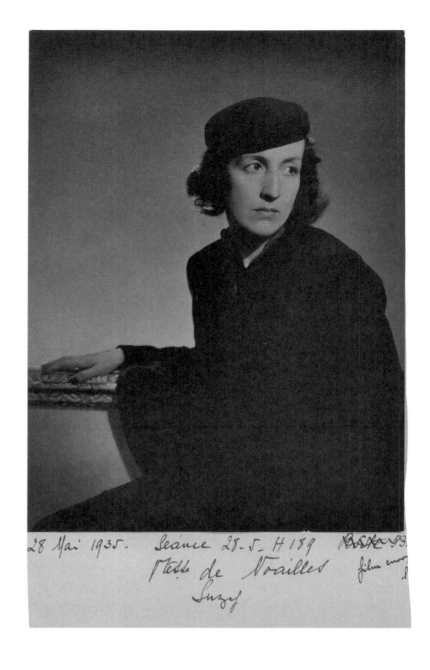

cat. 43 Horst P. Horst. Countess Alexandre de Castéja. Georgette Rénal ensemble, Suzanne Talbot
hat. *Vogue Paris*, July 1935, p. 29 and American *Vogue,* July 1, 1935, p. 26 (variation)

cat. 42 Horst P. Horst. Vicomtesse de Noailles. Schiaparelli ensemble, Suzy hat. *Vogue Paris*,
July 1935, p. 28 and American *Vogue,* July 1, 1935, p. 28

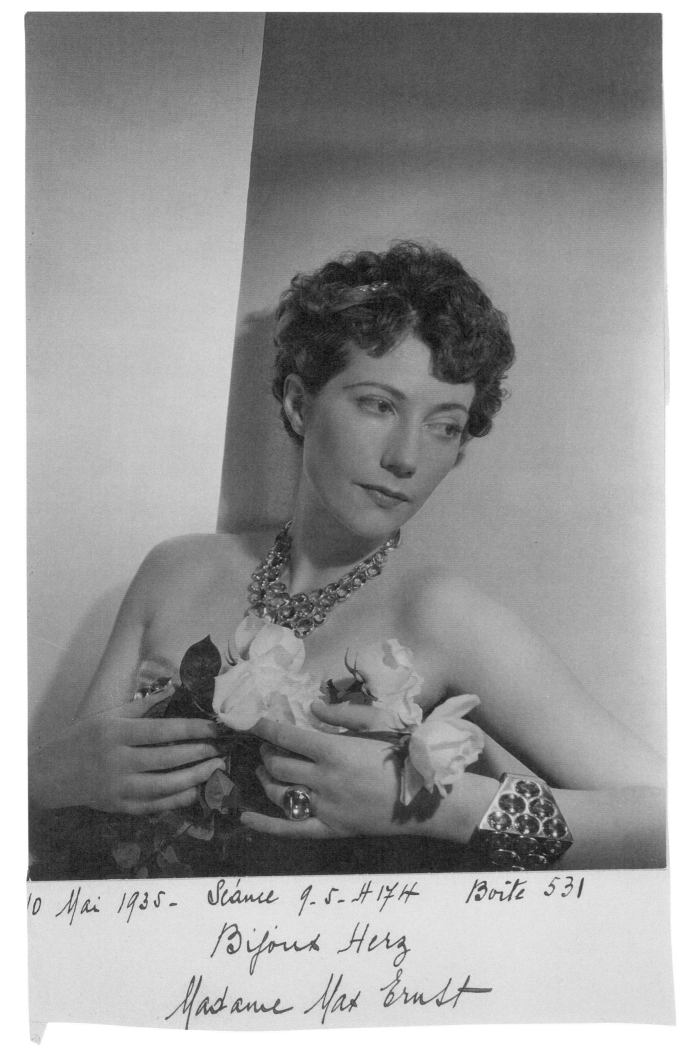

10 Mai 1935 – Séance 9.5.H174 Boîte 531

Bijoux Herz

Madame Max Ernst

cat. 44 Horst P. Horst. Madame Max Ernst (Marie-Berthe Aurenche). Herz jewelry. American *Vogue,*
July 1, 1935, p. 51 and *Vogue Paris*, September 1935, p. 41

JEUNESSE

par la Princesse Bibesco

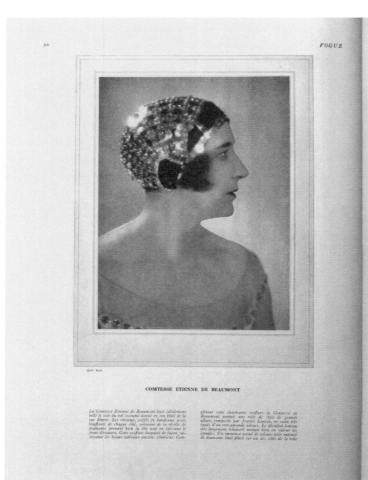

La Vicomtesse de Noailles

COMTESSE ETIENNE DE BEAUMONT

ÉLÉGANCE?... ÉCONOMIE?...

Par COLETTE

cat. 68 André Durst. Vicomtesse de Noailles. Text by Princess Bibesco. *Vogue Paris*, September 1933, pp. 26–27

cat. 63 Man Ray. Comtesse de Beaumont. Jeanne Lanvin headband and dress. Text by Colette. *Vogue Paris*, May 1925, pp. 30–31

1920–1938

cat. 39 Man Ray. Self-portrait with Meret Oppenheim, 1930 (unpublished)

34

Voici, prise par lui-même, la photographie de M. Man Ray, l'excellent opérateur américain qui est l'auteur des singulières fantaisies photographiques reproduites ci-dessus. La première impression produite, après un légitime étonnement, est une impression de modernisme qui apparente ces étranges compositions avec les plus récentes créations de l'art moderne en peinture et en mise en scène. Et cela nous plaît au premier coup d'œil

Comment sont faites ces études sur papier sensible exécutées sans l'aide de l'appareil photographique ? Des objets, qu'un examen de ces images vous fera peut-être identifier, sont placés sur la feuille de papier sensible, et c'est la lumière qui fait le tableau en noircissant les parties qui ne lui sont pas cachées par les objets. Et voilà un art charmant, qui donne des résultats d'un modernisme cocasse, d'un effet hallucinant, déconcertant et un peu mystérieux

ÉTUDES EN BLANC ET NOIR

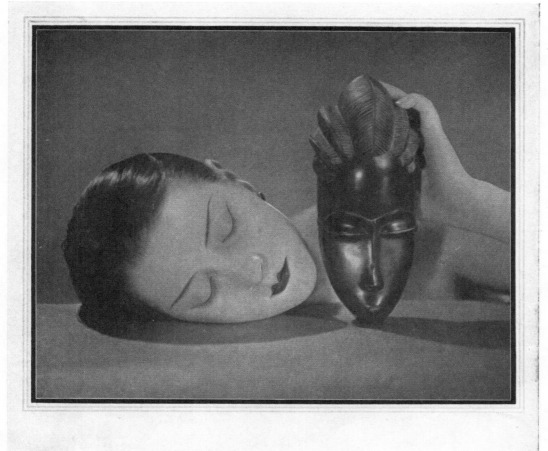

Photo Man Ray. Masque appartenant à M. Georges Sakier

Visage de la femme, doux œuf
transparent tendant à se débar-
rasser de la toison par où il
tenait encore à une nature pri-
mitive ! C'est par les femmes que
s'accomplira l'évolution qui por-
tera à son suprême degré l'espèce
au passé plein de mystère. Do-
lente parfois, elle revient avec un
sentiment de curiosité et d'effroi à
l'un des stades par où passa, peut-
être, avant de parvenir jusqu'à
nous, la blanche créature évoluée

VISAGE de NACRE
et
MASQUE d'ÉBÈNE

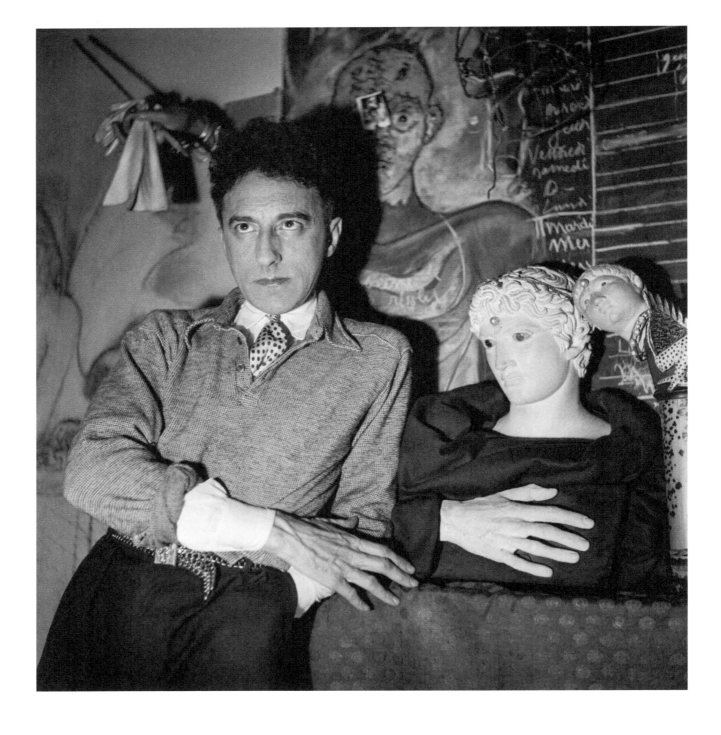

cat. 41 Studio Lipnitzki. Jean Cocteau, 1934 (unpublished)

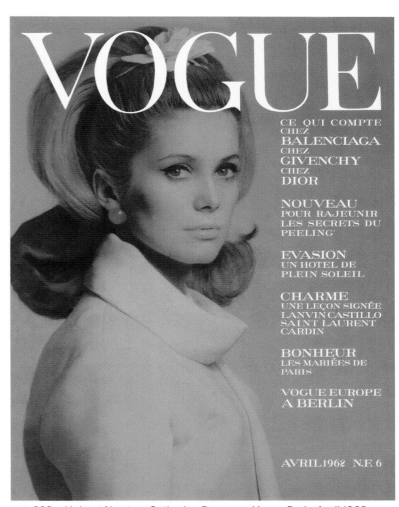

cat. 222 Helmut Newton. Catherine Deneuve. *Vogue Paris*, April 1962

On the cover of its first issue, French *Vogue* featured nothing particularly notable. There was no famous figure, no unforgettable attention-grabber, no irresistible fashion—only a colorful illustration by Helen Dryden depicting two elegant women about to play a game of badminton, the same image used on the cover of the June 1920 edition of American *Vogue*. Brushing aside its French distinctions, the newly born *Vogue* aligned itself with its New York predecessor and borrowed its covers, which were primarily filled by illustrations. Condé Nast recruited the best fashion illustrators in the United States, including Dryden and George Plank, who drew beautiful figures—refined, cultured, sometimes sporty, and always dressed in the latest fashion. Now the great Nast wanted to offer his aesthetic readers the thrill of modern art, and called on aspiring artists from the École des Beaux-Arts in Paris, under the aegis of Lucien Vogel. The first exclusive cover of French *Vogue* was by André Marty; in March 1922 the "new summer collections of the great couturiers" were advertised by the image of a cherry tree—a metaphor perhaps for the ephemeral nature of fashion. The "anxiety of war" was being left behind, and the world fell under the spell of the Roaring Twenties. French fashion illustrator Georges Lepape and Spanish fashion illustrator Eduardo Garcia Benito captured the flapper look like no one else. A disciple of Cubism, Benito propelled the magazine into the realm of art deco and emphasized *Vogue*'s modernist identity.

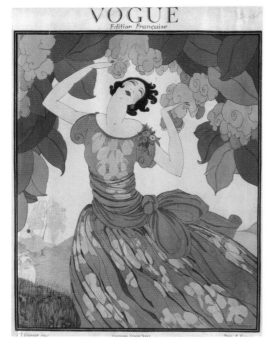

ill. 1

ill. 2

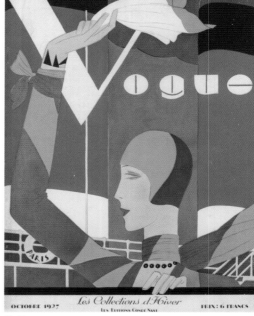

ill. 3

ill. 4

ill. 5

ill. 1 Helen Dryden. *Vogue Paris*,
 February 15, 1921
ill. 2 George Wolfe Plank. *Vogue Paris*,
 March 15, 1921

ill. 3 Georges Lepape. *Vogue Paris*,
 April 1928
ill. 4 André Marty. *Vogue Paris*, March 15,
 1922

ill. 5 Benito. *Vogue Paris*, October 1927

The stock market crash of 1929, which would ruin Nast, did not seem to affect the *Vogue* woman. While American fashion illustrator Carl Oscar August Erickson, known as Eric, offered her a new look in the 1930s, Edward Steichen photographed her in a bathing suit for the July 1932 cover, making *Vogue* the first magazine to put a color photograph on its cover. Although this marked a turning point, Michel de Brunhoff, the brother of Cosette Vogel, and now at the reins of French *Vogue,* clearly preferred the work of Christian "Bébé" Bérard. The latter designed two strikingly patriotic covers: Hands knitting in the colors of the French flag in December 1939, and a galleon bringing liberation to Paris in January 1945. When the Second World War ended, French *Vogue* returned and was determined to celebrate Paris, elevated by illustrators Coltellacci and Nobili and captured in photographs by Robert Doisneau and Robert Randall. For the first time, the figure of the Parisienne was shown smiling brightly, and the magazine took on its instantly recognizable cover typography.

Edmonde Charles-Roux brought a renaissance when she took control in September 1954. Christian Dior's new collection—the so-called "H" line—was splashed across the cover, captured by Clifford Coffin, who popularized the use of the ring light. New headlines heralded an impending baby boom. From "Finds for Young People"[1] to the "Special Ready-to-Wear Issue,"[2] the covers of *Vogue,* an elite

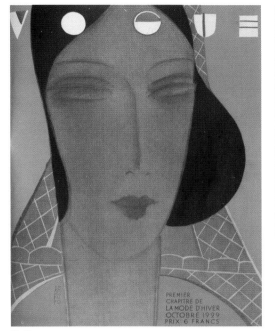

ill. 6

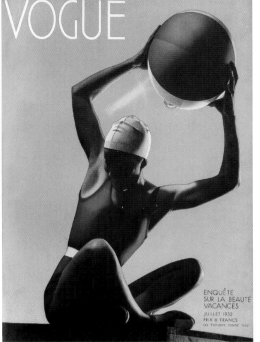

ill. 7

ill. 8

ill. 9

ill. 10

ill. 6	Benito. *Vogue Paris*, October 1929	ill. 8	Horst P. Horst. *Vogue Paris*, August 1936
ill. 7	Edward Steichen. *Vogue Paris*, July 1932	ill. 9	Carl Erickson, known as Eric. *Vogue Paris*, March 1936
		ill. 10	Horst P. Horst. *Vogue Paris*, May 1939

magazine, embraced the "ready made" on a grand scale as fashion grew into an industry—thanks to Lempereur, one of its major advertisers. The heirs of Dior and Balenciaga relaxed the rules of haute couture. In the wake of the "Moon Girl" by André Courrèges,[3] Yves Saint Laurent responded with a Mondrian dress, partly merging into its white background.[4] *Vogue Paris* reflected op art and left illustrated covers behind forever when Gruau passed the baton to Guy Bourdin,[5] a young rebel who would

become a key contributor to the venerable magazine. In the Swinging Sixties, it was Englishman David Bailey who made his mark on *Vogue* with his glamour girls, including Jean Shrimpton, the first star model to receive her own cover credit.[6] He also captured the cool charm of Catherine Deneuve, who smiled for his camera then said "I do" to him in real life in October 1965. This was his second cover; fourteen more would follow.

Vogue Paris now had its head in the clouds and its feet on the ground. It took a step toward change with Cardin's bold red miniskirt, showing a close-up of legs in motion and the big question: "Where are we going?"[7] Vogue wanted to reach young girls from good families—future subscribers—and celebrated Béatrice Dautresme, who had just turned twenty-two, in May 1968. Henry Clarke captured her sweet smile, contradicting his "rebel credentials."[8] General strikes in Paris meant

ill. 11

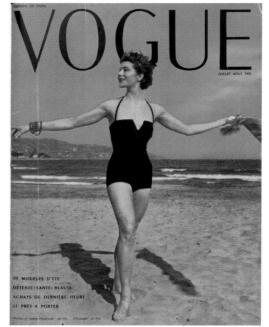

ill. 12

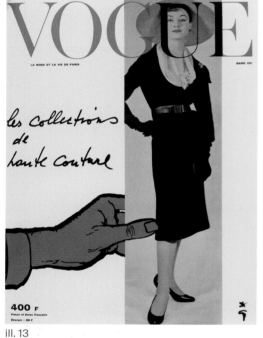

ill. 13

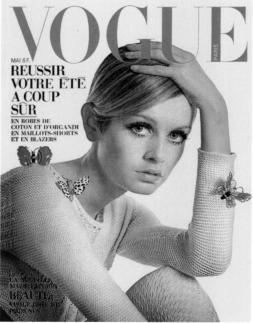

ill. 14

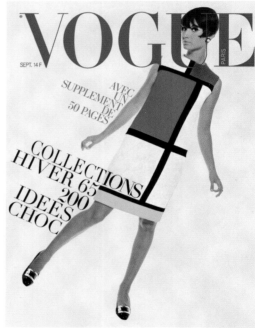

cat. 252

ill. 11 Henry Clarke. Régine Debrise.
Pierre Balmain Boutique ensemble.
Vogue Paris, July/August 1951

ill. 12 Robert Randall. Bettina. Lanvin-
Castillo Boutique jersey. *Vogue Paris*,
July/August 1953

ill. 13 René Gruau and Guy Bourdin.
Christian Dior suit. *Vogue Paris*,
March 1957

ill. 14 Henry Clarke. Twiggy. Dorothée Bis
dress, Cartier jewelry. *Vogue Paris*,
May 1967

cat. 252 David Bailey. Yves Saint Laurent
"Mondrian" dress. *Vogue Paris*,
September 1965

that there would be no issue in June. The maga-zine returned with the July/August issue and the gorgeous Veruschka modeling the "Jungle Look." Paris seemed far away, and yet the name of the city was now written inside the *o* of "Vogue."

Society was changing, and women along with it. *Elle* and *Marie Claire* gave them a voice; yet in *Vogue Paris*, it was a different story. In September 1973, *Marie Claire*'s headline was: "How Do You Get Divorced Without Being Swindled When You are a Woman?" while *Elle* visited brothels and discussed ménages à trois, but *Vogue Paris* chose to focus on "100 Ready-to-Wear and Haute Couture Styles." Jane Birkin, Sylvie Vartan, Dalila Di Lazzaro, and Charlotte Rampling posed in "SOIRissimo"[9] eve-ningwear for Newton and Bourdin. But although these photographers were the kings of the maga-zine's core pages, they showed little interest in its covers, chafing at the need to include words— the name "VOGUE" at the top, the month, the price, and the headlines—which detracted from their images.

"The Avant-Garde: A Look at the '80s":[10] Metallic, Mugler-clad, and goddess-like—American model Janice Dickinson faced the future, and the future belonged to her. Albert Watson and Bill King captured closeups of flawless faces fra-med by shimmering garments and adorned with jewels from the Place Vendôme. *Vogue Paris* became monumental in size. In September 1980,

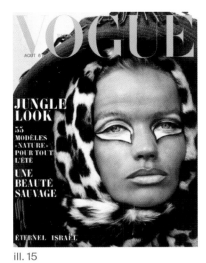

ill. 15

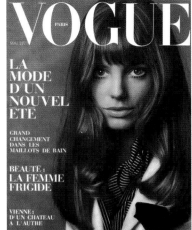

ill. 16

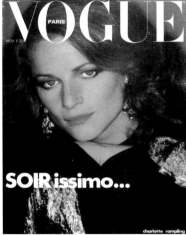

ill. 17

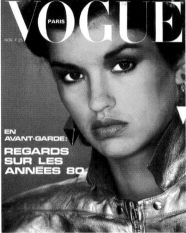

ill. 18

cat. 371

ill. 19

ill. 15 Franco Rubartelli. Veruschka. *Vogue Paris*, July/August 1968

ill. 16 Jeanloup Sieff. Jane Birkin. Cerruti ensemble. *Vogue Paris*, May 1969

ill. 17 Helmut Newton. Charlotte Rampling. Tan Giudicelli Soir dress. *Vogue Paris*, November 1976

ill. 18 Mike Reinhardt. Janice Dickinson. Thierry Mugler ensemble. *Vogue Paris*, November 1979

cat. 371 Albert Watson. Clio Goldsmith. Karl Lagerfeld for Chloé dress. *Vogue Paris*, October 1983

ill. 19 Bill King. Cindy Crawford. Claude Montana for Idéal Cuir tank top. *Vogue Paris*, February 1987

it measured 12.4 by 9.5 inches (31.5 by 24 centimeters) and weighed almost 5 pounds (2.2 kg) with 618 pages—a record since unmatched. Its glossy paper suited actresses, princesses, and queens of the modeling world: Kim, Renée, Anette, Paulina, then Christy, Cindy, Linda, Naomi. Naomi was a pioneer, becoming the first black model on the cover of *Vogue Paris*[11] in August 1988. Edmonde Charles-Roux had risked the same, but too soon, and the higher-ups at *Vogue* in New York were not

happy. Already taunting them with her friendships with Louis Aragon, Elsa Triolet, and other defenders of Communism (and in the middle of the Cold War!), Charles-Roux dared once again to flout authority by attempting to place on the cover, against all odds, model Donyale Luna, an African American of stunning beauty. But Mademoiselle Charles-Roux had gone too far and was dismissed.

Linda Evangelista was famed for her long flowing hair, but when she chopped it all off

in February 1989, readers were spellbound. Like the supermodel, *Vogue Paris* was also restyled into a new shape (9 by 11.5 inches/23 by 29.5 centimeters) and found new collaborators, including Peter Lindbergh who photographed Catherine Deneuve in broad daylight.[12] Isabelle Adjani was captured by Dominique Issermann in the backseat of a car discussing "love, betrayal, and friendship."[13] Emmanuelle Béart spoke about "her new image, her new desires, her new film,"[14] and

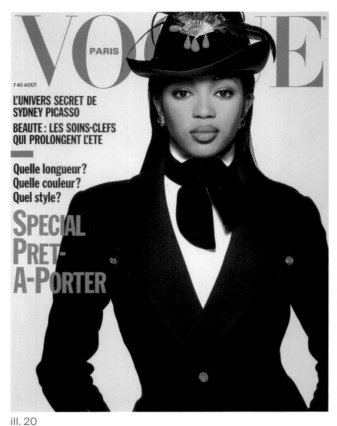

ill. 20

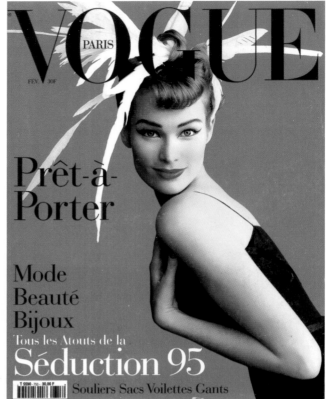

ill. 21

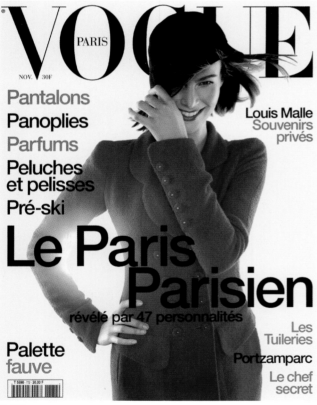

ill. 22

ill. 20 Patrick Demarchelier. Naomi Campbell. Karl Lagerfeld ensemble. *Vogue Paris*, August 1988

ill. 21 Mario Testino. Meghan Douglas. John Galliano dress. *Vogue Paris*, February 1995

ill. 22 Michael Thompson. Meghan Douglas. Chanel ensemble. Directed by Nathalie Marchal. *Vogue Paris*, November 1996

Carole Bouquet admitted, "I'm tired of being an icy beauty."[15] Celebrities ruled the roost and the headlines grew bolder. *Vogue Paris* was now being edited by American Joan Juliet Buck, who alternated between "The International Spirit"[16] and "The Parisian Paris."[17]

Mario Testino and Carine Roitfeld, style-setters at French *Glamour,* arrived to shake up French *Vogue* in February 1995. Meghan Douglas was crowned with a festoon of feathers against a

fuchsia background,[18] Stephanie Seymour resembled a high-fashion nurse,[19] Carolyn Murphy went peroxide blonde and stratospheric.[20] Roitfeld and Testino then took a break—allowing photographer Michael Thompson to take over—but returned to shoot a series of covers. Appointed editor in chief, Roitfeld brought beauty in her own rebellious image. To capture it, there were photographers Mario Testino, David Sims, Craig McDean, and Inez & Vinoodh. "Bad girls" became popular,

with Kate Moss in their vanguard. *Vogue Paris* also featured Natasha Poly and Lara Stone, revisited Christy, Linda, Claudia, Cindy, model Daria, and Natalia (before and after childbirth), and gave a new lease of life to Demi Moore, Sharon Stone, Nicole Kidman, and Sophie Marceau. Roitfeld put *Vogue Paris* back where it belonged to celebrate "90 years of excess."[21]

Emmanuelle Alt softened and switched "the codes of cool,"[22] showing Daria in a sequin

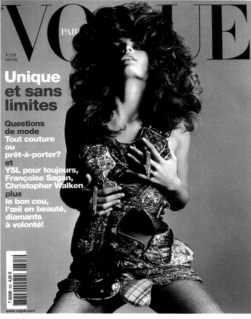
ill. 23

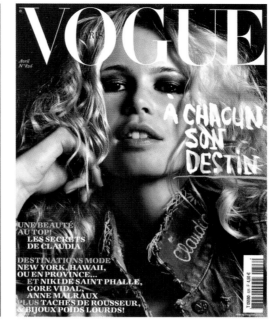
ill. 24

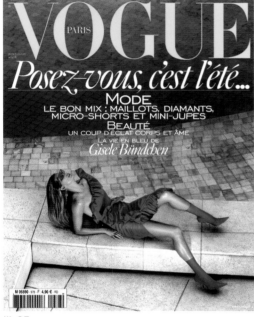
ill. 25

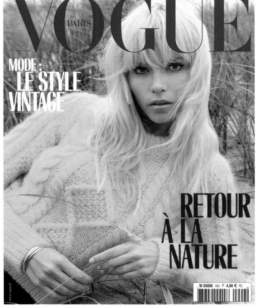
ill. 26

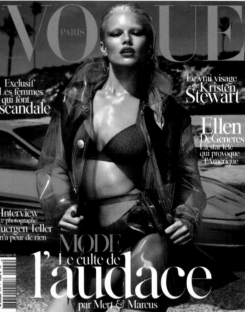
ill. 27

ill. 23 David Sims. Isabeli Fontana. Nicolas Ghesquière for Balenciaga dress. Diesel jeans. Directed by Marie-Amélie Sauvé. *Vogue Paris*, March 2002

ill. 24 Mario Testino. Claudia Schiffer. CK jacket, Calvin Klein jeans. Directed by Carine Roitfeld. *Vogue Paris*, April 2002

ill. 25 Mario Testino. Gisele Bündchen. Gucci dress, Balenciaga ankle boots. Directed by Anastasia Barbieri. *Vogue Paris*, June/July 2017

ill. 26 Inez & Vinoodh. Natasha Poly. Michael Kors Collection sweater. Directed by Emmanuelle Alt. *Vogue Paris*, November 2018

ill. 27 Mert & Marcus. Anna Ewers. Miu Miu ensemble. Directed by Emmanuelle Alt. *Vogue Paris*, August 2014

top and bikini briefs, revisiting timeless favorites such as Lara, Natasha, Natalia, Kate, and Gisele, and capturing Vittoria, Rianne, and the Hadid sisters. Although *Vogue Paris* embraces "the Instagirls generation,"[23] the women of Paris remain key to its success: Ines de la Fressange, the Birkin and Paradis clans, mother and daughter . . . "From twenty to sixty years old, in the prime of life."[24] It can also break down boundaries, featuring Valentina Sampaio as the face of "transgender

beauty,"[25] mesmerizing and inspiring, with provocative posturing being shunned in favor of the clever theatrical lighting of Mert & Marcus. *Vogue Paris* made the present presentable and practices what it preaches. With "Chic Animals and Faux Fur,"[26] Alt chose to put an end to the promotion of animal cruelty in a magazine that has long touted luxury furs. *Vogue Paris* is now ecofriendly and committed, in its own no-nonsense way, to a "return to nature"[27] because "without nature, there is no future."[28] Its

headlines have become slogans, giving a new twist to its covers, the distinctive heirs of a long and beautiful lineage.

Jérôme Gautier

1 *Vogue Paris* (November 1951).
2 *Vogue Paris* (August 1956).
3 *Vogue Paris* (March 1965).
4 *Vogue Paris* (September 1965).
5 *Vogue Paris* (March 1957).
6 "Jean Shrimpton lance la mode nouvelle," *Vogue Paris* (January 1967).

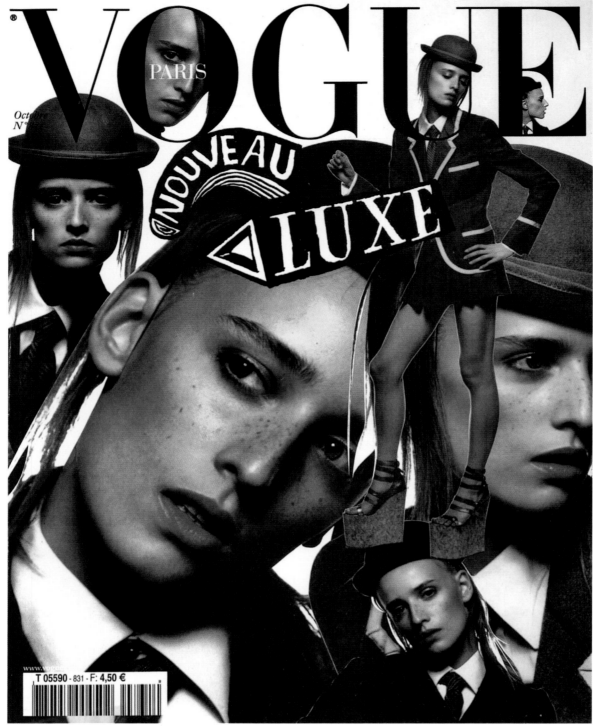

ill. 28

ill. 28 Inez & Vinoodh. Artistic direction
 M/M (Paris). Ann Catherine Lacroix.
 Alexander McQueen ensemble.
 Vogue Paris, October 2002

THE HARDSHIP
OF WAR
AND THE REBIRTH
OF *VOGUE PARIS*

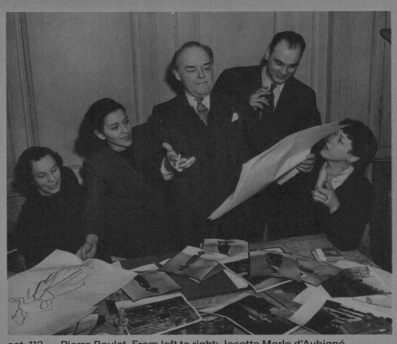

cat. 112 Pierre Boulat. From left to right: Josette Merle d'Aubigné,
Edmonde Charles-Roux, Michel de Brunhoff, Arik Nepo,
Nina Leclercq, 1948

When the Second World War began, *Vogue Paris* was under the direction of Michel de Brunhoff, who had already devoted ten years of his life to the magazine. As an experienced editor in chief, he had an established, professional relationship with Condé Nast based on trust. A charismatic personality, he enjoyed working in a friendly atmosphere conducive to dialogue, surrounded by his collaborators and also his friends, who included couturiers, illustrators, photographers, painters, and designers. During the war, Brunhoff had only two priorities: to remove Parisian couture from German control and to keep the aura of *Vogue Paris* intact. The choices he made from 1939 to the aftermath of the war until his replacement by Edmonde Charles-Roux in 1954 attest to his unwavering commitment to couture and fashion designers in Paris.

cat. 80 Christian Bérard. [Untitled]. *Vogue Paris*, December 1939, cover

Vogue Paris in the Turmoil of War, 1939 to 1940[1]

When France declared war on Germany on September 3, 1939, Brunhoff had been working with Thomas Kernan, Condé Nast's representative in Paris, for several days to put the affairs of French *Vogue* in order before leaving the office.[2] Learning that most magazines such as *Femina* and *Modes et Travaux* had ceased publication, Nast decided to also temporarily discontinue publication.[3] While most of the French population was contemplating a long war, Paul Reynaud, minister of finance in Daladier's government, was asking everyone to resume their normal activities. Similarly, Lucien Lelong, president of the Chambre Syndicale de la Couture since 1937, was in favor of keeping the fashion industry active.[4] This dynamic explains why, after a break from September to November, it was decided that *Vogue Paris* would resume for the month of December 1939.[5] In this issue, Brunhoff, fearing that American fashion designers would take advantage of the war to supplant Parisian fashion, stated, "the offices [of *Vogue Paris*] on the Champs-Élysées never closed and contact has always been maintained with the American publication. It is good, and it is useful to know, that along with our friends in America, even amid the anxiety of the first days of September, Parisian couture still existed and had no desire to perish. It is even better to know in France and in Europe that French fashion is still the first in the World."[6] However, Brunhoff and Nast's combined wishes were not enough, since, after this issue, *Vogue Paris* was unable to publish an issue in January or February 1940 due to practical difficulties with design and printing. It resumed only for two issues, in March and April/May 1940 (cat. 117). Beginning May 10, the layout was ready to be printed. However, in the face of the realities of war, and to preserve the stockpiles of paper needed, the editor in chief decided to postpone the publication.[7] On May 10, 1940, after the German breakthrough at Sedan launched by the Wehrmacht,[8] the magazine was shut down,[9] and Brunhoff decided not to publish the June issue. In June 1940, the offices and studio of *Vogue Paris* were raided by the Germans.[10]

On June 16, the same day that Marshal Pétain formed his government, Brunhoff joined Lucien Vogel in Bordeaux, where he had taken refuge at the beginning of the month.[11] There was no question of resuming the publication of the magazine, even on an irregular schedule.[12] From July 20, former colleagues of *Vogue Paris*—including the Duchess d'Ayen and Monique de Séréville (both fashion editors), Léone Friedrich (Brunhoff's secretary), Simone Eyrard

ill. 1 "Paris continued . . ."
 Vogue Paris,
 December 1939, p. 10

(the photography retoucher), Walter Mass (the representative of the Dorland agency in France), and Thomas Kernan—separated to various locations in France (Paris, Bordeaux, and Saint-Jean-de-Luz, in particular) and the United States (New York).[13] Throughout this period, contacts were maintained between the offices but the future of the French magazine remained unclear, as expressed by American *Vogue* on October 15, 1940: "There are three *Vogues:* one American, one French, and one British, but what about French *Vogue*? Many of our readers are asking. Similarly, what about British *Vogue*? Were they not swept away by the fateful events? Are there still three *Vogues*?"[14]

Vogue Paris Must Be Saved

As soon as they arrived in Paris, the Germans wanted to get their hands on the press, an obvious propaganda tool. The system of control of information and media, such as newspapers, books, and radio, was part of a broader view of the economic exploitation of the country.[15] At the end of May 1940, a decree suspended all newspapers and subjected their publication to the notice of the Kommandantur. The Propaganda-Abteilung Frankreich (the German propaganda department in France), created on July 18, 1940, and directed by Joseph Goebbels, was responsible for enforcing it in Paris.[16] Despite this rigid framework, there was no concerted action among the French press after the signing of the armistice on June 22, 1940. Four attitudes can be noted in the fashion press.[17] Some periodicals, such as *La Femme Chic*, resumed their production in the northern zone by submitting to German guidelines. Others, such as *Modes et Travaux,* took refuge in the southern zone to continue publication. Still others were created from scratch, such as *Pour Elle.* Finally, many magazines were closed completely. This was the case for *Vogue Paris*.

At the beginning of August 1940, Brunhoff returned to the capital.[18] He was struck by what he saw there: Following the German search of the *Vogue Paris* offices, the front door and safe were forced open, seals were placed on the addressing machines, and many documents were confiscated. As for the magazine's photography studio, it was commandeered and was no longer owned by Condé Nast, but by the Germans. The occupation forced Brunhoff to review the decisions he had made in early 1940. Like all publishers, he now had to obtain permission from the German authorities to resume publication of *Vogue Paris.* His request was forwarded to the director of General Intelligence on August 21, 1940.[19] When summoned to the Propagandastaffel, Brunhoff and Kernan learned that *Vogue Paris* was one of the magazines the occupiers wanted to see continue. But the relief was short-lived, since the Germans' intentions were clear: The publication of *Vogue Paris* would be under German control within a press group.[20] Brunhoff and Kernan understood that they would have to sell the majority of the magazine's shares to the occupiers.[21] Moreover, as further proof of goodwill, the Germans asked Brunhoff to demonstrate that the editors, funding, and professional relations of *Vogue Paris* were not of Jewish origins.[22] Brunhoff countered with an administrative argument: Since *Vogue* was an incorporated company, he could not speak on behalf of the magazine, which is not true, since at the beginning of the war, Nast assured Brunhoff that he left him full responsibility of *Vogue Paris*. At the same time, Brunhoff knew that if he stopped publishing, the Germans would not hesitate

to seize the magazine, only to have it republished in their own name to present their national fashion. Indeed, in terms of the textile industry, one of the ambitions of the enemy was to develop German fashion at the expense of French fashion, and to use magazines as promotional tools. Fashion was becoming an economic and cultural issue;[23] economic because the Germans had plans to take control of French clothing production, and cultural because French hegemony in couture was called into question.[24] That is why, for several weeks, Brunhoff made visits to the Propagandastaffel in the hope of negotiating the relaunch of the magazine.[25] In September 1940, he and Kernan embarked on a final initiative to save *Vogue Paris.* Since the magazine belonged to a company under American law, they solicited Robert Murphy (1894–1978), the American consul in Paris who spoke with the German authorities to defend the interests of American properties in the occupied zone.[26] However, their various discussions were of no help, and when the German verdict was announced, they no longer had any recourse. The sentence was handed down on October 21, 1940: No authorization would be granted for the publication of *Vogue Paris.*[27] Kernan left the capital, while for Brunhoff, his work on the magazine was now reduced to administrative tasks: liquidating the assets and settling the debts of the Nast publications, selling the remaining paper for cash, moving the archives as well as the accounts, and requesting the appointment of an interim administrator.

Postwar: *Vogue Paris*'s Difficult Recovery

At the end of 1944, Brunhoff's goal was to resume publishing the magazine as soon as possible. When he contacted Edna Woolman Chase in November,[28] he announced that he was preparing *Vogue Paris*'s first issue of the Liberation.[29] But despite the intention to revive the magazine, stocks of the materials needed to do so were sparse at the beginning of 1945. The offices of *Vogue Paris* were still lacking everything and had neither heat nor lighting before half past four in the afternoon. The resumption of work was accomplished while wearing a hat, coat, and gloves, and under the light of church candles. Bettina Ballard wrote: "I was watching Leone [Friedrich] trying to type on the machine with thick wool gloves covering her fingers; I looked at Michel's [de Brunhoff] many layers of sweaters, his pale complexion, and the despair in his eyes."[30]

Even before the end of the war, the restoration of the freedom of the press and its cleanup were the priorities of the French Committee of National Liberation and then the provisional government of the French Republic. In September 1944 newspapers that began publishing after June 25, 1940, as well as those that already existed on that date and continued circulation, whether more than fifteen days after the armistice in the northern zone or more than fifteen days after November 11, 1942, in the southern zone, were prohibited.[31] In contrast, newspapers that had voluntarily suspended publication during the aforementioned periods were allowed to resume publication. Brunhoff's refusal to publish *Vogue Paris* during the occupation allowed the magazine to be classified in the latter category. However, even though it did not fall under these restrictions, authorization still had to be requested in writing.[32] On September 10, 1944, Brunhoff made the application,[33] stating: "Before the war, our magazine was considered the leading propaganda tool for French high fashion and luxury industries. It was published once a month and was distributed and known

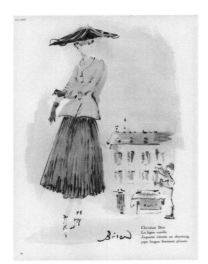

cat. 127 Christian Bérard.
Christian Dior, Spring/
Summer 1947. "Bar" suit.
Vogue Paris, May/
June 1947, p. 96

worldwide."[34] Brunhoff also explained that, deprived by the occupiers of any possibility of publication, *Vogue Paris* had been left dormant.[35] His application required him to produce documentation and proof that the magazine had never benefited from having contact with the Germans.[36] Brunhoff provided this solemn declaration and accompanied his letter with a request for material assistance. He also spoke with Iva S. V. Patcévitch, the new director of Condé Nast publications, to discuss the restarting of *Vogue Paris*.[37] For financial reasons, Patcévitch was opposed to an immediate resumption of publication on a regular schedule and convinced Brunhoff to produce *Vogue Paris* albums while waiting for the magazine's revival. The album format overcame the main obstacle faced by publishers, which was that of finding quality paper and technical equipment suitable for the production of a luxury magazine. This type of publication was not as demanding as publishing a monthly periodical. It could be published on a variety of papers and printed using different processes since there was no need for the various seasonal albums to remain consistent with one another.

On November 7, 1944, *Vogue Paris* finally obtained permission to resume,[38] accompanied by the delivery of ten tons of coated paper to allow Brunhoff to "pull a special issue at the end of the year."[39] This delivery, although essential, did not represent a large quantity of paper. The fate of *Vogue Paris* therefore was still unknown, although the minister of information planned to make more paper available in the following weeks as soon as an improvement took place in the fields of paper manufacturing and transport. The relaunch album of *Vogue Paris,* titled *Vogue Libération,* was published in January 1945. Brunhoff managed to produce a publication that was not only a success but also a triumph, according to Lucien Vogel.[40] For him, the reception of this first album took the form of a "personal and first-class success" since, he added, "Couture, and the government, are delighted."[41] This special issue received excellent reviews from professionals, with many among them considering it a "masterpiece of publishing" and a miracle given the laborious publishing conditions of the time.[42] Brunhoff wanted it to live up to the quality of the magazine of the 1930s.[43] The cover, by Christian Bérard (cat. 80), featured the colors red, white, and blue, and a galleon sailing the sea, while the fashion of the war period was reviewed year by year.

In July 1945, Brunhoff received a delivery of high-quality paper, enough for *Vogue Paris*'s needs for the second half of the year.[44] Two new albums could be considered. The second was published in the fall of 1945, for winter 1945/1946. Its cover, depicting the Place de la Concorde, had been prepared—but not used— in August 1939. This issue was also a great success and, on November 27, 1945, Vogel pointed out Brunhoff's talent to André Malraux,[45] the new minister of information who started on November 21, 1945: "I believe," he wrote, "that my brother-in-law Michel de Brunhoff can be congratulated for this work, which honors the French publication."[46] The year 1946 was still a difficult one in terms of paper supply, but there were also signs of hope that the magazine would soon be able to return to its regular schedule. *Vogue*'s last two albums were published, one in the summer of 1946, featuring the return of the "The Point of View of *Vogue*" section, and the other in the winter of that year, including photographs by Robert Doisneau, as well as illustrations by Lila De Nobili and Christian Bérard. The first bimonthly issues of *Vogue Paris* were released in January/February, March/April, and May/June 1947.[47] At the same time, the team left 65, avenue des Champs-Élysées for 4, place du Palais-Bourbon.[48]

At that time, Brunhoff agreed to take over as editor in chief of *Vogue Paris,* but no longer feeling that he had the soul of a "night owl," he set a condition: He must have a reliable assistant who would cover openings and social and cultural obligations. Edmonde Charles-Roux, then a contributor to the newspapers *Elle* and *France-Soir* since 1946, was approached for this position.[49] Hired in 1947, she first became a theater correspondent then was appointed head of the magazine's cultural pages. Three years later, she effectively became Brunhoff's right-hand woman before replacing him as editor in chief of the magazine when he left in 1954.[50]

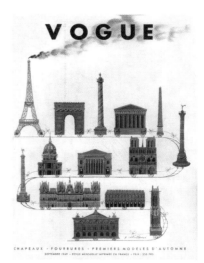

ill. 2 Giulio Coltellacci.
Vogue Paris,
September 1949, cover

Resume Publication . . . But Under What Conditions?

Beyond the issues related to the availability of paper, one of the big unknowns was whether Paris would still have a fashion industry. Some signs were promising: In December 1944, Lucien Lelong stepped up to explain the importance of haute couture to the French economy, while in March 1945, to encourage the revival of haute couture, French couturiers took part in an exhibition entitled "Le Théâtre de la Mode."[51] Two years later, Christian Dior's New Look gave signs of hope to fashion (cat. 127). Nevertheless, for publishers, particularly Brunhoff, the question arose as to what reception would be reserved for *Vogue Paris* after four years of absence and during which new magazines such as *Elle* (1945) had appeared.[52] Among the many questions about the magazine's relaunch, Brunhoff was certain that it was not possible to continue making the prewar magazine, that is, a fashion album dedicated to couturiers. *Vogue Paris* would have to adapt to its time. To distinguish it from a simple fashion magazine, but also from American and British *Vogue,* Brunhoff decided to add a section highlighting the cultural and artistic energy of Paris, beyond its place as the fashion capital.[53] Thus, in the postwar issues of *Vogue Paris,* the emphasis was on new theatrical productions and the work of designers and great painters. Charles-Roux, supporting this approach, also commissioned literary articles from writers who, she said, did not hesitate for long because "Michel de Brunhoff was not refused anything."[54] Colette, Paul Éluard, Germaine Beaumont, and Saint-John Perse were among those who responded. Even before the war, famous authors contributed to the magazine, but this movement grew in 1945, further distinguishing *Vogue Paris*. At the same time, the whole of France was photographically captured by Robert Doisneau,[55] who set out to document major cities such as Paris, Marseille, Lyon, and Bordeaux in his photo stories (cat. 133). Capturing the beauty and dynamism of France's cities was a way of rediscovering the French links that Brunhoff had given to the magazine before the war.[56] This "Frenchification" reached its climax in September 1951 with the editorial supplement subtitled on the cover: "Paris Edition."

Brunhoff's other priorities included the desire to help revive French haute couture. According to Charles-Roux, all his work was aimed at helping couturiers, by any means possible, to regain the audience they had in 1939. This momentum translated into support for new talent such as artist and designer Lila De Nobili[57] or, a few years later, photographer Guy Bourdin.[58] Brunhoff also continued spending time with Christian Dior, with whom he discussed the new collections.[59] But this desire was most strongly illustrated in the relationship

he forged with Yves Saint Laurent, whom he encouraged from the start.[60] After meeting him in Paris, where Saint Laurent arrived in December 1953 after winning the third prize at the International Wool Secretariat, Brunhoff advised him to return to his hometown of Oran to graduate before embarking on a career in couture. As early as 1954, the two began a correspondence[61] (cat. 242 and 243) that revealed a talented young man, imbued with the uncertainties and fragilities of youth, and an experienced media figure seeking to help a promising talent find his way. On June 20, 1955, Brunhoff introduced Saint Laurent to Christian Dior, who hired him as an assistant.[62]

In addition to his support for new artists, Brunhoff also helped *Vogue Paris* adapt to the two major developments of the time in the fashion and publishing industries: the democratization of fashion with the growth of ready-to-wear[63] and the rise of color photography in magazines. Although somewhat overwhelmed by these changes, Brunhoff initiated them in *Vogue Paris* before Edmonde Charles-Roux took over.[64]

In 1950 the topic of ready-to-wear was a difficult one for the editor. While the New York office urged him to open up the magazine to mass-produced fashion, he objected, convinced that as soon as *Vogue Paris* began to cover ready-to-wear, the couturiers, as well as the perfumers and fabric manufacturers who were then the magazine's main advertisers, would leave, refusing to see their products published alongside such clothes. Moreover, he believed that the aura of *Vogue Paris* risked being undermined if the magazine embraced ready-to-wear because it had always been dedicated to couture.[65] From this period, *Vogue* and *Vogue Paris* followed two different paths that reflected their national fashion industries: *Vogue* became the showcase of the burgeoning American ready-to-wear trend, while *Vogue Paris* remained the preserve of tailor-made couture born at the end of the nineteenth century. Léone Friedrich, Brunhoff's assistant, explained: "I even remember Edna Woolman Chase's last visit [in 1952] when she had an important meeting in Monsieur de Brunhoff's office with all of us where she commented on everything about the last issue that had just come out, page by page. She closed the magazine and said, 'Michel, you have to understand that the future of French *Vogue* is ready-to-wear.' This was a terrible shock for Michel; he started saying, 'No, it's not possible, all the couturiers, all the fabric manufacturers, all the fabric people, all the perfume people, are going to remove their ads if we do that.' She said, 'Mark my words.'"[66] Following this meeting, while major political and social changes were taking place in France, Brunhoff seemed to be gradually coming around to the idea of publishing a ready-to-wear section. In June 1950 *Vogue Paris* merely alluded to the democratization of fashion by designer boutiques in sections entitled "At Any Price" (ill. 7 p. 109) and "Discoveries for the Young." When the *Elle* magazine issue of February 18, 1952, opened the ready-to-wear discussion with the question "Would You Like to Find Ready-Made Dresses?"[67] the editor in chief, like it or not, had to make a decision, and in French *Vogue* in March 1952, Brunhoff included an "Everything Ready-to-Wear" column (cat. 130).

The rise of fashion photography was another challenge Brunhoff had to tackle. While the American edition declared itself in favor of this new medium, Brunhoff was initially reticent and preferred to continue publishing illustrations. As Charles-Roux explained, "He was the 'crusader' of illustration and wanted it that way,"[68] and the world of photography did not seem to suit him. Had the war, marked by a slowdown in photographic reproduction, strengthened his convictions, or was he just from an old-fashioned era? Charles-Roux recalled

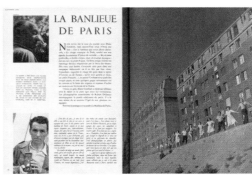

Brunhoff's reluctance: "They [Brunhoff and Vogel] tried to keep their illustrators as long as they could, even when America was barraging them relentlessly about it, explaining that illustrations no longer sold. They both remained indifferent and sent the Americans packing."[69] Brunhoff gradually agreed to open *Vogue Paris* to photographers, but on his own terms, refusing, for example, to put photographs on the cover on the grounds that the French public would not like it. In addition, he wanted to call on his own French photographers: Robert Doisneau, Guy Bourdin, and Jacques Verroust, especially. According to Charles-Roux, their recruitment was part of a business strategy that quickly became a cultural one, since by giving French photographers a chance, the "threat of invasion" by American photographers could be quickly dismissed.[70] She confessed, "Neither he nor I wanted the magazine to become Americanized right down to the pictures. Perhaps we perceived it as a form of danger?"[71]

cat. 133 Robert Doisneau. "La banlieue de Paris." *Vogue Paris*, November 1949, pp. 34–35

In 1954, Brunhoff left *Vogue Paris.* His departure, preceded by the deaths of Condé Nast in 1942 and Lucien Vogel in 1954, as well as the retirement of Edna Woolman Chase in 1952—contributed to the distance between *Vogue* and *Vogue Paris,* marking the end of a generation of Americans who were deeply Francophile and regarded Paris as the capital of elegance, in the words of Charles-Roux.[72] She took the place of Brunhoff, which then gave her the freedom to lead *Vogue Paris* in her own way. To some extent, carrying on the work of her mentor, the editor in chief gave a new place to literature and music and opened the magazine to writers far removed from fashion magazines, figures who were both unconventional and engaging, such as François Mauriac, Françoise Giroud, Françoise Sagan, Marguerite Duras, Simone de Beauvoir, and Jean Genet, while the magazine itself continued to evolve.[73]

1 See Sophie Kurkdjian, "Struggles to Maintain French Domination of Fashion in World War II on Both Sides of the Atlantic through Women's Magazines," in Marie McLoughlin and Lou Taylor (ed.), *Paris Fashion and World War Two: Global Diffusion and Nazi Control*, London, Bloomsbury (2020).

2 See Michel de Brunhoff's letter to Condé Nast (September 4, 1939), Condé Nast Archives, New York. See also Thomas Kernan, *Horloge de Paris, heure de Berlin*, Montreal, Éditions de l'Arbre (1944): 15.

3 See Michel de Brunhoff's letter to Condé Nast (September 15, 1939), Condé Nast Archives, New York.

4 See Michel de Brunhoff's letter to Condé Nast (September 15, 1939), Ibid.

5 See Serge Bernstein and Pierre Milza, *Histoire de la France au xxᵉ siècle, 1930–1945*, Brussels, Éditions Complexe (2003): 342.

6 *Vogue Paris* (December 1, 1939): 18.

7 See Thomas Kernan's letter to Condé Nast (May 23, 1940), Georgetown University Library, Thomas Kernan Papers.

8 See André Kaspi, *Chronologie commentée de la Seconde Guerre mondiale*, Paris, Perrin (2010).

9 See Iva S. V. Patcévitch's letter to Harry Yoxall (September 11, 1940), Georgetown University Library, Thomas Kernan Papers.

10 See Thomas Kernan's letter to Condé Nast (July 19, 1940), Georgetown University Library, Thomas Kernan Papers, and Michel de Brunhoff's letter to Lucien Vogel (July 27, 1940), private archive.

11 See Thomas Kernan's letter to Condé Nast (July 17, 1940), Georgetown University Library, Thomas Kernan Papers.

12 See Michel de Brunhoff's letter to Condé Nast (July 21, 1940), Condé Nast Archives, New York.

13 See Iva S. V. Patcévitch's letter to Harry Yoxall (September 11, 1940), *op. cit.*

14 Translation of an excerpt from "What about French *Vogue*?" *Vogue* (October 15, 1940): 39.

15 See Claude Bellanger, Jacques Godechot, Pierre Guiral, Fernand Terrou (ed.), *Histoire générale de la presse,1940–1958*, t. 4, Paris, PUF (1975): 10–13; Patrick Eveno, "*Entreprises et marchés de la presse sous l'Occupation.*" in *Culture et médias sous l'Occupation: Des entreprises dans la France de Vichy*, Paris, Éditions du CTHS, et al. "CTHS Histoire" (2009): 23.

16 See Laurent Martin, *La Presse écrite en France au xxᵉ siècle*, Paris, French general bookstore (2005): 103.

17 Clorinda Costantini, "La presse féminine des années d'occupation, juin 1940–août 1944," University of Paris II (1980).

18 See Michel de Brunhoff's letter to Condé Nast (July 27, 1940), Condé Nast Archives, New York.

20 See Patrick Eveno, *L'Argent de la presse française des années 1820 à nos jours*, Paris, Éditions du CTHS, et al. "CTHS Histoire" (2003): 117.

21 See the French *Vogue* files, request for republication, F/41/1682, French National Archives.

22 See Thomas Kernan, *Horloge de Paris, heure de Berlin, Op cit.*, 43, and Edna Woolman Chase, *Always in Vogue*, New York, Doubleday & Company (1954): 323.

23 See Dominique Veillon, "La mode comme pratique culturelle," in Jean-Pierre Rioux (ed.), *La Vie culturelle sous Vichy*, Brussels, Éditions Complexe (1990): 365 and 412; Fabienne Falluel and Marie-Laure Gutton, *Élégance et système D. Paris 1940–1944— accessoires de mode sous l'occupation*, cat. exp., Paris, Paris-Musées (2009).

24 See Lucien Lelong's report, "La Couture française de juillet 1940 à août 1944," French National Archives, C5 Z6, Archives of the Courts of Justice; Stone by Holden, "French Fashion Survives the Nazis," *Art and Industry* (1945): 2–15; and Dominique Veillon, *La Mode sous l'Occupation*, Paris, Payot and Rivages (2014): 152–157.

25 See Thomas Kernan, *Horloge de Paris, heure de Berlin; op. cit.*, 31 and 39; Gérard Walter, *La Vie à Paris sous l'Occupation, 1940–1944*, Paris, A. Colin (1960): 70, 177, and 253.

26 See Iva S. V. Patcévitch's letter to Condé Nast (September 11, 1940), Georgetown University Library, Thomas Kernan Papers.

27 See Lucien Vogel's letter to Nicolas Vogel (January 8, 1941), private archive.

28 See Edna Woolman Chase, "Ici Paris – Ici Paris," British *Vogue* (December 1944); "Paris: Lelong speaks for the Paris couture," British *Vogue* (November 1944).

29 See Edna Woolman Chase, *op. cit.*, 360.

30 Bettina Ballard, *In My Fashion*, New York, David McKay Co (1960): 194; also quoted in Harry Yoxall, *A Fashion of Life*, New York, Taplinger Publishing (1966): 189.

31 See Patrick Eveno, *L'Argent de la presse française des années 1820 à nos jours; op. cit.*, 121; Christian Delporte and Denis Maréchal (ed.), *Les Médias et la Libération en Europe, 1945–2005*, Paris, L'Harmattan (2006): 500; Laurent Martin, *La Presse écrite en France au xxᵉ siècle; op. cit.*, 122–123.

32 Laurent Martin, *La Presse écrite en France au xxᵉ siècle; op. cit.*, 128.

33 Official Telegram Cominform to Pressefrance, New York, no. 7664, written by Henri Bonnet (August 4, 1944), French National Archives, F/41/813.

34 Two letters from Michel de Brunhoff to the president of the Union des Syndicats de la Presse Périodique Française (September 29): 944, French *Vogue* files, request for republication, French National Archives, F/41/1256.

35 See Michel de Brunhoff's letter to the minister of information (September 10, 1944), *Jardin des modes*, request for republication, French National Archives, F/41/1256.

36 See Michel de Brunhoff's letters to the president of the Union des Syndicats de la Presse Périodique Française, *op. cit.*

37 See Michel de Brunhoff's letter to Iva S. V. Patcévitch (September 18, 1944), Condé Nast Archives, New York.

38 See the letter from the technical press office to Michel de Brunhoff, authorization for republication (November 7, 1944), *Jardin des modes* files, request for republication, French National Archives, F/41/1256.

39 Ibid.

40 See Lucien Vogel's letter to Iva S. V. Patcévitch (February 26, 1945), Georgetown University Library, Thomas Kernan Papers.

41 Ibid.

42 See William Packer, *The Art of Vogue Covers, 1909–1940*, New York, Bonanza Books (1985): 109–111.

43 See "À nos lectrices," *Vogue Paris* (January 1945): 37.

44 See the letter from the Ministry of Information to Lucien Vogel, director of *Vogue* magazine (July 26, 1945), *Jardin des modes* files, request for republication, French National Archives, F/41/1256.

45 André Malraux was first minister of propaganda, then minister of information, from November 21, 1945 to January 20, 1946.

46 Lucien Vogel's letter to André Malraux, minister of information (November 27 ,1945), French *Vogue* files, request for republication, French National Archives, F/41/1256.

47 The average circulation of *Vogue Paris* is 25,706 copies (Écho de la presse, November 15, 1947).

48 See the letter of Iva S. V. Patcévitch to Michel de Brunhoff (December 19, 1950), private archive.

49 See Edmonde Charles-Roux's interviews with the author (2007–2012), private archive.

50 See *Edmonde Charles-Roux. Les Années mode*, Marseille, Musée de la Mode (1995); 7–15.

51 See Dominique Veillon, "Le théâtre de la mode ou le renouveau de la couture création à la Libération," *Vingtième siècle, revue d'histoire*, no. 28 (October/December 1990): 118–120; Edmonde Charles-Roux, Susan Train (ed.), *Théâtre de la mode*, New York, Rizzoli International Publications, 1991.

52 See Denise Dubois-Jallais, *La Tzarine: Hélène Lazareff et l'aventure de ELLE*, Paris, Robert Laffont, et al. "Vécu" (1984).

53 See Edmonde Charles-Roux's interview with the author, *op. cit.*

54 Interview of Edmonde Charles-Roux with Susan Train (1995), Condé Nast Archives, New York.

55 Robert Doisneau (1912–1994), a humanist photographer, joined the Rapho agency in 1946 and distinguished himself as a photojournalist in France and abroad. He worked at *Vogue Paris* from 1948 to 1953.

56 See Edmonde Charles-Roux's interview with Susan Train (1995), *op.cit.*

57 Italian artist Lila De Nobili was noted for her romantic and theatrical style, often inspired by Christian Bérard, but also by the Impressionists. Her involvement with *Vogue Paris* began in the winter of 1946.

58 See Edmonde Charles-Roux's interview with the author, *op. cit.*

59 See Edmonde Charles-Roux's interview with Susan Train, *op. cit.*; "La mariée était en Dior," *Jardin des Modes* (April 1987).

60 See Laurence Benaïm, *Yves Saint Laurent*, Paris, French general bookstore (1995).

61 This correspondence belongs to Brunhoff's family and the Yves Saint Laurent Foundation. See letters dated February 16, 1954; February 24, 1954; March 14, 1954; April 14, 1954; April 26, 1954; May 6, 1954; June 28, 1954; letters from Charles Mathieu-Saint-Laurent to Michel de Brunhoff, January 14, 1955; February 16, 1955.

62 See Laurence Benaïm, *Yves Saint Laurent; op. cit.*, 44–45.

63 See Dominique Veillon, "Esthétique et représentation de la femme à travers la presse féminine (*Marie-Claire* and *Elle*, 1958–1975)," *Lettre d'information*, no. 26, "Les années 1968 : événement, cultures politiques et modes de vie" (June 9, 1997).

64 See Sophie Kurkdjian, "De la haute couture au prêt-à-porter : reconfiguration de la mode dans la presse féminine de l'après-guerre, de *Vogue français* à *Elle*," in Thomas Kirchner, Laurence Bertrand Dorléac, Déborah Laks, and Nele Putz (ed.), *Les Arts à Paris après la Libération: Temps et Temporalités*, Paris, German Center for Art History (2018).

65 See *Edmonde Charles-Roux. Les Années mode; op. cit.*, 7–15.

66 Interview of Léone Friedrich with Susan Train (1995), Condé Nast Archives, New York.

67 See Dominique Veillon, "Corps, beauté, mode et modes de vie: du 'plaire au plaisir' à travers les magazines féminins (1958–1975)," in Geneviève Dreyfus-Armand, Robert Frank, Marie-Françoise Lévy, and Michelle Zancarini-Fournel (ed.), *Les Années 68: Le temps de la contestation*, Paris/Brussels, IHTP-CNRS/Complexe, et al. "Histoire du temps présent" (2000): 161–177.

68 *Edmonde Charles-Roux, Les Années mode; op. cit.*, 7–15.

69 Quoted in *Lucien Vogel*, program "Profils Perdus," France Culture (December 1990), INA.

70 Ibid.

71 Ibid.

72 See Edmonde Charles-Roux's interview with Susan Train, *op. cit.*

73 See Olivier Saillard, "Edmonde Charles-Roux, le magazine: montrer la mode," in *Edmonde Charles-Roux, Les Années mode, op. cit.*, 7.

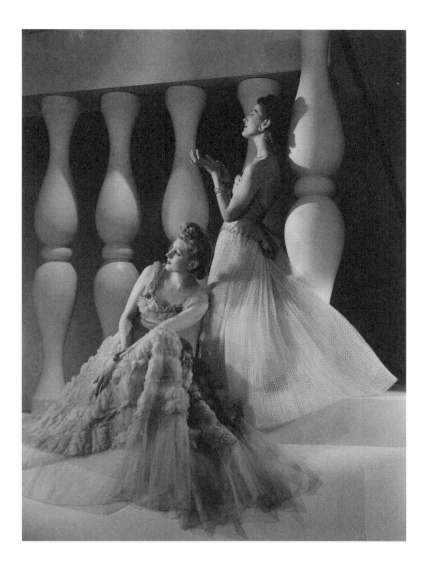 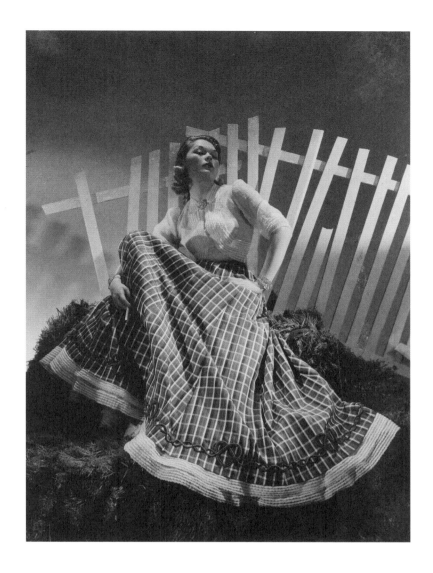

cat. 77 André Durst. Andrée Lorain, Marcelle Dormoy dress (left). Mme Chauvière, Lucien Lelong
dress (right). *Vogue Paris*, April 1939, p. 59

cat. 76 André Durst. Ludmila Feodoseyevna. Jacques Heim dress. *Vogue Paris*, April 1939, p. 53

cat. 74 Christian Bérard. Schiaparelli dress. *Vogue Paris*, April 1939, p. 61

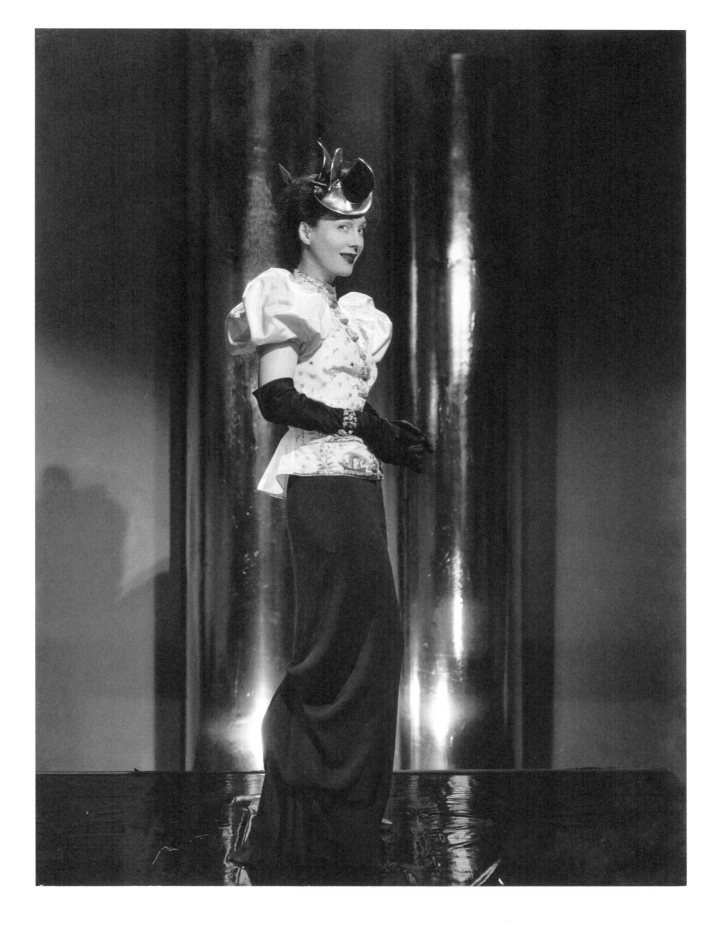

cat. 73 André Durst. Arletty. Schiaparelli ensemble, Reboux hat. *Vogue Paris*, May 1939, p. 36

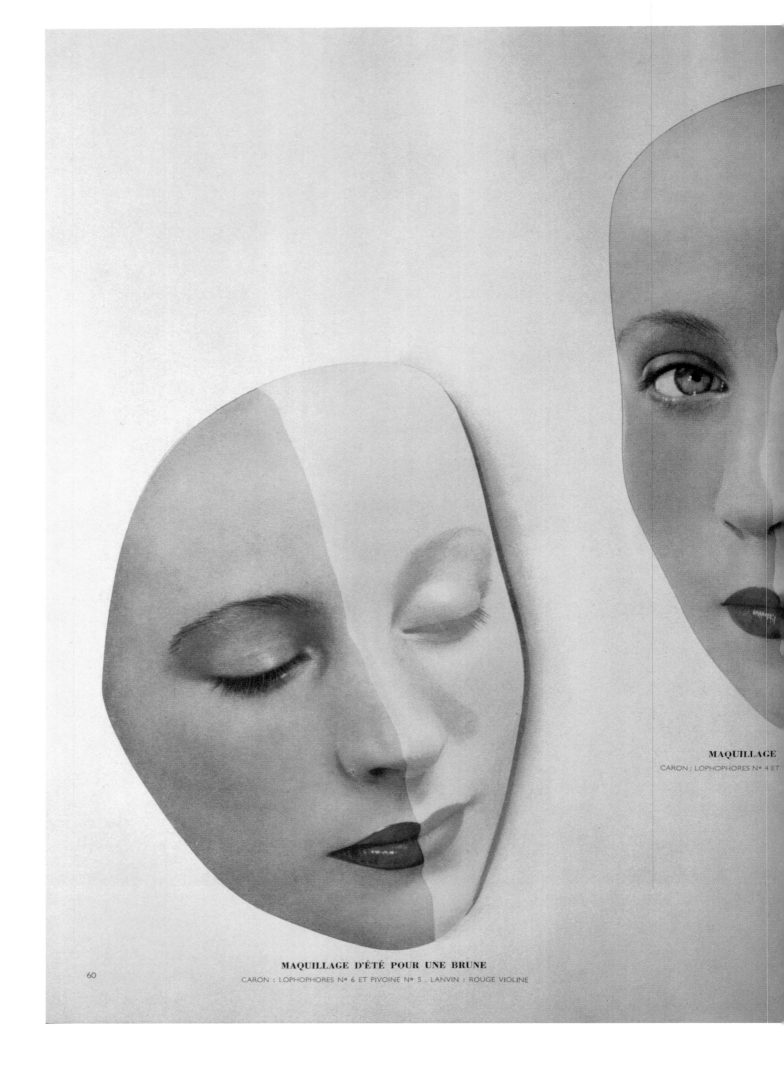

MAQUILLAGE
CARON : LOPHOPHORES N° 4 ET

MAQUILLAGE D'ÉTÉ POUR UNE BRUNE
CARON : LOPHOPHORES N° 6 ET PIVOINE N° 5 . LANVIN : ROUGE VIOLINE

60

cat. 121 Erwin Blumenfeld. *Vogue Paris*, May 1939, pp. 60–61

FELD

UR UNE BLONDE
2 . LANVIN : ROUGE SANGUIN

Lᴇꜱ ᴍᴀQᴜɪʟʟᴀɢᴇꜱ ᴅ'ÉTÉ doivent suivre les caprices de la mode et de la saison. Nous l'avons déjà dit, le charme a repris tous ses droits, la mode est de nouveau sentimentale et romantique. Il ne faut donc plus de maquillages violents aux teintes dures. Que vos maquillages soient légers et transparents dans des coloris d'aquarelle ou de pastel.

Les coiffures hautes et provocantes dégageant le visage sont devenues des boucles sages ou de lourdes tresses. Le maquillage doit avec elles baisser de ton. Les fières petites têtes aux cheveux complètement relevés pouvaient se permettre certaines exagérations de couleur dans les fards, qui ne s'accordent plus avec nos visages alourdis par les chignons et les boucles.

Avec les robes de cette saison, ne soulignez pas votre visage de traits durs, ne cherchez pas à ressembler à la Jane Avril de Toulouse-Lautrec.

On ne supporte plus sur les lèvres l'intensité de certains violets, à la mode l'an dernier, et qui étaient un rappel des coloris des tissus. Les tons des fards sont devenus plus romantiques.

Les fards de Caron ont été conçus dans cet esprit de douceur. Ainsi le Pivoine nº 2 s'estompera sur les joues des blondes, accompagné d'un fard bleuté aux paupières et du rouge sanguin de Lanvin sur les lèvres.

Au teint chaud des brunes conviendra mieux le Pivoine nº 5, avec un vert tendre pour les paupières et le rouge violine de Lanvin pour les lèvres.

De même pour les blondes le nouveau maquillage de Klytia sera composé d'un " pétale de roses " sur les joues et d'un rouge " groseille " sur les lèvres. Tandis que les brunes pourront choisir le rouge " incarnat " pour les joues et " fuchsia " pour les lèvres. Ainsi les couleurs des fleurs et des fruits se retrouveront sur votre visage, lui prêtant leur fraîcheur et leur éclat.

Séance D14 - 1 - 30 - Boîte 573
Coiffure Vincent
Lisa Fonssagrives

cat. 78 André Durst. Lisa Fonssagrives. Vincent hairstyle. *Vogue Paris*, March 1939, p. 47

cat. 125 Christian Bérard. *Vogue Paris*, January 1945, cover

VOGUE

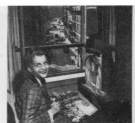

L'invité de Simone de Beauvoir fut une des révélations de 1945. Elle est aujourd'hui un espoir de l'intelligence contemporaine. Les Bouches inutiles, est sa première pièce, qui est jouée au Théâtre des Carrefours. Simone de Beauvoir cherche dans ses livres à dégager une morale pour l'homme.

Épouse du célèbre musicien Georges Auric, elle n'est pas seulement une belle et élégante jeune femme, c'est aussi un peintre plein de talent. Nora Auric aime surtout à peindre des visages. Son exposition de portraits à la Galerie Charpentier fut un grand succès et un événement très parisien.

Madame Claude Alphand n'avait jamais songé à devenir chanteuse, mais les récitals privés qu'elle a donnés en Amérique où elle vient de faire un long séjour prouvèrent d'une telle façon la qualité de son talent que ses amis parvinrent à la convaincre de poursuivre sa vocation.

SIMONE DE BEAUVOIR

MADAME CLAUDE ALPHAND

EMMANUEL D'ASTIER DE LA VIGERIE

REYNALDO HAHN

MADAME NORA AURIC

Emmanuel d'Astier de la Vigerie, Lieutenant de Vaisseau, membre du C.N.R., écrivain. Son livre Les Sept Jours est un passionnant roman d'aventures sur la Résistance. Alger, Londres, New-York, le maquis français. Pendant ces quatre ans d'Astier se trouvait partout où la France se battait.

Reynaldo Hahn vient d'être nommé au poste d'administrateur général de l'Opéra. Son grand talent de compositeur et sa connaissance parfaite de la musique le désignaient tout particulièrement pour prendre en mains notre premier théâtre musical et pour assumer cette tâche.

PHOTOS ANDRÉ OSTIER ET SAINT-PAUL

L e promeneur qui revient vers sa ville, après des années ou de longs mois d'absence, ne se lasse pas d'en contempler les vieux arbres mêlés à ses pierres et à ses monuments. Ces vieux arbres lui paraissent plus verts, plus vigoureux, plus solides qu'ils ne le furent jamais, les jeunes plus sveltes, plus élancés...

Cependant, c'est un Paris dépouillé, plus linéaire, qui accueille tous ceux qui accourent vers elle.

Qu'ils viennent de Londres, de New-York, ou de Bucarest, du Caire ou de Rio, chacun n'a qu'un cri : « Quel miracle de revoir Paris intact ! Nous avons l'impression que rien n'est changé. Nous nous retrouvons comme si nous n'étions jamais partis... comme si toutes ces années, c'était hier ! »

Chacun se précipite aussitôt vers ses lieux de prédilection. Chacun accomplit un pèlerinage ; l'un se penche en aval du pont des Saints-Pères, l'autre sous une arche en amont du Trocadéro près du fleuve « qui coule et ne tarit pas », un autre caresse les vieux pavés de Montmartre, un autre flâne sous les arcades de la rue de Rivoli, essuie la poussière du Palais-Royal, une autre retrouve sa table au Ritz, et j'ai même rencontré certaine dame illustre toute émue d'avoir vu des fruits sur le « figuier stérile » qui déborde des grilles de l'Église de la Mission Polonaise, figuier qu'elle associait dans sa mémoire à certains goûters des dimanches de son enfance qui suivaient chez un pâtissier en renom du voisinage des « matinées » enchanteresses au Nouveau-Cirque. « Paris n'a pas changé ».

Le savent-ils cependant que cette ville était exsangue, inanimée, que le passant avait peur de ses pas, que la nuit la plus étoilée était lourde d'angoisse et que la coquetterie des femmes n'était qu'un défi.

« Paris n'a pas changé ». Chacun veut y revenir. Chacun veut savoir ce qui s'y passe.

La tâche est aisée, car il semble que des effluves mystérieuses colportent aussitôt les nouvelles et que toute possibilité de joies artistiques ou intellectuelles attire aussitôt en foule ces êtres qui en furent si longtemps privés, pauvres humains

La Vie à Paris

PAR ANDRÉ OSTIER

LOUIS ARAGON ET ELSA TRIOLET

Louis Aragon et Elsa Triolet se regardent. Le poète et sa compagne. Elsa Triolet est aujourd'hui doublement célèbre. D'abord pour le Prix Goncourt qu'elle vient de remporter avec Le premier accroc coûte deux cents francs et pour avoir été chantée par les très beaux vers de son mari.

ANDRÉ MALRAUX

André Malraux ou la pensée en armes. Cet écrivain de génie s'est battu en Chine, en Espagne, dans le maquis français. Il est aujourd'hui colonel et est entré au Cabinet du Général de Gaulle. Il doit faire paraître un grand livre sur le mystérieux Colonel Lawrence qui l'a toujours intéressé.

ALBERT CAMUS

Albert Camus ressemble à un gangster. Mais c'est un des plus grands espoirs de la littérature française. Vous avez tous été sensible au ton et à l'élévation d'esprit des éditoriaux de Combat. Passionné par le théâtre, il donne un Caligula chez Hébertot, après Le Malentendu de l'hiver dernier.

72 — PHOTOS ANDRÉ OSTIER ET SAINT-PAUL

73

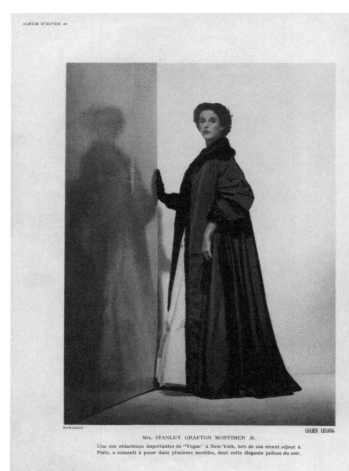

RAWLINGS

LUCIEN LELONG

Mrs. STANLEY GRAFTON MORTIMER Jr.

Une des rédactrices importantes de "Vogue" à New-York, lors de son récent séjour à Paris, a consenti à poser dans plusieurs modèles, dont cette élégante pelisse du soir.

130

LA VIE A PARIS
par André Ostier

Pendant qu'Yvonne Printemps rajeunit à longueur de soirée dans « Auprès de ma Blonde », avant que son rôle ne soit exporté en Amérique, son auteur Marcel Achard a terminé une farce qui porte encore le nom d'une chanson : « Savez-vous planter les choux ».

Francis Ambrière a remporté le Prix Goncourt avec son roman, « Les Grandes Vacances », inspiré par plusieurs pénibles années de longue captivité en Allemagne.

Les acteurs du Théâtre Français ont toujours été attirés par le Théâtre du Boulevard. Pierre Dux, Mary Bell et Debucourt jouent avec Suzanne Dantès, Hélène Perdrière et Pierre Jourdan chez « Bernstein », « Le Secret ».

On cherchait un « Peter Pan » pour jouer la pièce de Barrie on l'a trouvé en la personne de Pamela Stirling, adorable Anglaise, sortie du Conservatoire. Elle sera également « Poil de Carotte ».

Outre leurs dons de comédiens, ces autres transfuges de notre scène nationale, Madeleine Renaud et Jean-Louis Barrault, installés à Marigny ont leur violon d'Ingres. Elle possède une voix ravissante, lui aurait fait un excellent maître de ballet.

Elle a l'âge des ingénues, mais Dominique Blanchard songe depuis longtemps déjà à des « Emplois » plus dramatiques. Surprenante Agnès découverte par Jouvet, elle rêve d'être Camille.

Serge Reggiani le principal interprète du prochain film de Marcel Carné : « L'Île des Enfants perdus » aimerait le rôle de Julien Sorel dans « Le Rouge et le Noir ».

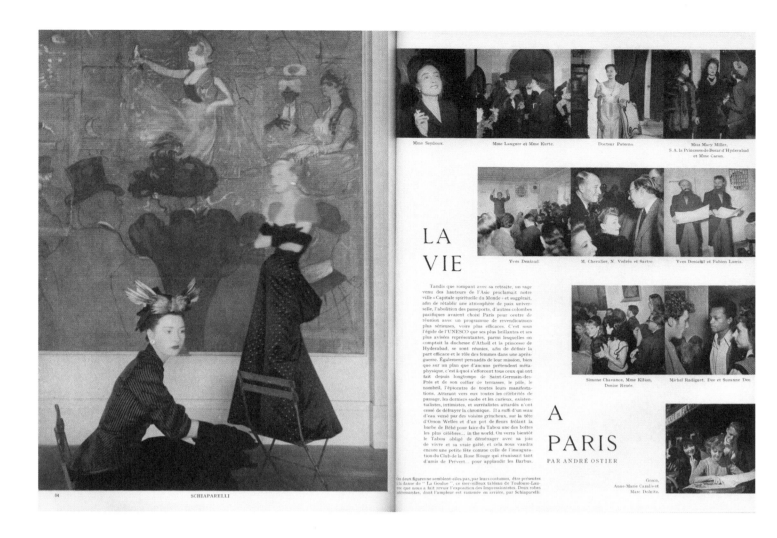

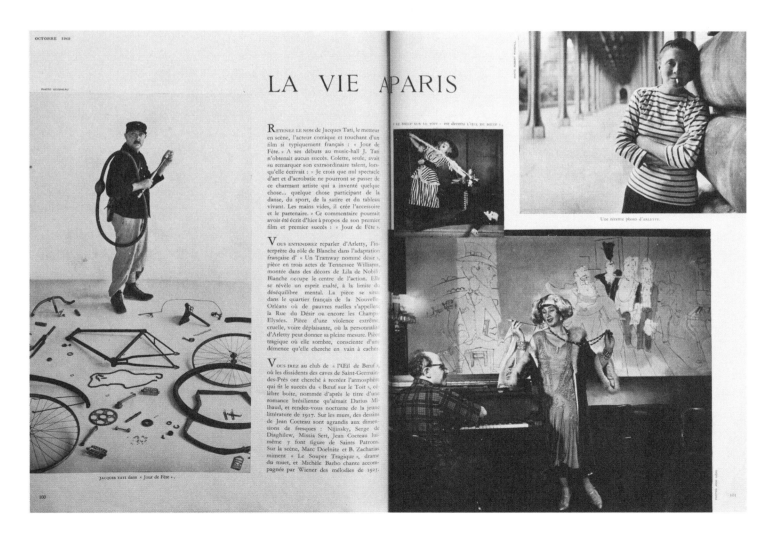

cat. 135 Serge Lido. Simone de Beauvoir at the Café de Flore. *Vogue Paris*, July/August 1947, p. 75
cat. 139 Robert Doisneau. Juliette Gréco at La Rose Rouge. *Vogue Paris*, December 1950/
January 1951, p. 66

UNE SCÈNE DU FILM "JAMMIN'THE BLUES" CHEF D'ŒUVRE PHOTOGRAPHIQUE DE GJON MILI.

JAZZ

Il existe dans New-York une boutique qui est un Lieu Saint, un temple, une caverne d'Ali-Baba, (avec ses trésors mais sans les 40 voleurs) une Mecque vers laquelle se tournent tous les amateurs de jazz. Les vrais, ceux qui ont cette musique dans le sang mais qui n'ont pas toujours de quoi s'offrir ses ivresses. Et les faux, c'est-à-dire les snobs toujours à l'affût du dernier bateau, les gens riches qui peuvent se payer le luxe de collectionner les vieux disques de « hot ». Cette boutique s'intitule « Commodore Music Shop ». Elle connaît la gloire depuis qu'on la mentionne dans un des derniers films policiers tournés à Hollywood. Elle connaît le succès commercial avec tout ce que ces mots comportent dans un pays comme l'Amérique. Mais avant d'en arriver là, elle a commencé par être une très mauvaise affaire, dirigée par Milton Gabler, un homme que ses contemporains jugeaient privés du sens commun.

Cette boutique avait en 1937 un passif de 20.000 dollars lorsque la fameuse firme « March of Time » décida qu'il était temps de tourner quelque chose sur « La Naissance du Swing ». Le film commençait par une scène représentant un client franchissant le seuil de la « Commodore Music Shop » et venant acquérir un disque de derrière les fagots, une insigne rareté des premiers âges du jazz. C'était une consécration pour la boutique. Pour le grand public, c'était la révélation d'une nouvelle mode. On collectionnerait désormais, on rechercherait dans les greniers et les fonds de tiroir, on s'arracherait à prix d'or les vieux enregistrements, en même temps qu'on mettrait son point d'honneur à posséder la série complète des nouveaux disques signés par Milton Gabler. Ce gros bonhomme ne connaît pas une note de musique mais, en matière de jazz, ce qu'il ignore ne vaut pas la peine d'être connu. Ce n'est pas un simple commerçant qui fait des affaires. C'est le grand prêtre d'un culte et il est cela avant d'être ce qu'il est aussi, c'est-à-dire un businessman américain fort averti. Son idée géniale a été de râfler tous les vieux disques, tous les incunables du jazz, à l'époque où le public n'en voulait plus et où les grandes compagnies qui les avaient fait estamper étaient trop contentes de s'en débarrasser, en vrac, pour quelques sous. Le jour où les amateurs commencèrent à rechercher ces raretés, les prix montèrent de telle sorte qu'on vit tel ou tel bon morceau se vendre jusqu'à trente-cinq dollars. Milton Gabler, pour garnir ses caves, ne négligea

BILLIE HOLLIDAY, UNE DES PLUS ÉTONNANTES CHANTEUSES DE "BLUES".

167

cat. 158 Robert Doisneau. *Vogue Paris*, July/August 1950, pp. 58–59

cat. 134 André Ostier. Léonor Fini during the Nuit du Pré Catelan, June 1946. *Vogue Paris*,
Winter 1946, p. 119

The Hardship of War
and the Rebirth of *Vogue Paris*

cat. 145 Robert Doisneau. Youly Algaroff and Jean Babilée at the Paris Opera. *Vogue Paris*,
March 1953, p. 116 and American *Vogue,* March 15, 1953, p. 72

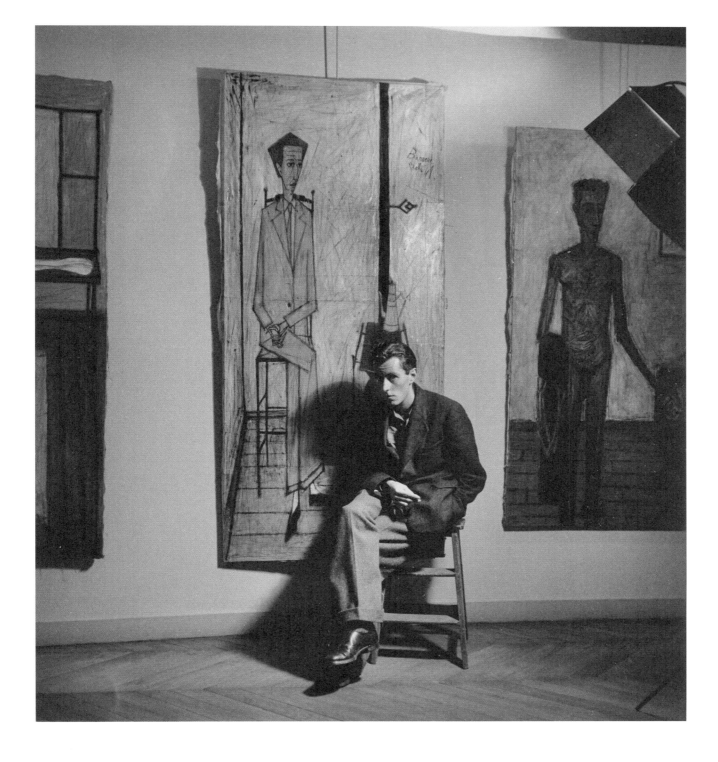

cat. 140 Arik Nepo. Bernard Buffet at the Salon d'Automne in 1948. American *Vogue*, November 15,
1948, p. 137 (variation) and *Vogue Paris*, December 1948/January 1949, p. 112

The Hardship of War
and the Rebirth of *Vogue Paris*

cat. 81 Émile Savitry. Marcel Dhorme trench coat. *Vogue Paris*, Winter 1945–1946, p. 133
and American *Vogue,* December 1, 1945, p. 174

cat. 82 Cecil Beaton. Pierre Balmain jacket and trousers. *Vogue Paris*, Winter 1945–1946, p. 156
and American *Vogue,* December 15, 1945, p. 59 (variation)

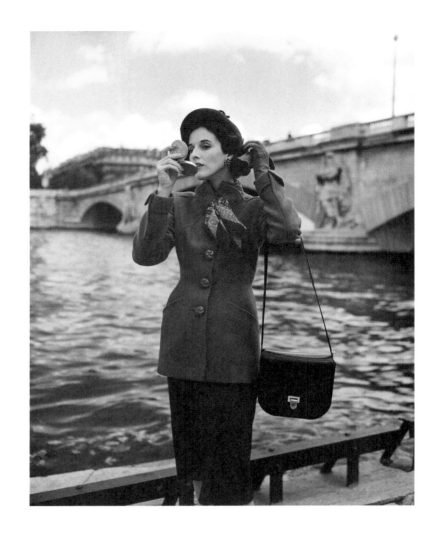

cat. 83 John Rawlings. Molyneux frock coat. American *Vogue*, October 15, 1946, p. 181 and *Vogue Paris*, January/February 1947, p. 83

cat. 85 John Rawlings. Wenda Rogerson Parkinson. Robert Piguet jacket. American *Vogue*, October 15, 1946, p. 183 and *Vogue Paris*, January/February 1947, p. 82

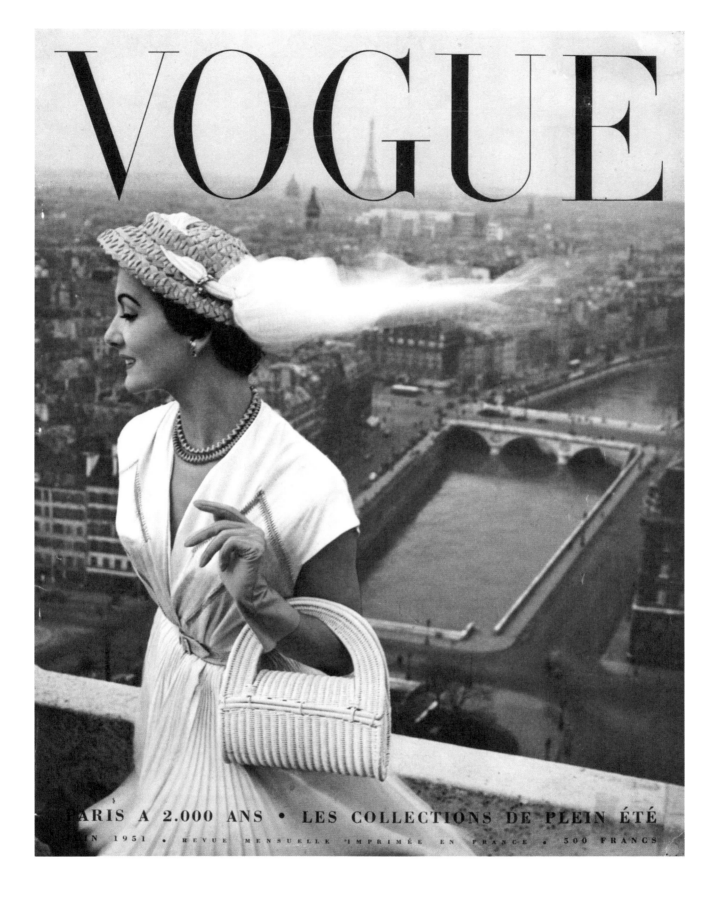

VOGUE

PARIS A 2.000 ANS • LES COLLECTIONS DE PLEIN ÉTÉ

JUIN 1951 • REVUE MENSUELLE IMPRIMÉE EN FRANCE • 500 FRANCS

cat. 129 Robert Doisneau. Jeanne Lafaurie dress, Paulette hat. On one of the towers of Notre-Dame.
Vogue Paris, June 1951, cover

The Hardship of War
and the Rebirth of *Vogue Paris*

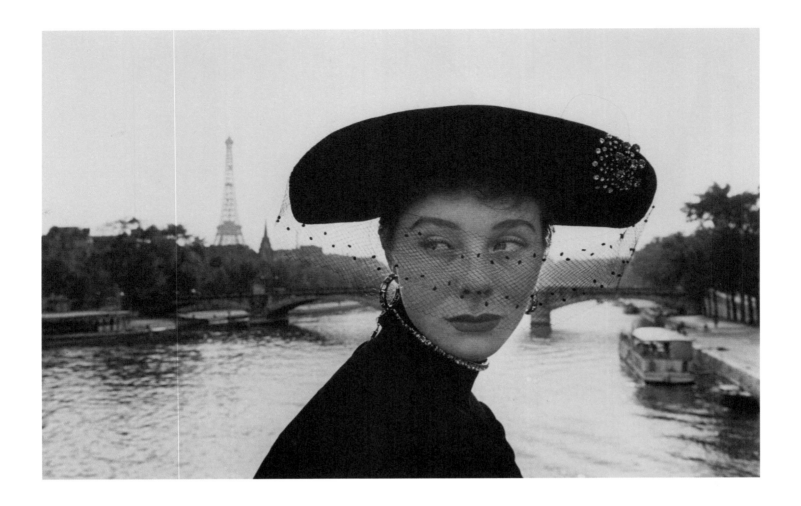

cat. 94 Arik Nepo. Bettina. Achille hat. *Vogue Paris*, September 1951, p. 109
cat. 93 Arik Nepo. Marie-Christiane hat. *Vogue Paris*, September 1951, p. 108

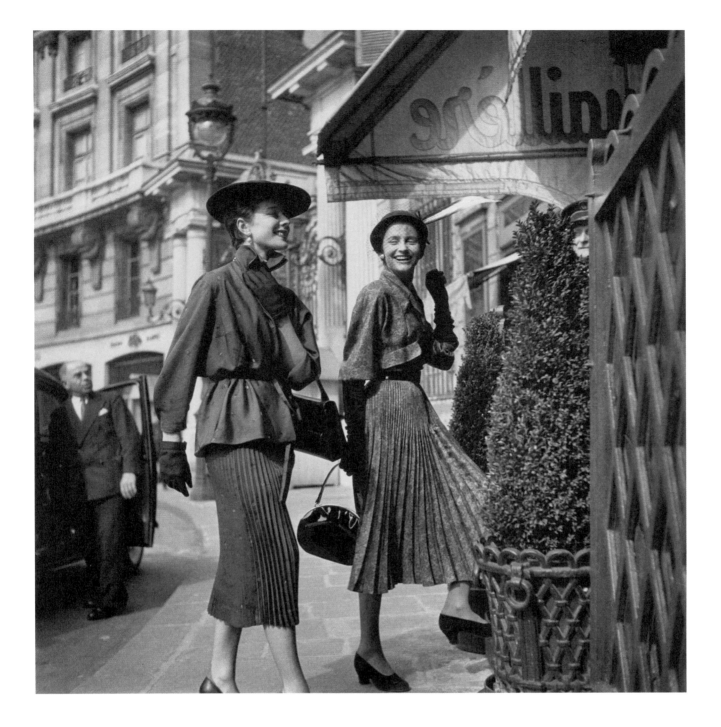

cat. 90 Robert Randall. Bettina, Jeanne Lafaurie ensemble (left). Marie-Claire Lafaurie,
Madeleine de Rauch ensemble (right). *Vogue Paris*, May 1950, p. 77

cat. 99 and 100 Tom Keogh. [Untitled]. Cover designs, April 1948

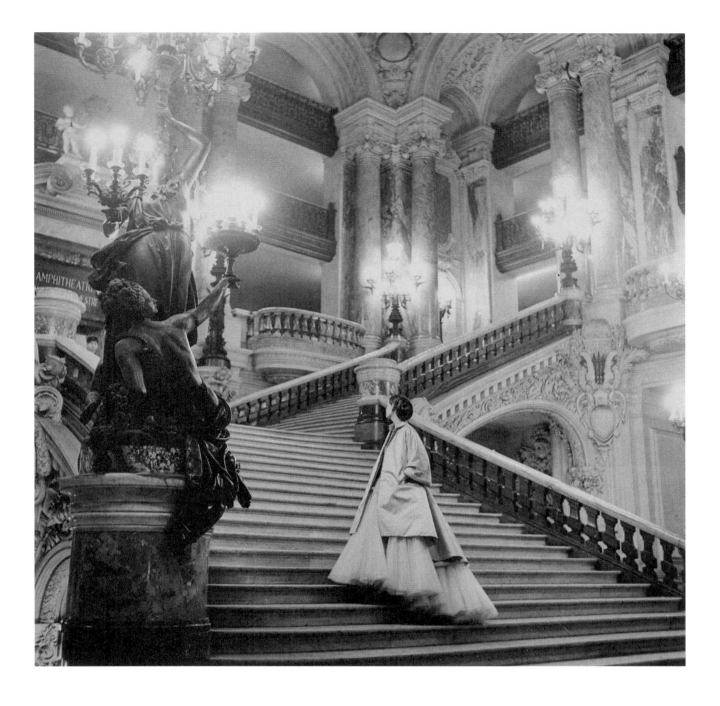

cat. 89 Clifford Coffin. Wenda Rogerson Parkinson. Christian Dior evening dress and coat.
Grand staircase of the Opera Garnier. *Vogue Paris*, May 1948, p. 28

The Hardship of War
and the Rebirth of *Vogue Paris*

OCTOBRE 1950

LES ROSES EN HIVER CHEZ CHRISTIAN DIOR
*Cette toque piquée de roses accompagne
une robe garnie de dentelle et de jais.*

LA FIN DU JOUR

TUNIQUE EN SPIRALE
CHEZ JEAN DESSÈS
*En moire noire de
Martelli, la tunique
s'enroule et se
double de velours.*

robe moulée sur quoi bouge une écharpe. Frileuse, ou pudique, elle ferme haut son corsage. Consciente de la perfection de son buste, elle consent aux audaces d'une échancrure plongeante. Les ensembles sont très en vogue : leur formule permet de les interpréter selon son goût sans enfreindre la règle : choisir un tissu de base et s'y tenir, avec la seule note de l'écharpe ou du nœud pour rompre la monotonie. Ou bien jouer franchement des contrastes : blouse adoptant la couleur, la douceur d'un fourrage, ample manteau sombre réservant la surprise de sa doublure claire assortie au tailleur. Certaines femmes se vantent de ne quitter le tailleur que pour la robe du soir : cette fidélité est admise, aux heures élégantes, à condition que le tissu soit noir, noble et qu'un gilet précieux luise entre les revers. Le lamé, en robe entière, n'est point banni de la table à thé si sa coupe est sobre, stricte. La dentelle rigide, la guipure rebrodée se peuvent porter de jour. Le manteau devient alors celui de Noé, pour cacher à la rue ce que celle-ci doit ignorer.

LE DÉCOLLETÉ DENTELÉ CHEZ GRÈS
*En taffetas de Chatillon, Mauly, Roussel,
cette robe se découpe en dents de scie.*

92

PENN

ill. 6 Irving Penn. Christian Dior ensemble (left). Grès dress (center). Lisa Fonssagrives,
Jean Dessès tunic (right). *Vogue Paris*, October 1950, pp. 92–93

1939–1954

cat. 96 Irving Penn. Lisa Fonssagrives. Balenciaga coat. *Vogue Paris*, December 1950, p. 120

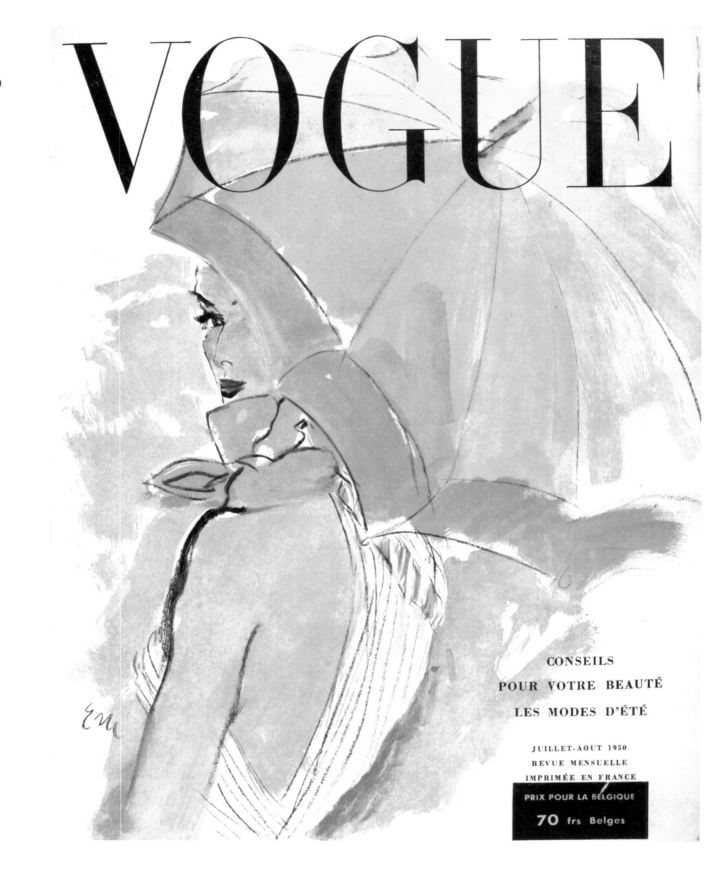

VOGUE

CONSEILS
POUR VOTRE BEAUTÉ
LES MODES D'ÉTÉ

JUILLET-AOUT 1950
REVUE MENSUELLE
IMPRIMÉE EN FRANCE

PRIX POUR LA BELGIQUE
70 frs Belges

VOGUE

ÉDITION
DE PARIS

LES MODES DE VACANCES

BIENFAITS ET MÉFAITS DU SOLEIL

LE "PRÊT A PORTER"

JUILLET-AOÛT 1952 • REVUE MENSUELLE • IMPRIMÉE EN FRANCE • PRIX : 500 FRANCS

cat. 109 Irving Penn. Lisa Fonssagrives. *Vogue Paris*, July/August 1952, cover

cat. 104 Sabine Weiss. Oriano jersey shorts for Les Galeries Lafayette (left). Robert Pitte
jumpsuit (right). *Vogue Paris*, July 1953, p. 72

cat. 105 Sabine Weiss. M.-R. Lebigot swimwear, Boutique Jacques Fath hat. *Vogue Paris*,
June 1954, p. 21

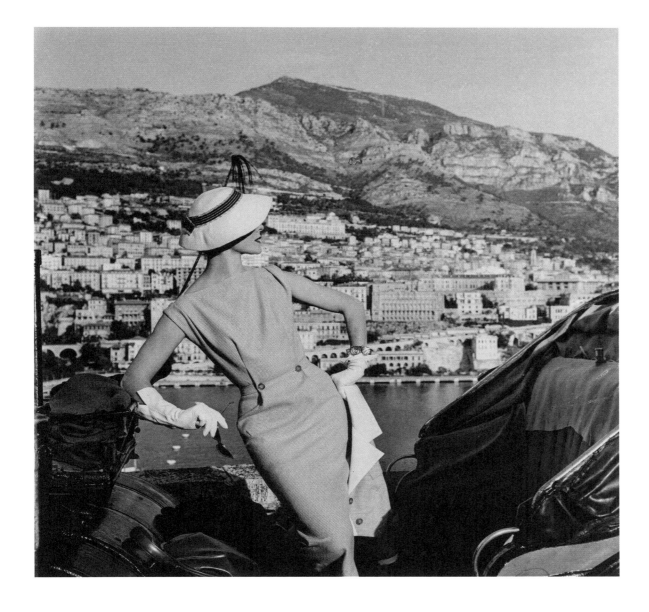

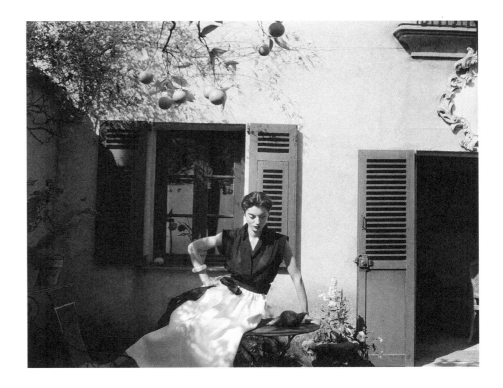

cat. 106 Henry Clarke. Bettina. Lanvin-Castillo-Boutique dress, Paulette hat. Monte Carlo.
 Vogue Paris, February 1954, p. 40
cat. 107 Henry Clarke. Régine Debrise. Maggy Rouff-Boutique blouse and skirt. Roquebrune.
 Vogue Paris, June 1951, p. 69

The Hardship of War
and the Rebirth of *Vogue Paris*

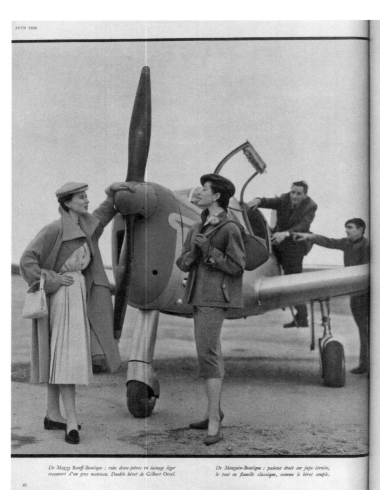

De Christian Dior-Colifichets : robe confortable accompa-
gnée d'une écharpe, le tout en jersey gris de Racine. →

Ces deux dernières années ont vu éclore les
Boutiques des grands couturiers. Formule
idéale non seulement pour les femmes que
les prix élevés ne rebutent pas, mais aussi
pour celles dont un budget modeste cherche
malgré tout une vêture bien coupée portant,
à des prix abordables, la griffe de bonne
maison. Les premières trouvent dans les
Boutiques la robe de " dernière heure ", un
modèle qui manque parfois même dans une
garde-robe bien conçue. Les secondes béné-
ficient de robes élégantes estampillées par la
haute couture. Enfin, pour la visiteuse qui
traverse Paris, ces boutiques sont précieuses.

De Jean Dessès-Boutique : blouse et pantalon aux genoux
en coton tabac. La jupe en forme est en satin à pois. →

A TOUS PRIX

De Jean Patou-Boutique : robe souple en jersey jaune.
Valise de Roger Model. Couverture de voyage de Rodier.

Souvent, si la robe existe en plusieurs
exemplaires, elle peut l'acheter et la porter
immédiatement : de toute façon, elle n'atten-
dra jamais plus de huit jours. Les prix s'éche-
lonnent de 18.000 à 40.000 francs pour la
robe, le tailleur dépassant rarement 45.000
francs. Une variété infinie d'accessoires,
sacs, écharpes, jupes, robes de plage, est
à la disposition de la cliente. Chaque
Boutique rivalise d'idées originales. Plusieurs
modistes tiennent également Boutique,
notamment Paulette, Claude Saint-Cyr,
Gilbert Orcel qui, en plus de mille et un
colifichets, présentent, entre 5.000 et 8.000
francs, des chapeaux typiquement de Paris.

Photos prises par Arik Népo au terrain de Toussus-le-Noble.

De Maggy Rouff-Boutique : robe deux-pièces en lainage léger recouvert d'un gros manteau. Double béret de Gilbert Orcel.

De Manguin-Boutique : paletot droit sur jupe étroite, le tout en flanelle classique, comme le béret souple.

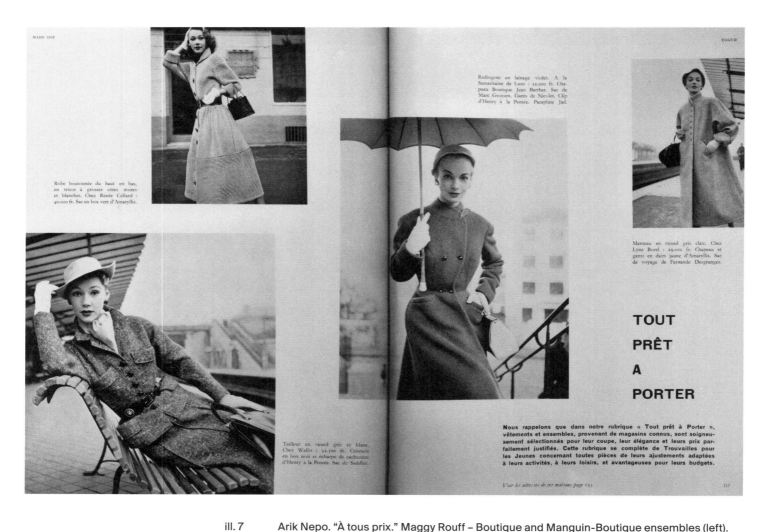

Robe boutonnée du haut en bas, en tricot à grosses côtes noires et blanches. Chez Renée Collard : 40.000 fr. Sac en box vert d'Amaryllis.

Redingote en lainage violet. A la
Samaritaine de Luxe : 32.000 fr. Cha-
peau Boutique Jean Barthet. Sac de
Marc Grossen. Gants de Nicolet. Clip
d'Henry à la Pensée. Parapluie Jad.

Manteau en tweed gris clair. Chez
Lyne Borel : 29.000 fr. Chapeau et
gants en daim jaune d'Amaryllis. Sac
de voyage de Fernande Desgranges.

Tailleur en tweed gris et blanc.
Chez Wallis : 32.100 fr. Ceinture
en box noir et écharpe de cachemire
d'Henry à la Pensée. Sac de Saddler.

TOUT
PRÊT
A
PORTER

Nous rappelons que dans notre rubrique « Tout prêt à Porter »,
vêtements et ensembles, provenant de magasins connus, sont soigneu-
sement sélectionnés pour leur coupe, leur élégance et leurs prix par-
faitement justifiés. Cette rubrique se complète de Trouvailles pour
les Jeunes concernant toutes pièces de leurs ajustements adaptées
à leurs activités, à leurs loisirs, et avantageuses pour leurs budgets.

ill. 7 Arik Nepo. "À tous prix." Maggy Rouff – Boutique and Manguin-Boutique ensembles (left).
Christian Dior–Colifichets ensembles, Jean Dessès-Boutique and Jean Patou-Boutique
(right). *Vogue Paris*, June 1950, pp. 48–49

1939–1954 cat. 130 Robert Randall. "Tout prêt à porter." *Vogue Paris*, March 1952, pp. 116–117

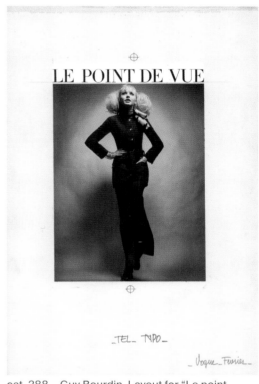

cat. 288 Guy Bourdin. Layout for "Le point de vue de Vogue." Maudie James. Saint Laurent–Rive Gauche ensemble. *Vogue Paris*, February 1969, p. 81

"The Point of View of *Vogue*": This is the heading under which *Vogue Paris* chooses to address its readers. Appearing in every issue since 1928, this traditional editorial is the link that brings together all the issues into a coherent, immediately identifiable collection.

The heading clearly announces *Vogue Paris* as a magazine with a particular perspective, which guides the choice of photographs, illustrations, and text contained within it and their positions amid its pages. Many other of the magazine's columns and customs have also given the publication an opportunity to (re)present itself to its audience. For example, in the 1930s, card inserts kept readers informed about the daily life of the magazine (changes of address, price or pace of the publication, services offered by Condé Nast—ranging from other magazines to the dedicated photography studio—and so on). In the 2000s, "The Eye of *Vogue*" playfully showed readers behind the scenes of its photo shoots.

However, none of these sections occupies the same position as the editorial, a vital space establishing the authority of the magazine and from which the magazine's content radiates. Over the years, the characteristic tone of *Vogue Paris* has noticeably evolved. While a somewhat muted respectability marked the 1930s, the issues of the 1950s highlighted the cultural renaissance of Paris—a celebratory tone that represented a strong editorial choice, both symbolically and economically, but which was also politically diplomatic in the context of the postwar period. In the 1960s, 1970s, and 1980s, the themes explored across the issues were presented using a narrative approach that befitted the times. In more recent years, this page has featured the subjective opinions of the editors in chief, who have increasingly become a focus of attention in themselves.

In addition, each editorial is visually striking: Text and images are closely harmonized in a unique way. Its layout changes from one issue to another, which is a crucial design task and attests to the increasing prominence of the "Point of View." Together, the editorials form a micro-history of the magazine over time while testifying to the ongoing collective work (journalistic, stylistic, photographic, and graphic) required for the creation of each issue. The editorial of *Vogue Paris* has thus become, because of its continuity and longevity, the setting for an extraordinary exercise in self-examination.

The "Point of View" embodies qualities that are specific to magazines: serialized, versatile, hierarchical, and diverse, with a fluid approach to contemporary subjects. These are presented, over the years, within a constant and instantly recognizable framework. It is the distinctiveness of *Vogue Paris* as a magazine, poised between fleeting fashion and lasting continuity, that this series of editorials manages to capture.

Alice Morin

106

ill. 1

ill. 2

ill. 3

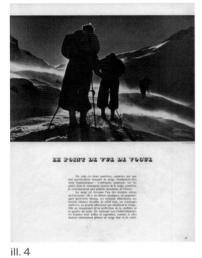

ill. 4

ill. 5

ill. 6

ill. 7

ill. 8

ill. 9

ill. 1 George Hoyningen-Huene. *Vogue Paris*, March 1929, p. 1

ill. 2 George Hoyningen-Huene. *Vogue Paris*, April 1929, p. 1

ill. 3 John Kabel. *Vogue Paris*, July 1933, p. 9

ill. 4 Karl Machatschek. *Vogue Paris*, November 1937, p. 29

ill. 5 Maurice Tabard. *Vogue Paris*, November 1933, p. 17

ill. 6 Le Monnier. *Vogue Paris*, September 1937, p. 13

ill. 7 Henry Clarke. Suzy Parker. Jacques Fath – Boutique coat, Hermès bag. *Vogue Paris*, February 1954, p. 33

ill. 8 René Gruau. Christian Dior dress. *Vogue Paris*, March 1955, p. 113

ill. 9 Henry Clarke. Van Dongen and Dior hats. *Vogue Paris*, November 1960, p. 45

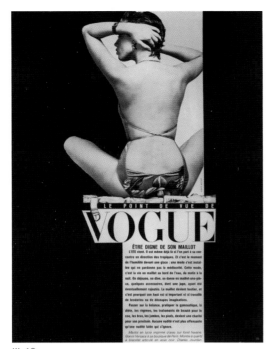

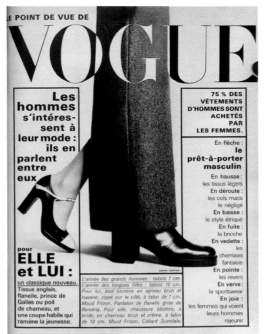

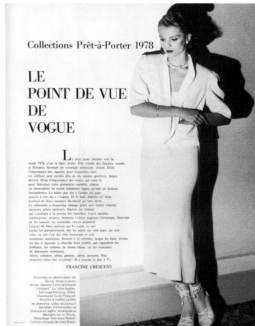

ill. 10

ill. 11

ill. 12

ill. 13

ill. 14

ill. 15

ill. 16

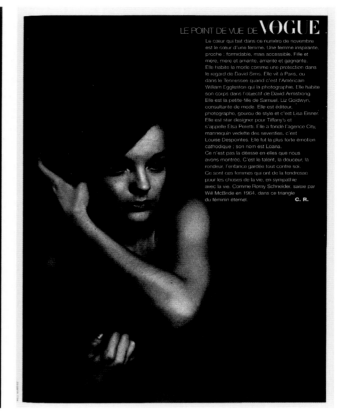

ill. 17

ill. 18

ill. 19

ill. 16 *Vogue Paris*, April 2001, p. 173
ill. 17 Will McBride. Romy Schneider, 1964.
Vogue Paris, November 2001, p. 187

ill. 18 Mario Testino. Tom Ford for Gucci
dress. *Vogue Paris*, March 2004, p. 84

ill. 19 Anonymous. Emmanuelle Alt
and Karl Lagerfeld. *Vogue Paris*,
December 2016/January 2017, p. 58

III

"LA MODE ET LA VIE DE PARIS"

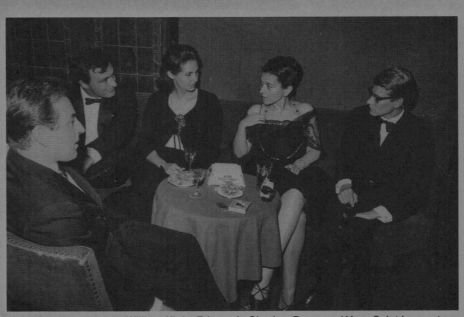

ill. 1 Anonymous. William Klein, Edmonde Charles-Roux, and Yves Saint Laurent,
at Vodka, Paris, 1962

Vogue Paris has done much to forge collective notions of Paris. Its pages place the reader in the city through the textual and pictorial information conveyed, and this spatiality is fortified through physical handling. Editorial imagery organizes this data—from shop locations to current events articles—presenting understandable "whole" visual pictures, whereby Paris is defined and wound together by a sacred trinity of elements: the city's spaces, fashion, and *la Parisienne*. This formula is a constant, though it adapts to the particular concerns and identities of each era. In the September 1958 issue, William Klein photographed a model gingerly ascending the Eiffel Tower, stilettos clanging against its metal steps, with one hand on the railing and the other holding a miniature tower as though to explain the abstract mass of girders behind her (ill. 3). She was the archetype of 1950s composed femininity: perfectly posed and made up, armed with the appropriate accessories to match her belted New Look silhouette by Guy Laroche. Whereas, through Helmut Newton's 1965 lens, models with tousled coifs in ready-made jersey shift dresses—straight, short, and unstructured—are precariously lodged amid the tower's girders and railings; yet they appear fearless with their elasticized, lightweight clothing allowing them to travel to the city's hard-to-reach interstices (cat. 199). From a strained ascent to audacious, destabilizing viewpoints, both images convey tensions in relation to women's wider conditions, but in different ways. This chapter examines fashion and Paris of the 1950s and 1960s—and the transition between these two images and cultural situations—through the lens of *Vogue* while under the editorship of Edmonde Charles-Roux.

One constant is the models' location. In his 1964 essay on the Eiffel Tower, Roland Barthes notes its perpetual and universal presence, stating firstly that the tower is "there."[2] It is there physically, present from most viewpoints in Paris, and symbolically: "It is everywhere on Earth where Paris is to be expressed in image."[3] For Barthes, however, the tower is more than a symbol of Paris; it functions as the ultimate modern sign, able to be appropriated and deconstructed in countless ways, as Klein and Newton have done. According to Agnès Rocamora, the tower is one of the key "signs of French fashion discourse, which contribute[s] to the construction of Paris as fashion center and capital of fashion" in fashion magazines.[4] In particular, in connection with Paris's label as "the City of Light," she considers it a "metaphor for Paris as a guiding light" in fashion.[5] Likewise, magazines visualized Paris's centralization and design leadership, undertaking the symbolic production of fashion in the Bourdieusian sense.[6] Through image, magazines instructed readers on how to view and experience fashion. Their mythologization of Paris fashion relied on the juxtaposition of haute couture and privileged spaces such as Paris's bridges, squares, and monuments, as seen in ills. 3 and 5, so that, as Rocamora notes, "the Parisian fashion geography is often narrowed down to its foremost region, its luxurious side."[7]

In the 1950s and 1960s, however, there was a palpable nostalgia in these views, as postwar Paris—in the throes of rapid urbanization—underwent physical transformation. In 1958 construction began on both the Boulevard Périphérique, a ring road that cut through the city, and the business district La Défense, transforming underdeveloped land and factories into skyscrapers throughout the 1960s. At the same time, the city expanded to incorporate new suburbs, filled with *habitations à loyer modéré* (low-rent housing) to accommodate its growing population, which notably included immigrants from France's former colonies in Asia and Africa. Although Paris continued to be an incubator where

ill. 2 William Klein. Lanvin ensemble. *Vogue Paris*, October 1957, cover

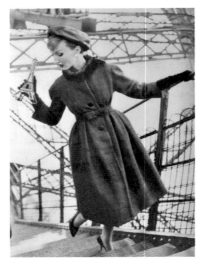

ill. 3 William Klein. Guy
 Laroche ensemble.
 Vogue Paris,
 September 1958, p. 116

artists, filmmakers, photographers, designers, and writers thrived, it was in fact a battleground between old and new, stasis and flux. The city was on display not only in fashion magazines but also in documentary photography and *Nouvelle Vague* (New Wave) cinema. Is it not true that Paris of the 1950s and 1960s has produced images that fixed the city at this time in the imaginary of generations thereafter? But beyond that, France was modernizing its industries, transforming from agrarian to technocratic systems, decolonizing and opening its government to new global alliances, gestating tensions that led to May 68, when Paris would be thrust into the spotlight on the world stage. Fashion, which is both forward-thinking and nostalgic, realizes the tensions implicit in modernity, and this is especially apparent in the period studied here: The industry clung to haute couture, so embedded in national identities, while it promoted prêt-à-porter and the modernities it symbolized. Studying representations of dressed women is key to understanding how fashion and modernity are embodied; and in the mid-1950s, only ten years after French women attained suffrage, national and industrial messages informed pictorial depictions of their new roles and attitudes. Female professionalism in the press can also be seen to have a direct tie to more practical, accessible ready-made garments. The writer Edmonde Charles-Roux became editor of *Vogue Paris* in September 1954 after having worked there, and at *Elle* and *France Soir* from the 1940s; Maïmé Arnodin shaped *Le Jardin des Modes* between 1951 and 1958, while Hélène Lazareff led *Elle* from its inception in 1945. Like the tower, however, *Vogue Paris* remained the ultimate guiding light, steering readers through shifts in fashion and space.

Changing Landscapes: Design and Paris in the 1950s

According to a 1956 article, *Vogue Paris,* "since its creation in 1921, has always been the flag bearer of Haute Couture."[8] A page from the March 1957 issue typified the dissemination of this message, showing three sketched figures in garments by Lanvin-Castillo, Revillon, and Dior, their poses and silhouettes rendered through René Gruau's minimalist lines (cat. 161). The late 1950s approached the end of couture's "golden age," where old and new names collided, from Madame Grès, Nina Ricci, Balenciaga, and a returning Chanel with her iconic suit, to the postwar houses Balmain, Dior, Givenchy, and Cardin. Throughout the 1950s, the preeminence of Dior's *Ligne Corolle*—the New Look—worked to uphold couture's function as a trendsetting mechanism. This historicizing silhouette, with its long, voluminous skirt and cinched-in waist, was one of the many styles that dramatically changed the way bodies looked in this decade—styles with features such as enormous collars or high-contrasting cuts that ballooned out or tightly molded to the figure. Cristóbal Balenciaga in particular rethought dressmaking and tailoring techniques to produce his sculptural constructions. Photographers such as Irving Penn and Richard Avedon immortalized these various looks in the pages of American, French, and British *Vogue*.

Despite the centrality of these couture-led styles, the above-mentioned 1956 article pinpointed an industrial shift toward ready-made production due to both the rise of couture's labor costs (which fell on the consumer) and the progresses of prêt-à-porter, normally not promoted in the fashion press. It explained that, since 1952, *Vogue Paris* was the first magazine to note

the importance of French prêt-à-porter, which now offered good design as well as financial accessibility. Not to stray too far from its raison d'être, it described how couture also transformed itself through *moyens industriels* (industrial means). Because haute couture was becoming less financially sustainable, the houses channeled efforts into their ready-made operations. *Vogue Paris* upheld the industry's strategy of adaptation. Drawing on an older visual language, the article featured illustrations by Eve of couture ready-to-wear, such as Givenchy-Université and Maggy Rouff-Extension Couture. But it also integrated photographs by Henry Clarke of the high-end ready-made brands which magazines almost exclusively presented in the 1950s: *Couture en gros* manufacturers such as Wébé, Basta, Lempereur, and Germaine et Jane.

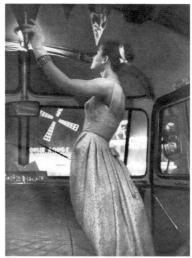

ill. 4 Sabine Weiss. O. F. Delapierre dress. *Vogue Paris*, April 1956, p. 129

From the 1950s, women's magazines focused more on ready-made clothes, which necessitated a new definition of fashion and image of a multifarious femininity. As alluded to previously, *Vogue Paris* implemented a regular section devoted to prêt-à-porter in 1952, "Tout Fait Tout Prêt-à-Porter" (All Ready, All Ready-to-Wear), to which photographers such as Robert Randall, Jacques Boucher, and Sante Forlano contributed until it ceased mid-decade. Under Charles-Roux, the August 1956 issue was the first devoted to prêt-à-porter collections. These examples illustrated how women's changing roles were tied into the fashions being promoted, couched in a language of productivity and readiness, so relevant during the early years of the *Trentes Glorieuses* (The Glorious Thirty, 1945–75), as well as the decade following female suffrage. Accordingly, the 1956 ready-made collections addressed *la femme qui travaille* (the working woman), and images narrated the experience of fashion, showing professional women posed with the tools of their trade: easel, typewriter, files, and telephone. The garments were also employed as tools in women's active styling—a clear departure from couture trends mandated by the industry. In another 1956 example, practical ready-made clothing, made from synthetic *Tissus miracle* (miracle fabrics),[9] facilitated their bus and rail travel around Paris to tourism sites. The editorial's final image skirts precariously around the boundaries of acceptable space in its depiction of a woman nearing the Moulin Rouge at night, yet contained within the walls of the bus, as well as her stiff dress, made from Nylfrance, a *dentelle de nylon* (nylon lace) fabric, by O.F. Delapierre (ill. 4). This was the material of scientific modernity that fostered women's independence and movement across the city. The above imagery, all by Sabine Weiss, is noteworthy for its application of narrative, portraying women as actors, albeit in staged scenarios.

Over the course of the 1950s and 1960s, the gap between staged and "real" street scenes narrowed as photographers drew from the style and quotidian content of documentary photography. Focus on the space of everyday Paris also served to reposition fashion as informal and practical. In this way, fashion connected to wider thinking by theorists such as Henri Lefebvre, who identified the quotidian as a concern during the rapid modernization of the postwar period. For Lefebvre, the street, "a place of passage, of interaction, of movement, and communication,"[10] best represented the lived everyday. So it also stands for the public, professional spaces where women's mere presence was meaningful and contested. In *Vogue Paris* the street became a vital fashion studio. Photographs by Willy Ronis in 1958, for instance, that depicted street scenes chimed with Lefebvre's description of movement and life. One model, wearing a coat with a high fur collar by Gattegno, a *couture en gros* label, made her way through automobile traffic with a commanding walk. Models—and magazine

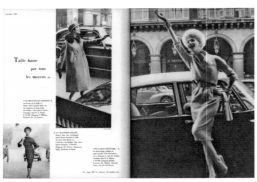

ill. 5 Willy Ronis. "Taille haute par tous les
 moyens." *Vogue Paris*, October 1958,
 pp. 168–169

readers through the activity of page turning—assumed an active value attached to urban movement. They became agents and authors of fashion as opposed to the passive couture model in the studio, as scholars such as Martin Harrison have discussed.[11]

Garments with straighter and somewhat looser shapes, such as the "sack" dress by Algo, fit this newer pace of urban life, suggested by the movement of cars and passersby behind the model (ill. 5). Aided by his 35mm Foca camera, Ronis sometimes employed reportage techniques to achieve high-graphic energy such as blurred motion, informal framing and close-ups. As a member of the humanist photography agency Rapho with Robert Doisneau and Sabine Weiss, who both also contributed to the magazine, he was largely informed by photojournalism, to capture the familiar "everyday" in Paris.[12] Along with others such as Robert Randall and Henry Clarke, these photographers fostered the fusion of the developing fields of photojournalism and fashion photography in *Vogue Paris* to depict the changing city that, beginning in the 1950s, was characterized by a new energy after its wartime occupation.

This photographic lens resonated with Charles-Roux's aims to document Paris life. She considered Doisneau in particular to be complicit in this goal: "Together we hopped from café-concerts, café-théâtres, design factories, dance studios, dressing rooms, backstage areas, and workshops of illustrious painters. . . ."[13] These explorations centered around cultural and artistic circles; and the literary editor staged the magazine as a space to highlight the work and activities of philosophers, writers, actors, playwrights, artists, and other cultural players. Alongside its fashion editorials and advertisements were the many portraits of these subjects that Charles-Roux commissioned, such as Georges Braque, Nathalie Sarraute, Pierre Dumayet, and J.M.G. Le Clezio. So just as fashion, due in part to the emergence of prêt-à-porter, became synonymous with women's active lifestyles, during this period the magazine broadened its scope beyond topics of fashion. Therefore, in consuming the magazine that increasingly mixed the everyday and highbrow, women readers also accessed this Parisian world of ideas, barred from the city ever so slightly still through their gender.

Beyond Paris?

In the 1960s movement continued to be a powerful construct in *Vogue Paris* in relation to women's clothing and active lives, as imagemakers experimented with how to visualize it in ways that referenced the moving image—a measure of realism. A 1961 prêt-à-porter themed issue presented "les collections dans le mouvement," as the cover clearly stated. An editorial within implicated the magazine and reader, writing that "*Vogue* puts you in motion" (ill. 6). Images by William Klein blurred together the repeated photograph of models, playing with the exposure to give the illusion of their motion. In one, text equated the material qualities of a suit by Chloé with its capacity for wearer movement through the "flexibility of the wool crepe . . . the casualness of the open jacket [and the] comfort of the skirt."[14] Yet, as opposed to earlier imagery that portrayed ready-made dress as a tangible tool of models' physical action and productivity, here, movement was metaphorical, a surrogate for women's decision-making. "Being in motion is a matter of choice. You can do this

by wearing comfortable skirts, flowing lines, and soft fabrics. Your time is a time of movement, don't forget it."[15] Models' timely movement and the power to decide their next steps perhaps held heightened meaning during a time when commentators and feminist organizations such as the Mouvement démocratique féminin (MDF, est. 1962) worked to help women understand their rights and choices in life.

Shifts in image production, in addition to the advent of new brands, challenged couture houses' strict control of images and hegemonic claim to creation. These changes occurred at a moment of change in the speed of communication, signaled by the Telstar satellite in July 1962, which allowed for a transatlantic television transmission between Europe and the United States. This included a live preview of garments by Balmain and Dior throughout the United States during fashion week. Until then, couture collections were kept secret until magazines unveiled them officially to the public. Emma McClendon argues that the event helped "chang[e] the dynamic of the fashion industry by disrupting the traditional flow of information."[16] It was indicative of a general shift in communication technology through the women's press, film, radio, and television, so that, according to Bruno du Roselle, the one-time president of the Fédération française du vétement féminin (French Federation of Women's Clothing), "a woman . . . is surrounded by a huge network of information about fashion."[17] This affected the speed and means through which fashion imagery was disseminated and received (*Vogue* faced more competition), as well as shifted the industry away from a "slow-moving, codified seasonal rhythm" set by haute couture.[18]

An earlier hint at couture's cracking facade occurred when Yves Saint Laurent presented his final, scandalous Beatnik collection for Dior in Fall 1960, with its allusion to subcultural street styles, notably in the form of knitted "helmets" and a "motorcycle" jacket in crocodile leather. Fashion was becoming less formal to address younger consumers and liberalized attitudes, which *Vogue* linked to prêt-à-porter. By the early 1960s the industry changed its focus from *couture en gros* brands to the *styliste*, the new type of designer who created collections for other labels, such as Pierre d'Alby and Cacharel. Like their couturier counterparts earlier, these designers were named and promoted in the press and included Sonia Rykiel, Emmanuelle Khanh, Christiane Bailly, Michèle Rosier, Daniel Hechter, and Karl Lagerfeld. In February 1964 the magazine's section "Paris on en parle" introduced Khanh and Bailly, distinguishing their production as inventive: "They no longer want Ready-to-Wear to be a distant copy of haute couture; they want it to be original." As many of these designers were young women, journalists conflated them with fashion consumers and magazine readers, transferring creativity in design to the wearer's self-presentation, a marketing tactic. Later that year, another article addressed the *moins de vingt ans* ("under twenty somethings"), with a familiar narrative of the stagnancy of couture-led design, one framed as though from the consumer's voice. It explained how "they wanted a fashion of their own, a fashion a little crazy at times, but full of ideas and movement."[19] The designers solved the problem "in their own way; that is, by shaking everything up!"[20]

Just like the audacious women regularly featured in the pages of *Vogue*, these designers "have dared, and want each of us to be a woman who dares."[21] They dared women to wear trousers and caper around Paris with their lovers, as suggested in a 1965 issue subtitled *la rue en pantalon* (the street in pants). In one image, a couple embraced in the Jardin des Tuileries, he in an all-black

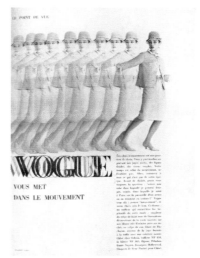

ill. 6 William Klein. Chloe, Selena suit. *Vogue Paris*, February 1961, p. 33

anorak look, she in a tunic ensemble by Khanh for I.D. Perhaps they purchased their clothes from one of the new multibrand boutiques such as Dorothée Bis, Vog, or Réal, pegged as young and vibrant in the fashion press. It was, as *Vogue Paris* discussed Le Knack in 1966, "The most musical boutique on Avenue Victor-Hugo: Try on dresses to the tune of 'Pussy Cat.'"[22] These shopping columns in particular did much to locate readers in Paris but rezone the city in relation to the experience of fashion. The following year, Saint Laurent made a statement when he opened his ready-made line and boutique Rive Gauche (Left Bank), its bohemian location in direct contrast to the rarefied couture ateliers north of the Seine.

This world of avant-garde design envisaged movement on a grander scale, beyond the spatial confines of Paris. Space exploration became an exciting reality in France after the 1961 opening of the Centre Nationale d'Etudes Spatiales (CNES). As Jane Pavitt argued, "The Space Race not only provided an enduring stream of technological innovations and material developments that could be adapted to everyday use, but also a host of imaginative possibilities for how products, clothing, environments—even the human body—might be redesigned in the future."[23] Creators such as Paco Rabanne rethought traditional dressmaking materials, borrowing those from jewelry-making to construct metallic chain-linked dresses that evoked heavy technology and science-fiction narratives. Likewise, shiny plastic surfaces, such as Khanh's rhodoid collar dresses and Rosier's vinyl creations, served as potent metaphors for the future.

Couturiers Pierre Cardin and André Courrèges also created within this context. Cardin's 1965 Cosmos collection—variations of a tunic or pinafore over a ribbed sweater and tights or trousers—stands as a testament to unisex minimalism. Whereas Courrèges insulated his models in slim-cut pantsuits, or short dresses and cropped jackets paired with sunglasses, boots, gloves, and headgear in a white palette, William Klein photographed their robotic poses (cat. 211). Courrèges, along with Emanuel Ungaro, was particularly known for the square, short-skirted silhouette, made via precision cutting in heavy worsted fabrics. Short shift dresses with simple collarless necklines and geometric textiles, such as Louis Féraud's jersey black-and-white shirtdress with red topstitching, were slightly less extreme expressions of futurity (ill. 7). Guy Bourdin shot the look in 1966, and the model's angular pose, coiffure, and earrings by Rabanne completed the *Gesamtkunstwerk*. That year, Ronald Traeger's similarly photographed Donyale Luna, the first Black model in *Vogue Paris*, crouching down and twisting her body on bended knee (cat. 184). As seen here, much of the clothing during this period was made from supple knitted fabrics such as jersey, allowing for heightened movement. But they also hugged and contained bodies in the style of a spacesuit.

This work inspired imagemakers such as Helmut Newton to rethink the spatial experience of fashion: Conceiving worlds where models in vinyl coats and helmets by Rosier were astronauts exploring desolate landscapes peppered with power line towers (cat. 193). It was linked to the new "everyday world" *Vogue Paris* described in a subsequent issue: "A world populated by televisions, Dictaphones, tape recorders, electronic computers."[24] Accompanying photographs showed models surrounded by screens much like Bert Stern's 1967 imagery (cat. 186). This viewpoint was indeed becoming more everyday as French households increasingly had televisions in the decade after Telstar—in reading *Vogue Paris*, readers associated them to more arcane forms of technology from computers to satellites.

Yet imagery constantly relocated nostalgic readers to more familiar sightlines of Paris—to its gardens and cafés, its monuments and stone edifices. *New Wave* cinema reinforced the documentary foundation set by photographers such as Ronis and Doisneau. Fashion images that were cropped, fleeting snapshots of everyday Paris life, like those by Chadwick Hall (cat. 191), resembled its aesthetic, which sought realism over scripted visual compositions. The pervasiveness of these films during the 1960s, along with the everydayness they attached to fashion and Paris space, further helped viewers insert themselves into these pictures.

As this chapter has suggested, *Vogue Paris* realized the contested nature of the street for women and instructed its readers to employ city space boldly in the lead-up to May 1968. Yet it left out many potential fashion practitioners who did not see themselves represented in its pages as France's population became increasingly diverse, despite the multifarious femininity and realism of prêt-à-porter messaging. Just as the American model Luna helped pave the way for models of color in the 1970s, women were preparing for their next step forward—to an era of heightened movement. In the period studied here, the Parisienne is in constant flux: from her challenging ascents up towers to expressions of audacity laid bare on the streets of the city.

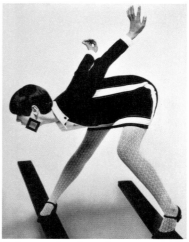

ill. 7 Guy Bourdin.
Louis Féraud dress.
Paco Rabanne jewelry.
Vogue Paris,
January 1966, p. 61

1 From September 1956 to December 1958 (with the exception of the March 1958 issue), *Vogue Paris* had the subtitle "La mode et la vie de Paris."
2 Roland Barthes, *La Tour Eiffel* (Paris: Delpire, 1964), 27.
3 Ibid.
4 Agnès Rocamora, *Fashioning the City: Paris, Fashion and the Media* (London: I.B. Tauris, 2009), 156.
5 Ibid., 164.
6 Pierre Bourdieu, *The Field of Cultural Production*, ed. Randal Johnson (Cambridge: Polity, 1993), 15.
7 Rocamora, 81.
8 "Le Point de Vue de *Vogue* . . . Sur l'Evolution du Prêt à Porter," *Vogue Paris*, February 1956, 17.
9 *Vogue Paris*, April 1956, 124–125.
10 Henri Lefebvre, *Critique of Everyday Life. Volume II: Foundations for a Sociology of the Everyday*, trans. John Moore (London and New York: Verso, 2002 [1961]), 310.
11 Martin Harrison, *Outside Fashion: Style & Subversion* (New York: Howard Greenberg Gallery), 1994, n.p. See also Hilary Radner, "Roaming the City: Proper Women in Improper Places," in *Spaces of Culture: City, Nation, World*, ed. Mike Featherstone and Scott Lash (London: Sage, 1999), 86–100.

12 See Peter Hamilton, *Willy Ronis: Photographs 1926-1995* (Oxford: Museum of Modern Art, 1995), 30.
13 Edmonde Charles-Roux, April 1994, in Robert Doisneau. *Les années Vogue* (Flammarion, 2017), 15.
14 "Vogue vous met dans le mouvement," *Vogue Paris*, February 1961, 33.
15 Ibid.
16 Emma McClendon, "First Paris Fashions out of the Sky: The 1962 Telstar Satellite's Impact on the Transatlantic Fashion System," *Fashion Theory* 18 (June 2014)," 297.
17 Bruno du Roselle, *La Crise de la mode; la révolution des jeunes et la mode* (Paris: Fayard, 1973), 34.
18 Ibid., 5–6.
19 "Soyez la femme qui ose!" *Vogue Paris*, August 1964, 19.
20 Ibid.
21 Ibid.
22 "Boutiques de Vogue," *Vogue Paris*, February 1966, 7.
23 Jane Pavitt, *Fear and Fashion in the Cold War* (London: V&A Publishing, 2008), 10.
24 "Vivez en 1965," *Vogue Paris*, October 1965, 71.

cat. 162 Anonymous. Claude Saint-Cyr hats. *Vogue Paris*, September 1958, p. 154

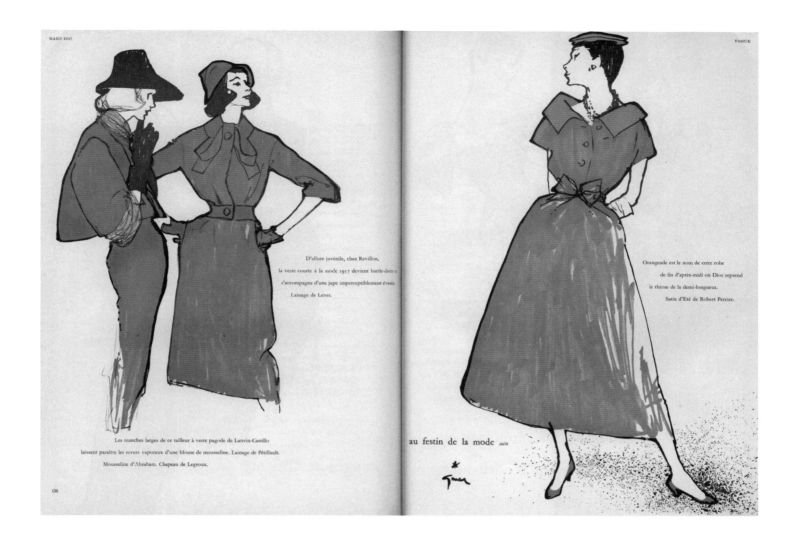

D'allure juvénile, chez Revillon,

la veste courte à la mode 1917 devient battle-dress et

s'accompagne d'une jupe imperceptiblement évasée.

Lainage de Lesur.

Orangeade est le nom de cette robe

de fin d'après-midi où Dior reprend

le thème de la demi-longueur.

Satin d'Eté de Robert Perrier.

Les manches larges de ce tailleur à veste pagode de Lanvin-Castillo

laissent paraître les revers vaporeux d'une blouse de mousseline. Lainage de Pétillault.

Mousseline d'Abraham. Chapeau de Legroux.

au festin de la mode *suite*

cat. 161 René Gruau. Lanvin-Castillo suit, Revillon dress (left page). Dior dress (right page). *Vogue Paris*, March 1957, pp. 138–139

"La mode et la vie de Paris"

cat. 171 Guy Bourdin. Odile Kern. Germaine Lecomte ensemble. *Vogue Paris*, April 1955, p. 93
cat. 169 Guy Bourdin. Jacques Fath ensemble. *Vogue Paris*, April 1955, p. 92
cat. 173 Guy Bourdin. Hubert de Givenchy ensemble. *Vogue Paris*, April 1955, p. 95

cat. 174 Guy Bourdin. Manguin ensemble. *Vogue Paris*, April 1955, p. 94 "La mode et la vie de Paris"

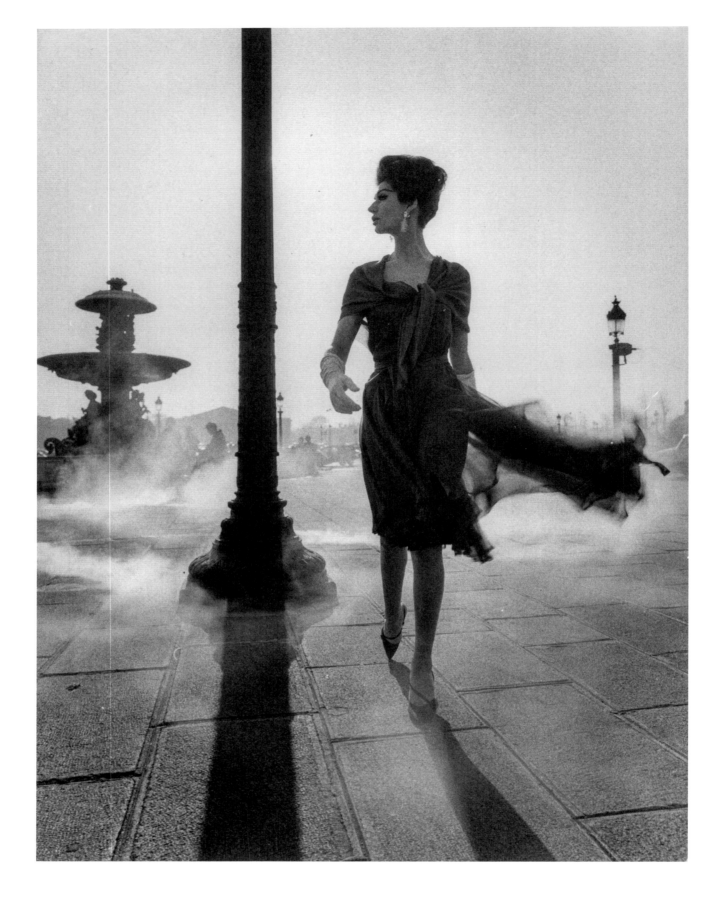

cat. 178 William Klein. Simone d'Aillencourt. Maggy Rouff dress. *Vogue Paris*, April 1961, p. 146

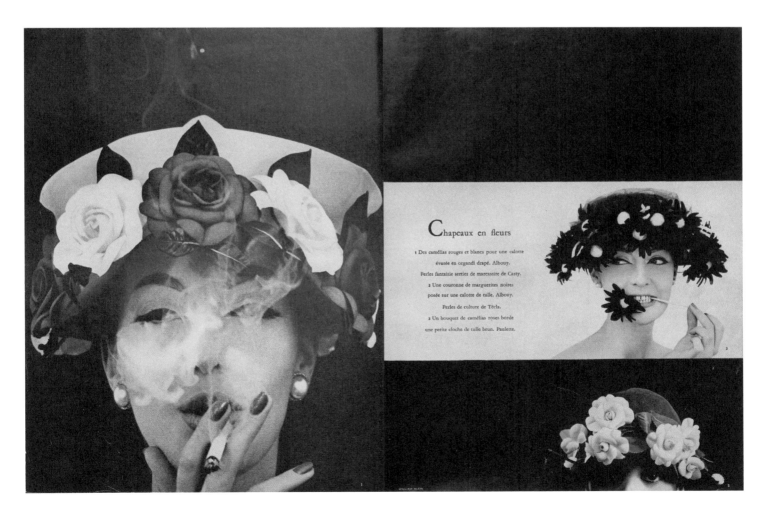

cat. 175 William Klein. Simone d'Aillencourt (left page). Nina Ricci, Revillon, Virginie, Jean Patou,
 Maggy Rouff, Pierre Balmain ensembles. *Vogue Paris*, March 1956, pp. 142–143
ill. 8 William Klein. Barbara Mullen. Albouy and Paulette hats. *Vogue Paris*, May 1956, pp. 48–49 "La mode et la vie de Paris"

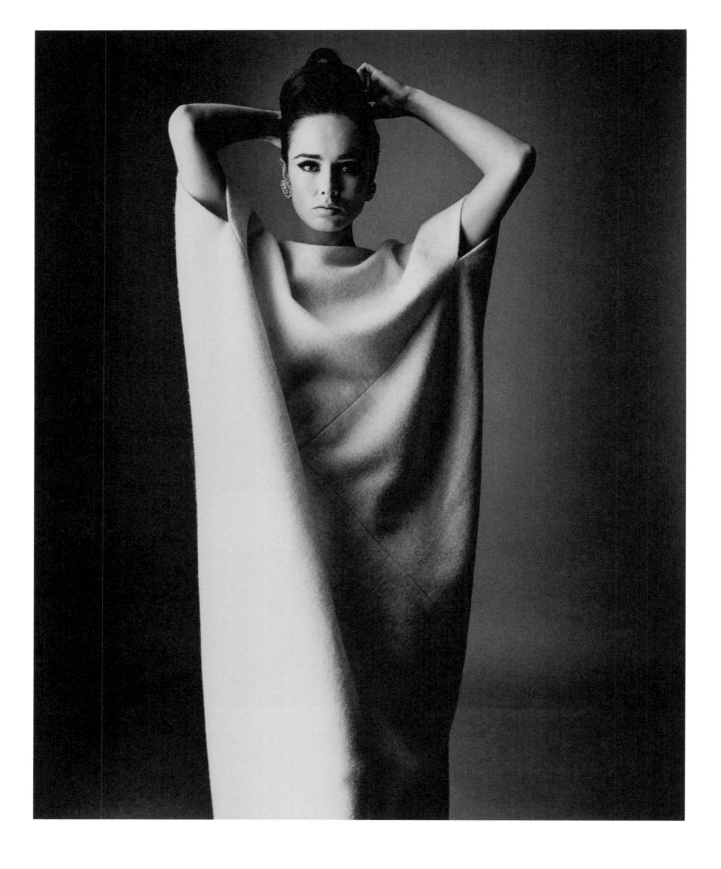

cat. 180 Irving Penn. Sondra Peterson. Grès dress. American *Vogue*, September 15, 1963, p. 116
and *Vogue Paris,* October 1963, p. 132

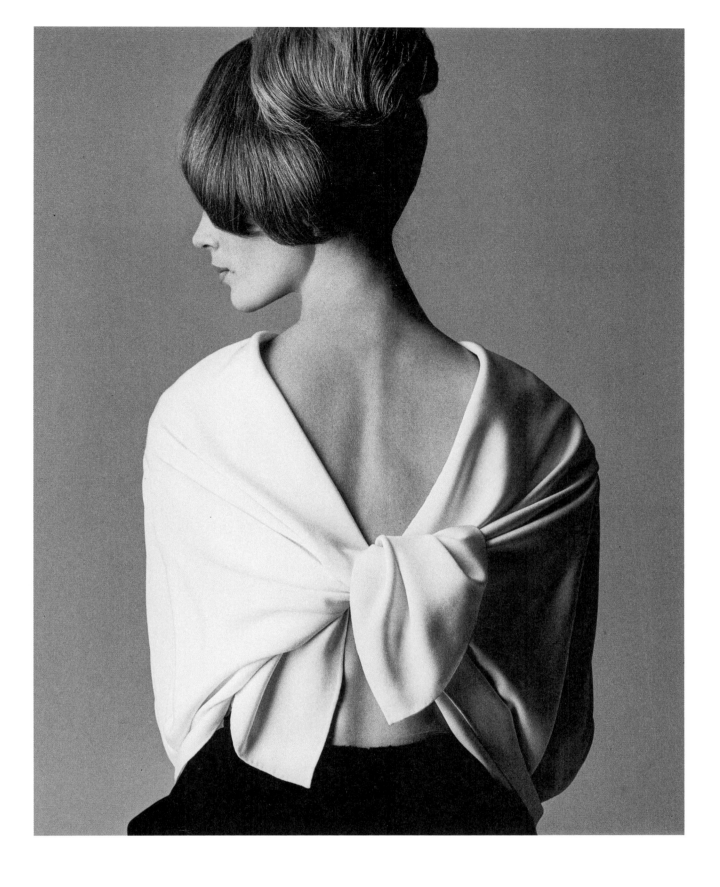

cat. 179 Irving Penn. Pierre Cardin ensemble. American *Vogue*, September 15, 1963, p. 117
and *Vogue Paris,* October 1963, p. 133

"La mode et la vie de Paris"

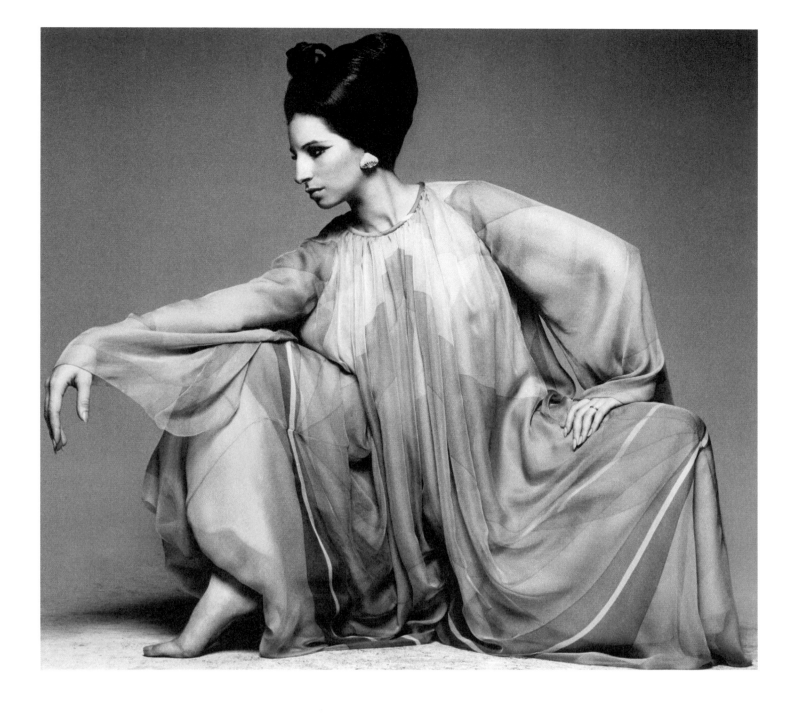

cat. 182 Richard Avedon. Barbra Streisand. Christian Dior dress. American *Vogue*, March 15, 1966,
 p. 70 (variation) and *Vogue Paris*, April 1966, pp. 106–107 "La mode et la vie de Paris"

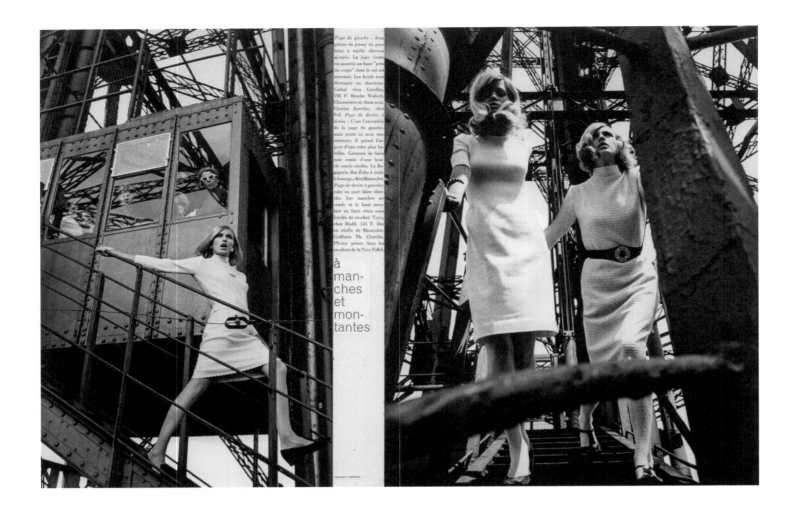

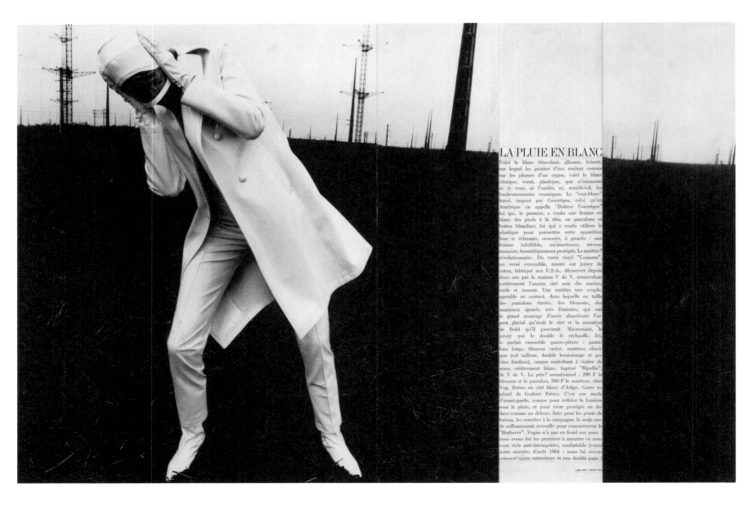

cat. 199 Helmut Newton. Christa Fiedler. Yoyo dress from Madd, and Cathal ensemble from Corolles. *Vogue Paris*, August 1965, pp. 34–35

cat. 193 Helmut Newton. V de V ensemble. *Vogue Paris*, February 1965, pp. 38–39

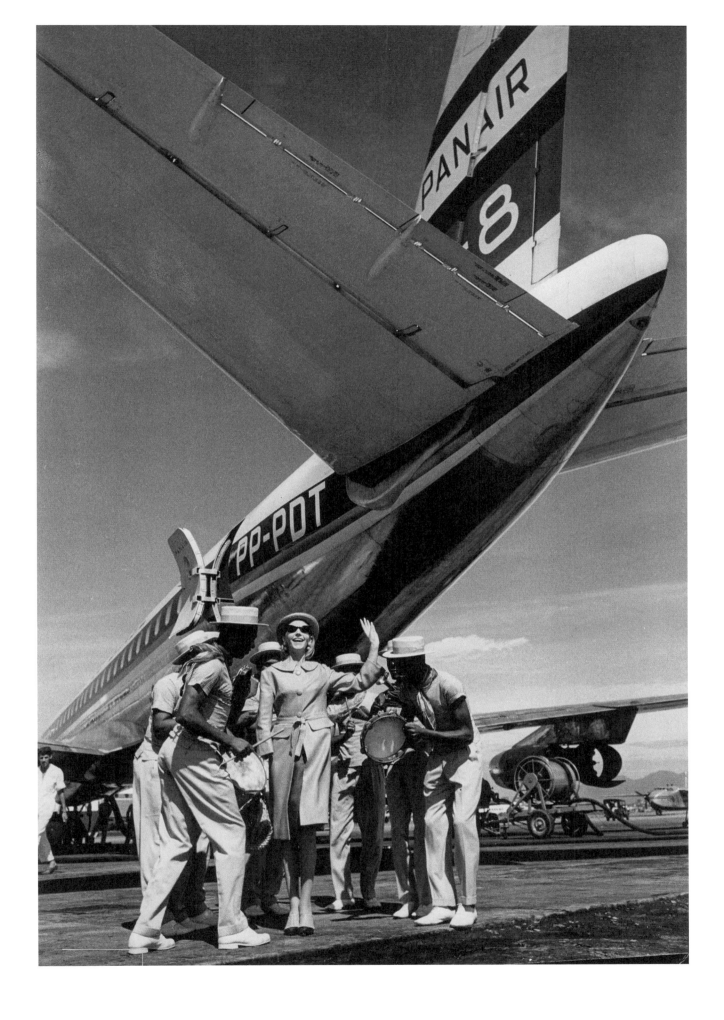

cat. 192 Helmut Newton. Denise Bonan. Gérard Pipart ensemble. Rio de Janeiro. *Vogue Paris*,
May 1962, p. 63

"La mode et la vie de Paris"

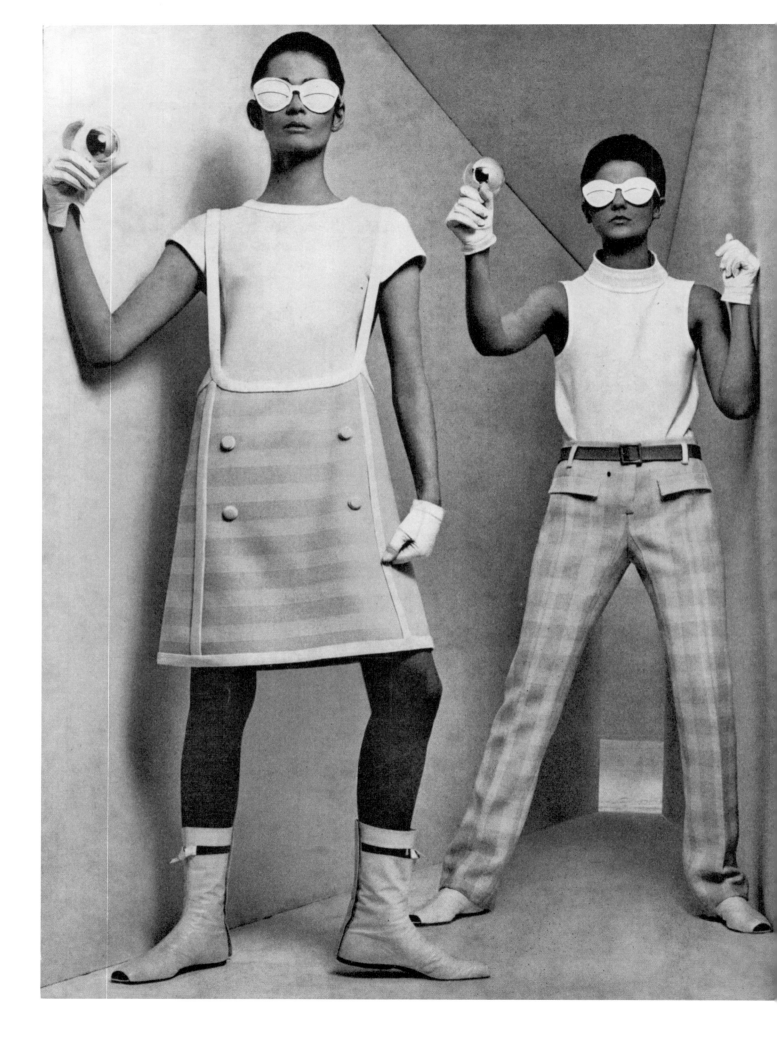

cat. 211 William Klein. Courrèges ensembles. *Vogue Paris*, March 1965, pp. 138–139

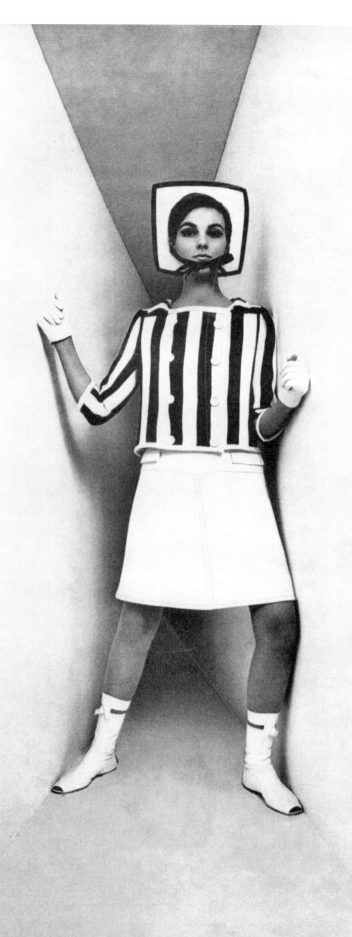

BREVETÉ
COUR-
RE-
GES

De l'humour avant toute
chose. Mais aussi
la science
d'un architecte.
Chaque détail,
depuis les lunettes
jusqu'aux petites bottes
aérées par des
découpes, tout a été inventé,
étudié, breveté
par Courrèges
pour une femme nouvelle :
bien campée
sur des jambes sans
artifice, et qui
évoquent davantage
l'innocence et la vigueur
de la jeunesse
que l'efficace provocation
des jambes de
Marlène Dietrich.
La peau : hâlée.
Les cheveux : coupés
courts, par Carita.
Des vêtements épurés.
rigoureux, dont les
proportions parfaites sont
souvent soulignées
par des soutaches.
Page de gauche, à g.,
la jupe à bretelles rayée
bleu glacier et blanc
en gabardine double face.
T-shirt à manches
très courtes
en flanelle de laine
blanche. *A dr.,*
pantalon à
damiers bleus et blancs.
T-shirt à emmanchures
échancrées et petit col
montant. *Ci-contre,*
jaquette à
larges rayures
marine et blanches en
satin de laine double face.
Chapeau carré soutaché.
Robe page suivante.

WILLIAM KLEIN

cat. 184 Ronald Traeger. Donyale Luna. Safino jersey from Dorothée Bis. *Vogue Paris*, April 1966, p. 108

"La mode et la vie de Paris"

cat. 190 Hervé Dubly. "Un style qui fait la loi." *Vogue Paris*, August 1963, p. 49

cat. 186 Bert Stern. Twiggy. Lanvin dress. *Vogue Paris*, April 1967, p. 128

"La mode et la vie de Paris"

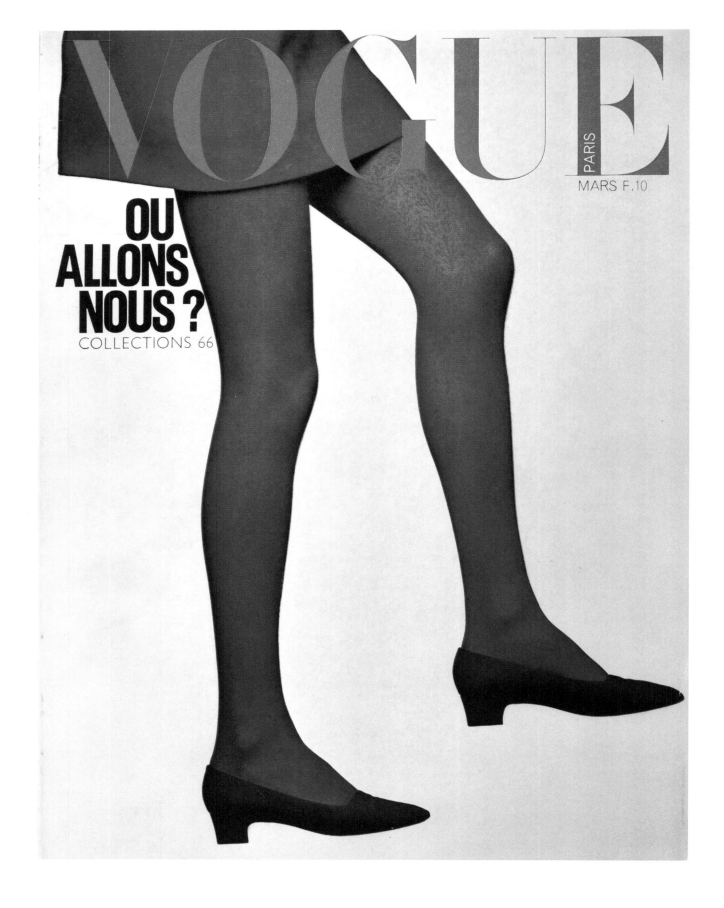

VOGUE

PARIS

MARS F.10

OU ALLONS NOUS ?

COLLECTIONS 66

cat. 213 Guy Bourdin. Boutique Pierre Cardin bottoms, Pierre Cardin dress, Charles Jourdan for Pierre Cardin shoes. *Vogue Paris*, March 1966, cover

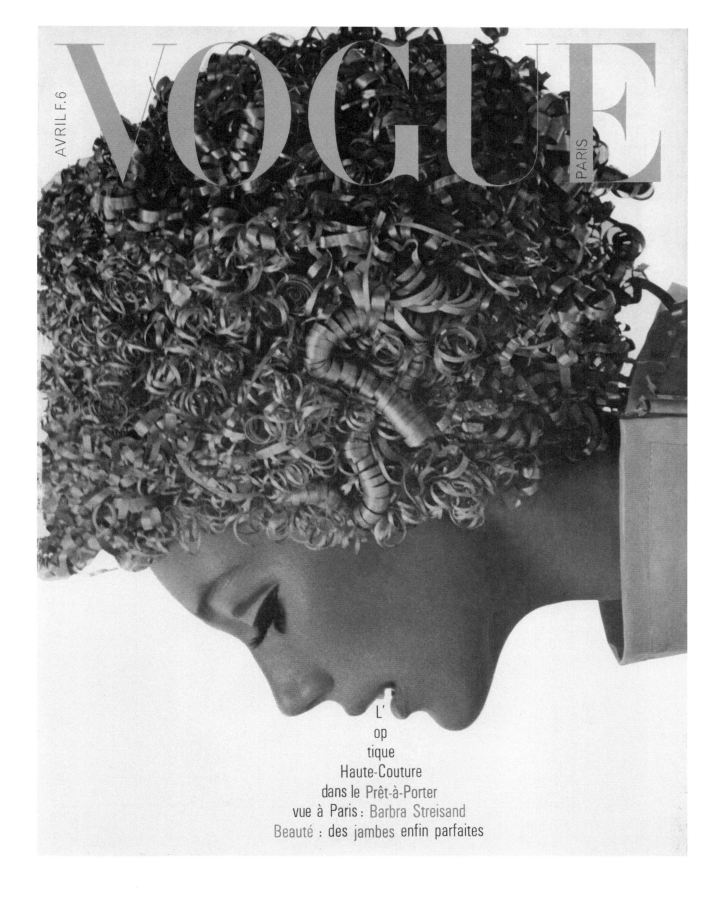

AVRIL F.6

VOGUE

PARIS

L'
op
tique
Haute-Couture
dans le Prêt-à-Porter
vue à Paris : Barbra Streisand
Beauté : des jambes enfin parfaites

ill. 9 Richard Avedon. Marisa Berenson. Emanuel Ungaro dress, Alexandre wig. *Vogue Paris*,
 April 1966, cover

"La mode et la vie de Paris"

cat. 201 Guy Bourdin. "Chaussures: Mat ou Brillant," Karl Lagerfeld for Charles Jourdan shoes.
Vogue Paris, February 1967, p. 64

cat. 194 Roman Cieślewicz. "Les Double Face." *Vogue Paris*, February 1966, p. 51

"La mode et la vie de Paris"

BULLETIN BEAUTÉ

LES TROP MAIGRES

Cela saute aux yeux! Ce que vous lisez ci-dessous, en bas de page, n'est qu'une infime partie de ce que vous lisez tous les jours sur les murs, dans les journaux, partout... Nous l'avons extrait du "Bulletin du Laboratoire Coopératif d'Analyses et de Recherches" de février 1966. Les trop-maigres sont celles que l'on oublie toujours. Comment pensez-vous qu'une femme qui désire grossir puisse encore essayer de se nourrir? **Tout fait maigrir!** Pas de fromage de Hollande, pas de lait, pas de pain, pas de poulet, pas même de pâtes... ni de moutarde! Il y a de quoi avoir une crise de dépression nerveuse. Les publicistes, les affichistes, les vendeuses, les chroniqueuses.

Les spécialistes, les chimistes, tous, ils ne pensent qu'aux femmes qui veulent maigrir. Mais celles qui ont besoin de grossir? Celles qui voient arriver avec angoisse les mois d'été, les vacances à la mer, et l'épreuve du maillot de bain? Celles que l'on console en leur disant : "c'est bien plus chic" et qui n'osent pas se déshabiller? Celles que l'on rassure en leur démontrant qu'elles vivront bien plus longtemps (c'est vrai : les statistiques établies par les compagnies d'assurance américaines sont très favorables aux maigres) et qui envient les vamps aux formes opulentes étendues au bord des piscines? Mais ces fofolles de seize à vingt-cinq ans qui, sous prétexte qu'elles sont "énormes", disent-elles, sautent des repas, fument sans arrêt, boivent de vinaigre en cachette, et deviennent de vraies détraquées. Au point de "dévorer" des yeux au cours d'une représentation théâtrale, telle ou telle ballerine et d'être prise à ce moment-là d'une crise de tremblements maxillaires l'obligeant à quitter la salle. On appelle cela l'anorexie mentale. C'est une maladie presque à la mode, tellement de jeunes filles en sont actuellement atteintes. Et une enquête faite en 1965 sur "le devenir des anorexies mentales" par différents médecins dans le cadre des problèmes d'endocrinologie et de nutrition du Collège de Médecine, expose, à côté de chiffres et de statistiques saisissants, les causes profondes de ce

peut-être. Mais aux corps solides, sains, souples. Et ronds. Et fermes. La nouvelle femme montre ses épaules, ses bras, même en ville. Elle refuse les salières, le visage émacié, les seins effondrés, les omoplates saillantes, les genoux osseux. Vous n'en serez pas là. Vous n'en serez jamais là. Il y a du très nouveau pour les maigres. Des recettes (au vrai sens du mot), des exercices, des thérapies, des découvertes inattendues. Et même du trompe-l'œil.

L'important avant tout, c'est d'**être une maigre intelligente.** Il y a plus de maigres par bêtise qu'on ne le croit. Comme

conflit (en particulier entre mères et filles, la mère étant trop dominante) qu'un peu d'intelligence aurait évités. Le problème de **l'appétit** est un problème passionnant. On commence seulement à s'en rendre compte et à l'étudier. La diététique est une science toute neuve. L'Institut Scientifique d'Hygiène Alimentaire de la rue de l'Estrapade n'existe pas depuis si longtemps. Et nous avons appris, aux Journées d'Endocrinologie et de Nutrition des 2 et 3 octobre 1965, les significations profondes de la faim et de l'appétit, et donc les causes de certaines maigreurs et leurs remèdes. Il y a une nouvelle science des **habitudes alimentaires.** Chez l'homme *(suite page 64)*

Il existe de "fausses maigres", ci-contre, à musculature longitudinale. Habillées, on les croirait maigres et elles peuvent tout porter : en maillot, elles sont minces sans être anguleuses. Maillot-tunique-robe d'enfant en jetons de rhodoïd à emmanchures très échancrées de Paco Rabanne. Coiffure Christophe de Vidal Sassoon. Maquillage "Mexicain" de Lancôme : aux yeux "Lancomatic" bleu foncé, résistant à l'eau de mer; rouge à lèvres "Tequila"; vernis à ongles opalescent "argent".

Exigez du vrai Hollande. C'est meilleur et cela ne vous fera pas grossir. Le pamplemousse de Floride est bon pour la ligne. Celui de Jaffa nous dit : "Soyez svelte". Les pâtes Rivoire et Carret sont recommandées à toutes celles qui surveillent leur ligne. La bière est l'amie de votre ligne. LA CHOUCROUTE, LÉGUME POUR MAIGRIR. CHOCOLAT VENTRE EFFACÉ. Le cidre doux permet de rester jeune et mince. *Banania ne fait pas grossir* LE LAIT STÉRILISÉ CODISANTÉ NOURRIT MIEUX SANS FAIRE GROSSIR. Le lait écrémé Lorso nourrit sans engraisser. Le lait écrémé Heudebert n'alourdit pas votre ligne. Gloria écrémé et votre ligne reste jeune. Le lait dégraissé en poudre France-Lait supprime embonpoint et cellulite. La moutarde Bornibus est un aliment amincissant. LE PAIN JACQUET EST AMAIGRISSANT *LE PAIN DE CAMPAGNE BRETON COMBAT L'OBÉSITÉ.* LE THE LIPTON EST L'AMI DE VOTRE LIGNE AVEC LE YOGOURT DANONE NULLE CRAINTE D'EMBONPOINT. SKOFIR EST LE MEILLEUR AGENT AMAIGRISSANT LE VINAIGRE DE CIDRE COMBAT L'EMBONPOINT... LE POULET FIGURE DANS TOUS LES RÉGIMES, Y COMPRIS LES RÉGIMES AMAIGRISSANTS.

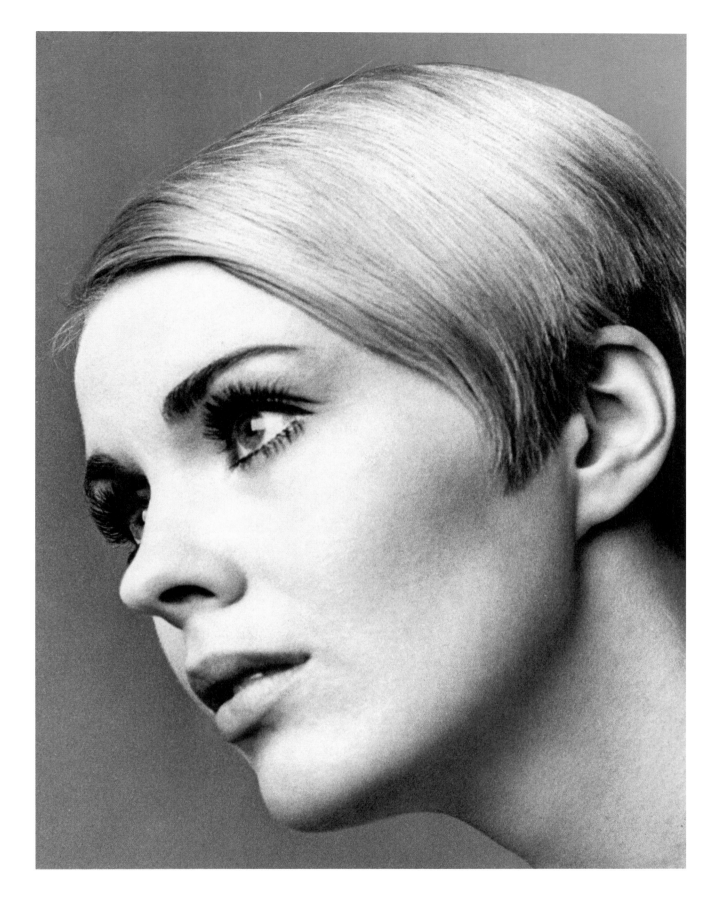

cat. 196 Helmut Newton. Jean Seberg. Jacques Dessange hairstyle. *Vogue Paris*, March 1967, p. 241 "La mode et la vie de Paris"

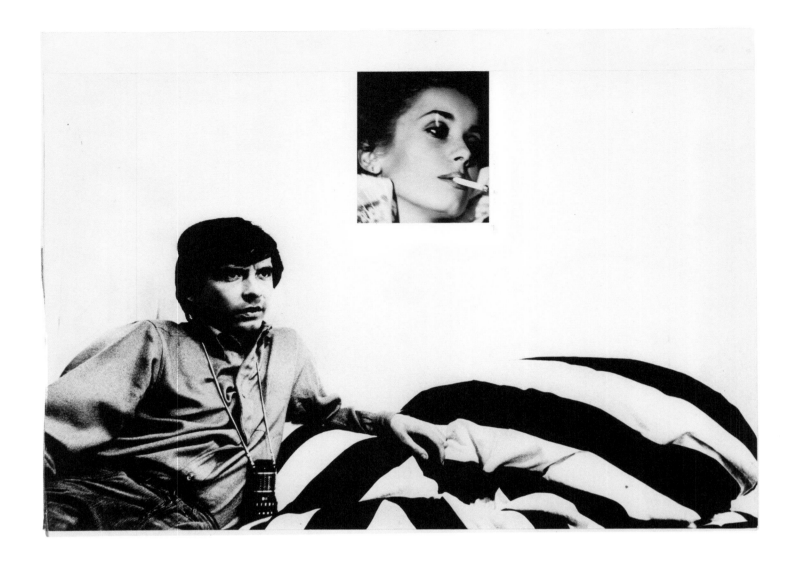

cat. 218 David Bailey. "Deneuve et David." *Vogue Paris*, September 1966, pp. 262–263

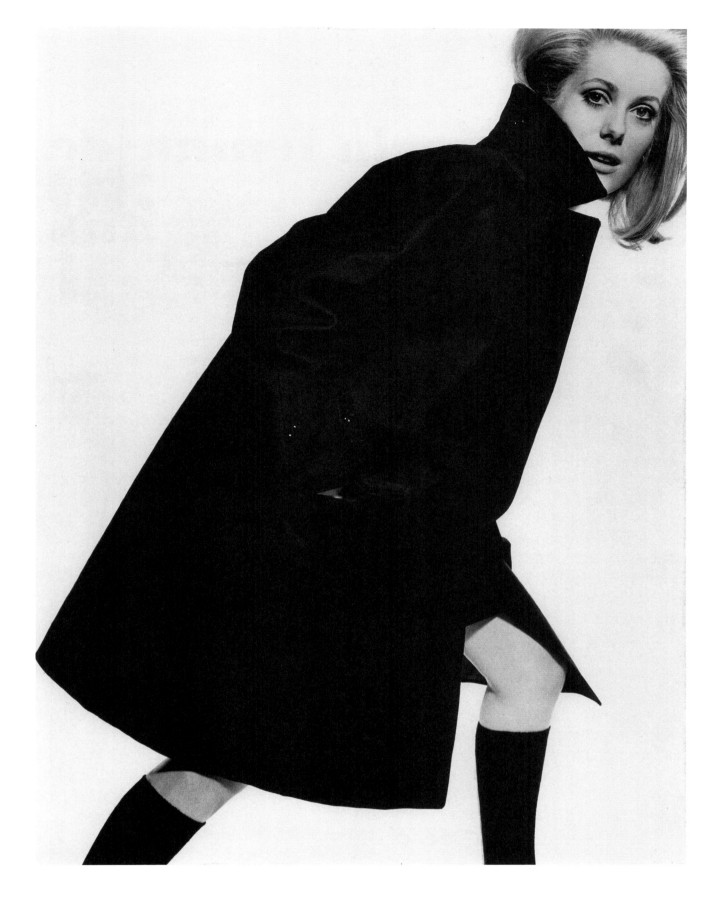

cat. 219 David Bailey. Catherine Deneuve. Newmarket overcoat. *Vogue Paris*, May 1966, p. 113 "La mode et la vie de Paris"

la femme de 30 ans

Sauf à cinq ans, où l'on décida abruptement de m'envoyer en classe, j'ai toute ma vie pensé que mon âge présent était l'âge idéal. Idéal à quinze ans de se découvrir la littérature sans avoir à me mêler à des histoires d'adultes qui me semblaient bien surfaites; idéal à dix-huit ans de me mêler à ces histoires d'adultes; idéal à vingt-cinq ans d'en paraître bien revenue. Et à présent, la trentaine venant à grands pas, idéal de constater que toutes les femmes de mon âge en sont enchantées : Brigitte Bardot est encore plus jolie qu'il y a cinq ans, Mrs. Kennedy encore plus présidente des U.S.A. et tutti quanti.

Entre vingt et trente ans se déroule dans la vie d'une femme une longue période que je nommerai l'été. On se sent obligée d'y brûler. Parce qu'on vous répète sans cesse que ce sont les meilleures années de la vie, que dans dix ans, ce ne sera plus la même chose et autres sornettes. Ce sont dix années pénibles où l'on se livre à des choses excessives, presque par respect humain : on se marie, on tombe amoureuse, on travaille beaucoup, on réfléchit au sens de sa vie, j'en passe. A la fin de ce service militaire, si l'on me permet l'expression, on se retrouve brusquement démobilisée : c'est enfin le printemps, le charmant printemps de la trentaine : on ne se marie plus que pour des raisons précises, l'amour est aussi et surtout un plaisir, et l'on découvre des moyens de vivre matériels et moraux beaucoup moins fatigants. Devant nous s'étend une verte et molle prairie qui nous mène doucement à la quarantaine avec tous les égards possibles : les hommes auront beaucoup plus de mal à nous faire souffrir, d'abord, ce qui n'est pas rien, et ils le savent. Des brûlants ennemis trop aimés de nos vingt ans, ils deviennent nos tendres complices (vaguement dangereux quand même, il faut bien le dire) de

nos trente ans. Nos armes, ils les saluent au passage : cette légère ride au coin de la bouche qui nous agace devant notre miroir, ils savent qu'elle est la cicatrice d'un autre amour, d'un grand amour qui nous empêchera de nous jeter par la fenêtre pour eux, ou de les suivre aveuglément dans leurs caprices (1). Ce sourire un peu distrait parfois devant leurs discours, s'il les énerve, leur assure quand même qu'en cas d'ennuis, ils auront une épaule tranquille, le soir, et non pas l'épaule pointue et énervée d'une jeune fille qui veut parler "sentiments". Ils en deviennent plus respectueux et plus familiers, presque apprivoisés. Ce n'est pas l'amitié amoureuse, mais l'amour amical. Et ce n'est pas sans de grandes délices.

Enfin c'est l'âge suprêmement plaisant où l'on peut jeter avec entrain les yeux derrière et devant soi. On pose la tête sur son passé, qui est bien rembourré, où les aventures, les livres et les enfants pullulent. On ferme les yeux, la conscience tranquille. Quand on les ouvre, on voit un agréable futur où les aventures, les enfants, les livres pullulent aussi. La fatigue et l'entrain font ensemble une douce musique, contrebasse et flûte, en attendant les grands violons d'une hypothétique passion qu'on souhaite à peine. Je ne puis imaginer d'âge plus heureux. Peut-être quarante, évidemment, mais je dois attendre d'y être pour découvrir qu'à trente ans, ce n'allait pas du tout et que je comprenais rien au charme de l'existence.

La femme de trente ans fut comme on le sait défendue par Balzac en des termes trop agréables pour que je n'en cite pas quelques-uns : "A un certain âge seulement, certaines femmes choisies savent seules se donner et savoir garder une attitude... A trente ans seulement, une femme... sait rire,

plaisanter, s'attendrir sans se compromettre. Elle possède alors le tact nécessaire pour attaquer chez un homme toutes les cordes sensibles et pour étudier les sons qu'elle en tire. Son silence est aussi dangereux que sa parole." Certaines femmes que je connais et qui gémissent sur leurs dix-huit ans tout en s'affublant de jupes plissées écossaises et de queues de cheval devraient relire Balzac. Elles sortiraient de cette lecture vêtues de strass et de perles noires, enchantées d'elles-mêmes : les hommes plus âgés leur apprendront tout ce qu'ils savent et elles apprendront aux jeunes hommes ce qu'elles savent elles-mêmes.

Enfin, par un heureux hasard, la génération qui nous suit a la tête froide et les dents longues. La jeune fille de dix-huit ans, l'actuelle, à quelques exceptions près, s'est blindée l'âme depuis longtemps à force de coca-colas et de précoce promiscuité avec les garçons. A dix-huit ans, nous sortions des livres et l'on ne perd pas facilement l'usage de la tendresse. Les preux chevaliers d'aujourd'hui, ceux qui ont le goût de la protection, savent qu'ils ne sauraient l'exercer sur ces fruits verts et indépendants que sont les jeunes filles 63. Ce qu'ils pourront protéger à leur aise ce sont les femmes de trente ans dont ils aimeront le côté périssable et qu'ils craindront toujours de devoir quitter — à moins qu'elles ne les quittent elles-mêmes avec beaucoup de douceur. Nous leur ferons l'exquis aveu de notre faiblesse : "Je n'ai plus vingt ans, tu sais", "Oui, j'ai beaucoup aimé X... j'étais bien jeune." Ils s'attendriront, s'enliseront doucement dans notre passé, émus, pensifs, sans remarquer au passage l'insouciance triomphante de notre vie présente. Il n'est point de faiblesse qui, bien employée, ne devienne une force.

(1) Touchons néanmoins du bois.

par françoise sagan

UNE VILLE C'EST UNE FEMME PAR

VIOLETTE LEDUC

Une ville c'est une femme, donc c'est un ventre. Cette femme, ce ventre prennent et donnent de la vie à ceux qui sont fous d'eux. Les adjectifs du dictionnaire ne suffiraient pas à qualifier les amants d'une grande ville, depuis le rentier qui vient adorer chaque année, avant le printemps, la floraison de l'arbre de Judée, place Saint-Germain-des-Prés, jusqu'au danseur de bostella qui s'éprend chaque nuit du plafond de la boîte de Régine : un sombre ciel en remous. Paris est la femme qui a le plus d'amants épris d'elle. Non, ils ne lui font pas de déclarations. Pour elle, ils cherchent dans l'ombre comment l'embellir, l'épanouir, l'envelopper de lumière. Ce sont des artisans. Semblables aux mathématiciens qui cherchent, trouvent, s'enfoncent plus loin, ils montent à ce dernier échelon où patience, efforts, besogne deviennent imagination. Enfin le chic de Paris. Ce sont des modestes, les célèbres artisans de Paris. Je les ai rencontrés chez eux, près de leurs trésors. Ils m'ont offert les Noëls fastueux que je n'ai pas eus quand j'étais enfant, ils m'ont donné de leur temps avec gentillesse et simplicité. Comme ceux qui travaillent avec amour et en secret. Montrer ce qu'ils font sans gestes inutiles, l'expliquer à voix basse avec des yeux brillants, voilà de l'émotion et de l'humilité.

D'un tricot noir et d'un pantalon noir sont pareillement vêtus ceux qui m'ont déclaré qu'ils étaient le sang de la couture. Mme Rébé, avec ses cheveux raides et gris tombant sur les épaules à la Françoise Hardy, est plutôt excentrique que son mari; Mme Rébé a les yeux lumineux de la raison et de l'avenir. Elle est plutôt pessimiste. Les longues robes brodées pour le soir, selon elle, n'ont pas d'avenir. Tout se standardise : même la broderie en perles, en paillettes, en navettes sera vendue au mètre... Mme Rébé me parle ainsi

sans se décourager, sans faiblir. Elle voit clair et continue de créer des poufs de fleurs et de feuillages, des bonnets, des béguins, des coiffes, des corbeilles de lis, des crinières de jument en plumes d'autruche pour le masque et le voile des mariées. M. Rébé est plus idéaliste avec son col blanc d'étudiant sur son pull noir. Il est né brodeur comme Shéhérazade était née brodeuse. Il n'en finit pas d'émerveiller. M. Rébé, deux mois avant que naissent les nouvelles collections, s'en va, en roi mage, présenter à Dior, à Balenciaga, ses dessins, ses coloriages, ses paillettes qu'il a teintes, ses Mille et Une Nuits sur fond de tulle. Ceux qui offrent vieillissent moins que les autres. A soixante-dix ans, M. Rébé est resté le grand brodeur de Paris. Cet homme, qui ne cache pas qu'il ne serait rien sans les vieilles ouvrières dans ses ateliers, est un délire d'imagination contrôlée. Le ciel étoilé est en lamé argent avec des reflets barbares ou bien un seul pendeloque bleu. Il sort cent cinquante, deux cents échantillons d'un carton... Pas un ne ressemble à l'autre. Il y a dire têtes sous doués qu'un ciel en tête de juillet. Proche de ces arrogants scintillements de paillettes, des navettes, des perles, à deux pas de ces clins d'œil superbes des pierres enchâssées dans le strass, brode en public une modeste. C'est une enfant et c'est une abeille au visage près du tulle étoilé. La jeune fille porte une jaquette de laine rose, ce qui souligne sa modestie. M. Rébé ne serait rien sans elle, il l'a dit et je l'ai retenu. Elle est amputée cette appliquée... Son bras, pour soutenir le tulle, a disparu sous le métier. Je m'approche, je parle à voix basse à cette enfant parce que je vis de son travail pendant que je regarde comment elle brode. Son aiguille, à la vitesse d'une perforeuse électrique, pique toutes sortes de perles sur une

pelote ronde à compartiments. "C'est un pâté" me dit la jeune fille qui a encore l'âge de jouer. Moi je songe à la margelle du puits de Mélisande... Comment pourrais-je imaginer une enfant plus concentrée, plus fixée sur son devoir de brodeuse des marguerites en soie, des cœurs vert tendre, des parterres de perles blanches? C'est sa jeunesse, et c'est mon avenir selon ses désirs, qu'elle décore. Je suis émue, elle baise trop la tête. Après tout, nous baisons aussi la tête pour voir nos jardins en fleurs. Déroulement, dépliement, cœur entr'ouvert de la rose, c'est dans la nature que M. Rébé a trouvé des doigts de fée pour ses métiers et ses ateliers. J'oubliais : une autre enfant, de temps en temps, entrait, venait des provisions de perles dans "le pâté". L'infiniment petit, l'infiniment grand lorsque le chauffeur donne du charbon au mécanicien d'un train, immense confrérie de ceux qui travaillent sans penser à eux. M. Rébé m'a prêté plusieurs échantillons de broderie. Ils sont sur ma table. Le jour baisse, j'écris à la lueur de leurs lames bleu acier. Le jour va disparaître, je vois mieux ce que sont les paillettes cuivrées sur le tulle blond : des nuages cotonneux — ces petits nuages qui ont déjà là quand nous nous levons en été —, des rouges et des dents pris à une monture, des anneaux emmêlés de jongleurs, des topazes fumées, toute une ville-lumière pour le buste d'une femme. Des algues, des coraux, de la mousse, des cascades et des sources de perles bleues, des gouttes de rosée résistent à la nuit d'hiver qui noiera cette montagne... Passe sur mon dictionnaire Larousse un fleuve bleu lavande et une rivière de fleurs endormie, dans un monde où le printemps sommeille et ne s'effeuille pas. C'était si reposant que j'ai mis ma joue dessus. C'est frais.

(Suite page 228)
Photo Guy Bourdin

"Ces arrogants scintillements de paillettes...". Cette phrase de Violette Leduc ne suffit-elle pas à décrire les femmes-lumières de Courrèges?

1955–1967

cat. 210 Text by Françoise Sagan. *Vogue Paris*, August 1963, pp. 70–71
cat. 212 Guy Bourdin. Courrèges ensemble. Text by Violette Leduc. *Vogue Paris*, March 1965, pp. 152–153

p. 178

p. 179.

cat. 191 Chadwick Hall. Jill Kennington. Haas & Lambert and Eric Schäffer ensembles.
Café Kempinski, Berlin. *Vogue Paris*, October 1966, pp. 178–179

"La mode et la vie de Paris"

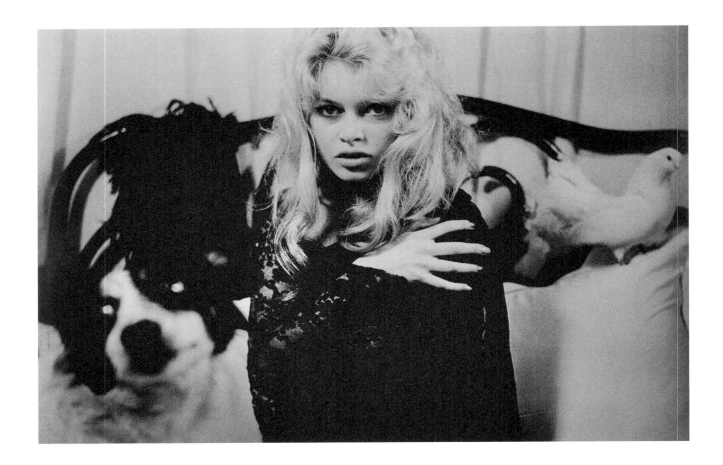

cat. 149 William Klein. Brigitte Bardot. *Vogue Paris*, March 1958, pp. 182–183
ill. 10 Sabine Weiss. Françoise Sagan. Hermès ensemble. *Vogue Paris*, May 1959, p. 79

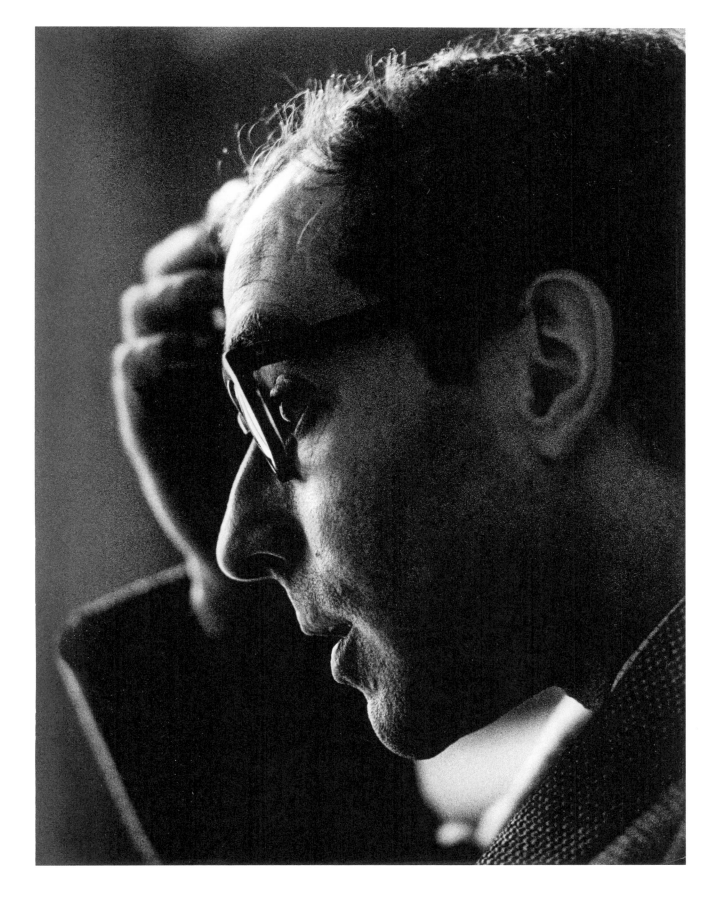

cat. 153 Jeanloup Sieff. Jean-Luc Godard. *Vogue Paris,* March 1965, p. 181 "La mode et la vie de Paris"

cat. 151 Tony Kent. Serge Gainsbourg. *Vogue Paris*, May 1967, p. 112

cat. 385 M/M (Paris). *Carine*, 2003

From the illustrated album of the nineteenth century to the porno-chic experiments of the 2000s and the avant-garde magazine of the 1930s to the bold graphics of the 1960s, *Vogue Paris* has keenly reflected the style of each era. A century of graphic innovations has accompanied the magazine's transition from illustrations to photography, enriching the history of editorial design and giving rise to a new position: the art director.

Built around the design established by the parent company, the first issues of French *Vogue* were akin to the fancy albums typical of the nineteenth century. Without a clear direction, the magazine was page after page of illustrated plates accompanied by decoratively framed vignettes. Following Lucien Vogel's first experiments with building a connection to the world of art publishing, the appointment of Mehemed Fehmy Agha as art director of Condé Nast Publications (from February 1929 to January 1943) left a lasting mark on the magazine. Agha's first change was to modernize the layout designed by Heyworth Campbell, the typesetter for American *Vogue*, based on three principles: clarity, modernity, and legibility. Inspired by European avant-garde styles, Agha established a graphic style guide and updated the design of the covers, typeface, headlines, layout, printing, and color scheme. He used wide headlines, a sans serif typeface, and larger print, giving the magazine

a more attractive appearance. By inventing the concept of the flatplan, which provided an overview of the magazine, he emphasized the notion of double-page spreads and spaciousness, and gave pride of place to photography, therefore creating a generation of fashion photographers adhering to the techniques of the Vogue studio. On the page, he grouped shots together so that each series would tell a story in an asymmetrical way.

It was a desire for a cinematic rhythm that motivated Agha's successor, Alexander Liberman. Trained by Vogel at *Vu* magazine and fascinated by the graphic revolutions taking place in the news press, Liberman was inspired by the Franklin Gothic typeface (the favorite of the *Daily News*) as well as the use of captions and informative blocks of text to bring vitality to the pages. Through his appreciation of high and low culture, Liberman instituted changes during the pop art years, paving the way in 1960 for art directors Jacques Faure and Antoine Kieffer. While many graphic designers enjoyed a great deal of freedom under these art directors and lent their personal touch to the look of the magazine, many unfortunately went uncredited on the masthead, but the signature designs of Roman Cieślewicz are clearly discernable. Infused with futuristic and constructivist principles, this graphic designer made his mark during his brief stint from 1965 to 1966 with his iconoclastic covers

and experimental double-page spreads: Images of truncated bodies were juxtaposed with photomontages, collages, and cropped shots. This wide latitude for creation, which reflected a utopian perspective and a decade of carte blanche freedom, heralded the approach seen in the work of M/M (Paris). These two art directors, Mathias Augustyniak and Michael Amzalag, appointed in 2002, created a collegiate structure: Stylists, photographers, and graphic designers worked collectively in a new arena, allowing every voice to express itself. M/M (Paris) left their imprint on only fifteen issues. With a limited typographical palette, they applied a scalable graphic language to the magazine, combining drawings and collages while introducing the notion of a person who would bring to each publication a unique identity through a singular narrative. The typographic system they created and named after the editor in chief, Carine Roitfeld, is the graphic embodiment of their multifaceted focus, timeless and classless. This was a period during which fashion, visual art, music, photography, and live performance intertwined, ignoring hierarchies between disciplines and financial concerns.

Marlène Van de Casteele

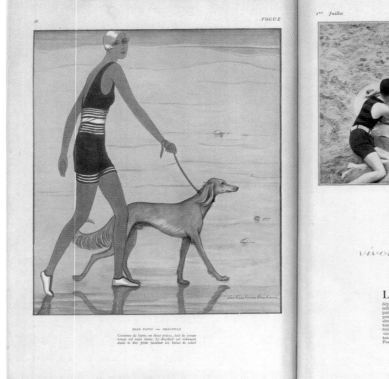
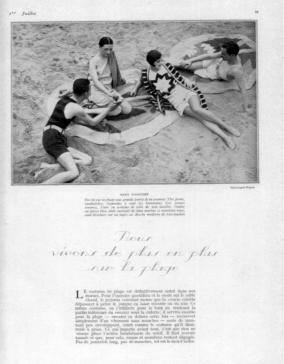

ill. 1

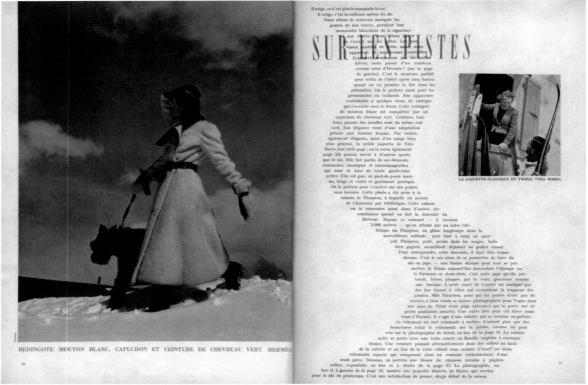

cat. 70

ill. 1 Lee Creelman Erickson. Jean Patou
 suit (left page). George Hoyningen-
 Huene. Mary Nowitzky beach
 ensemble (right page). *Vogue Paris*,
 July 1927, pp. 18–19

cat. 70 Roger Schall. Hermès coat.
 Vogue Paris, December 1936,
 pp. 30–31

ill. 2

cat. 208

ill. 2 André Durst. Madame Kyra Nijinsky-Markevitch. *Vogue Paris*, May 1938, pp. 36–37

cat. 208 Guy Bourdin. Albouy (left page) and Claude Saint-Cyr (right page) hats. *Vogue Paris*, February 1955, pp. 62–63

cat. 215

cat. 406

cat. 215 Peter Knapp. Artistic direction
Roman Cieślewicz. Graziella Fontana
for Chloé coat. *Vogue Paris*, July 1966,
pp. 32–33

cat. 406 Mario Testino. Artistic direction M/M
(Paris). Gisele Bündchen. Missoni skirt.
Prada sandals. *Vogue Paris*, December
2002/January 2003, pp. 204–205

"*VOGUE* AS SEEN BY . . .": THE AGE OF PHOTOGRAPHERS

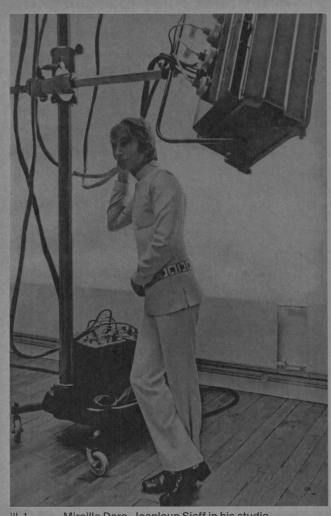

ill. 1 Mireille Darc. Jeanloup Sieff in his studio.
Cerruti ensemble. *Vogue Paris*, March 1968, p. 229

The years spanning 1968 to 1986 hold a special place in the history of *Vogue Paris*, an opinion held at the time that still remains true today. In the eyes of its collaborators, as well as those of a broader audience, the magazine during these years experienced what is described as a "golden age," marked by its reputation and influence within the fields of fashion and visual arts, as well as by the careers of the generation of photographers whose names are associated with this period. Helmut Newton and Guy Bourdin were in the forefront,[1] as well as Sarah Moon, Arthur Elgort, Albert Watson, Mike Reinhardt, Patrick Demarchelier, and Daniel Jouanneau, all of whom shot iconic images for the magazine that remain inscribed in the memories of the public as well as industry experts. These classics of the genre are a result of the technical advances of the time, the opportunities offered by a magazine so completely focused on images, and above all, an abundance of imagination whose evocative power still resonates today in the aesthetic fantasies seen in the contemporary media.[2]

ill. 2　　Harry Benson. "Vadim: les coulisses des collections." *Vogue Paris*, March 1977, p. 145

This visual style gradually developed over the course of two decades that were nonetheless distinct from each other in political-economic contexts, cultural sensibilities, and approaches. The 1970s was a hybrid period, marked by both progressive change (particularly in the field of women's rights) and the fallout from sociopolitical upheavals; its aesthetics favored narrative expression, sometimes realistic and sometimes expressed through wild, experimental staging. The 1980s embraced consumerism, which was reflected in a fascination with the United States as well as a striking globalization of culture and fashion. Both conservative and avant-garde, the style of this period was less emotionally charged, more colorful, and more ironic—a quality that embodies the detachment that was a characteristic of both decades.

Throughout these eighteen years, Francine Crescent held the position of editor in chief of *Vogue Paris*. She functioned as the bridge between the 1970s and 1980s, applying her own approach to the magazine and, above all, to fashion photography, which would find within her pages an ideal vehicle for expression.

A Pair of Creative Rivals, 1968 to 1977

The period between 1968 and 1986 is characterized by the constant presence of Francine Crescent at the top of the editorial pyramid. The unusual longevity of her tenure partly explains the consistent style of French *Vogue* during these years. The collaborative work required to produce a magazine cannot be overemphasized, and no issue is possible without the collective commitment of a team, within which communication must remain fluid and constant. However, even if each person's role is not always explicitly defined, all magazines are governed by strict hierarchies. Editors hold immense power, determining the editorial agenda that will guide the choice of content and layout while ensuring overall consistency. Specifically, these women (or men) are the final arbiters of approval for every topic covered, with the power to veto the publication of any particular article or image.

However, this statement and the idea of an undisputed and easily established authority must be qualified. Indeed, at the beginning of the years addressed here, *Vogue Paris* was—for the first time—led by a team of two. In 1968 Francine Crescent took the helm of the fashion section, while Françoise Mohrt oversaw

cat. 364 Helmut Newton.
Karl Lagerfeld.
Vogue Paris,
November 1973, p. 67

beauty, news, and features. This dual leadership was indicated on the masthead, where both were listed under the title "Editor in Chief." The result was a prosperous time for the magazine: While the number of pages increased dramatically (with issues often having more than five hundred in the 1980s), their composition also reflected a fruitful rivalry. Joining as editors in chief in the turbulent political and sociocultural context of the post-1968 period, Crescent and Mohrt ushered in a new era on which they were asked to make their mark. Both saw *Vogue Paris* as a space for possibilities. This magazine represented a platform for exploring the themes of (French, but not only French) fashion, beauty, and lifestyle in all their abundant variations, through words and pictures.

The duo invited leading figures from many fields to contribute to the magazine, making this period a time of collaborations: Jacques Henri Lartigue, Roger Vadim (ill. 2), Alain Resnais, Gina Lollobrigida, Marcel Carné, Jacques Tati, and even Lord Snowdon reported on the collections (March 1976, March 1977, March 1978, September 1978, September 1979, and March 1986, respectively). Crescent and Mohrt also regularly gave couturiers a voice, with one example being "The Great Favorites" by Uli Rose, a photo shoot whose subhead read: "Chosen by the great couturiers, here are their favorite designs from their own collections. We photographed them with the creators themselves, in their personal space or at work." In the 1980s pages were dedicated to the "great favorites" of the day (Karl Lagerfeld, Claude Montana, and Oscar de la Renta) who discussed their inspirations and personal tastes. Crescent and Mohrt also sought out contributions from unusual reporters: Mick Jagger interviewed Jerry Hall for the May 1981 issue, and Andy Warhol explored New York for the April 1984 issue. Moreover, they introduced an enduring series of Christmas issues with guest male and female editors (Françoise Sagan in 1969), actresses (Jeanne Moreau in 1970, Marlene Dietrich in 1973, and Lauren Bacall in 1978), directors (Federico Fellini in 1972, Alfred Hitchcock in 1974, and John Huston in 1981), artists (Salvador Dali in 1971, Marc Chagall in 1977, and David Hockney in 1985 [ill. 7]), and more. In this way, they ensured that the magazine not only contained an impeccable cast of characters, but also a diverse range of points of view, which nonetheless always retained a connection with fashion and/or beauty.

Beyond the obsession with fame and celebrities that was characteristic of the period, and which was mutually beneficial to both the star guests and the magazine, this series reflected a specific and fruitful editorial approach: The magazine became a catalyst, a powerful tool, because it was able to choose who should be given a voice. This version of *Vogue* drew on a variety of sources to create a unique whole. While necessarily heterogenous, it was unified by being presented in the same medium and given a shared identity through the editorial mediation that is the prerogative of the magazine. Crescent and Mohrt were not the first to embrace this vision of *Vogue*—and *Vogue Paris* in particular; traces of it can be found in the earliest issues, and it has been a basis of the magazine since its inception. But they took the concept to its highest peak, making it a complete reality. When Crescent took over as sole editor in chief after Françoise Mohrt's departure in 1977, she continued to follow this approach.

In the meantime, under Mohrt's direction, the beauty section underwent a striking and significant metamorphosis, although its expansion had in fact begun in the previous period. (This era was indeed a time of taking ideas forward

rather than winding them backward.) Throughout the 1960s, the beauty pages had gradually grown apart from the orchestrated whole that made up the magazine.[3] At the time, this section represented a field for experimentation. Articles extolling different treatments, products, and other trends in self-care were illustrated with brilliant photography, that was also often experimental. It could feature details culled from a fashion shoot or specially shot images, but the magazine's primary role was to chronicle fashion, with beauty being relegated to the margins. This marginalization, however, opened up a space where photographers had greater visual freedom since the illustrations were subject to fewer editorial constraints.

The 1970s brought this approach to its peak as beauty shifted from the margins toward the center. Meanwhile, cosmetics was becoming a powerful industry, and the resources allocated to photo shoots showcasing its products increased accordingly. From this point forward, *Vogue Paris* contained two magazines (which explains, in some cases, the double editorials signed by the two editors, or the use of two themes within the same issue). This partly explains the "boom" in beauty pages at the time, in terms of both volume and creative quality.

Fashion was never left behind, however. The photo shoots themselves, as well as first-hand accounts, tell us that the creation of editorial images for both fashion and beauty[4] was still a central element of the magazine, remaining a considerable investment (in financial, human, symbolic, and creative terms) and a key to its success.

ill. 3 Françoise Mohrt. "Le point de vue de *Vogue*" on beauty. *Vogue Paris*, March 1975, p. 178

The Greatest Photo Shoots and the Quest for Shock Visuals

French *Vogue* in the 1970s and 1980s is characterized by the longevity of its relationships. This is especially true of the connections it maintained with its "house" photographers. The working relationship was a truly collaborative one, even though, perhaps paradoxically, the photographer retained the primary credit for the work; this may partly explain the level of creative freedom they enjoyed during what was otherwise a collective process.

It is quite surprising that such freedom could be wielded within a set format bounded by numerous constraints. These constraints, which are intrinsic to all magazines, were reflected in the subjects and objects photographed, as well as limited the framework in which the photographs were created. In a magazine such as *Vogue Paris*, the fashion calendar dictates each issue and its themes. The financing of publications, which has long relied more on advertisers than on subscribers (although one does not exist without the other), grants advertisers some leeway to influence content. And yet, despite (or rather within) these restrictions on subject matter and its treatment, creativity continued to flourish. The result was major photo shoots whose aesthetics were distinctive and instantly recognizable, even to the modern eye, and which, on many occasions, were laid out ambitiously across multiple double-page spreads.

It is interesting to look more closely at the photo shoots where these images that formed the very core of *Vogue Paris* were born, and how they reflected many aspects of the period. Even when the subject is clearly defined (and agreed upon by all those involved), the approach to be taken is often hotly debated, usually between the editor managing the shoot and the photographer, with occasional

cat. 287 Jeanloup Sieff.
Barbara Barnard. Lacoste
shirt and Dorothée Bis
pants. *Vogue Paris*,
May 1970, cover

interventions from the editor in chief. The biggest challenge is to take subjects that are constantly being represented in the fashion industry and press, and to keep finding creative new ways to depict them. The sources of inspiration are manifold, and draw increasingly from broader fields. Ideas often result from encounters with people, places, or moods; coming up with these imaginative connections is a large part of the job of fashion imagemaking, interweaving the private, social, and professional realms, and thus naturally tends to favor those who "make" a magazine. But many other people also play a part in a photo shoot. The choosing of models, lighting, makeup, hairdressing, and sometimes staging requires the expertise of many hands. All of those involved converge on the set (in the studio or outdoors) for the shoot. Afterward, it is up to the design department to make its contribution, arranging the images and text in the layout according to the magazine's style guide and the effect the editors wish to achieve. Every department is thus involved in the production of the photo shoots for the fashion and beauty sections, bringing each issue of *Vogue Paris* to life and in some instances, leaving a mark on the history of photography.

Testimonies from staff emphasize both the craftsmanship involved in the magazine's photography and the lack of limitations when it comes to concept and execution. Patrick Hourcade, former art director, recounts Guy Bourdin's fascination with a plastic fabric with a lacquered finish which he used to cover the walls and ceiling of the studio as a backdrop. Marc Soussan, a location manager at the time, remembers painting stalks of wheat yellow in a field in Gers because Bourdin thought they weren't bright enough. Editors such as Franceline Prat, Barbara Baumel, and Martine de Menthon were also involved at every stage of these shoots. Both Hourcade and Soussan recall sessions where hours were spent waiting for the right light that would create the best image—a key concern during this era. The intention was to capture a particular atmosphere that would emanate from the finished images.

The time spent on each session was a luxury and, indeed, a form of craftsmanship, or a refusal to accept average results. Without idealizing the sometimes demanding and difficult daily toil required to produce a fashion magazine, the work dynamics, although still shaped by power relationships, were particularly organic in this era. The imaginative drive that characterized this period was apparently boosted by joyful and often friendly collaboration. The hierarchical relationships and pervasive power issues were not a hindrance, and seem to have fitted neatly into a mode of operating that promoted a closeness fueled by the longevity of the working relationships involved.

In fact, it was these working processes, strictly controlled yet constantly varied, that provide a common link between the striking photo shoots of the 1970s and 1980s. The great latitude that Crescent and Mohrt granted to the photographers with whom they surrounded themselves is explicit in their work. The resulting images are provocative, balanced, and eminently meaningful; it can be argued that no other period could have produced them.

A "World Image": Fashion Photography between
Detachment and Fantasy

The idea that *Vogue Paris* experienced a true "golden age" between 1968 and 1986 is fully justified on a visual level and is evident in terms of creativity

and the joy of making. Its impact, however, is restricted mainly (if not purely) to this level. *Vogue Paris* was a fashion magazine, not a lifestyle magazine. The result was a detachment from reality that not only made these images more alluring, but also lent them a mythical status. It can therefore be said that although these *Vogue Paris* shoots were emblematic of their time, they did not reflect it, or at most did so in a minor way.

The contemporary positioning of French *Vogue* explains a great deal about this combination of freedom and detachment. Along with the magazine's lack of financial constraints, its modest circulation allowed it to distance itself from controversies experienced, for example, by the American edition of *Vogue*.[5] What's more, the Paris edition was not aimed at a broad audience; on the contrary, it was practically a niche magazine reflecting the interests of a small circle of professionals and creatives from the fashion and media worlds, among whom the magazine found an enthusiastic following. This group, often made up of socialites and the self-involved, existed within its own landscape. It was in its leisure resorts and vacation spots, over the course of shared events, where the working relationships reflected in the magazine's photographs were forged. Within this setting, a permissive climate formed that was not in sync with the "real" daily concerns of society in a broader sense, and therefore represented something of an escape route.

Moreover, artistic creativity was coupled with a social conservatism that slowly seeped into the pages of the magazine, which remained resolutely impervious to the social changes of the time. To take just one example, the representation of women in *Vogue Paris* was, at that time, often ambivalent. Although successful figures were celebrated for their emancipation and their careers, especially in the "Contemporary" section (cat. 291), they were always celebrities, singled out by name. By contrast, the treatment of the uncredited models in fashion and beauty shoots has been strongly criticized in recent years.[6] Hypersexualized, objectified, and nearly always shown lying down, they contradicted the liberated discourse promoted (sometimes without much conviction) by the magazine, and embodied a throwback to the social, sexual, and gender norms that had been brought into question throughout this period and the previous one—though rarely in the pages of *Vogue Paris*, admittedly. As if the pendulum had swung in the opposite direction, a certain kind of authority emerged during these two decades. First it was a male authority, represented symbolically in many of the photo shoots and also embodied in the figure of the author-photographer, in which *Vogue* actively promoted and which begs many questions about whose gaze is being served. And second, it was the magazine's authority, expressed through the many constraints applied to the fashion and beauty pages, and even in the lifestyle pages, which took on a dictatorial tone.

These mixed messages did not detract from the allure of the images; on the contrary, they seemed to reinforce it. The detachment that characterizes this period is part of the iconic power of these photographs. Through fantasy, they define and shape a set of specific stereotypes, establishing a powerful visual repertoire. When viewed as a whole, they form a cohesive body of work that reflects the distinct styles of the various photographers who followed (and sometimes contradicted) each other. The layout was designed to accentuate these relationships even further, with articles and images presented in a similar way, often linked by text explaining the connections between subjects that were sometimes explored in a fragmented way across the many pages of the magazine,

cat. 291 Jeanloup Sieff.
Anonymous.
"Les contemporaines."
Vogue Paris,
December 1968/
January 1969, pp. 118

ill. 4 Frank Horvat. Grès dress. *Vogue Paris*, March 1978, pp. 186–187

ill. 5 Arthur Elgort. Chanel ensemble. Philippe Venet coat. *Vogue Paris*, September 1984, pp. 394–395

yet which worked cohesively together. Although reading in this way can seem, at first glance, more difficult, evidence shows an ambition to create a whole object in which the various obsessions of the craftsmen are manifested, always under the leadership of *Vogue Paris*, who was simultaneously and effectively defining its identity.

The distinct aesthetics and symbolism of this period add to this evocative power. The narrative nature of photo shoots such as the one presenting the collections of March 1978 by Frank Horvat (ill. 4), the many visual quotations such as those seen in "Presenting Christmas" by Guy Bourdin in December 1975, and the frequent use of deliberate provocation, as exemplified by Helmut Newton's swimwear shoot of May 1976, led to a redefinition of what it is possible to depict, and of the boundaries of fantasy itself. The careful balance between different kinds of content[7] resulted in a rich, inspiring, and alluring magazine—all the more so when the images were provocative, whether for their eroticism or their sensory or visual potential.

In the 1980s there was a penchant for spectacular images, such as Arthur Elgort's "A Matter of Style" in September 1984 (ill. 5). In editorials we find unusual or evocative sets and grandiose architecture (the museum fashion shoots by Fabien Monthubert and Jean Larivière in November 1984 are examples) or elaborate staging (as in "Video Vedettes" by Albert Watson, also in 1984), sometimes exaggerated to the point of absurdity. This kind of visual scriptwriting broadened the range of escapist imagery, while giving it a new mysterious and theatrical quality. In addition, still life images were tackled in a manner that was very free and visibly celebratory, turning the beauty and cooking sections—often shot by Daniel Jouanneau (cat. 278, 279, ill. 6)—into a field for photographic experimentation; this was also reflected in the fashion pages, such as the series "Precise and Tailor-Made," again by Jouanneau, in September 1980. All of these photo shoots show a consistent visual approach, with the issues from this period forming a coherent whole in terms of aesthetics and design.

Even today, images from this richly creative era are regularly emulated as sources of inspiration, in the pages of *Vogue Paris* or elsewhere, both in images and text. The years 1968 to 1986 played a major role in the construction of a visual language, with its own codes and vocabulary, metaphors and accents. The departure of Crescent meant the end of an era, with the next one taking a radically different turn. However, her legacy was revived in the pages of the magazine in the early twenty-first century, while the work of her photographers now enjoys institutional and cultural recognition, further boosting her legend.

1 Exhibitions devoted to both from the 1980s onward—Newton's first two exhibitions were held in galleries in Paris and Amsterdam in 1975 and were followed by many others in galleries and museums—as well as their current collection, still today, impose them as the masters of the period. On the subject, see Val Williams, "A Heady Relationship: Fashion Photography and the Museum, 1979 to the Present," *Fashion Theory*, 12, no. 2 (2008): 197–218.

2 Most notably we find numerous references in later fashion shoots, but also in films, advertisements, or artworks, such as those of the American photographer Cindy Sherman which, although critical, are suffused with the aesthetics of the period.

3 This had already occurred in earlier periods, particularly the 1930s: During periods when the consumerist society is booming, it is notable that beauty pages grow particularly plentiful and impactful.

4 Although this essay focuses specifically on photography, it should be remembered that *Vogue* then contained illustrations, which were fewer in number than in previous periods but nevertheless carefully selected.

5 A series by Helmut Newton entitled "The Story of Ohhh . . ." published in American *Vogue* in May 1975, provoked a wave of indignation among its readers (see Alistair O'Neill, "Fashion Photography: Communication, Criticism, and Curation from 1975," in Stella Bruzzi and Pamela Church Gibson (ed.), *Fashion Cultures Revisited: Theories, Explorations and Analysis*, London/New York, Routledge (2013): 150–151. However, it is far less provocative than those published in *Vogue Paris*.

6 For a summary of these critiques, see Valerie Steele, "Anti-Fashion: the 1970s," *Fashion Theory*, vol. 1, no. 3 (1997): 279–295.

7 On this subject, see Cathy Griggers, "A Certain Tension in the Visual/Cultural Field: Helmut Newton, Deborah Turbeville, and the *Vogue* Fashion Layout," *Differences*, vol. 2 (1990): 76–104.

List of references
The author's interview with Patrick Hourcade, December 20, 2019, Paris.
The author's telephone interview with Marc Soussan, April 17, 2020.

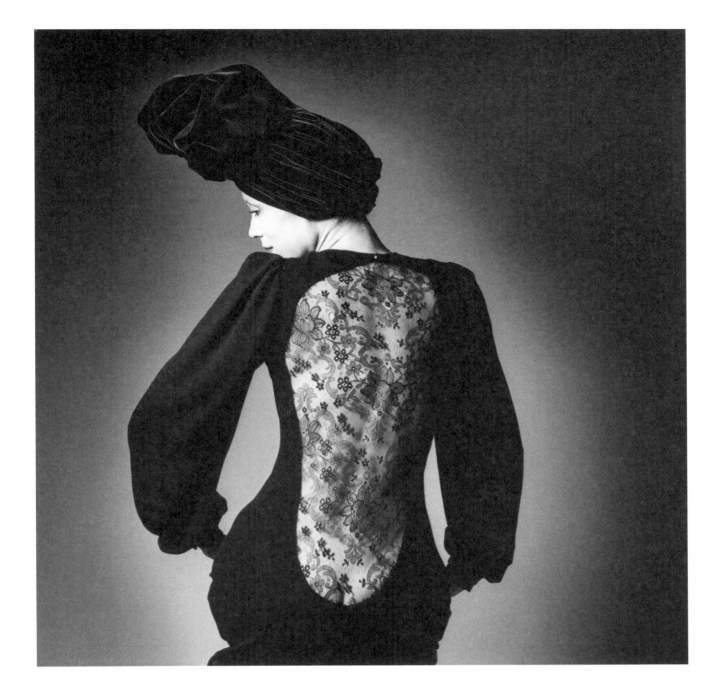

cat. 282 Jeanloup Sieff. Marina Schiano. Yves Saint Laurent dress. *Vogue Paris*, September 1970, p. 257

cat. 254 and 255 Urs Landis. "Votre passeport couleur." Makeup. *Vogue Paris*, February 1970, p. 91
and 93

cat. 256 Guy Bourdin. Jane Birkin. Vager Nastat Réal dress and Karl Lagerfeld for Chloé ensemble.
Vogue Paris, May 1969, pp. 90–91

laisser le fond -papier - *-Hélio-* *Vogue. Avril*

 cat. 257 Jeanloup Sieff. Georges Rech suit. *Vogue Paris*, April 1971, p. 68

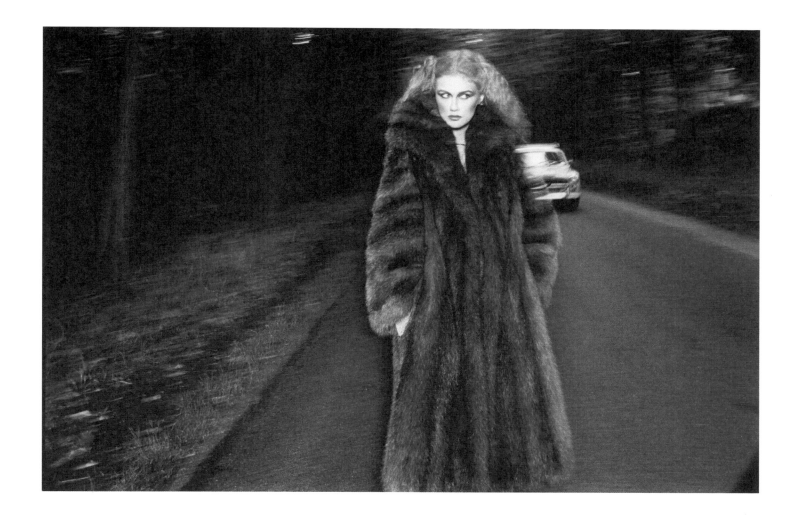

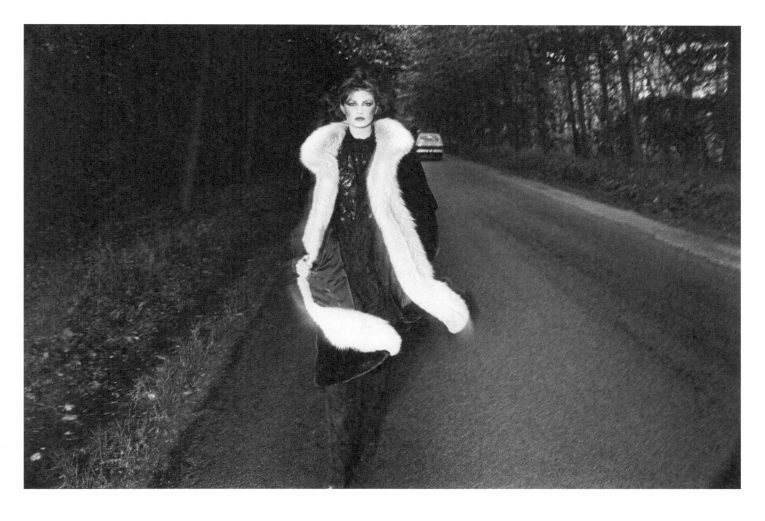

cat. 263 and 262 Gian Paolo Barbieri. Tree Allen (top) and Liselotte Zinglersen (bottom).
Grosvenor Canada coats. *Vogue Paris*, September 1977, pp. 432–433

A

B

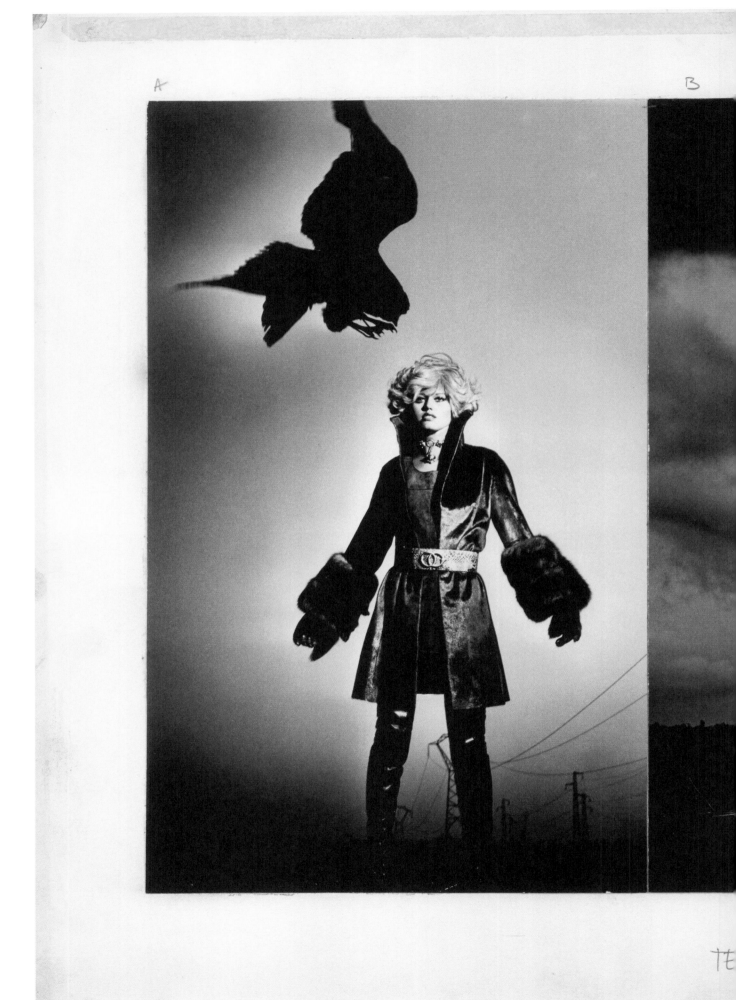

cat. 259 Helmut Newton. Ulla Danielsen. Vikt Körper (left) and André Sauzaie (right) coats.
Vogue Paris, December 1969/January 1970, pp. 110–111

TE

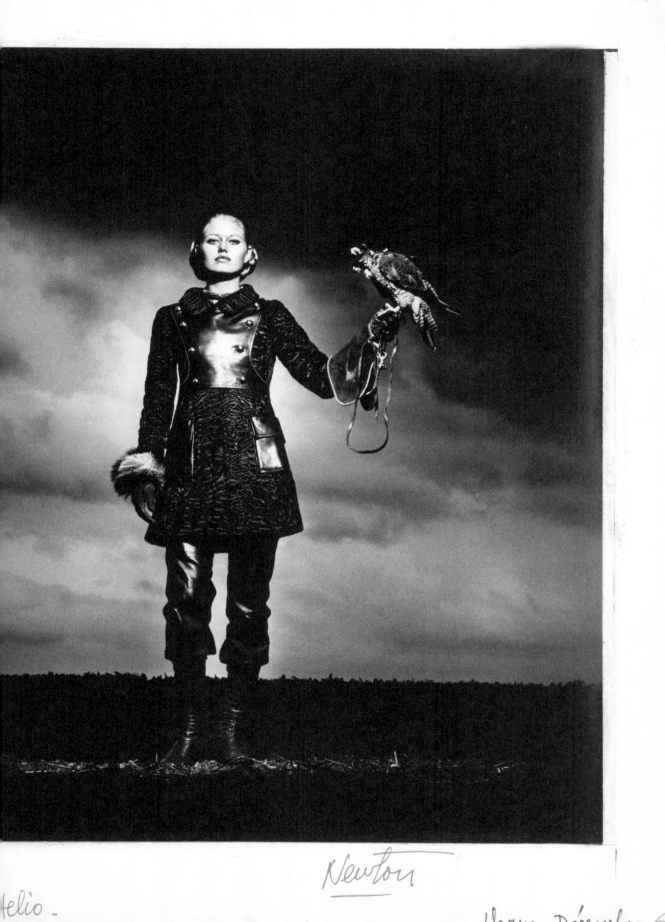

Helio.

Newton

Vogue. Décembre 69

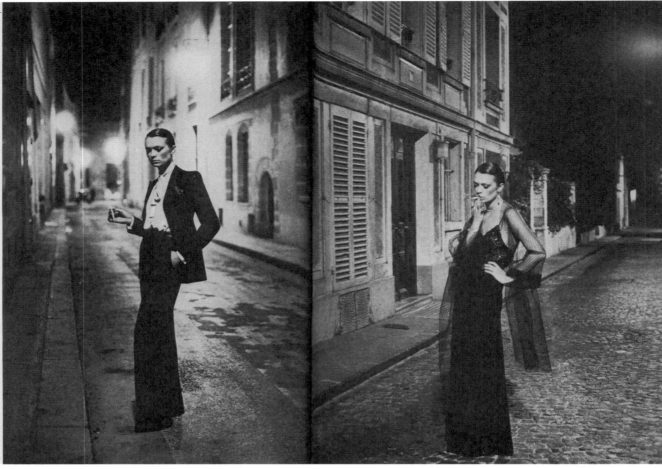

LE COSTUME-
PANTALON
DU MATIN
AU SOIR

"J'ai voulu," dit
Yves Saint Laurent,
"simplement mettre
l'accent sur une
vraie collection de
haute couture, luxu-
euse et qui s'adresse
à une certaine clien-
tèle pour laquelle
la haute couture est
faite et par qui elle
doit vivre."
(Ci-contre), d'une
coupe insurpassa-
ble, le costume-pan-
talon à porter tôt
le matin et même
tard le soir ; un
costume masculin
très féminin, en lai-
nage tennis gris
foncé et gris perle
de Besson. Blouse
en crêpe marocain
gris perle d'Abra-
ham à l'étroit col
noué et fermé par
une barrette de
strass. Yves Saint
Laurent. Coiffure
"nouvelle garçon-
ne" Alexandre. Ma-
quillage Charles of
the Ritz.

LA ROBE DE
GUÊPE

La robe du soir à
corselet de guêpe,
en mousseline de
soie noire de Bian-
chini-Férier. Le cor-
sage, à fines bre-
telles, en forme
de cuirasse arach-
néenne descendant
sur les hanches, est
brodé de jais par
Lanel sur fond trans-
parent. Étole de tulle
point d'esprit. Yves
Saint Laurent. Bi-
joux Yves Saint Lau-
rent. Coiffure Ale-
xandre. Maquillage
Charles of the Ritz.
Photos prises sur
Vibeke, notre man-
nequin-vedette (voir
p. 265).

146 HELMUT NEWTON

cat. 293 Helmut Newton. Yves Saint Laurent pantsuit (left page). Yves Saint Laurent evening dress
and jewelry (right page). *Vogue Paris*, September 1975, pp. 146–147

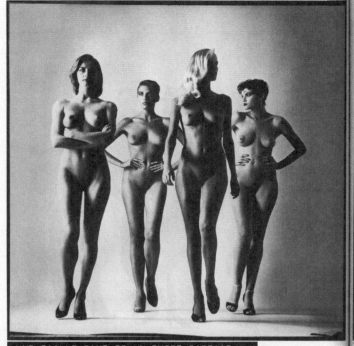
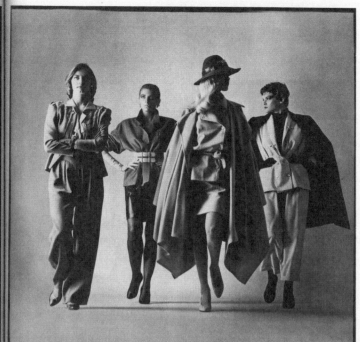

UNE TAILLE FINE ET UN BUSTE PARFAIT

Malgré l'ampleur ou l'épaisseur des vêtements, la taille est soulignée. Attention au ventre qui ressort. Il doit être plat et musclé. Adoptez tout de suite un régime qui élimine les féculents ou les crudités (qui font gonfler l'estomac). Pour le buste, quelques mouvements quotidiens aideront à sa remusculation. Ci-dessous à gauche, après sa gymnastique et sa douche, elle se masse la taille et les hanches avec la "Crème Multi-Réductrice" de Clarins. Pour la poitrine, elle fait deux fois par an une cure de douze ampoules de "Tenseur Bust" de Clarins raffermissant et revitalisant. Ci-dessus au fond, elle conserve sa taille fine en associant à un régime équilibré des massages effectués avec le "Gel Amincissant" de Stendhal. Pour la beauté de son décolleté, elle utilise régulièrement le coffret "Raffermissement des Seins" de Stendhal : composé de dix ampoules, une crème et une lotion. Ci-dessus, de face, elle suit chez elle le programme "Douceur Active du Corps" de Jeanne Piaubert et pour conserver à son buste toute sa fermeté, elle va régulièrement à l'Institut Jeanne Piaubert. Ci-dessus à l'extrême droite, elle a choisi de faire tous les matins le traitement amincissant de Lancaster pour le corps ainsi que le soin "Specific Buste" tonifiant et raffermissant. Maquillages José-Luis pour Yves Saint Laurent Beauté. Coiffures Bruno.

Des tissus impondérables, des lainages luxueux par leur finesse même autorisent des formes souples, non engonçantes. De gauche à droite, tailleur à veste ras de cou, aux épaules froncées, en crêpe de laine bronze de T.N.P. brodé de perles au décolleté, sur un pantalon à pinces sous empiècement assorti ; chemisier en soie façonnée bronze de Cinoc. Emmanuelle Khanh. Escarpins Laurent Mercadal. Gants Hermès. Veste bord à bord en drap de laine vert cru de Garigue, sur une jupe portefeuille en agneau plongé noir. Chloé par Karl Lagerfeld. Ceinture Chloé. Escarpins Charles Jourdan. Ample cape en lambswool et cachemire beige de Weil Der Stadt, sur une veste longue croisée et ceinturée, et une jupe courte assortie. Angelo Tarlazzi. Escarpins Carel. Chapeau Paulette. Sur les épaules, pardessus croisé à col châle en angora et laine noir de Fournier, sur un tailleur en gabardine de laine beige de Wurmser, à blazer croisé ample, à col châle orné d'un clip argent, et pantalon court à revers ; chemisier en mousseline de soie grise de Bianchini-Férier. Chantal Thomass. Gants Chantal Thomas. Escarpins Maud Frizon. Maquillages José-Luis pour Yves Saint-Laurent Beauté. Coiffures Bruno.

cat. 299 Helmut Newton. *Vogue Paris*, November 1981, pp. 164–165

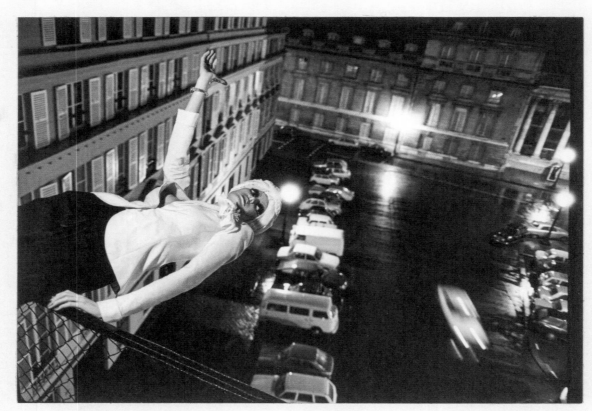

TEL Mars 78

cat. 261 Helmut Newton. Hanae Mori ensemble. Place du Palais-Bourbon, Paris. *Vogue Paris*,
 March 1978, p. 221

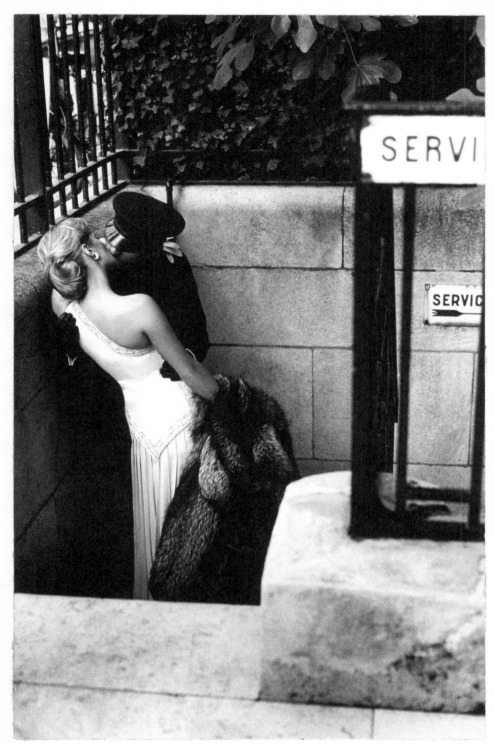

TEL_ Vogue - Décembre 75
 Newton

cat. 260 Helmut Newton. Gilles Dufour for Marie-Martine dress. *Vogue Paris*, December 1975/ "Vogue as Seen by . . .":
January 1976, p. 166 The Age of Photographers

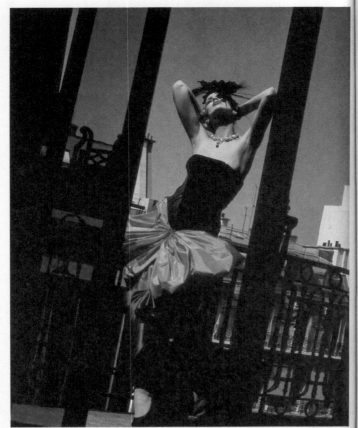

Chez Ungaro, toutes les femmes sont des enchanteresses armées de drapés et de nœuds éclatants, prêtes à séduire dans des fourreaux courts ou longs qui ont souvent le noir comme leitmotiv avec des notes de couleurs vives et hautes comme des arias de divas. Ci-dessus, fourreau en satin de Taroni et velours de Clérivet, à large drapé sur les hanches et grand nœud en taffetas de Taroni. Emanuel Ungaro. Parure perles fines blanches et grises naturelles et diamants ronds. Alexandre Reza Paris-Genève-New York. Coiffure-feuille en satin noir et strass d'Emanuel Ungaro.

Karl Lagerfeld s'y entend à électriser la ligne Chanel. Ce fourreau-armure est brodé aux armes de la fantaisie pleine d'humour et d'esprit. Il lui fallait l'Opéra. Il l'a eu pour sa collection spectaculaire. Ci-dessus, robe fourreau en satin ardoise d'Abraham, brodée or "Armure Douce" par Lesage. Chanel. Bijoux Chanel. Maquillages Chanel. Coiffures Bruno Decurjis pour Lucie Saint Clair. Photos prises à l'Hôtel Royal Monceau qui vient d'être rénové et d'ouvrir deux restaurants, l'un, "Le Jardin", l'autre "Le Carpaccio" dédié à la gastronomie italienne.

cat. 301 Patrick Demarchelier. Jerry Hall. Emanuel Ungaro dress (left page). Karl Lagerfeld for Chanel dress (right page). Hôtel Royal Monceau. *Vogue Paris*, September 1984, pp. 456–457

cat. 266 Bill King. Paulina Porizkova. Azzedine Alaïa dress. *Vogue Paris*, February 1986, p. 270

cat. 296 Albert Watson. Muriel Grateau Croisière dress, Muriel Grateau jewelry, Charles Jourdan
 sandals (left page). Emmanuelle Khanh glasses (right page). *Vogue Paris*, May 1979,
 pp. 152–153

cat. 298 Steve Hiett. Popy Moreni ensemble (left page). Jean-Charles de Castelbajac for Ko & Co
 ensemble (right page). *Vogue Paris*, May 1981, pp. 162–163

<div align="right">

"Vogue as Seen by . . .":
The Age of Photographers

</div>

cat. 268 Antonio Lopez. "Et pourquoi pas St Trop." Cacharel ensemble (left).
Tan Guidicelli for Micmac dress (right). *Vogue Paris,* June/July 1970, p. 75

cat. 267 Franco Rubartelli. Veruschka. Emo swimwear. Rio de Janeiro. *Vogue Paris*, April 1969, p. 76

cat. 277 Mike Reinhardt. "La beauté efficace." Janice Dickinson. Beauty pages. *Vogue Paris*,
April 1979, p. 226

cat. 276 Hans Feurer. "Dix remèdes nouveaux contre le mal de dos." Beauty section. *Vogue Paris*, March 1975, p. 184

76

cat. 274 Guy Bourdin. "Bulletin beauté spécial jeunes. Rush sur le rouge."
Harriet Hubbard Ayer makeup. *Vogue Paris*, May 1970, pp. 76–77

BULLETIN BEAUTE SPECIAL JEUNES

RUSH SUR LE ROUGE

Une bouche, des ongles libres à nouveau d'utiliser le rouge vif. A cause de l'été. A cause des nouvelles longueurs. Lisez pourquoi ces "Rose d'Égypte", à la page suivante.

GUY BOURDIN 77

cat. 272 Guy Bourdin. "Point de vue sur une nouvelle beauté." Christian Dior makeup. *Vogue Paris*, March 1972, p. 155

cat. 273 Guy Bourdin. Kathy Quirk. Nuits d'Élodie panties. *Vogue Paris*, December 1976/January 1977, p. 262

cat. 278 Daniel Jouanneau. "Aujourd'hui comme demain." Cooking pages. *Vogue Paris*, March 1977, p. 261

cat. 279 Daniel Jouanneau. "Des plumes mais en casserole." Cooking pages. *Vogue Paris*,
 September 1977, pp. 472–473
ill. 6 Daniel Jouanneau. "Les solutions du futur." *Vogue Paris*, February 1983, pp. 296–297

186

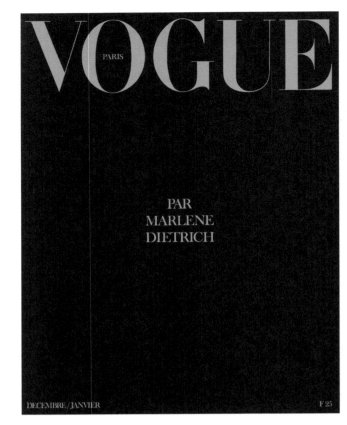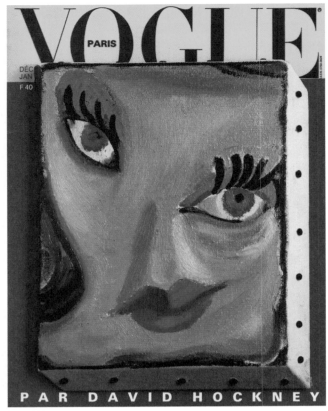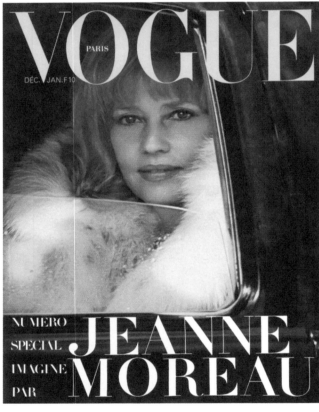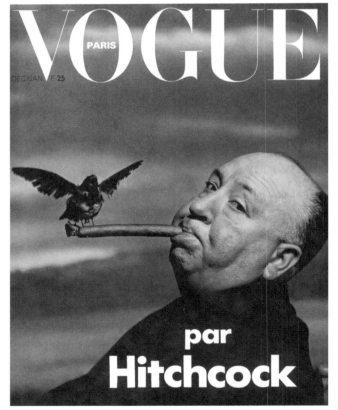

1968–1986

cat. 369 *Vogue Paris*, December 1973/January 1974, cover
ill. 7 David Hockney. *Vogue Paris*, December 1985/January 1986, cover
ill. 8 Helmut Newton. *Vogue Paris,* December 1970/January 1971, cover
ill. 9 Philippe Halsman. *Vogue Paris*, December 1974/January 1975, cover

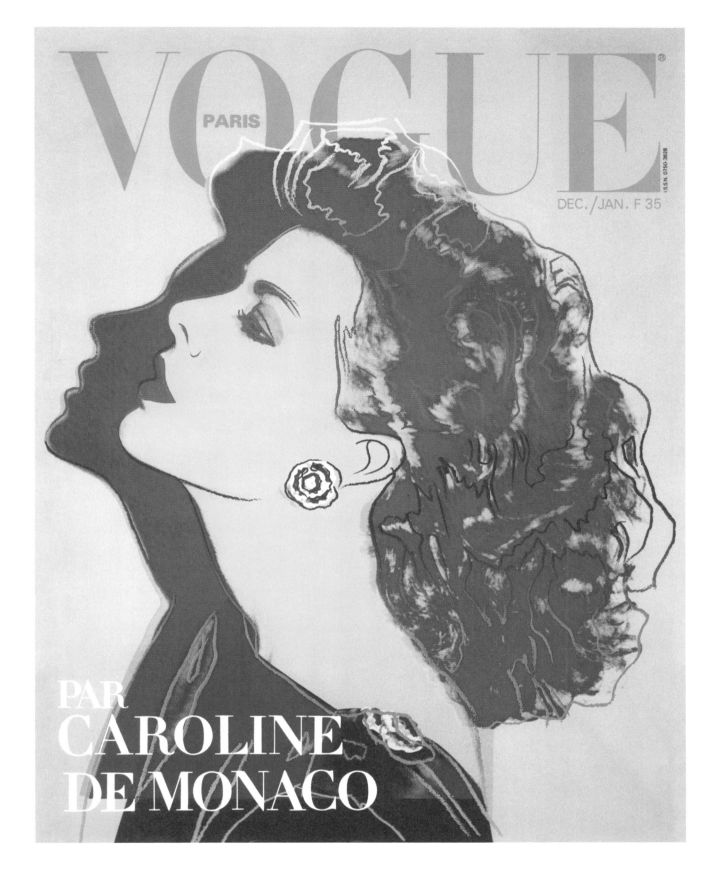

cat. 286 Salvador Dalí, David Bailey. "Giambattista Della Porta (1536–1615)." *Vogue Paris*,
December 1971/January 1972, pp. 186–187

cat. 285 Salvador Dalí, Henry Clarke. "Cravate du bon chasseur." Yves Saint Laurent tie. *Vogue Paris*,
 December 1971/January 1972, p. 199

Dans un petit livre intitulé "Lettre sur le sujet de la Princesse de Clèves", son auteur, Valincourt, reproche à Mme de La Fayette d'avoir permis dans son récit que la fille de Mme de Chartres allât seule chez le joaillier italien où elle rencontre pour la première fois le prince de Clèves... Depuis lors, les jeunes femmes ont appris à sortir sans leur mère... mais il arrive encore que leur destin se noue chez un joaillier de la place Vendôme, ou que ce soit l'une d'elles qui fasse le destin du joaillier...

Émeraudes de van Cleef & Arpels.
C'est ainsi qu'un après-midi de 1930, une dame très pressée, s'étant attardée à bavarder avec Louis Arpels, jeta pêle-mêle dans une grande boîte de Lucky Strike en métal quelques cigarettes, un miroir et un tube à rouge. Louis Arpels, deux mois après, sortait la première "minaudière" que l'on s'arracha bientôt dans le monde entier. La collerette d'émeraudes ovales montées sur or et de brillants ronds montés sur platine, *page de droite*, se prolonge d'une grosse émeraude de Colombie, entourée d'émeraudes et de brillants sertis par van Cleef & Arpels d'une manière si mystérieusement parfaite que c'est entre soixante des plus grands joailliers du monde, que Sa Majesté Impériale Farah Pahlavi les choisit pour réaliser avec 36 rubis, 36 émeraudes, 105 perles et 1 469 brillants la somptueuse couronne du Sacre.

Le couple de l'année.
Si le visage de droite a été entièrement perlé à la main par Serge Lutens, la grâce de Jane Birkin, à *gauche*, en robe-pantalon frangée de Berluc, est celle du naturel en liberté. Avec Serge Gainsbourg, habillé sur mesure par le tailleur Paul Portes d'une veste en peigné blanc à raies bleues, ils viennent tous deux de recevoir "Le Triomphe du Cinéma Français 1969" pour le couple qu'ils forment dans le film "Slogan" de Pierre Grimblat. Lisez les prix de ces cadeaux page 61.

...Et des extravagances de costumes, de plumes et de bijoux...

cat. 292 Guy Bourdin. Jane Birkin, Berluc dress pants. Serge Gainsbourg, made-to-measure suit by Paul Portes (left page). Van Cleef & Arpels emeralds (right page). *Vogue Paris*, December 1969/January 1970, pp. 128–129

réduire à 321 ᵐ/ₘ x 245 ᵐ/ₘ – Helio – Beauté – Vogue Mars –

cat. 280 Alexis Waldeck. Jim Morrison and Donna Mitchell. Beauty section for men. American *Vogue*,
November 15, 1967, p. 84 and *Vogue Paris*, March 1968, p. 242

cat. 271 Sarah Moon. Susan Moncur (center), Carole Singleton (right). Lancaster by Heidi Morawetz makeup, draped veils by Jeannine Montel with the advice of Karl Lagerfeld. *Vogue Paris*, February 1973, pp. 114–115

THE FASHION PHOTOGRAPHER AS SUBJECT

ill. 1 Helmut Newton. From left to right: Emerick Bronson, Roger Prigent, Henry Clarke, Guy Bourdin, William Connors, Joseph Leombruno, Jack Bodi, Maurice Pascal, Willy Rizzo, Helmut Newton. In the center, Dorian Leigh. *Vogue Paris*, October 1962, p. 125

In "The Point of View" section of the May 1931 issue, a photograph credited to George Hoyningen-Huene provides a glimpse behind the scenes of a photo shoot taking place in the studios of *Vogue Paris*. Posing in profile in front of a decorated backdrop and crowned with a halo of artificial light, muse and model Lee Miller poses with all eyes upon her. On seeing this image, the reader is pulled into the world of a movie set, where the same technical and stylistic devices are used: a tangle of cables and cameras, a set plunged into darkness, a bright screen, and a model playing a role in a narrative sequence.

If this behind-the-scenes photograph reveals the commercial reality of such a spectacle, why was it published? Is it to show the readers of *Vogue Paris* how complex it is to produce this type of image, as suggested by the accompanying text? Is it to allow photographers a space in which they can not only witness the latest technological innovations in the field of photography, but also watch them in action? Or is the photo positioning itself between the world of art and the world of commerce?

Several later depictions of fashion photographers in the pages of French *Vogue* make use of the same setting. In the March 1968 issue, French photographer Jeanloup Sieff is shown leaning on a huge lighting rig. In a clever game of flipped gazes and role reversal, he takes a playful attitude with his own playboy image in front of a camera wielded by French model Mireille Darc—just as Franco Rubartelli did in the same year for Veruschka.[1] The presence of these two fashion photographers inside the frame of the image reflects the iconic status that these professionals achieved in the 1960s. While only Hoyningen-Huene's profile can be seen in the shadows of the 1931 image—a metaphor for his imminent rise to fame as a fashion photographer—Sieff stands in full view. During the 1960s, the photographic image was transformed into a network of symbols,[2] designed to increase the reader's belief in the value of entertainment and conspicuous consumption.

While the media hype of the 1980s and 1990s allowed photographers to assume greater power within magazines, more recent images have established them as all-powerful figures. In the October 2010 issue of *Vogue Paris*, a shoot by Inez van Lamsweerde and Vinoodh Matadin entitled "The Party," directed by Emmanuelle Alt, demonstrates this shift in scale. In the digital age, fashion photographers are at the helm of a megaproduction, as evidenced by the massive set and many assistants present at this shoot—so much so that putting the photographers in the spotlight is not necessary; they remain spatially separated from their subjects while attention is focused on the lead models and the various other collaborators on set.

These three images are also united by the magazine's desire to use the medium of photography to reinforce its own mythology. They show the ambiguous position of photography within the art world by reflecting its connection with film and demonstrating that fashion photography, whether in the 1930s, the 1960s, or the 2010s, is a dual process that simultaneously creates art and sells a product.

Marlène Van de Casteele

1 See *Vogue Paris* (January 1968): 9.
2 See Roland Barthes, *Système de la mode*, Paris, éditions du Seuil (1967).

LE POINT DE VUE DE VOGUE

ill. 2

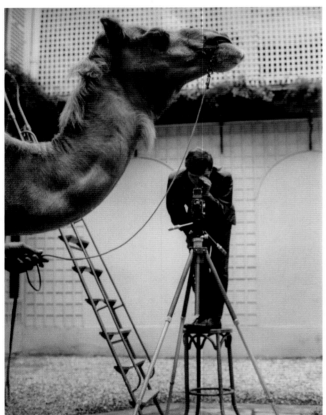

cat. 204

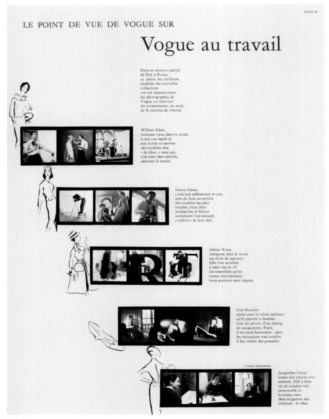

ill. 3

ill. 2 George Hoyningen-Huene. Lee Miller. Vogue Paris Studio. *Vogue Paris*, May 1931, p. 23

cat. 204 Sabine Weiss. Guy Bourdin at work in the courtyard of *Vogue Paris*, 4, place du Palais-Bourbon, 1956

ill. 3 Jacques Bachmann. "Vogue au travail." *Vogue Paris*, August 1956, p. 29

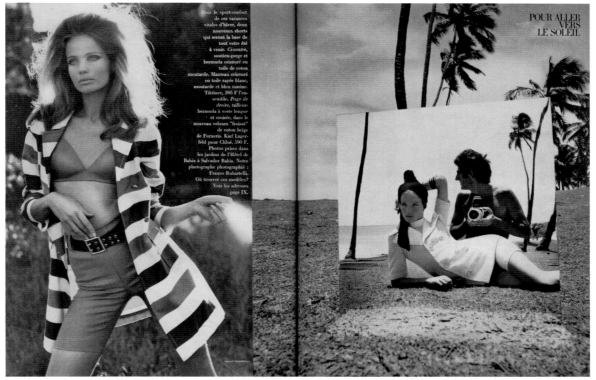

ill. 4

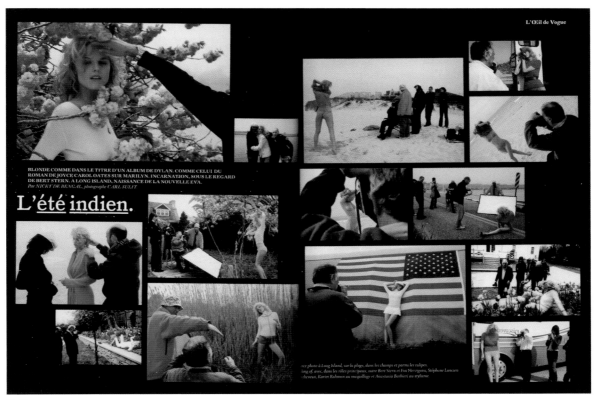

ill. 5

ill. 4 Franco Rubartelli. Veruschka and
Franco Rubartelli. Tiktiner ensemble.
Karl Lagerfeld for Chloé Bermuda suit.
Vogue Paris, January 1968, pp. 8–9

ill. 5 Carl Sulit. Eva Herzigová, Bert Stern,
Anastasia Barbieri, Stéphane Lancien,
Karim Rahman. *Vogue Paris*,
October 2002, pp. 322–323

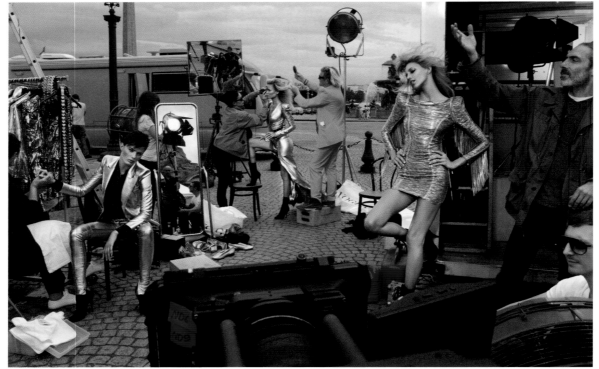

ill. 6

ill. 6 Inez & Vinoodh. "The Party."
 Isabeli Fontana, Natasha Poly,
 Anja Rubik. Balmain ensembles.
 Directed by Emmanuelle Alt.
 Vogue Paris, October 2010,
 pp. 492–493

V 1987—2000

THE NEW "POINT OF VIEW" OF *VOGUE PARIS*

cat. 350 Jean-Luce Huré. Colombe Pringle, Nelson Mandela, and Jean Poniatowski, Paris, 1993

As Colombe Pringle and Irène Silvagni, then editors in chief of the magazine, announced in the February 1989 issue: "Without losing sight of its traditions of audacity and quality, *VOGUE* is moving forward!" In fact, the years 1987 to 2000 would be marked by profound and lasting changes to the magazine. Stretching between two long reigns of leadership, during which the magazine held an important and undisputed position, this period saw numerous breaks with the past that, paradoxically, shed a light on the overall historical evolution of *Vogue Paris*.

This era is primarily characterized by a generational shift that extended from the editorial team and the magazine's content to the readership. Starting in the late 1980s, Pringle (for the magazine sections) and Silvagni (in charge of fashion) set out to rethink the entire magazine. Both were former collaborators at *Elle* where they helped to showcase a new wave of fashion designers including Miuccia Prada, Azzedine Alaïa, Rei Kawakubo for Comme des Garçons, Agnès b., and Dorothée Bis, among others. At *Vogue Paris,* too, there was a desire for transformation:[1] For the first time in the magazine's history, the director, Jean Poniatowski, called on two people outside of the editorial staff to modernize its high-end formula.

American Joan Juliet Buck, an occasional contributor to American *Vogue* with no particular institutional ties to *Vogue Paris*, succeeded Pringle and Silvagni in 1994.[2] The changes that all three editors would bring, although at first superficial, would nevertheless introduce a contemporary vision of French *Vogue,* exemplified by a new format with new content, the effects of which would last well beyond the 1990s and up to today. The advent of a whole new generation of producers, creators, and readers ushered in a transformed approach to images, as well as to their chosen medium of distribution, the "magazine-as-object" as defined by its design as well as its purpose.

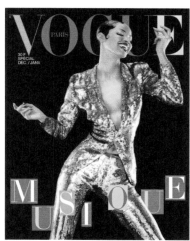

ill. 1 Jean-Baptiste Mondino. Georgianna Robertson. Jean-Paul Gaultier ensemble. *Vogue Paris,* December 1996/ January 1997, cover

Toward New Content

The layout of a magazine, although it may occasionally be refreshed, tends to follow entrenched rules that have been defined over time by the industry and are rarely questioned in depth. Its great strength, therefore, stems from its sustainability. Through the ages, the magazine's basic layout makes it recognizable (as a structured medium)[3] and weaves a relationship between those who produce it on the one hand and those who read it—or flip through it[4]—on the other. *Vogue* in all its international editions, like other luxury women's publications,[5] follows the traditional formal structures of a fashion magazine. The division of content into sections is crucial. The prominence of an editorial "core" devoted to fashion and beauty, which groups together all the images shot for the magazine[6] and displays them uninterrupted by advertising, is a common characteristic. Around this sacred space the more ephemeral content is arranged, featuring news stories that the editorial team believe will be of interest to readers while fitting the editorial line; these often include cultural events, book launches, exhibition openings, and a range of fashion and lifestyle advice.

This section of the content, under headings that have changed throughout the history of *Vogue Paris,* acts as proof that the magazine has its finger on the current pulse, a crucial fact in the pre-Internet era when news was disseminated mostly by traditional media. The chosen stories are then conveyed

ill. 2 Contents. *Vogue Paris*,
 March 1993, p. 7

ill. 3 Column "On en parle . . ."
 Vogue Paris, March 1995,
 p. 35

to readers in a specific way. However, prior to the period now being discussed, the pages positioned before the "core," which included the "news" sections, were not considered central to the magazine—a position held instead by the major photo shoots.

In the 1990s there was a rebalancing of forces, with the "magazine" pages increasing both in number and scope. Changes of this kind, made first by the Pringle/Silvagni team and then by Buck, are profound and major. As a result, French *Vogue* of the 1990s can be considered the first truly contemporary version of the publication as we know it today.

The approach taken by Pringle and Silvagni is a clear break from that of the previous generation. The table of contents, revised under their mandate, provides early proof of this. This opening page lists the contents under headings that give shape to the magazine and offer clues about the prominence granted to the different topics. Thus, while in the 1980s the table of contents included three "blocks" that provided conceptual and visual organization for the images and text, in the order: "Fashion," "Beauty," and "People and Ideas," the succeeding period included—for the first time—the heading "Magazine" in its table of contents alongside the former two sections, which remain pillars of the publication (ill. 2).[7]

The updated layout allocated more than two-thirds of the contents page to the Magazine section, demonstrating a new interest in recent events and other consumable "cultural products" but also an increased focus on social issues. Within the layout, in which slight but frequent adjustments were made according to the issue, the "News" pages, sometimes subtitled "Paris is Talking About it"—a long-standing column in the magazine (ill. 3)—still occupied pride of place in the table of contents. This section often included articles about Milan, Los Angeles, or New York—a sign of the increasing globalization of Western consumer society. The Culture pages, which reported the latest news in film, theater, books, architecture, and the art market, undeniably aspects of *Vogue Paris* tradition, were also highlighted, as were the sections Cooking, "Live in *Vogue*," and "Travel in *Vogue*." But above all, it was their presentation that was significantly altered.

In fact, this structural change, which seems superficial, shook up the entire magazine. Pringle and Silvagni surrounded themselves with a strong team of journalists such as Paquita Paquin, Francis Dorléans, and Brigitte Paulino-Neto, among others, who wrote monthly in-depth articles and simple reports on trends. Professional feature columnists, writing in the language (and thus the point of view) of the time, replaced the specialist contributors who, especially during the time of Edmonde Charles-Roux, wrote articles on their favorite topics.

The editorial team formed a small circle of insiders who were socially well connected and played a key role in the influence of *Vogue Paris*, which was determined to stay in tune with the times. Stories showing the fashion world from behind the scenes,[8] which had a dedicated section starting in 1989, were particularly dynamic during this period and offer proof of the privileged access enjoyed by the magazine and its representatives.

Additionally, contributions by prestigious experts such as Jean Baudrillard in April 1995 and Michel Pastoureau in February 1998 were regularly commissioned. Such endorsements added to the magazine's luster without the need to structure the issue around their words, a factor that only added to the "winning formula" the magazine had established. This structure set a systematic style for the

magazine and its contents and signaled a new relationship with the reader, as well as a willingness to meet her (supposed) expectations.

The collaborations featured in the traditional Christmas issues also demonstrated this revised arrangement: The same overall approach was retained, but the range of guest stars, especially in more recent years, testified to a broader vision of what personalities could bring to the "universe" that was *Vogue Paris*. The Dalai Lama (1992) and Nelson Mandela (1993) (cat. 358), contemporary public figures from the headlines, ushered in an inclusion of political figures that had never before been seen in French *Vogue,* and which highlighted its desire to embrace the changes of the time. However, the tone remained light; these subjects were generally approached in a nonconfrontational way, as was appropriate for a fashion magazine.

Buck, upon her arrival in September 1994, moved even further in this direction. During her tenure, the magazine tended to stick to this formula while allowing slight adjustments from one issue to the next. Now more spacious, clear, and readable, the magazine also became more methodical and static. The editorial that opens the "core" pages, titled "The Point of View," stopped altering its design with each issue. Instead, it now took the form of black text on a white background, with a consistent length and typographic styling. This did not prevent creativity within the layout, however, as the art director employed the use of changing color schemes to match the theme of each issue or, in some cases, to alert readers to visual content (in blue) or text (in black). It was therefore the entire approach to the magazine itself—and magazines in general— that evolved to provide readers its monthly offerings in a standardized format.

The editorial also became a space where the editor in chief set out the theme of the month, regularly signing it with her initials "JJB." Every month was now given a theme, which was reflected in articles and photo shoots, in addition to the special issues "Couture" and "Ready-to-Wear." The May 1991 issue, for example, was devoted to the color green, April 1998 to DNA, and May 2000 to Latin America. Each issue thus became a "special edition" that fit within the constraints of the editorial calendar (based around the release of twice-yearly collections, as well as accessories, swimwear, and more) and made every issue an event in itself. *Vogue Paris* had thus cleverly adopted the increasingly frantic pace of the contemporary world, at a time when the fashion industry was also undergoing major changes, with production and distribution accelerating and globalizing to reach new markets. French *Vogue* of the 1990s, like those of previous decades, fit easily into this industry, one in which the publication had naturally found its place since its inception.

Other monthly columns of the period also reflected the magazine's new direction. Profiles of celebrities who connected the worlds of fashion and film became, under Pringle, a key feature. Buck strengthened these ties even more and added the "Flash" section, featuring both emerging and well-established personalities from the world of film and culture in general. Moreover, regular articles on a range of subjects related to the world of fashion and beauty attested that the generation that made and read *Vogue Paris* during this time was also concerned with social issues.

In short, the magazine, which had once been threated by rival publications, cleverly adapted to the demands of its time by offering new content in a revised format, and successfully repositioned itself within a media landscape that was witnessing a complete reconfiguration of the press.

ill. 4 Jerome Esch. Column "Flash." Philippe Decouflé. *Vogue Paris*, November 1995, p. 142

The new approach adopted by *Vogue Paris* was reflected not only in its content, but also in its form. In a sign of a major shift in its editorial design, the magazine as a physical object was materially transformed. Its size and layout changed, a fact that was highlighted and justified by the editors in chief in their previously mentioned editorial of February 1989. They described the new "dimensions" of *Vogue Paris* (11.7 by 8.9 inches/29.7 by 22.7 centimeters), while promising that the "paper [will be] even more beautiful, [the] finishes even more immaculate, [the] images always top notch"—changes which, they emphasized, reflected those within the world of contemporary fashion that remained at the heart of the magazine. This explanation, a kind never before seen in the pages of *Vogue Paris,* went on to combine current events (the opening of the Opera Bastille and the renovation of the Louvre museum), fashion trends (wide trousers, hippie details, and the craze for white), and messages addressed to readers in a light tone within the new format. This editorial, manifesto-like in its approach, implicitly addressed all the current issues at stake.

As an object, the "new *Vogue*" was more compact, more transportable, and less expensive to produce. The number of pages decreased considerably, from more than five hundred to an average of about three hundred, a consequence of regulatory changes that led to a repositioning of the advertising market, but also the result of a more concise, less flowery style of presentation. This resized magazine reflected a new reality that offered new potential. Less spectacularly, however, it no longer stood out as much among other magazines; in short, it switched from a status symbol to an object of immediate consumption (although the two ideas are not mututally exclusive; a transportable object can embody status, and vice versa).

This significant change in format is still reflected in the tone of the magazine today. More familiar, and more willing to address its (often female) readers, albeit indirectly, it has also become more informative while remaining very opinionated. What was once implicit is now explained in full, in editorials, in extended subheads, and even on the covers, which are increasingly dominated by text and often read like lists. In this we see the tremendous democratization of *Vogue Paris* as it freed itself from the rules of sociocultural class that had prevailed up to this point. The codes that had long been comprehensible only to "those in the know" were now dissected for a wider audience. Of course, the magazine remained exclusive by definition, yet it now invited a section of the population that had formerly been excluded to read it as an "aspirational" source. This was the contribution of editors in chief who came from a field of the press with a broader reach; a way of life that had once been reserved for the elite was now being sold to a wider audience in the context of the uninhibited liberalism of the post-1989 period.

In addition, the magazine expanded to include supplements (on watches and other accessories, beauty, and more), small gifts, and pull-out pages, making it not only an object that could be consulted or flipped through, but also one that was filled with elements that offered the potential for reuse. Its democratization thus extended to its usefulness, which until then had been relatively limited by its format. For a luxury magazine such as *Vogue Paris,* this approach—which has never gone out of style—was very modern; and its success, measured by the loyalty of its readers, was maintained. Perhaps one of the best examples of this new type of interactivity is issue number 700

from October 1989.[9] To celebrate this anniversary, the reader was presented with the very first cover of *Vogue Paris* (dating from June 1920) as well as the first editorial, reproduced in facsimile form on two pull-out perforated pages.

This desire to streamline the magazine can be seen also in the use of standardized features aimed to increase profitability. This is evidenced by the frequent reuse of archive images to illustrate the Trends pages. This practice had a two-part advantage: In addition to a reduction in production costs, the reuse of images from the *Vogue Paris* archives (or press images or from the fashion shows) allowed the magazine to maintain an aesthetic and symbolic continuity between its different sections and eras, linked by its recognizable personality. Paradoxically, during this eclectic and innovative period, the magazine's past was not erased, in fact far from it—even with its modernized format—and good use of it was made.

However, this triumph of commercialization and rejuvenation was never considered or presented by the magazine as a bitter defeat. On the contrary, in line with the consumerist, libertarian, and post-pop hedonistic irony of the 1970s,[10] the shift was communicated in a detached, playful tone, presented naturally within the pages and accompanied by a new iconic positioning.

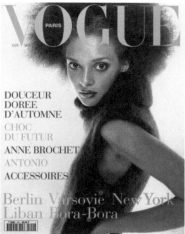

ill. 5 Craig McDean. Chrystèle Saint Louis Augustin. "Et vous dress." *Vogue Paris*, October 1994, cover

Toward a New Relationship with Images

As has been stated, editorial images remained the primary focus within the pages of *Vogue Paris.* But they seemed to be better integrated into a coherent, dynamic whole, where the flow of reading was updated and simplified.

The interest in new media at a time when cinema, for example, had established itself as a cultural field in its own right, sheds light on this updated way of working. The "MTV generation"—the US cable channel was featured in the December 1996 music issue (cat. 360)—had a very different relationship with images than previous ones. Articles featuring music releases, music videos, video games, manga, and comics were flourishing. These subjects and their associated imagery became a new source of inspiration, but above all, reflected what was now considered a shared visual culture, harmonized by the fluid flow of aesthetics and forms between different media formats.

Vogue Paris, like many other products of culture, began to include a larger quantity of reinterpretations and reuses of iconic images and tributes, following a trend toward historicism in fashion and fashion photography, as in "La Touche 38" by Wendelien Daan in August 2000. Additionally, these images were juxtaposed in an "intericonic" way.[11] Far from the tensions of previous decades, images became hybrids, fitting easily into a range of styles and registers.

Illustrations also played a key role in this "mix-and-match" aesthetic. Graphic designers and fashion illustrators, such as Mats Gustafson, Jean-Philippe Delhomme, and Art Spiegelman, produced artwork that accompanied topics as varied as fashion collections, relationship advice, or society events.

Vogue Paris continued to use both famous and lesser-known photographers on its fashion shoots, including Taryn Simon (a regular collaborator) and David LaChapelle (notably in March and December 1996). The fact that a set of photographs by Philip-Lorca diCorcia was presented as a portfolio (in the December 1999 issue) tells us, however, that a hierarchy did exist, and that advertising art was used to elevate the rest of the content with which

ill. 6 Ferdinando Scianna. "Moments Volés."
 Christian Dior ensemble. *Vogue Paris*,
 September 1989, pp. 212–213

it interacts in the unique context offered by the magazine. Finally, the "Pause on the Image" section, introduced by Buck in September 1994, highlighted one of the images presented in the issue by explaining its subject and/or aim, again establishing a hierarchy within this otherwise consistent ensemble.

The fashion and beauty shoots featured in the "core" of the magazine also adopted this shared visual language. The photographers of the period produced a huge range of images that were nonetheless identifiable as "*Vogue* creations." Throughout the decade, we see shoots that may be more raw (often grainy), more snapshot-like, and more slick than in previous years; they may favor the purity of ghostly black and white or, conversely, the opulence of deliberately faded colors, the restraint of lines and tones or, as seen later, the electric vivacity of pop art. Some, such as Peter Lindbergh's shoots on the beaches of Le Touquet and Beauduc in collaboration with Silvagni, or the portraits of Brigitte Lacombe or Dominique Issermann, have become famous. Other examples as diverse as "Stolen Moments" by Ferdinando Scianna (September 1989) (ill. 6), "Fatal Allure" by Max Vadukul (September 1992), "Entrance of Artists" by Ellen von Unwerth (September 1993), or "Radical Elegance" by Wayne Maser and Steven Meisel (June/July 1994) illustrate the themes and aesthetics previously mentioned. The iconic and specific visual style they shaped is marked in particular by a love of the spectacular—an approach that was necessary in order to stand out amid the surrounding chorus of voices. The relationship between readers and images seemed to be one of immersion, even fascination, a connection that is even more intense because it is so brief, spanning across a series of overlapping images on one or more pages. At the same time, a well-established set of references shows that forms encoded in earlier periods have now become highly recognizable signs within visual culture.

The text-heavy covers of this decade, already mentioned, seem to indicate, with their dense mix of text and images that can be viewed in many ways, that, from this point forward, the relationship between different kinds of content would be governed by juxtaposition and a style of reading that was intermittent but free flowing. All of these characteristics shaped French *Vogue,* and more broadly, the editorial concepts of all magazines of the 1990s, both upstream (on the production side) and downstream (on the consumer side).

The position formerly held by *Vogue Paris* in the 1970s and 1980s, as a visual landmark, was occupied in the 1990s by niche magazines that commissioned striking photo shoots.[12] French *Vogue* was shifting toward a new positioning in which trends, relayed in various ways, were the focal point. The innovations of that period can still be seen today in the editorial concerns that lie at the heart of the magazine—an openness to current events and a need to speak out on social issues—testifying to the importance of the transitions and rethinks of those few years.

Starting in October 2000, the *Vogue Paris* website address began to be featured regularly on the covers. The end of this period thus marks yet another shift into a new era and a new generation, which will bring its share of new challenges leading to new solutions, and new formats.

1 The history of the magazine is closely intertwined with that of the group Condé Nast France which, in 1988, launched a French edition of *Glamour*. Its success reflected the public's appetite for "younger" publications that were less elite and more diverse in their content; *Glamour*'s profitability also made it possible to envisage a financially lucrative *Vogue*, which changed the way the magazine was approached (Irène and Alexia Silvagni, 2020; and Colombe Pringle, 2020).

2 See Joan Juliet Buck, "*Au Revoir* to All That," *The Cut/New York* magazine (February 6, 2017), https://www.thecut.com/2017/02/joan-juliet-buck-the-price-of-illusion-french-vogue.html.

3 See Nicola Kaminski and Jens Ruchatz, "Journalliteratur - ein Avertissement," *Pfennig-Magazin zur Journalliteratur*, vol. 1, Hanover, Wehrhahn Verlag (2017).

4 The notion of flipping, as discussed by Thierry Gervais in the context of early illustrated periodicals, conveys the idea that, rather than being read, a magazine is browsed (not necessarily in order, nor end to end), with its readers focusing only on the pages that attract their attention—a process in which photographs and their visual immediacy become very important. (See Thierry Gervais, "L'invention du magazine. La photographie mise en page dans *La Vie au grand air* [1898–1914]", *Études photographiques*, no. 20, June 2007: 50–67).

5 High-fashion magazines are so called because they cover not only luxury fashion, but most importantly "fashion of the fashion world," which is not intended to be sold as-is. They represent a separate branch among magazines and women's publications.

6 Editorial images are those that the magazine itself produces to fill its pages; conversely, advertising images are produced by the brands and inserted into dedicated spaces.

7 It should be noted that in the 2000s, this structure would be further formalized by the splitting of the table of contents over two pages, one devoted to the "core" and the other to "magazine" content.

8 Although articles of this type have been featured throughout the history of *Vogue*, which enjoys unique access to couture designers, the number of reports and the angles they took increased considerably.

9 This is even more notable since the October issue is traditionally significant in the editorial calendar; often longer and more lavish in content than other issues, it mainly presents the autumn/winter fashion collections.

10 Joan Juliet Buck began her career as a journalist by collaborating with *Interview*, the iconic lifestyle magazine of the 1970s and 1980s, launched by Andy Warhol in New York.

11 The term is explained by Clément Chéroux in an essay on press photographs and on September 11, 2001 ("Le déjà-vu du 11-Septembre," *Études photographiques*, no. 20, June 2007: 148–173). For more on "intericonicity" in photography, see Julie Morère, "Intericonicity in Disguise in Madame Yevonde's *Goddesses* Series and Cindy Sherman's *History Portraits/Old Masters*," *E-Rea. Revue électronique d'études sur le monde anglophone*,13/1 (2015), https://journals.openedition.org/erea/4659. For more on intericonicity in cinema, see Mathias Kusnierz, "L'usure iconique. Circulation et valeur des images dans le cinéma américain contemporain," *Transatlantica. American Studies Review*, 2 (2016), https://transatlantica.revues.org/8330.

12 On this subject, see Ane Lynge-Jorlén, "Between Frivolity and Art: Contemporary Niche Fashion Magazines," *Fashion Theory*, vol. 16, no. 1 (March 2012): 7–28.

List of references
The author's interview with Irène Silvagni and Alexia Silvagni, July 3, 2020, Paris.
The author's interview with Colombe Pringle, October 22, 2020, Paris.

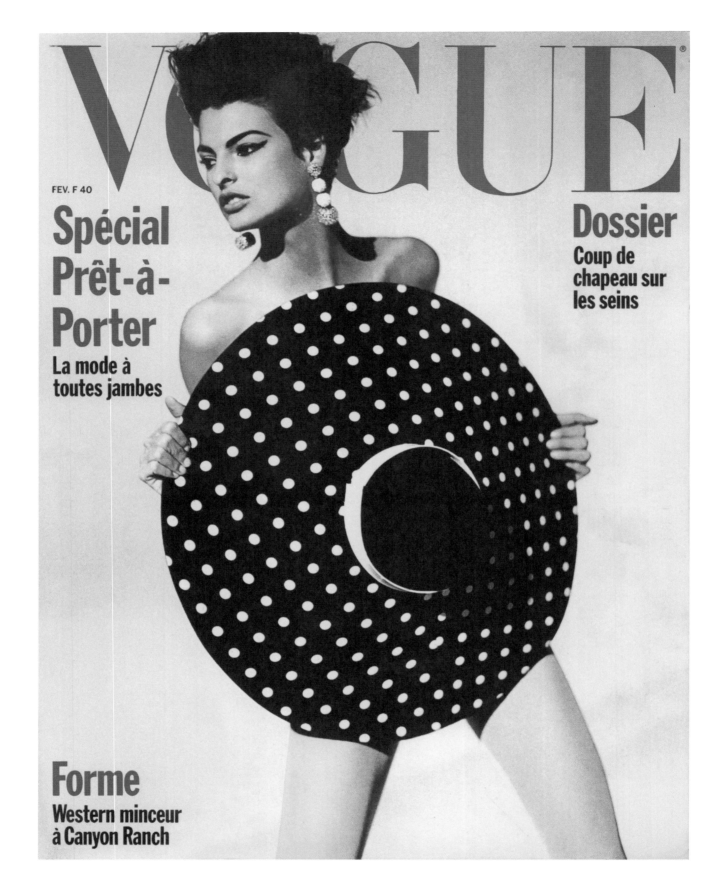

FEV. F 40

VOGUE

Spécial
Prêt-à-
Porter
La mode à
toutes jambes

Dossier
Coup de
chapeau sur
les seins

Forme
Western minceur
à Canyon Ranch

ill. 7 Arthur Elgort. Linda Evangelista. Pierre Balmain hat. *Vogue Paris*, February 1990, cover

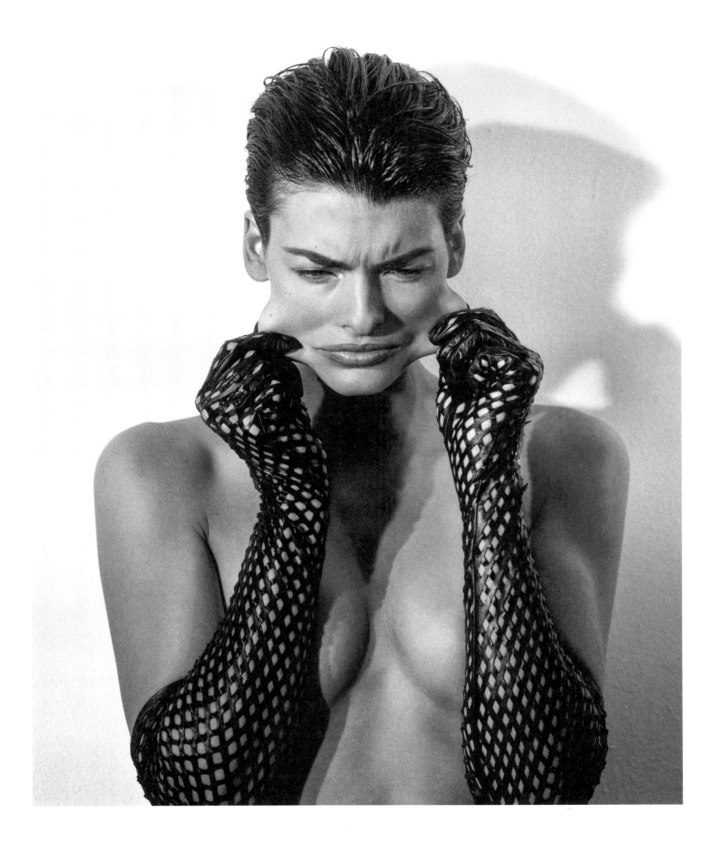

cat. 302 Steven Meisel. "Le diable au corps." Linda Evangelista. Azzedine Alaïa gloves.
Nicoletta Santoro styling. *Vogue Paris*, June/July 1989, p. 117

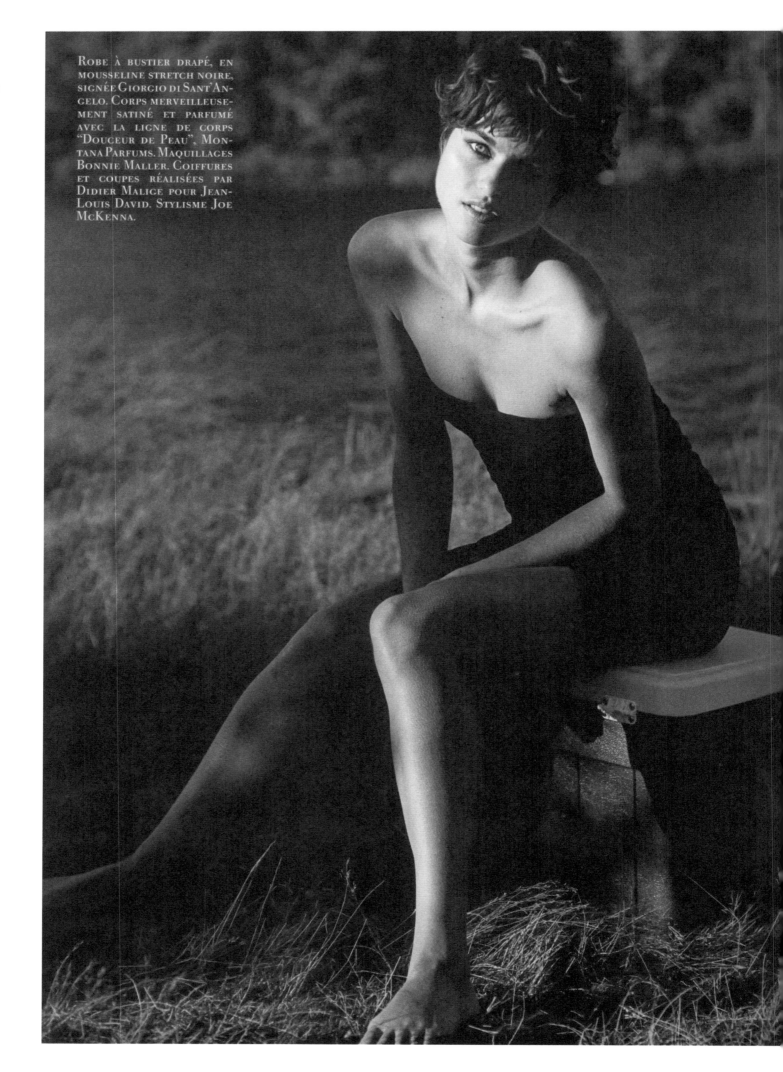

ROBE À BUSTIER DRAPÉ, EN
MOUSSELINE STRETCH NOIRE,
SIGNÉE GIORGIO DI SANT'AN-
GELO. CORPS MERVEILLEUSE-
MENT SATINÉ ET PARFUMÉ
AVEC LA LIGNE DE CORPS
"DOUCEUR DE PEAU", MON-
TANA PARFUMS. MAQUILLAGES
BONNIE MALLER. COIFFURES
ET COUPES RÉALISÉES PAR
DIDIER MALIGE POUR JEAN-
LOUIS DAVID. STYLISME JOE
MCKENNA.

cat. 355 Bruce Weber. "La maison du lac." Marielle Macville Drake. Giorgio Di Sant'Angelo dress.
Joe McKenna styling. *Vogue Paris*, December 1989/January 1990, pp. 292–293

The New "Point of View"
of *Vogue Paris*

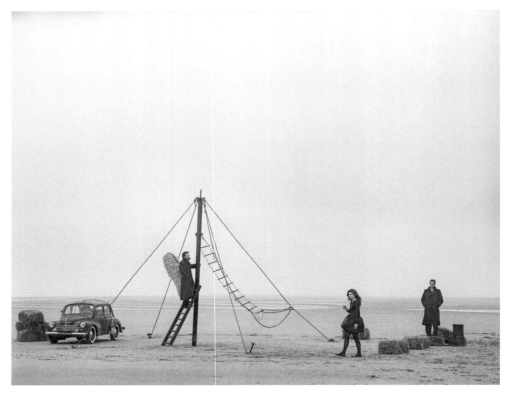

cat. 303–311 Peter Lindbergh. "Désir d'ailes." Le Touquet. Nicoletta Santoro styling.
Vogue Paris, May 1989
Philippe. School Rag coat, Agnès b. suit and shirt, pp. 160–161
Cordula Reyer. Alaïa dress, pp. 162–163
Cordula Reyer. Alaïa dress, p. 164
Cordula Reyer, Tanel Bedrossiantz, Philippe. Martine Sitbon ensemble,
School Rag coat, Agnès b. costume, p. 165
Cordula Reyer, Tanel Bedrossiantz, Philippe. Comme des Garçons ensemble,
School Rag coat, Agnès b. suit, pp. 166–167
Cordula Reyer, Tanel Bedrossiantz, Philippe. Comme des Garçons ensemble,
School Rag coat, Agnès b. suit, p. 168
Cordula Reyer. Jean-Paul Gaultier ensemble, p. 169
Tanel Bedrossiantz and Philippe. Agnès b. ensembles, p. 170
Cordula Reyer. Jean-Paul Gaultier ensemble, p. 171

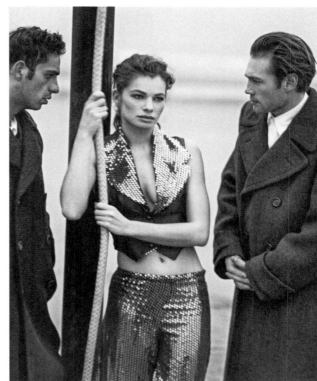
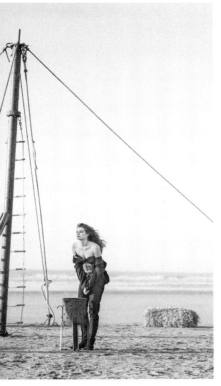
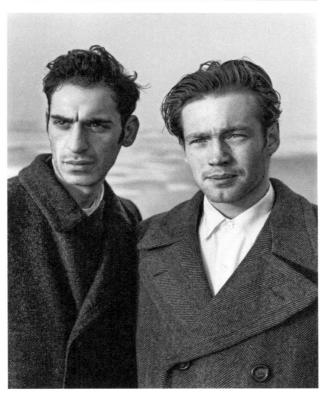
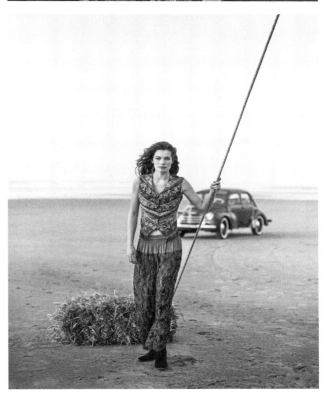

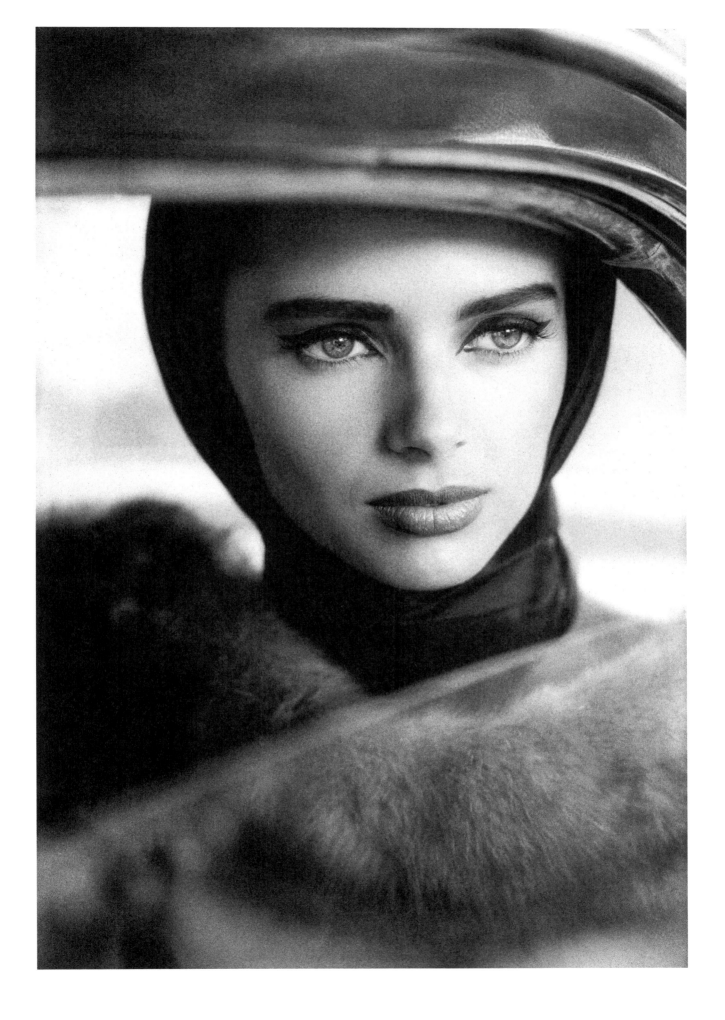

cat. 316 Dominique Issermann. "À la légère." Heather Stewart-Whyte. Christian Lacroix dress.
Vogue Paris, September 1991, cover

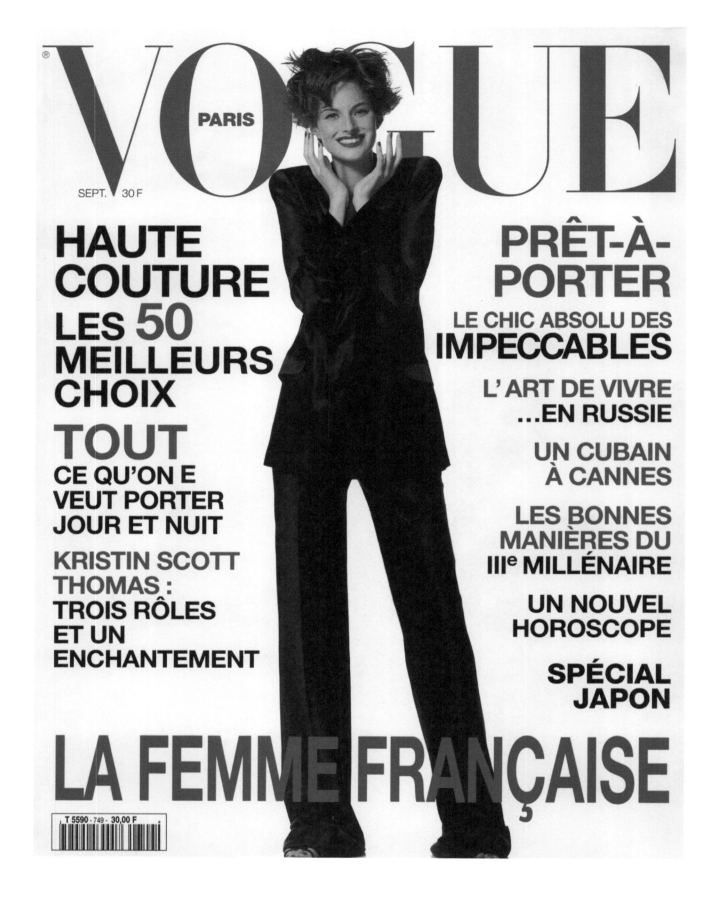

® VOGUE PARIS

SEPT. 30 F

HAUTE COUTURE LES 50 MEILLEURS CHOIX

TOUT
CE QU'ON E
VEUT PORTER
JOUR ET NUIT

**KRISTIN SCOTT THOMAS :
TROIS RÔLES ET UN ENCHANTEMENT**

PRÊT-À-PORTER

LE CHIC ABSOLU DES
IMPECCABLES

L'ART DE VIVRE
...EN RUSSIE

UN CUBAIN
À CANNES

LES BONNES
MANIÈRES DU
IIIe MILLÉNAIRE

UN NOUVEL
HOROSCOPE

**SPÉCIAL
JAPON**

LA FEMME FRANÇAISE

T 5590 - 749 - 30,00 F

cat. 314 Max Vadukul. "La Dolce Vita 89." Vanessa Duve. Giorgio Armani smoking jacket.
Nicoletta Santoro styling. *Vogue Paris*, February 1989, p. 221

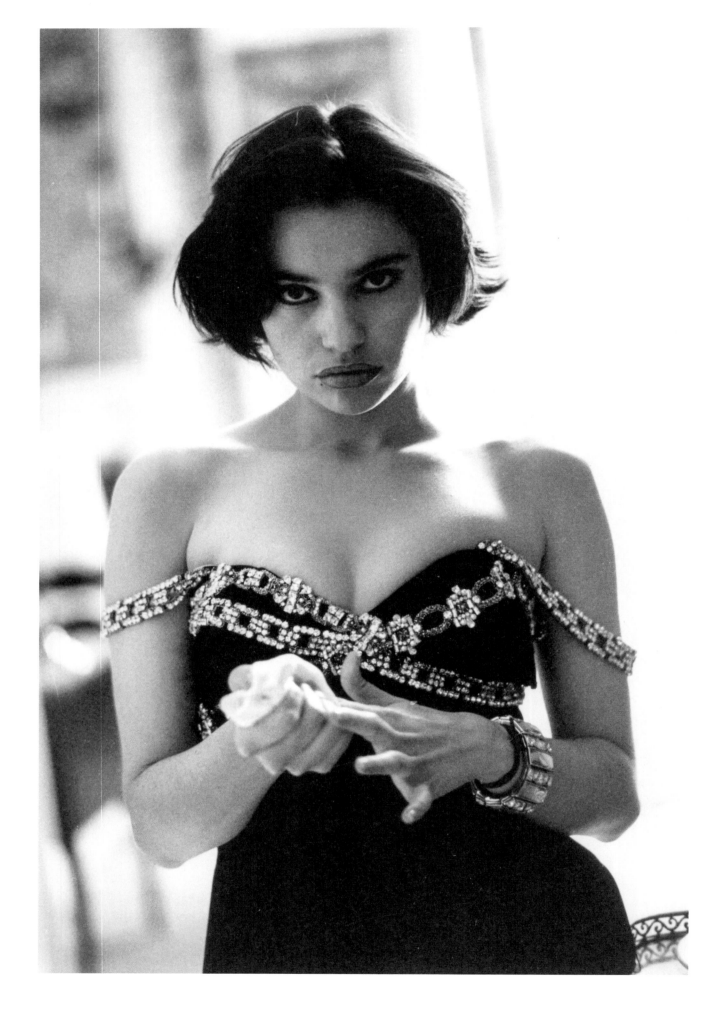

cat. 319 Arthur Elgort. Béatrice Dalle. Marc Bohan for Dior dress. Hotel Lancaster, Paris. *Vogue Paris*,
March 1989, p. 189

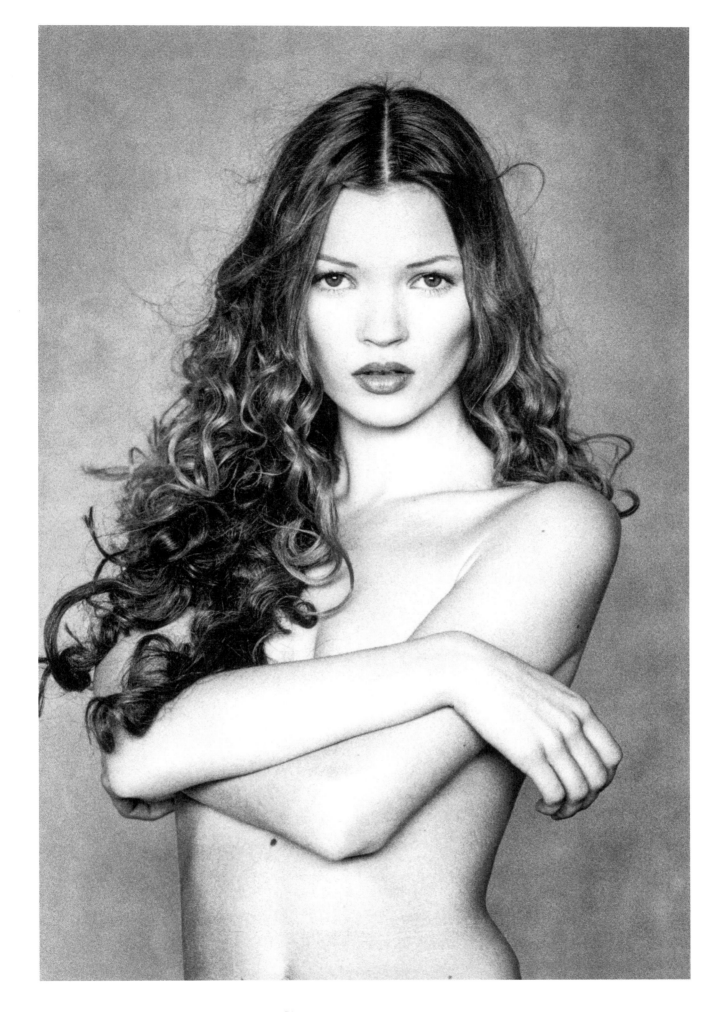

cat. 415 Max Vadukul. "La nouvelle allure." Kate Moss. *Vogue Paris*, March 1993, p. 142

cat. 320 Mats Gustafson. "Verts libres." Thierry Mugler dress and accessories. *Vogue Paris*, November 1989, p. 225

cat. 336 Pierre Le-Tan. "Variétés. Mélodies du bonheur." *Pull Marine*. Lyrics Isabelle Adjani
and Serge Gainsbourg. Music Serge Gainsbourg. *Vogue Paris*, December 1996/
January 1997, p. 82

L'ESPRIT B.D.

Libre cours à l'expression personnelle. On lave, on sèche et on se dessine de nouveaux volumes aux doigts et au brillant. Explications.
Par Sophie Mazeaud. Photos Eric Traoré.

Dans les salons de pointe, la coiffure façon bande dessinée, c'est la folie du moment. Nicolas Jurnjack, conseiller artistique chez Dessange, s'est inspiré des héroïnes des mangas, des blondes de Bob Morane et de Manara pour réaliser les images de ces pages avec son ami Topolino, le roi des maquilleurs de studio. Il s'explique : «Aujourd'hui, priorité à la liberté : des cheveux sains et brillants, des mèches dessinées à la main, plus de gonflant mémère, du gras non gras pour faire une texture de cheveux moderne et facile à modeler. L'essentiel, c'est le soin : un baume léger à appliquer sur les pointes, rien sur le cuir chevelu qui se nourrit de son propre sébum. Un seul shampooing à la fois, en alternant shampooing neutre (Charlieu Ph5) et traitant. Et un coiffant non gras et ultra-brillant pour dessiner sa coiffure mèche par mèche. Mes préférés pour les cheveux courts : Discostar fixation forte à diluer dans un peu d'eau, ou Pento qui pénètre tout de suite sans graisser. Pour les cheveux longs : la Crème au coco pur (le surtraitant des blacks) ou la bombe Glyssane qui empêchent les pointes de se dessécher» (chez MGC, passage de l'Industrie).

LE BOOM DE LA COLORATION. Relancée avec les mèches pastel par les coiffeurs de podiums, la couleur s'impose aujourd'hui partout sur la planète (en France 70 % des femmes trafiquent le naturel). En 97, les techniques s'affinent pour donner aux cheveux du corps, du relief et plein de reflets différents. De Paris à New York, voici les adresses secrètes des actrices et des top models.
A Londres, la célèbre Jo Hansford a sa technique bien à elle : elle travaille la couleur comme un peintre avec 4 bols contenant 4 nuances différentes. D'abord, elle prend un temps incroyable pour combiner d'avance ses effets de lumière en préparant les mèches raie par raie, en les tricotant en diagonale pour suivre la coupe. Ensuite, elle applique ses couleurs sous papillotes en jouant avec les reflets dorés, cuivrés, cendrés. Le résultat, génial, coûte entre 1 500 F et 2 000 F (9, Mount Street Mayfair. Tél. 171.495.77.74).
A Paris, au Salon Bleu comme Bleu, les coloristes, formés directement chez Jo Hansford, prennent la relève et appliquent sa technique à la lettre. Vous pouvez y aller les yeux

POUR L'AMAZONE, BLONDEUR, PURETÉ ET LÉGÈRETÉ. SHAMPOOING ET SOIN RESTRUCTURANT SANS RINÇAGE SUBLIMÉCLAT DE **JACQUES DESSANGE**. MAQUILLAGE TOPOLINO POUR **GUERLAIN** AVEC LE TEINT FLUIDE PERFECT LIGHT, LE FARD JOUES ROSE, LE ROUGE KISSKISS OPALE SATIN. REGARD BLEU SAPHIR AVEC LES LENTILLES FRESHLOOK CHEZ **WESLEY JESSEN**. RÉALISATION NATHALIE MARCHAND.

cat. 361 Éric Traoré. "L'esprit B.D." Inna Zobova. Jacques Dessange hairstyle, Topolino for Guerlain makeup. Directed by Nathalie Marchand. *Vogue Paris*, March 1997, pp. 206–207

cat. 333 Éric Traoré. "Les ailes du plaisir." Audrey Marnay. Keita Maruyama headpiece and dress.
Directed by Delphine Tréanton. *Vogue Paris*, May 1999, p. 120

The New "Point of View"
of *Vogue Paris*

Féerie des préparatifs chez Chanel.

Esquisse rencontre de deux oiseaux bleus chez Nina Ricci.

MON SHOPPING COUTURE

Debra Scherer a vécu, en cliente haute couture, l'émotion de ces dernières collections. Récit, sur mesure, d'une semaine somptueusement étoffée. Illustrations Jean-Philippe Delhomme.

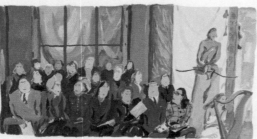

Longue attente de la révélation Mc Queen, chez Givenchy.

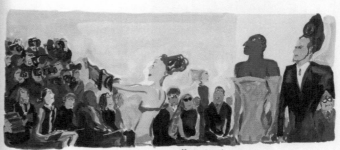

Jean Paul Gaultier : provocation en forme de veille à plumettis Ninja.

Samedi midi. A peine débarquée d'avion, je presse mon chauffeur chez Nina Ricci. Sur le podium, je note de ravissants petits bibis à plumes. Ça commence bien.

Ensuite, installation au Ritz, et essayage pour la soirée tendance rock and roll très royale organisée à l'hôtel par l'Atelier Versace.
Samedi soir. Ambiance très star. Me voilà placée entre Elton John et autres dieux de la scène. En avant la musique, et le style Versace sous une avalanche de lumières. Quelle ambiance. Du nouveau chez le créateur : des lignes plus épurées qui soulignent d'autant ses coupes extraordinaires et ses mariages de couleurs uniques.
Dimanche après-midi. Ça va être au tour d'Alexander McQueen, le mauvais garçon de l'*english fashion*. Pour sa première collection Givenchy, il a choisi l'école des Beaux-Arts, dans un espace aussi vaste qu'éthéré. Parmi la foule impatiente — dont je suis —, de jeunes garçons déguisés en anges — ou inversement — attendent, comme nous, mais impassibles, le début du défilé. Une vraie surprise : des ensembles simplissimes parsemés d'or et de plumes. Je prends rendez-vous pour un essayage.
Dimanche, début de soirée. La première collection couture de Jean Paul Gaultier ? Je ne raterais ça pour rien au monde. Lieu intime, atmosphère presque feutrée, je ne résiste pas à une combinaison-pantalon dos nu et sa petite veste kimono. Parions sur le succès de la maison.
Lundi midi. Hôtel Intercontinental, le défilé Emanuel Ungaro. Toute la collection est là. La collection est somptueuse. De toute façon, j'ai toujours adoré ses mélanges de dentelle, d'or et d'impressions dont lui seul a le secret. Ensuite,

Magnifique pousselé d'un déjeuner de fleurs pour les clientes d'Ungaro.

Dior : juxtaposition pipelise d'une terrine et d'une terrine d'inspiration transi. A droite, la délicieuse Debra Scherer.

172 173

L'ÉDUCATION SENTIMENTALE
FLAUBERT REMIXED*

par Jean-Philippe Delhomme.

✱ *Les «samples» de Flaubert sont en italique dans le texte.*

LA RENCONTRE Le jeune Frédéric Moreau fait la connaissance d'un personnage important dans la salle d'embarquement d'un vol Paris-Province : Il s'agit de Jacques Arnoux, propriétaire de l'Art industriel. Alors que l'on appelle les sièges 28 à 56, Frédéric découvre madame Arnoux. *Ce fut comme une apparition : elle était assise, au milieu du banc, toute seule ; ou du moins il ne distinguait personne, dans l'éblouissement que lui envoyèrent ses yeux. (Alors qu'assis par hasard à côté, il y avait un important décisionnaire du bouquet numérique, ainsi que le responsable de la rubrique «Styles» d'un grand quotidien.)*

Quels étaient son nom, sa demeure, sa vie, son passé ? Il souhaitait connaître les meubles de sa chambre, toutes les robes qu'elle avait portées, les gens qu'elle fréquentait ; et le désir de la possession physique même disparaissait sous une envie plus profonde, dans une curiosité douloureuse qui n'avait pas de limites. Comme de la photographie, ou plutôt, d'écrire sur elle, et de la proposer en sujet à «Wall Paper» ou à «Dutch».

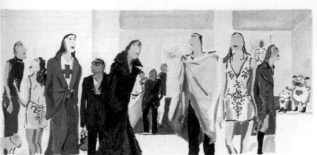

GILBERT : DÉBARDEUR **TRUSSARDI**, ANNE VICTOIRE : ROBE **PRADA**, REBECCA : **JEAN-CHARLES DE CASTELBAJAC**, OLIVIER : VESTE DES PUCES, FRÉDÉRIC : MANTEAU EN FAUSSE FOURRURE, **YOHJI YAMAMOTO** POUR HOMME, HUBERT : **HELMUT LANG**, ANNA : **PRADA**, CÉCILIA : **HELMUT LANG**.

VERNISSAGE A L'ART INDUSTRIEL *L'art industriel était un établissement hybride,* comprenant un magazine d'art et de mode mélangés, ainsi qu'une boutique où l'on trouvait une sélection de CD, G-Shock Casio, vêtements difficiles à trouver et des tirages photo de gens de «The Face» ou «ID». Frédéric n'y manque aucun vernissage, et tous les prétextes lui sont bons pour s'y rendre dans l'espoir vain de croiser Mme Arnoux : c'est ainsi qu'il revient dix fois de suite prendre des conseils quant à la manière de scotcher à même le mur une photo d'Anette Aurell dont il vient de faire l'acquisition - croyant s'attirer ainsi les bonnes grâces du mari.

DÎNER CHEZ LES ARNOUX Frédéric est enfin invité à dîner chez les Arnoux. Pris de panique, il court chez Colette s'acheter un nouveau costume, ainsi que des chaussures. Puis les convives arrivèrent tous, presque en même temps : les photographes Dittmer et Lovarias, un D.J. français, un journaliste du câble, deux critiques d'art, un éditeur de CD Rom, et enfin l'illustre Pierre-Paul, le dernier représentant de la grande peinture Support-Surface, qui portait gaillardement avec sa gloire ses quatre-vingts années et son gros ventre. *Lorsqu'on passa dans la salle à manger, Mme Arnoux prit son bras. (...)*

Il eut à choisir entre dix espèces de moutarde. Il mangea du daspachio, du cari, du gingembre, des merles de Corse, des lasagnes achetées le matin même, chez Balducci's à New York et qu'un ami lui avait ramenées en Concorde ; *il but des vins extraordinaires, du lip-fraol et du saké. Arnoux se piquait effectivement de bien recevoir (...) et il était lié avec plusieurs grands chefs qui lui communiquaient des sauces.*

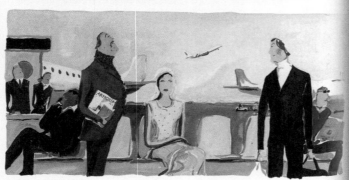

JACQUES ARNOUX EST EN **VERSACE HOMME**, MME ARNOUX EST EN **COMME DES GARÇONS**, FRÉDÉRIC PORTE UN COSTUME EXÉCUTÉ PAR LA COUTURIÈRE DE SA MÈRE À NOGENT-SUR-SEINE.

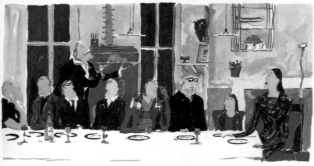

FRÉDÉRIC EST EN **LUCIEN PELLAT-FINET**, MME ARNOUX EST EN **VALENTINO**.

145

1987–2000

cat. 329 Jean-Philippe Delhomme. "Mon shopping couture." *Vogue Paris*, March 1997, pp. 172–173
ill. 9 Jean-Philippe Delhomme. "L'éducation sentimentale." *Vogue Paris*, November 1997, pp. 144–145

cat. 328 Jean-Philippe Delhomme. "L'éducation sentimentale." *Vogue Paris*, November 1997, p. 147

cat. 358 Tommy Motswai. *Vogue Paris*, December 1993/January 1994, cover

cat. 326 Jean-Baptiste Mondino. Karen Elson. Versace dress. Directed by Debra Scherer.
Vogue Paris, December 1997/January 1998, cover

cat. 327 Jean-Baptiste Mondino. Linda Nyvltova. Cartier bracelet. *Vogue Paris*, December 1999/ January 2000, cover

The New "Point of View" of *Vogue Paris*

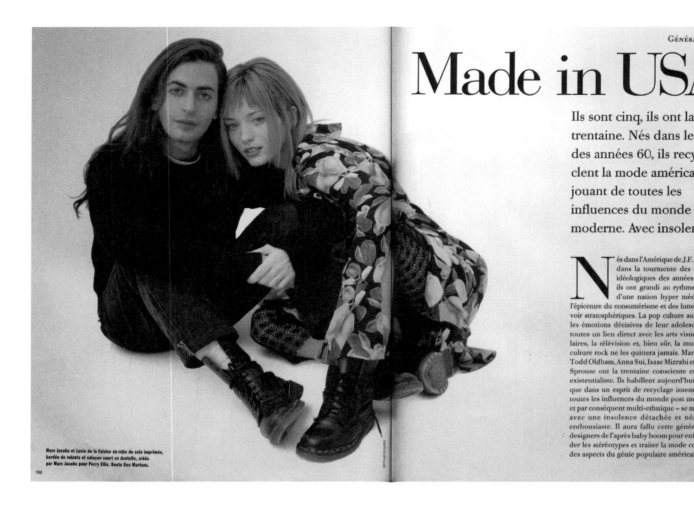

Made in USA

Ils sont cinq, ils ont la trentaine. Nés dans le rock des années 60, ils recyclent la mode américaine, jouant de toutes les influences du monde postmoderne. Avec insolence.

Nés dans l'Amérique de J.F. Kennedy, dans la tourmente des croisades idéologiques des années soixante, ils ont grandi au rythme sidérant d'une nation hyper médiatisée, à l'épicentre du consumérisme et des luttes de pouvoir stratosphériques. La pop culture au berceau : les émotions décisives de leur adolescence ont toutes un lien direct avec les arts visuels populaires, la télévision et, bien sûr, la musique. La culture rock ne les quittera jamais. Marc Jacobs, Todd Oldham, Anna Sui, Isaac Mizrahi et Stephen Sprouse ont la trentaine consciente et un rien existentialiste. Ils habillent aujourd'hui l'Amérique dans un esprit de recyclage intempestif où toutes les influences du monde post moderne, – et par conséquent multi-ethnique – se mélangent avec une insolence détachée et néanmoins enthousiaste. Il aura fallu cette génération de designers de l'après baby boom pour enfin bazarder les stéréotypes et traiter la mode comme un des aspects du génie populaire américain.

Marc Jacobs et Lucie de la Falaise en robe de soie imprimée, bordée de volants et caleçon court en dentelle, créés par Marc Jacobs pour Perry Ellis. Boots Doc Martens.

192

LES GRANDES EXCENTRIQUES

PREMIÈRE À LACÉRER LES JEANS, À SE CRÊPER ROCK, MAIS DERNIÈRE À ARBORER DES COLLANTS COULEUR CHAIR, COMME POUR PARFAIRE UNE ALLURE D'INSTITUTRICE DEVENUE PUNK À 35 ANS, QUEEN VIVIENNE WESTWOOD, VICTORIA DE LA FASHION, PRÉTEND QUE "LA REINE EST LA PERSONNE LA MIEUX HABILLÉE DU MONDE". AMAZING, ISN'T IT? PAR LAURENCE BENAÏM.

V.W.

Par une matinée frileuse, à Battersea Park, Vivienne Westwood pose pour Vogue, en robe camouflage néo-dix-huitième, parmi les arbres. Un assistant a apporté les platform shoes, qu'il sort de son sac à dos. Elle enlève son manteau de fourrure synthétique imitation léopard rose, fait plisser un peu ses bas filés pour l'occasion et s'étire sur un banc public. "What's that?" lance méchamment une jeune mère de famille en poussant son landau. Un vieux monsieur passe, et souffle innocemment: "She's tall!" Nous sommes en 1993. Vivienne Westwood se définit toujours contre. Contre la mode "casual" et "la banalité". Contre "le pragmatisme", qu'elle associe à la "barbarie américaine": "Ils jugent les choses en fonction de ce qu'elles coûtent". Contre Madonna: "Elle a fait de la pornographie en packaging. Elle est trop prévisible. She's a cliché". Vivienne Westwood, au contraire, s'applique à être son personnage comme un acteur se met à son rôle. "J'ai totalement rejeté l'idée d'attaquer l'establishment. Je préfère l'ignorer. Attaquer c'est être victime. Moi, je préfère avoir des désillusions, plutôt que des illusions. Je ne m'accroche pas à une croyance, comme les jeunes, qui sont souvent fanatiques. C'est facile de se reposer sur des certitudes ! Moi, je suis une idéaliste. Aujourd'hui, la dernière manière d'être subversif, c'est de réfléchir". Vivienne Westwood a lacéré les jeans avant tout le monde, coupé les crinolines en mini-jupes. Elle s'est toujours prise pour son propre modèle, a eu les cheveux rouges, jaunes, blancs, elle a été la première à se coiffer à la "punk rock", à porter des collants couleur chair avec une feuille de vigne, avant de se métamorphoser quelques années plus tard, en Margaret Thatcher pour la couverture du Harpers and Queen. Il y a toujours chez elle ce côté jusqu'au-boutiste, l'énergie de la dernière suffragette de la mode. Cet entêtement à vouloir imposer des vêtements qu'on porte moins par plaisir, ou facilité, que pour se rallier au parti des Vivienne. Elle vient de signer cinq contrats de licences au Japon, et lance même une pop Swatch griffée. Comme dit l'un de ses collaborateurs: "Nous sommes très limités avec l'argent. C'est peut-être mieux : on doit trouver des alternatives qui sont parfois plus excitantes que les rêves". Ses boutiques ont gardé ce côté "club", qu'elle décore comme une parfaite maîtresse de maison : une banquette Louis XVI tendue de blue-jean, et sur la cheminée, on trouve des objets disposés en toute innocence, entre un catalogue Sotheby's et une paire de

chaussettes en cachemire, une pile de Sex Maniac bible. Dans ce pays où la culture aristocratique et la culture populaire ne se mélangent pas, Vivienne Westwood emprunte aux deux univers ses références, dans un kaléidoscope d'images empruntées au Sun et à Ascot, à Buckingham Palace et à Benny Hill. A chaque fois, c'est toute l'Angleterre qui défile, avec ses ladies Chatterley de latex et ses gentlemen rose bonbon. Et c'est dans l'accumulation contradictoire de signes grivois et puritains qu'elle travaille son style, s'imposant la Queen Vivienne de la fashion. Son sigle ? Une couronne royale cernée d'un satellite, "cliché futuriste". Aînée d'une famille de trois enfants, née dans le Derbyshire, elle se marie à vingt ans avec Derek Westwood, dont elle a un premier fils, Ben. Son aventure professionnelle a été largement influencée par sa rencontre avec Malcom Mac Laren, l'homme qui lança les Sex Pistols, le Marcel Duchamp du punk, aiguillonné par une intuition juste de l'époque. Caméléon, bien avant Madonna, elle reste pourtant une référence, à laquelle s'identifie toute une génération. "Pour nous, elle était la seule", dit le modiste londonien Stephen Jones. Nous détestions les hippies. Ils étaient sales et ils sentaient le patchouli. Toutes ces fleurs, c'était pour les jeunes filles. Nous étions plus stricts, plus urbains. L'esprit punk trouve son origine dans la musique de Londres. A l'époque, il n'y avait pas de journaux pour les jeunes, à part New Musical Express ou Melody Maker. La mode se diffusait par la musique, et la musique par la mode". Il reçoit dans son salon rose

A Londres, Vivienne dans sa robe camouflage. "Dans cet océan de banalité, le raffiné et l'élégance sont plus précieux que jamais", dit celle qui a présenté en mars son défilé "Anglomania". Décorée par la reine Elisabeth de l'Ordre de l'Empire en décembre 1992, elle rédige actuellement sa biographie. "Je ne suis pas nationaliste, j'ai horreur de la middle class et de l'underground".

138

ill. 10 Arthur Elgort. Marc Jacobs and Lucie de la Falaise. Marc Jacobs for Perry Ellis dress. *Vogue Paris*, March 1993, pp. 192–193

cat. 357 Juergen Teller. Vivienne Westwood. Vivienne Westwood dress. London. *Vogue Paris*, August 1993, pp. 138–139

MTV L'IMAGE DU SON

Propulsée en août 1981 sur les écrans américains, MTV lance la culture du vidéo-clip. Fusion passionnelle d'une chaîne musicale à un style de vie et symbiose entre mode et musique, la formule colle à la jeunesse mieux qu'un jeans unisexe. La génération MTV est née. Success story. Par Camille Labro. Photos Brigitte Lacombe, à l'occasion des MTV Awards à New York.

BECK
L'enfant terrible du folk, après le succès de «Loser», reçoit le prix de la meilleure vidéo masculine pour «Where it's At».

196

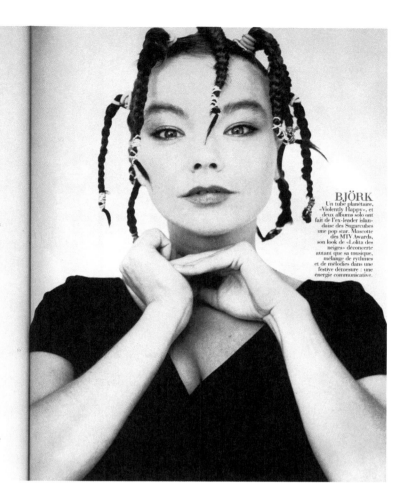

BJÖRK
Un tube planétaire, «Violently Happy», et deux albums solo ont fait de l'ex-leader islandaise des Sugarcubes une pop star. Mascotte des MTV Awards, son look de «Lolita des neiges» déconcerte autant que sa musique, mélange de rythmes et de mélodies dans une festive démesure : une énergie communicative.

L'HOMME ET LA MODE

JAY McINERNEY

Vêtir les femmes est un plaisir à la fois égoïste et généreux pour l'écrivain américain Jay McInerney, donc une sorte de ravissement. L'auteur de «Glamour Attitude» (éd. de l'Olivier), un des best-sellers du printemps, connaît aussi le bottin de la mode sur le bout des doigts. Les émotions d'un spécialiste.
Photo Brigitte Lacombe

On ne saurait mieux apprécier le privilège qu'il y a à déshabiller une femme qu'en s'intéressant d'abord à l'habiller. Certes, il est tout à fait possible, comme tant d'hommes l'ont prouvé, d'adorer la beauté féminine sans en apprécier particulièrement la parure, comme on peut admirer un Matisse en dehors de toute référence à l'histoire de l'art ou aux théories de la forme et de la couleur. Mais l'ignorance n'est pas forcément le bonheur suprême.

J'aime acheter des vêtements pour les femmes, particulièrement pour les femmes que j'aime. C'est à mes yeux une partie intégrante de la cour qu'on leur fait — mais, bien sûr, il arrive que les étapes de cette cour soient réduites à quelques heures, l'espace d'une nuit, quand les boutiques Prada et Gucci sont fermées. Cependant, dans toute relation amoureuse d'une durée plus sérieuse, apprendre comment vêtir une femme est un aspect important et excitant de la découverte de son corps et de son esprit. Quand j'aime une femme, acheter pour elle des vêtements est un plaisir à la fois égoïste et généreux — mélange idéal dans toute transaction humaine. A cet égard, l'équilibre entre égoïsme et altruisme est délicat. Quand ils choisissent pour une femme, les hommes sont portés à dériver du côté des vêtements qui s'approchent le plus de leur propre idéal de nudité : moulants, minuscules et transparents. Je dois reconnaître qu'il m'est arrivé de me rendre coupable de cette dérive.

Voilà quelques années, je sortais avec une femme à la silhouette voluptueuse dont les courbes pleines étaient bien peu caractéristiques de sa profession de mannequin. Or, on était justement aux plus beaux jours d'Azzedine Alaïa, dont la tendance était aux vêtements aussi étroitement ajustés qu'une couche de peinture aérosol. D'un point de vue strictement théorique, les robes d'Alaïa étaient conçues précisé-

ment pour une silhouette comme celle de Marla. Et, d'un point de vue masculin, il était difficile d'imaginer plus séduisant. L'espace d'une année, j'achetai plusieurs Alaïa mais ne pus, à la longue, m'empêcher de remarquer qu'elle ne les portait presque jamais. Quand nous étions en train de nous habiller pour une soirée, je la pressai de mettre l'Alaïa blanche, ou la verte, et, toujours, elle trouvait une bonne raison de choisir autre chose. Je finis par la convaincre un soir de revêtir une de ces robes pour assister à la première d'un film. Debout devant le miroir, je la vis faire la grimace. De par sa profession, dont l'attitude envers l'image du corps est d'une brutalité clinique, elle était plus sensible encore que la plupart des femmes aux quelques centaines de grammes superflus, aux défauts réels ou imaginaires de sa silhouette. En l'occurrence, s'en prit à moi. «Tu n'as pas acheté cette robe pour moi, dit-elle, tu l'as achetée pour toi. Pour le plaisir de me montrer.» Et, bien sûr, elle avait raison. C'était à moi que je pensais en achetant cette robe. Je suis sorti avec d'autres femmes qui aimaient faire étalage de leur corps et j'ai toujours été heureux de les y aider. Mais dans le cas de Marla, j'aurais dû penser à ce qu'elle ressentirait en portant cette robe — serait-elle à l'aise ? — plutôt qu'au plaisir que j'aurais à la lui voir porter.

Lors d'une relation nouvelle, ou brève, on peut sans doute offrir un vêtement un peu voyant et sexy ; on n'a pas forcément envie d'offrir un tailleur gris et «raisonnable» à une femme qu'on ne verra peut-être plus la semaine suivante. (La lingerie est un cas particulier — mon préféré ; mais ces articles, les plus intimes, demandent une connaissance tout aussi intime du corps en question.) A plus long terme, l'homme doit s'efforcer de découvrir le style qu'une femme a peu à peu mis au point pour elle-même et improviser sur cette base. Si je tombe amoureux d'une femme, il y a de fortes chances pour que j'aime d'emblée son goût *(Suite page 214)*

148

Quand ils choisissent pour une femme, les hommes sont portés à dériver du côté des vêtements qui s'approchent le plus de leur propre idéal de nudité : moulants, minuscules et transparents. Je dois reconnaître qu'il m'est arrivé de me rendre coupable de cette dérive.

cat. 360 Brigitte Lacombe. Beck (left page), Björk (right page). *Vogue Paris*, December 1996/
 January 1997, pp. 196–197
cat. 342 Brigitte Lacombe. Jay McInerney. *Vogue Paris*, June/July 1999, pp. 148–149

cat. 323 Mario Testino. "Boogie Days." Liisa Winkler. Missoni coat, Tomas Maier bikini. Directed
 by Carine Roitfeld. *Vogue Paris*, August 1999, p. 85

The New "Point of View"
of *Vogue Paris*

BOUFFÉES DE BLANC. CI-DESSUS, CHEMISE SANS MANCHES EN POPELINE DE COTON, **GUY LAROCHE**, SUR UN T-SHIRT EN MOUSSE DE COTON, **Y'S** [...] TAFFETAS FROISSÉ, **LACOSTE**. VERNIS BLANC GIVRE GEMEY. PAGE DE DROITE, PULL-OVER COL ROULÉ EN CACHEMIRE, **RALPH LAUREN COLLECTION CLASSIQUE** [...] OXYGÈNE ON THE LE JOUR À LOS ANGELES.

cat. 362 Mario Testino. "Blanc absolu." Eva Herzigová. Guy Laroche jacket, Y's T-shirt,
Lacoste pants (left page). Ralph Lauren Collection Classique sweater (right page).
Directed by Carine Roitfeld. *Vogue Paris*, April 1998, pp. 116–117

cat. 322 Herb Ritts. "La vie." Esther Cañadas. Viktor & Rolf Haute Couture ensemble. Directed by Marcus von Ackermann. *Vogue Paris*, December 1998/January 1999, p. 195

234

cat. 363 Raymond Meier. "Haute définition." Free Lance shoe, Martine Sitbon leg warmer (left page).
Christian Louboutin shoe, Trussardi tights, Hermès glove (right page).
Directed by Aleksandra Woroniecka. *Vogue Paris*, October 1999, pp. 256–257

CI-CONTRE, ESCARPIN BIMATIÈRE, EN VEAU GLACÉ ET CRÊPE, LACÉ À LA CHEVILLE, TALON DE 8 CM, **CHRISTIAN LOUBOUTIN**. COLLANTS DD. JUPE EN AGNEAU PLONGÉ, **TRUSSARDI** MITAINE EN AGNEAU GLACÉ, **HERMÈS**.
PAGE DE GAUCHE, ESCARPIN EN CHEVREAU, BOUT POINTU, TALON EN ACIER GRAVÉ «2000», SÉRIE LIMITÉE, **FREE LANCE** GUÊTRE EN MAILLE DE LAINE, **MARTINE SITBON**.

The New "Point of View"
of *Vogue Paris*

cat. 318 Helmut Newton. "Tranches de vie." Bulgari jewelry. *Vogue Paris*, June/July 1994, p. 109

To Our Readers . . . : How to Read Vogue Paris

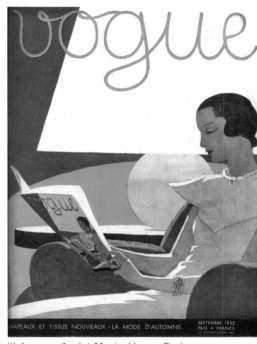

ill. 1 André Marty. *Vogue Paris*, September 1932, cover

Beginning with its very first issue, a magazine exists because of its readers, and *Vogue Paris* has always delighted in this notion, often in a witty way. Whether read from end to end, casually flipped through, or simply left on display, it is these actions, especially during the age of print media and analog photography, that turn each magazine and each issue into a tangible object that can be experienced in a range of places, from public spaces to the most intimate of settings.

The concept of its ideal female reader is fundamental to *Vogue Paris,* as it is to all magazines. This image, sometimes purely imaginary, sometimes based on statistics (through market research, subscriber analysis, or surveys), most often rests on a combination of these two notions. Naturally, the reader of *Vogue*, as viewed by *Vogue*, evolves according to the times, depending on whether the magazine is targeting a more or less elite audience and reflecting the standards of the period. Thus, the addition of the "Youth" pages in the 1950s, the columns on France's more rural areas (the provinces) in the late 1960s, and the photo shoots on European fashion in the 1970s all give cause to imagine that *Vogue Paris* had expanded, or wanted to expand, the range of its audience.

Among these initiatives, it is notable that from September 1922 to June 1923, the magazine presented a gallery of female characters, "The Six Friends of *Vogue*": Sophie, Sylvie, Toinon, Rosine, Palmyre, and Françoise, whom it followed through various activities and outings such as at the couturiers, at the opera, or on vacation on the Basque coast. Their adventures were chronicled every month in a series of texts, illustrated by drawings in which each was depicted with recognizable characteristics. Presenting these ideal personalities was also an opportunity to interact with readers, who were often addressed directly during the 1920s, and who were also invited to participate in competitions, a practice common at this time. In its early years, *Vogue Paris* worked hard to forge strong links with its audience.

These readers would be frequently called upon through the years, whether to justify a choice of theme or to speculate on purposes that the magazine could serve. *Vogue Paris* aimed to be a landmark, a helper, a display cabinet, and a tangible luxury item in itself. Of course, it is impossible for editorial staff to dictate or be aware of how the magazine is treated once it is published. But specifically, there seems to be a fascinating interplay between its intended purpose and its true function. The tension created by the distance between the former and the latter is what gives the magazine a large part of its liveliness.

However, interactions in which readers communicate directly with the magazine are rare. From 1922 to 1928, *Vogue Paris* set up an "Information Office," a service that acted as a kind of concierge. In 1924, a correspondence address was published, from which the magazine answered the practical questions submitted by readers. However, it was not until 1992 that *Vogue Paris* would publish, for only a few years, actual letters from readers—a column to which the magazine rarely added its own responses, perhaps in order to preserve its fundamental status as an authority. Despite this lack of public interaction, or perhaps echoing it, any consideration of the unspoken yet constant and inbuilt presence of the magazine's real or imagined readers can cast light on the mechanisms behind the creation of *Vogue Paris* throughout its first century of existence.

Alice Morin

ill. 2

ill. 3

ill. 4

ill. 2 Pierre Brissaud, André Marty, Martin,
 Mario Simon, Benito, Georges Lepape.
 Vogue Paris, September 1922,
 pp. 24–25

ill. 3 Ad for the Information Office
 of *Vogue Paris*. *Vogue Paris*, July 1922,
 p. 49

ill. 4 George Hoyningen-Huene. "Enquête
 sur la beauté." *Vogue Paris*, July 1932,
 p. 13

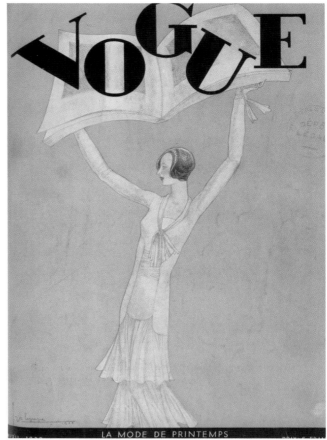

ill. 5

ill. 6

ill. 5 Roger Schall. *Vogue Paris*,
September 1934, p. 13

ill. 6 Georges Lepape. *Vogue Paris*,
April 1930, cover

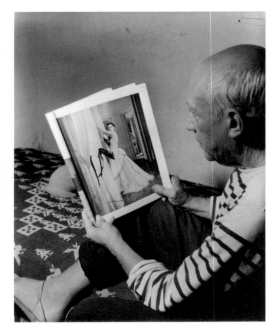

ill. 7

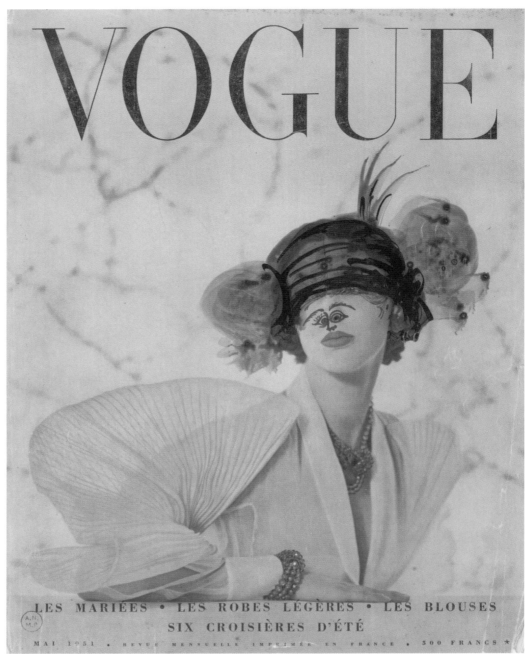

cat. 160

ill. 7 Robert Doisneau. Pablo Picasso, 1952 cat. 160 *Vogue Paris* (May 1951) edited
with humorous illustrations by Picasso

VI

2001—2020

SELLING DREAMS

ill. 1 Anonymous. Mario Sorrenti, Carine Roitfeld, and the team of *Vogue* on the November 2009 cover shoot. *Vogue Paris*, October 2009 supplement, p. 30

In an image shot by Steven Klein and styled by Marie-Amélie Sauvé for the October 2007 issue of *Vogue Paris*, two models are placed among the produce in a supermarket. One, dressed in an embellished cocktail dress, lights a cigarette, with a clutch bag tucked under her arm as she pushes a supermarket cart piled high with bottles of Beck's beer with the other. The second model stares ahead into the distance, with one hand placed on her stomach, deep in thought. You imagine their relationship; are they a mother and teenage daughter, or is it a disillusioned housewife and her wayward friend? Is this what *Vogue Paris* suggests we should wear when shopping for groceries? Julia Child, the chef credited with bringing French cuisine to America, wrote in a letter to culinary editor Avis DeVoto that whenever she read *Vogue*, she "felt like a frump . . . but I suppose that is the purpose of all of it, to shame people out of their frumpery."[1]

When assessing the archive of *Vogue Paris* in the period that spans 2001 to 2020, it is imbued with the clarion call to celebrate fashion, to revel in the joys of dressing up, even when participating in something as banal as supermarket shopping. The semiotics in the images created were of sheer escapist fantasy. Constructing a dreamscape, sometimes comical, oftentimes ludicrous, the images mythologized body and place, and when slotted together, they realize a terrain steeped in the extremes of historical modes of glamour. The images constructed fiercely defend the bastions of fashion photography and its goals. Employing visions of nostalgia particularly harking back to the 1970s, in both the women presented and visions of Paris as a city, the era is one that ideologizes luxury. This period was a destabilizing time politically, socially, and economically; and in times of upheaval, people long for a brand they are familiar with. *Vogue* provided this, and *Vogue Paris* responded by strengthening their national identity, offering patriotism within an increasingly globalized world.

Fashion exists to be full of the electricity of the moment, and to fashion image-making and fashion writing, the context is key. The magazine forms as a document of the time in which it is produced; its ephemerality seductive. Leafing through the pages of this French incarnation of *Vogue*, which will be referred to as simply *Vogue* throughout the rest of the piece, you breathe a sniff of the zeitgeist. The cultural expectations throughout the 2000s and into the teens were for the publication to encourage consumerism by selling visions of fantasy, using not only the clothing but also the women that it featured, who were employed to represent a highly stylized and fashioned lifestyle.

Two editors sat at the helm of *Vogue* during this time, first Carine Roitfeld from 2001 to 2011, and then Emmanuelle Alt beginning in 2011. Alt still held the position at the time of publication in 2021. Alt served as the fashion director under Roitfeld's editorship before she became the editor in chief herself. Together, their dual approach made up the vision of the magazine throughout the twenty-year span that is the focus of this essay. Therefore, this text considers Alt's time as editor in chief as a progression of the vision laid out by Roitfeld. When appointed to take on the role in 2011, Alt said she had been chosen because "they know my work by heart, and probably thought it was safe."[2]

To find inspiration, Roitfeld and Alt both turned inward and used their own identity; they became their own muses, and visions of themselves appeared in their work. The roles that Roitfeld and Alt carved to act out in the public domain were two sides of the same coin, each adhering to different stereotypes of the French woman. Roitfeld was the seductress, a coquettish vamp poured

ill. 2 Inez & Vinoodh. "Sleeping
 Beauties." Anja Rubik.
 Zuhair Murad Couture
 suit. Directed by
 Emmanuelle Alt. *Vogue
 Paris*, April 2018, p. 175

into a black pencil skirt, as her doe eyes, blacked with kohl, looked up through
her parted hair. Alt was the tall, carefree, and undone Parisian; you might
assume she doesn't brush her hair or put on makeup. Her image rooted in
the natural, it implies that she simply has good genes. Agnès Rocamora defines
the concept as *la Parisienne*,[3] a figure that "is presented as the apex of fashion.
The incarnation of Paris, she is the model to follow, a visual and written
metaphor to the French capital."[4] Both Roitfeld and Alt embody *la Parisienne*;
each woman was born and grew up in the rarefied world of bourgeois Paris
and entered the Parisian fashion industry in early adulthood.

These signifiers of *la Parisienne* were evident not only in the way Roitfeld
and Alt styled and commissioned the photo shoots for the magazine, but also
as individuals, as they became brands in their own right. The dawn of the new
millennium saw the birth of the Internet 2.0 and websites and social media
networks that enabled Roitfeld and Alt to reach greater audiences internationally,
as they distilled their fashionable lives into content beyond the pages of the
magazine and shared it with their followers. Shot by street-style photographers
at fashion shows and by the paparazzi at other events, Roitfeld and Alt became
real-life versions of the Théâtre de la Mode,[5] traveling the world and disseminating
their image as the paradigm of French style and taste. This was representative
of the 2000s and 2010s, which saw those who had once been behind
the scenes and responsible for the mechanics of the fashion system coming
to the forefront of fashion culture. Alt said in 2019 about her work at *Vogue*,
"I'm a journalist, but then I am also an ambassador for the brand. For a ten-
minute Cruise show, you spend three days traveling. . . . In 2019, people like
a brand to have a face."[6]

In the work they produced, they became known for their individual approaches.
Roitfeld was daring, controversial, and risqué. Alt acted as a counter; her styling
offered a softer approach, taking inspiration from female icons from recent
French history, for example, as opposed to Roitfeld's more conceptual referencing
system—numerous shoots were inspired by her love of cutting up raw meat.
Although Roitfeld and Alt had commodified themselves in a similar way
to the editorials in the pages of *Vogue*, you soon realized the fantasy wasn't
for sale. Using online communication, video content, and social media allowed
the increasing democratization and demystification of fashion, yet a mirage
was maintained. When British journalist Hilary Alexander asked Alt what it took
to look like her, she said, "I don't look after myself. I don't do yoga, Pilates,
those things. I hate physical effort . . . Makeup? I just black my eyes and that's it.
My hair? I get it cut on set . . . I never go to a hairdresser."[7] Roitfeld concurs
that what she has is also not for sale. She told *Vogue Arabia*, "I think you are
born chic. . . . It is something you cannot learn."[8] A hallmark of the era, it was
a time of the peripheral carrot dangling, and one of the reasons that *Vogue* was
so commercially successful. The yarns they spun, through images and words,
were nothing but fiction, a world that one could only dream of—you longed
to purchase it, though once you thought you had it in your grasp, it slipped
through your fingers like sand.

In tandem, the boundaries, propelled by the Internet and social media,
began to fall around when and where the consumer was being sold to, and the
editorial images that were featured in *Vogue* foreshadowed this by resonating
closely with advertising images. To construct these images, they commissioned
the photographers that make up the canon of twentieth and early twenty-first
century fashion photographic history: Bruce Weber, Terry Richardson,

Mario Testino, Patrick Demarchelier, Juergen Teller, Corinne Day, Collier Schorr, Inez and Vinoodh, Mert and Marcus, Steven Klein, Hedi Slimane, Craig McDean, David Sims, Hans Feurer, and Mario Sorrenti an exemplary sample. All of these photographers gained prominent success before this period and were considered at the pinnacle of their careers when working with *Vogue* during this time. The work produced was vital in upholding a sense of status quo; it offered nostalgia amid the upheaval of the times, when global events such as the Great Recession of 2008 and numerous terrorist attacks throughout the Western world disrupted the equilibrium.

These images also offered an invented depiction of beauty through digital manipulation, which became the norm during this era. By shooting the images on digital cameras, it allowed easy construction and reconstruction on set, with the photographs instantly visible on a monitor and often the files were edited in real time. This ensured that there were no accidents and that everything was in the control of the photographer and the magazine. Then, after the shoot, the images would be heavily retouched, the hair and the skin smoothed and *perfected*, the colors edited—the end product, highly manipulated, was far from reality. This group of images are the strongest and lasting material from this period of *Vogue*, which is a testament to Roitfeld and Alt's experience as stylists. They are both image-makers, not writers, as many magazine editors usually are, and they both maintained styling credits while in their roles as editor in chief. Alt sums up the visual approach as "it's simple fashion. You can see the clothes perfectly."[9]

The photographs produced were glamorous and elite, presenting unobtainable scenarios that take root from the constructed fashion symbols of high fashion and luxury. In a Mario Testino image from February 2007, a woman poses with one hand on her hip (cat. 378); she is naked apart from a black patent belt around her midriff; half her face is obscured by a blunt cut mop fringe, a straw to her lipsticked lips, she drinks from a bottle labeled "Chanel Eau de Cologne." Roitfeld captioned this image in her book *Irreverent* with the thought, "It could be an advertisement—it's such a beautiful image."[10] Roitfeld uses the achievement of aping the advertising image in an editorial context as a benchmark for success. In another shoot by Craig McDean for the March 2002 issue, Roitfeld chose to focus on designer handbags, pairing them with T-shirts she had made with the bag brand logo across the front. In each image, the model stands on a podium as if an object for sale in one of the luxury boutiques the bags were destined for. Presenting the bag in affiliation with the brand helped fuel a ferocious consumer trend for designer bags that hit its peak in the mid-2000s. As proof that Roitfeld's *Vogue* had begun to impact the global fashion landscape, she was starting trends as opposed to following them.

One of the reasons for this success was Roitfeld's decision to make the magazine more Parisian. She engaged the graphic design agency M/M Paris to undertake a redesign of the magazine; she also ensured the masthead consisted of an all-French staff. Upon taking the role, Roitfeld had been tasked to expand upon the profits of the magazine, and to achieve this growth, she set out to sell her fashioned version of Paris to the world. The Parisian fashion industry has long been tied to the French economy and reconnecting with this history helped *Vogue* reassert a unique position within a changing global landscape. In 2011 Roitfeld explained, "I really tried to restore [*Vogue's*] sense of luxury, and to give French fashion a certain stature. In the early 2000s, Paris was starting to lose its brilliance and aura. Milan was becoming increasingly

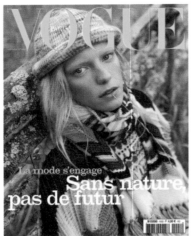

ill. 3 Mikael Jansson. Erika Linder. Missoni ensemble. Directed by Emmanuelle Alt. *Vogue Paris*, November 2019, cover

important, as was New York, with Anna Wintour's work on the international scene. My job as *Vogue's* editor in chief was to restore the prestige of Paris in fashion terms."[11] She achieved this by staging shoots dedicated to French designers such as Saint Laurent and profiling chic Parisians that worked among the fashion industry. In 2011 Wintour, the editor in chief of American *Vogue*, said, "Carine, and her vision of *Vogue Paris*, embodies all that the world likes to think of as Parisian style: A sense of chic that's impeccable—and sometimes idiosyncratic—and which lives on a moonlit street, as seen through the lens of Helmut Newton."[12]

This Parisian mythmaking is potent. Valerie Steele wrote in her book *Paris Fashion: A Cultural History* that the city upholds its place globally as the capital of fashion due to the "fashion culture" that exists there. The architecture acts as a backdrop for the performers and the spectors to interact, all of whom have the knowledge and sophistication to decode the deeper meaning embedded in the clothing.[13] Agnès Rocamora gives the city an active role in the fashion system too, stating, "the word 'Paris' no longer simply refers to a geographical origin. Rather, it is turned into a fashion signifier whose value resides in its power to evoke the world of fashion, with the word 'Paris' now a synonym for 'chic' and 'elegance.'"[14] This idea of the dreamlike city and the magic it holds can be traced to the *Vogue* of the 1970s when Helmet Newton and Guy Bourdin crafted their visions of *la Parisienne*, and in Roitfeld's and Alt's *Vogue*, these codes are still relevant. Borrowing from them, they sell a nostalgic fantasy using not only the mirage of Paris, but also the women who inhabit and embody it. Roitfeld, entrenched in this nostalgia, said, "Newton's archetypal woman was more amusing, more elegant and cultivated, and more rock and roll than the Parisian woman today. Newton's woman no longer exists," she goes on to say. "Her charm resides in the mystery she surrounds herself with."[15]

Although this mysterious woman had vanished from reality, she was revived to tempt through the pages of *Vogue*, where, captured by a mostly male cohort of photographers, she stalked the Parisian "moonlit street." The shoot photographed by Mario Testino and styled by Carine Roitfeld for the August 2008 issue captures a model wearing fur and engaging confrontationally with animal rights activists. In one image, the model puts her middle finger up at a protester who holds a sign that reads FUR IS DEAD. Using a ring flash, a tool employed throughout this era of photography, the architecture of Paris is illuminated to provide a backdrop as the model sternly gazes in the direction she is walking. Although it loosely conjures the image by Helmut Newton of a woman walking in a Paris street wearing an open fur coat that reveals her naked body underneath, here the model is not passive, she is active. The viewer is not left to imagine who this woman might be or what she might be thinking— she is given a character to act out. The image, in the hands of Roitfeld and Testino, becomes an illustration of the rebellious woman. They assemble the aesthetic signifiers of nostalgia, but they enable the viewer to easily imagine herself in the subject's role. It invites you to splurge on the clothing, to recreate the makeup and the hairstyle, in the hope that if you purchase a slice of the fantasy, you too may be thought of as rebellious, individual, and carefree. Roitfeld said that she was interested in "women's attitude toward fashion, the way they stand, walk, cross their legs, and how they wear their clothes."[16]

Varied female archetypes appear consistently, and are similar to Roitfeld and Alt's personal brands; the models inhabit different stereotypes of the French woman. Roitfeld's woman is the seductress, and in the media, her work

became known as porno chic, although she preferred the term "erotic chic."[17] A shoot by Terry Richardson, a photographer whose work is composed of provocative clichés, captured curvaceous model Crystal Renn eating for the October 2010 issue (cat. 388). Shot from the waist up and dressed in knitwear worn with silver screen starlet-inspired hair and makeup and extravagant jewelry, in one image she glances into the lens while sucking on two fingers and forking an eel. In another, she bites down greedily on a rare steak; in one more, she throws back her head, her mouth open, as if experiencing orgasmic pleasure from an overflowing plate of spaghetti. The images, inspired by *Deep Throat*, the 1972 pornographic film, are at the same time humorous, camp, and concerning. In another shoot by Richardson that appeared in the September 2003 issue, an image depicts a model gazing forward, wearing a fur coat, her legs open; you notice that a man with a Playboy tattoo on his back has his head in her crotch, the suggestion is that he is performing a sexual act, although her face suggests she experiences no erotic pleasure. Roitfeld explained, "My job allows me to give expression to erotic fantasies and depict them in pictures, to experience them through image-making, but not in reality. My private life is a lot more ladylike and less sultry than the fashion photos I imagine."[18] Roitfeld once again is eager to remind us that this is make-believe and that she is playing dress-up.

The women in the images dress up as many different characters, often informed by the scenarios they are placed in. As a viewer, you question, how did that woman find herself there, what is she doing, why is she wearing that outfit? This is used as a device for escapism, a respite from the banalities of the day-to-day; this is a space where the world is painted "fashion." In one image styled by Roitfeld and shot by Mario Sorrenti for the June/July 2009 issue, a model wearing sunglasses holds her torso up with her hands, which are placed on a grass lawn; her feet held aloft by another model wearing a cutout swimsuit and black leather trousers, she resembles a human wheelbarrow (cat. 377). Roitfeld captioned the image, "My vision of gardening."[19] Another charts a model getting plastic surgery; when she arrives home, she takes a shower wearing diamond jewelry as well as the bandages (Tom Ford, December 2010/ January 2011). A model picks up dog poop wearing laser cut leather gloves (Mario Testino, February 2006); another stands aboard a boat among the fishing nets wearing an Azzedine Alaïa crop top and full-length skirt (Mario Sorrenti, February 2011); another passes out in the Landmark Diner in front of a burger and fries, wearing a fringed and beaded Zuhair Murad short jumpsuit (Inez and Vinoodh, April 2010). This is make-believe, and we are not asked to consider it as real. It transports you to another place and space, with the viewer as a voyeur traveling gleefully around this fashion universe. Roitfeld said that "a good fashion photo is where you put your desires, your fears, your obsessions, and your fantasies. Otherwise, it is boring."[20]

In Alt's work, a more relaxed vision of beauty and fashion appears, sometimes placing the woman in the role of the mother. In the October 2014 issue, which was dedicated to motherhood, Natasha Poly is photographed by Testino posing with her baby and styled by Emmanuelle Alt. In one image, mother and child look into the camera; with Poly's face obscured by a net veil, she crouches down wearing a black coat by Chanel, while the baby, dressed all in white, bounces on her knee. In another shoot by Inez and Vinoodh from April 2009, a model wears a diaphanous pink evening gown as she bends over to clasp the hands of a child who wears a donkey costume over his pajamas.

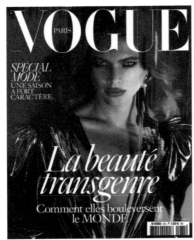

ill. 4 Mert & Marcus. Valentina
Sampaio. Saint Laurent
dress by Anthony
Vaccarello. Directed
by Emmanuelle Alt.
Vogue Paris, March 2017,
cover

Is she saying good night to her son before embarking on an evening out?
The scene evokes the trope of the absent, glamorous mother. In 2018,
for the December/January 2018 cover (ill. 2), Lachlan Bailey shot Jane Birkin with
her two daughters, Charlotte Gainsbourg and Lou Doillon. When she took
the role as editor in 2011, Alt said that she would include "more French girls,
more French lifestyle . . ."[21] Here she fulfills that promise by placing three women
of different ages and all non-models in the position of guest editors for the issue.
Alt explained, "I love models, but when we put celebrities in shoots and
on the cover, I try to push the French ones—French characters and French girls."[22]

Alt's editorship straddled a time of great change where, by the late 2010s,
the pendulum of fashionability had moved on from these dreamscapes to a time
that demanded inclusion and versions of reality. This resulted in visions
of identity coming to the fore, and Alt responded by featuring, for example,
the transgender model Valentino Sampaio on the cover of the March 2017 issue,
photographed by Mert and Marcus (ill. 4). Alt also represented women of different
ages in the magazine throughout her time as editor. In addition to new visions
of beauty being presented, this time saw a more tangible threat to the fashion
business which lay in the form of the impending climate crisis. In 2019 the
mainstream media, including *Vogue*, embraced the reality of the role humanity
had played in the planet's demise, and as a result, it became fashionable
to stand for the environment, to consume less, and to think responsibly.
The beginning of 2020 also saw the coronavirus global pandemic shut down
much of the global economy, including the fashion industry. This had a huge
impact on the fashion industry, as designers forgoed collections, fashion weeks
moved online, and production shut down in different parts of the world.
The summer of 2020 also saw the Black Lives Matter social justice movement
spread through the world in the wake of the killing of George Floyd in America.
This led to calls for inclusivity and equity in fashion.

At the beginning of this twenty-year period, *Vogue* was a niche fashion
publication, and at the end, it was a global brand. In 2019 Alt held the first *Vogue
Paris* Fashion Festival; she explained her reasoning was to celebrate that "the voice
of *Vogue* is more than a magazine. We have a strong place in the fashion
territory. We have the power and access to people. If you compare it to a fashion
company that starts with a few dresses and then they have handbags, then
they need the fragrance. They need to be everywhere, stores, the Internet,
Net-a-Porter. We have to grow the same way."[23] With this reach, there comes
influence, and Alt explained that in 2020 sustainability had become a top priority.
She created two issues dedicated to nature, and the coverline on the November
2019 issue advised "without nature, there is no future." In 2017 (ill. 3) Alt also
decided to no longer include any fur or animal skin garments or accessories
in *Vogue*. "I don't regret it for a second" she said. "There is no legitimacy in 2020
to kill animals to be on a coat."[24] At the helm of the *Vogue* brand, Alt had power
and sway, and she was pleased to learn that "less than a year later, Gucci
also declared that they were going to stop using fur."[25]

It can seem confusing when *Vogue*, a magazine that had once stuck
its middle finger up to fur protesters, had changed its mind. Yet, this is one
of the most inspiring things about fashion; in the malleable minds that work
among the fashion industry can come such a vehement response to change,
so swiftly, their antenna poised to feel out the moment. When talking about
the approach to consumption in 2019, the scientist and policy analyst Vaclav
Smil said, "There is this louder voice calling for more consumption and a bigger

bathroom and an SUV, but it's increasingly apparent that cannot go on. It will be something like smoking, which was everywhere fifty years ago. But now that people realize the clear link to lung cancer, this is restricted. The same will happen when people realize where material growth is taking us. It is a matter of time, I think." The fashion system is set to be reshaped in the coming years, far beyond seasonal trends, and in response, it will be incredibly interesting to see what the shapeshifters at *Vogue* come up with.

1 Julia Child quoted in Karen Karbo, *Julia Child Rules: Lessons in Savouring Life*, (Guildford, CT: Skirt!, 2013), 44.
2 Cathy Horyn, "New Star in the Front Row," *The New York Times*, February, 10 2011, https://www.nytimes.com/2011/02/10/fashion/10ALT.html (accessed April, 24 2020).
3 *Ibidem.*
4 Agnès Rocamora, *Fashioning the City: Paris, Fashion and the Media* (London and New York: I.B. Taurus & Co Ltd, 2009), xvi.
5 Théâtre de la Mode was a touring exhibition that traveled around Europe and then the United States from 1945 to 1946. Exhibiting fashion mannequins, approximately one third the size of human scale, made by the top Paris fashion designers, it was created to raise funds for war survivors and to help revive the French fashion industry in the aftermath of World War II.
6 Lauren Indvik, "Emmanuelle Alt: 'Vogue is more than a magazine,'" *Vogue Business*, August 8, 2019, https://www.voguebusiness.com/talent/articles/emmanuelle-alt-editor in chief-vogue-paris-interview/ (accessed on April, 23 2020).
7 Hilary Alexander, "Emmanuelle Alt Interview," *The Telegraph*, March 7, 2011, http://fashion.telegraph.co.uk/news-features/TMG8364869/Emmanuelle-Alt-interview.html (accessed on April 23, 2020).
8 Matthew Schneier, "What Is Chic?," *Vogue Arabia*, October 17, 2012, https://en.vogue.me/archive/culture/what-is-chic/ (accessed on April 23, 2020).
9 Miles Socha, Emmanuelle Alt's Alternative Take on Vogue," *Women's Wear Daily*, March 18, 2011, https://wwd.com/business-news/media/alt-s-alternative-take-on-vogue-3558684/ (accessed on April 24, 2020).
10 Carine Roitfeld quoted in Alex Wiederin and Olivier Zahm, eds., *Irreverent* (New York: Rizzoli, 2011), 337.
11 Wiederin and Zahm, *Irreverent*, 307.
12 Wiederin and Zahm, *Irreverent*, 209.
13 Valerie Steele, *Paris Fashion: A Cultural History* (Oxford: Oxford University Press, 1988).
14 Agnès Rocamora, "Paris Capitale de la Mode: Representing the Fashion City in the Media," in *Fashion's World Cities*, eds. Christopher Breward and David Gilbert (London: Bloomsbury, 2006), 43–54.
15 Wiederin and Zahm, *Irreverent*, 348.
16 Wiederin and Zahm, *Irreverent*, 88.
17 Wiederin and Zahm, *Irreverent*, 124.
18 Wiederin and Zahm, *Irreverent*, 134.
19 Wiederin and Zahm, *Irreverent*, 83.
20 Wiederin and Zahm, *Irreverent*, 151.
21 Mark Holgate, "Emmanuelle Alt, The New Editor of Vogue Paris, on Daria Werbowy, Celebrity Covers, and New Designers," *American Vogue*, February 7, 2011, https://www.vogue.com/article/emmanuelle-alt-editor-of-vogue-paris-on-daria-werbowy-celebrity-covers-and-new-designers (accessed on April 27, 2020).
22 Emmanuelle Alt. Interview by author. Phone recording. New York City, April 27, 2020.
23 Lauren Indvik, "Emmanuelle Alt: '*Vogue* is more than a magazine,'" *Vogue Business*, August 8, 2019, https://www.voguebusiness.com/talent/articles/emmanuelle-alt-editor in chief-vogue-paris-interview/ (accessed on April, 23 2020).
24 Emmanuelle Alt. Interview by author. Phone recording. New York City, April 27, 2020.
25 Emmanuelle Alt. Interview by author. Phone recording. New York City, April 27, 2020.

cat. 375 Inez & Vinoodh. Tasha Tilberg. Miu Miu jacket, pants, and shirt; Charvet sweater.
Directed by Marie-Amélie Sauvé. Evian. *Vogue Paris*, September 2001, p. 286

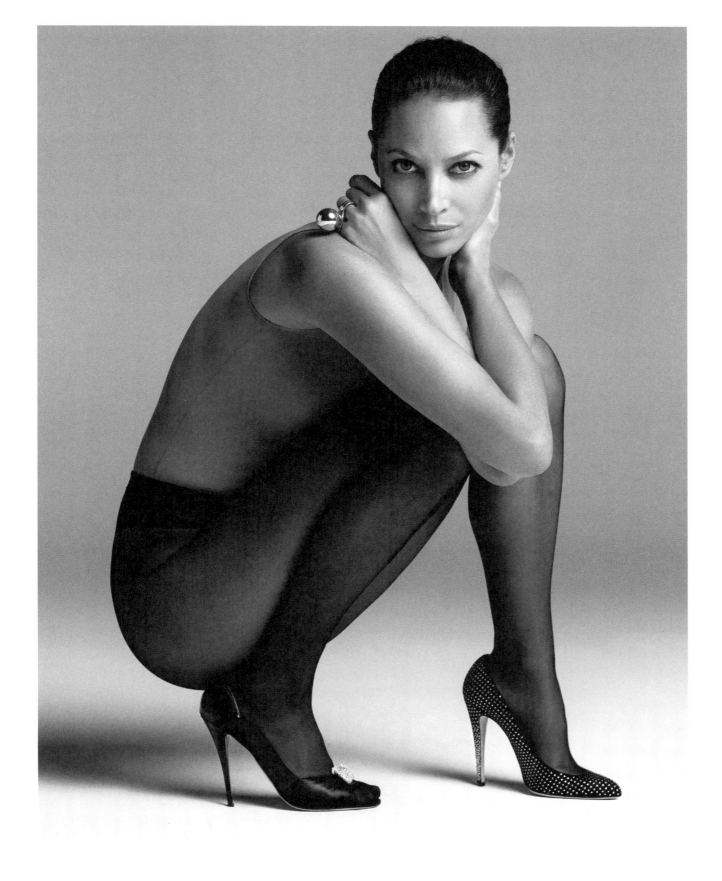

cat. 379 Inez & Vinoodh. "L'escarpin." Christy Turlington. Giuseppe Zanotti and Brian Atwood shoes.
Directed by Carine Roitfeld. *Vogue Paris*, October 2008, p. 296

cat. 405 Inez & Vinoodh. Artistic direction M/M (Paris). "Le plus bel âge." Ann Catherine Lacroix.
Directed by Marie-Amélie Sauvé. *Vogue Paris*, October 2002, pp. 222–223

Coiffure Jimmy Paul.
Maquillage Lisa Butler.
Assistantes réalisation
Kathrin Lezinsky
et Mélanie Huynh.

Photographes INEZ VAN LAMSWEERDE & VINOODH MATADIN,
réalisation MARIE-AMÉLIE SAUVÉ.

Au centre, pull-tunique en
maille de laine, Comme des
Garçons. Mini-kilt écossais
en pure laine, Burberry.
Sandales en cuir argenté sur
semelle en liège, Christian
Louboutin, sur commande.
A gauche et à droite, veste
cache-cœur en laine, mini-
jupe portefeuille et ceinture
en denim, Sonia Sonia
Rykiel. Sac en cuir et toile,
Martin Margiela
Ligne 1. Bottines en cuir
verni, Trash & Vaudeville
N.Y. Flamand rose en
peluche, Le Nain Bleu.

Selling Dreams

cat. 403 Craig McDean. "À la folie." Sasha Pivovarova. Chanel Haute Couture dress, Manolo Blahnik
shoes, Peter Philips veil. Directed by Carine Roitfeld. *Vogue Paris*, April 2006, p. 245

Selling Dreams

cat. 377 Mario Sorrenti. "Série noire." Guinevere van Seenus, La Perla Mare jersey, Camille Fournet choker, Jil Sander cuff, Chrome Hearts bracelet, Dolce & Gabbana Eyewear glasses (bottom). Enikő Mihalik, Versace jersey, Max Mara pants, Furla bag, Cartier and Hermès jewelry (top). Directed by Carine Roitfeld. *Vogue Paris*, June/July 2009, p. 171

cat. 387 Mario Sorrenti. "Jeu de paumes." Beauty pages. Enikő Mihalik. Repossi ring,
 Bulgari solitaire. Directed by Carine Roitfeld. *Vogue Paris*, August 2010, p. 185

cat. 388 Terry Richardson. "Festin." Crystal Renn. Buccellati buckles; Bulgari necklace; Chopard, Chanel Joaillerie, Buccellati, Adler, and Piaget rings; Prada cardigan; DeLaneau watch. Directed by Carine Roitfeld. *Vogue Paris*, October 2010, p. 602

cat. 380 Mario Sorrenti. "Cil icône." Natasha Poly. Frank B makeup, Recine hairstyle,
Anny Errandonea nails, Tom Ford anti-UV goggles, faux theater eyelashes.
Directed by Carine Roitfeld. *Vogue Paris*, September 2009, p. 327

cat. 378 Mario Testino. "Réjouissances." Patricia Schmid. Chanel perfume and makeup,
Dolce & Gabbana belt. Directed by Carine Roitfeld. *Vogue Paris*, February 2007, p. 259

Selling Dreams

La femme FORD

**Photographes Mert Alas & Marcus Piggott.
Réalisation Carine Roitfeld.**

*Blouse roumaine en georgette de soie, et pantalon
taille haute en jacquard de laine mohair.
Sur toutes les pages, vêtements Tom Ford printemps-été 2011.*

cat. 408 Mert & Marcus. "La femme Ford." Daphne Groeneveld. Tom Ford blouse and pants.
Vogue Paris, December 2010/January 2011, pp. 184–185

Ribaut asymétrique en taffetas de soie, et jupe en lainage metal lamé, Lanvin. Gilet d'homme en peau façon léopard, Lost Art NY. Bracelet or et jaune émaillé, David Webb. Bague «Quatre» or blanc, rose, jaune et or Boucheron, Boucheron. Bague «Trinity» trois ors, Cartier. Page de gauche, robe asymétrique en soie imprimée léopard et bordée de perles, Maison Martin Margiela. Manteau en renard blanc, Jil Sander. Bague «Quatre», Boucheron. Bague «Trinity», Cartier. Bottes lacées en cuir, Prada.

cat. 407 Mert & Marcus. "Hors-la-loi." Anna S. Maison Martin Margiela dress, Jil Sander coat
(left page). Lanvin ensemble, Lost Art NY jacket (right page). *Vogue Paris*, September 2008,
pp. 324–325

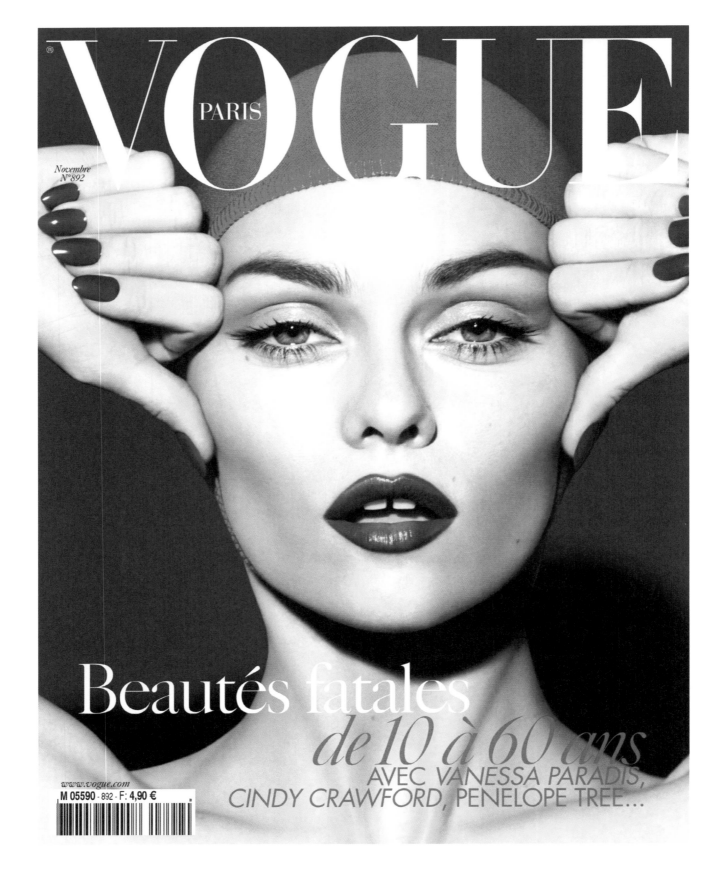

ill. 5 Mert & Marcus. Vanessa Paradis. Miu Miu hood. Directed by Joe McKenna. *Vogue Paris*,
November 2008, cover

cat. 381 Mert & Marcus. "Néoclassiques." Lara Stone. Chanel cardigan, Balenciaga
by Nicolas Ghesquière jacket, Maison Martin Margiela Ligne 1 leotard, Boucheron hoop
earrings. Directed by Carine Roitfeld. *Vogue Paris*, March 2008, p. 333

Selling Dreams

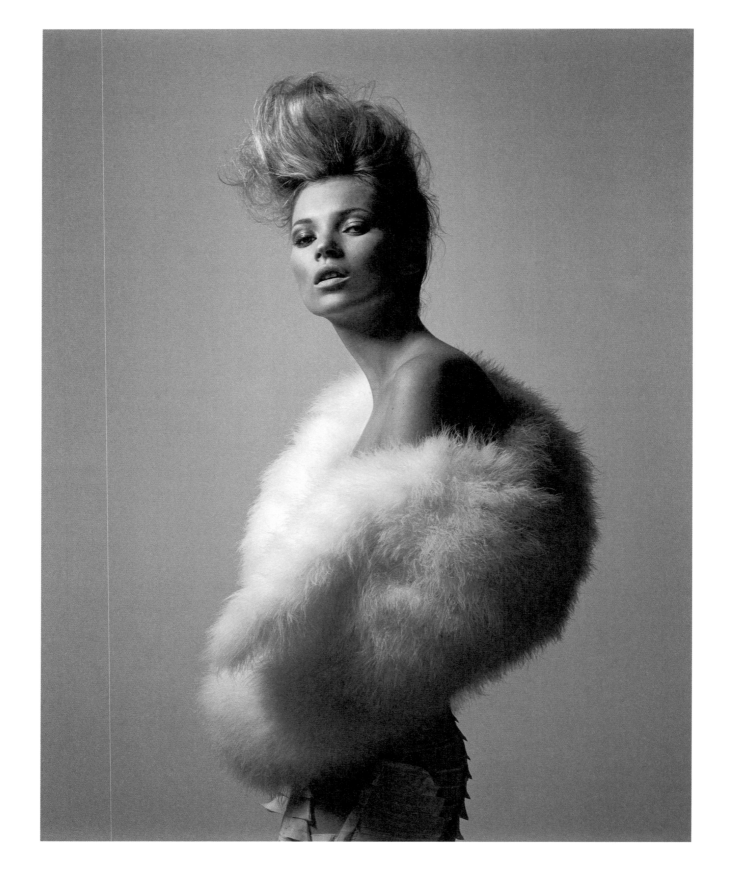

cat. 413 David Sims. Kate Moss. Gucci bolero. Directed by Joe McKenna. *Vogue Paris*, March 2004, cover

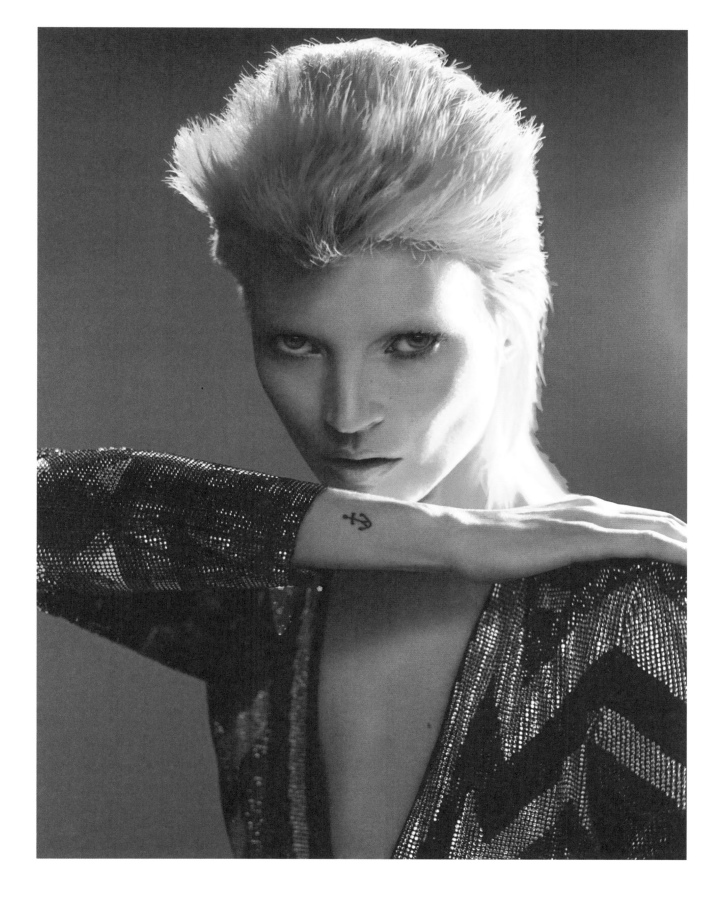

cat. 419 Mert & Marcus. Kate Moss. Balmain jumpsuit. Directed by Emmanuelle Alt. *Vogue Paris*,
December 2011/January 2012, cover

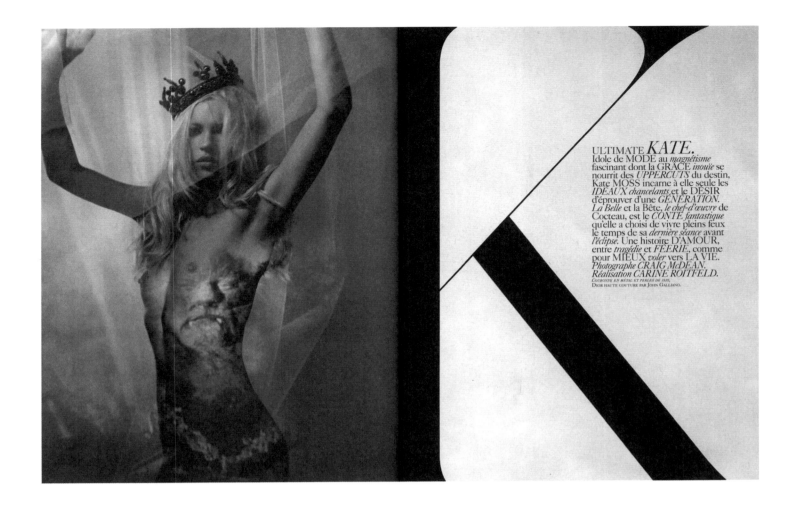

ULTIMATE *KATE*.
Idole de MODE au *magnétisme*
fascinant dont la GRACE *inouïe* se
nourrit des *UPPERCUTS* du destin,
Kate MOSS incarne à elle seule les
IDÉAUX chancelants, et le DÉSIR
d'éprouver d'une *GÉNÉRATION*.
La Belle et la Bête, *le chef-d'œuvre* de
Cocteau, est le *CONTE fantastique*
qu'elle a choisi de vivre pleins feux
le temps de sa *dernière séance* avant
l'éclipse. Une histoire D'AMOUR,
entre *tragédie* et FÉERIE., comme
pour MIEUX *voler* vers LA VIE.
Photographe CRAIG McDEAN.
Réalisation CARINE ROITFELD.
Couronne en métal et perles de jais,
Dior haute couture par John Galliano.

cat. 421 Craig McDean. "Ultimate Kate." Kate Moss. Dior Haute Couture by John Galliano crown.
Directed by Carine Roitfeld. *Vogue Paris*, December 2005/January 2006, pp. 194–195

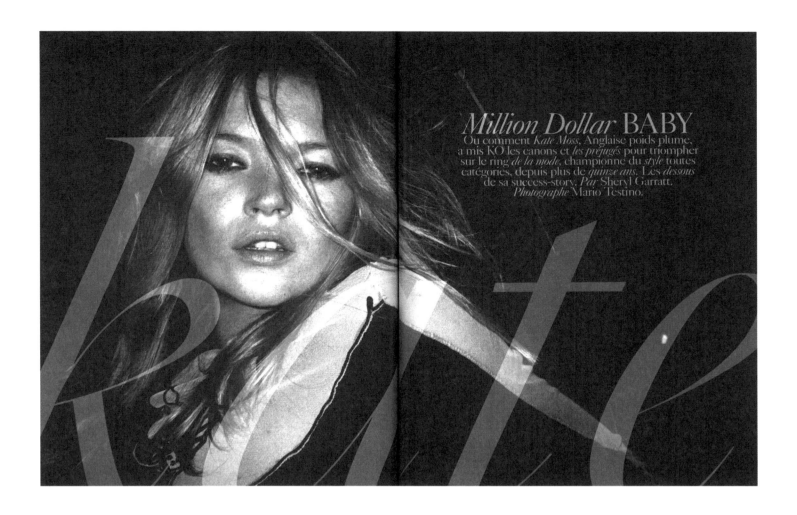

Million Dollar BABY

Ou comment *Kate Moss*, Anglaise poids plume,
a mis KO les canons et *les préjugés* pour triompher
sur le ring *de la mode*, championne du *style* toutes
catégories, depuis plus de *quinze ans*. Les *dessous*
de sa success-story. *Par Sheryl Garratt.*
Photographe Mario Testino.

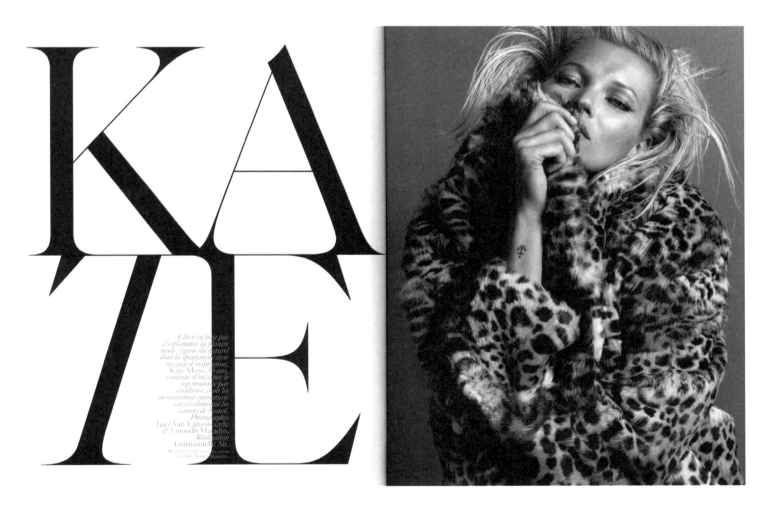

Elle n'en finit pas
d'enflammer la planète
mode, régnre du naturel
dont la spontanéité reste
un gage d'inspiration,
Kate Moss, 35 ans,
continue d'incarner le
top model se par
excellence, dont les
mensurations miniatures
ont révolutionné les
canons de beauté.
Photographes
Inez Van Lamsweerde
& Vinoodh Matadin.
Réalisatrice
Emmanuelle Alt.

cat. 390 David Sims. "Pull Lover." Edie Campbell. Balenciaga sweater. Directed by Emmanuelle Alt.
Vogue Paris, September 2017, p. 260

cat. 383 David Sims. "Commando." Iselin Steiro. Balmain ensemble. Directed by Emmanuelle Alt.
Vogue Paris, March 2010, p. 299

PORTRAIT OF A LADY

Balade intrigante dans un LONDRES CACHÉ.
Où le NOUVEL ESPRIT PUNK, quoique plus doux,
donne toujours autant de piquant à l'allure.

Photographe Alasdair McLellan. Réalisation Aleksandra Woroniecka.

Top en organza de soie motif floral et détails or, **Fendi**. Boucles d'oreilles en métal doré, **Valois Vintage**.

Quelque part à Paris

Manteau en patchwork de peau lainée, chemise en soie imprimée Monogram, et jupe en soie imprimée carreaux et pois, **Burberry**. Lunettes de soleil, **Karen Walker**. Boucles d'oreilles, **Vhernier**.

Photographe Sam Rock. Réalisation Aleksandra Woroniecka.

Utopies

Photographes Mert Alas et Marcus Piggott.
Réalisation Emmanuelle Alt.

*Veste en crêpe de soie,
GIORGIO ARMANI.
Maquillage Estée Lauder
avec le fond de teint Double
Wear Medium, la Palette
Pure Color 5 Couleurs Bronze
Dunes et, sur les lèvres, le
Double Wear Stay Scarlet.*

Androgyne

David Sims, 2010

Réalisation Emmanuelle Alt.
*Veste croisée en gabardine de lin et coton, Bottega Veneta.
Gilet en satin de soie, Lanvin. Chemise à col cassé en coton, Charvet.
Nœud papillon en piqué de coton, Brioni. Pantalon taille flottante
bi-matière, cuir devant et dos en drap de laine, Maison Martin
Margiela. Chapeau en feutre velours, Chapellerie Traclet.*

ill. 6 Mert & Marcus. "Utopias." Suvi Koponen. Giorgio Armani jacket.
 Directed by Emmanuelle Alt. *Vogue Paris*, March 2013, pp. 294–295
cat. 391 David Sims. "Androgyne." Iselin Steiro. Bottega Veneta jacket, Lanvin waistcoat,
 Charvet shirt, Brioni bow tie, Maison Martin Margiela pants, Chapellerie Traclet hat.
 Directed by Emmanuelle Alt. *Vogue Paris*, October 2010, pp. 566-567

cat. 382 Mert & Marcus. "Le Noir, partie 4." Daria Werbowy. Viktor & Rolf coat, Carine Gilson
camisole, Chantal Thomas panties, Falke bottoms, Valentino Garavani shoes,
Henri J. Sillam earrings. Directed by Emmanuelle Alt. *Vogue Paris*, September 2012, p. 34

UN ÉTÉ PAS COMME LES AUTRES

Photographe *Mikael Jansson*. Réalisation *Emmanuelle Alt*.

Mini-robe plissée en crépon de soie avec harnais brodé de pierres, <u>Chloé</u>. *Boucle d'oreille,* <u>Jessie Western</u>.

120

cat. 397 Mikael Jansson. "Un été pas comme les autres." Rianne Van Rompaey. Chloé dress, Jessie Western earrings. Directed by Emmanuelle Alt. *Vogue Paris*, May 2019, pp. 120–121

cat. 394 Inez & Vinoodh. "L'hippie trendy d'Etro." Daria Werbowy. Etro ensemble, Jill Heller hoop
earrings. Directed by Emmanuelle Alt. *Vogue Paris*, February 2010, p. 170

cat. 401 Inez & Vinoodh. "Parlez-vous français?" Edie Campbell, Valentino Haute Couture dress.
Rianne ten Haken, What Goes Around Comes Around jacket, American Apparel armband
and leggings. Directed by Emmanuelle Alt. *Vogue Paris*, May 2015, p. 162

Selling Dreams

cat. 395 Inez & Vinoodh. Gisele Bündchen. Directed by Emmanuelle Alt. *Vogue Paris*, June/July 2012, cover

ill. 1 Pierre Brissaud and Georges Lepape.
Vogue Paris, March 1923, cover

Throughout its history, *Vogue Paris* has marked its milestone years—thirty, fifty, seventy-five, and ninety—with anniversary issues that serve to showcase the magazine's history and its links with the Condé Nast group. The tale is told through a presentation of the magazine's identity, its readers, and the various collaborators who have shaped the story of *Vogue*: publishers, editors, editors in chief, art directors, fashion editors and stylists, photographers, models, authors, artists, and so on. These anniversary issues reveal how *Vogue Paris* has chosen to portray its own past and to tell stories about its collaborators.

While acting as a manifesto for the role of *Vogue*, these special issues also celebrate, in an implicit way, the magazine's connection to French couturiers and creators. The desire to reflect these relationships—starting with the first anniversary issue of March 1923[1]—paradoxically falling on the thirtieth anniversary of American *Vogue*, as French *Vogue* was not yet emancipated from its parent publication—can be seen in particular detail in the seventy-fifth anniversary issue of *Vogue Paris*,

with a focus on its close relationship with Chanel. Monographic articles and letters from couturiers demonstrate that French *Vogue* was built around Paris and its central role as a fashion capital.

Starting in the 1980s, the anniversary issues took into account the changing status of photography and showed how that artform had become part of its legacy. In 1982, in an anachronistic way, *Vogue Paris* commemorated its fiftieth anniversary with a retrospective of striking photographs at the Jacquemart-André Museum.[2] The magazine highlighted its own role in training a generation of talented photographers, which was also highlighted by the seventy-fifth-anniversary issue (with several articles devoted to Helmut Newton[3] and Guy Bourdin[4]), and the ninetieth issue, which was accompanied by both a short film, directed by Steven Klein and showing the making of a beauty shoot with Mario Sorrenti, and a collector's portfolio of one hundred pages containing the most daring shots from the magazine.[5] By offering never-before-seen images and testimonials from many of its collaborators, these two issues also

demonstrated *Vogue Paris*'s emerging interest in the promotion of its own archives[6] and its desire to value its own heritage.

Although observers may challenge the way this story, dictated by promotional aims and the goal of self-celebration, was presented and narrated, these special issues nevertheless allow us to observe how *Vogue Paris* has established itself as a leading magazine in contemporary visual culture.

Marlène Van de Casteele

1 "Où l'on expose le rôle de *Vogue*," *Vogue Paris* (March 1, 1923): 33.
2 See *50 années de photographies Vogue Paris*, cat. exp., Paris, Jacquemart-André Museum (January 28–April 11, 1982).
3 "'Héros de l'éros:' un florilège des plus belles photos de Newton," *Vogue Paris* (December 1995/January 1996): 204–209.
4 "Guy Bourdin a enchanté *Vogue* pendant presque 30 ans," *Vogue Paris* (December 1995/January 1996): 216–219; "La naissance de Vénus," Tribute to Guy Bourdin by David Lachapelle, *Vogue Paris* (December 1995/January 1996): 220–223.
5 "*Vogue*, 90 ans d'audace," supplement to *Vogue Paris* (October, 2010).
6 See Susan Train, "Ils ont fait *Vogue*," *Vogue Paris* (December 1995/January 1996): 20–30.

ill. 2

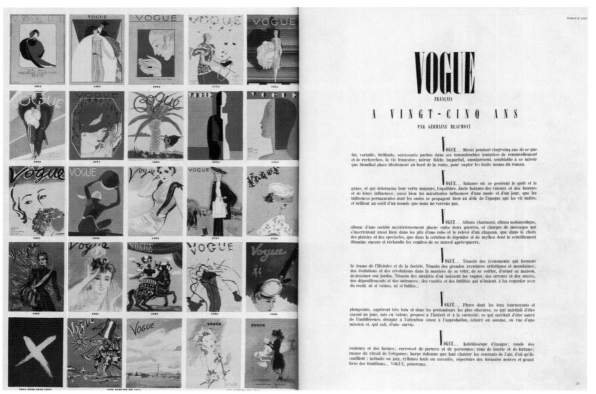

ill. 3

ill. 2 "Nos artistes français." *Vogue Paris*,
 March 1923, pp. 24–25

ill. 3 "Vogue Français a vingt-cinq ans"
 by Germaine Beaumont. *Vogue Paris*,
 January/February 1947, pp. 76–77

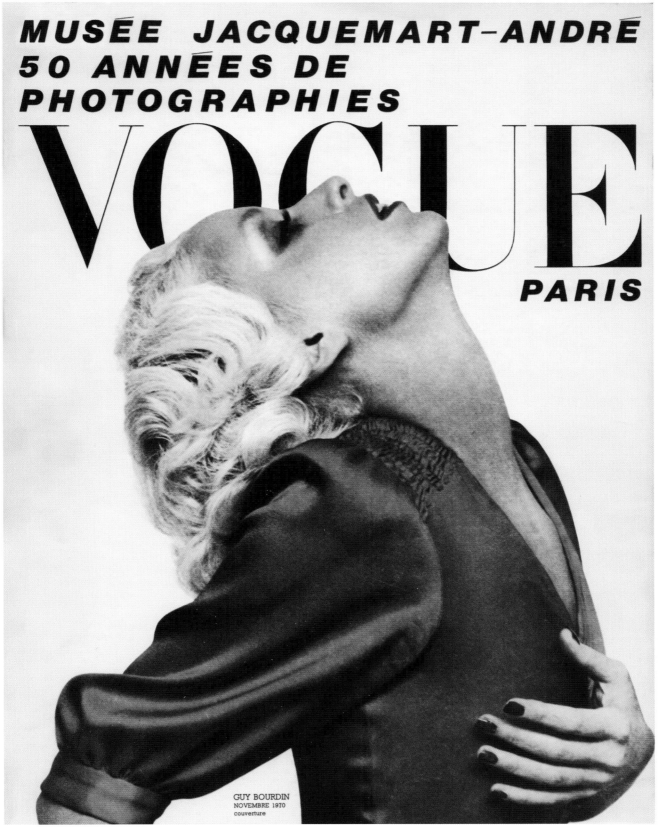

ill. 4

ill. 4 Guy Bourdin. Cover of the catalogue
of the exhibition "50 années
de photographies *Vogue Paris*"
(Jacquemart-André Museum, 1982).
Donna Jordan. *Vogue Paris*,
November 1970, cover

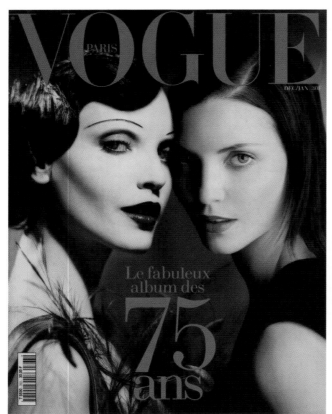

ill. 5

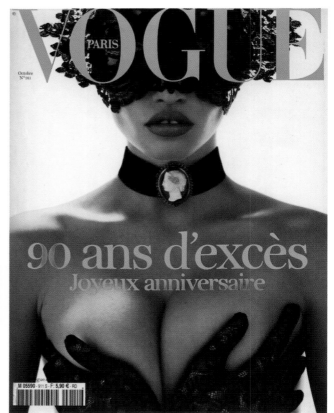

ill. 6

ill. 5	Michael Thompson. Nadja Auermann.	ill. 6	Mert & Marcus. Lara Stone.
	Montana dress, Helmut Lang tank top.		Philip Treacy mask, Delft Vase cameo,
	Directed by Delphine Tréanton.		Mokuba choker, Alice Cadolle gloves.
	Vogue Paris, December 1995/		Directed by Carine Roitfeld.
	January 1996, cover		*Vogue Paris*, October 2010, cover

BIOGRAPHIES

DOCUMENTS

EXHIBITED WORKS

BIOGRAPHIES

Condé Montrose Nast, born in New York in 1873, entered the world of publishing after studying law. He began as an advertising director at *Collier's Weekly* before becoming vice president of the Home Pattern Company, a manufacturing and distribution company whose patterns for home dressmakers were sold through *Ladies' Home Journal*.

In 1909 Nast purchased *Vogue* magazine, a weekly gazette published for the wealthy classes of New York. He completely rebuilt the magazine in both content and form. *Vogue* was modernized and changed to a bimonthly publication aimed at female readers who were wealthy and eager to learn about European trends. A visionary publisher aware of *Vogue*'s international potential, Nast made

plans in 1915 to launch country-specific editions. In 1920 he created *Vogue Paris* with the collaboration of Lucien Vogel. Through intermediary Edna Woolman Chase, whom he appointed editor in chief the same year, and her successors, Nast supervised and guided the French edition of *Vogue* for more than twenty years.

He was director of Condé Nast Publications (*House & Garden, Le Jardin des modes, Vanity Fair,* and *Glamour,* among others) until his death in 1942.

CONDÉ NAST

1909–1942
Director, Condé Nast Publications

Anonymous. Condé Nast, c. 1923

Horst P. Horst. Edna Woolman Chase, c. 1954

EDNA WOOLMAN CHASE

1920–1928
Editor in chief, *Vogue Paris*

Edna Woolman Chase, née Allaway, joined American *Vogue* in 1895 at the age of eighteen, just three years after the founding of the magazine. She soon was responsible for managing the publications, particularly overseeing subscriptions. Shortly after joining, she became the right-hand woman of the magazine's editor in chief and creator, Arthur Baldwin Turnure. Recognizing her efficiency and good eye for detail, Turnure gave her more editorial responsibilities. In 1914 she was appointed editor in chief of American *Vogue*.

In 1920 she became the first editor in chief of the French edition, which she directed from the New York offices. Heavily involved in the choice of content for the

magazine, she traveled often to Paris to interact with the teams and to stay up to date with trends.

Starting in 1928, she oversaw the three editions of *Vogue* (American, British, and French) as managing editor. Despite the increasing independence of the French edition, she maintained the link between New York and Paris. When she left the office in 1952, she became chair of the editorial board of Condé Nast Publications, a position she held until her death in 1957.

Cosette Vogel, née de Brunhoff, began her career as a journalist alongside her husband, Lucien Vogel, with the launch of the *Gazette du bon ton* in 1912. She actively participated in the content of the magazines Lucien created in collaboration with her brother Michel de Brunhoff.

In 1922, two years after the founding of *Vogue Paris*, Condé Nast offered her the role of editor of the magazine. As a fashion journalist well acquainted with Parisian cultural and artistic circles, she shifted the content toward a more targeted readership—Parisian women—and added a shopping section, a readers' letters page, a travel section, and a news section. Despite her major role in the magazine, Cosette was not credited on the masthead. In 1927

she left the editorial staff of *Vogue Paris* and continued her career as a freelance journalist.

COSETTE VOGEL

1922–1927

Editor, *Vogue Paris*

Anonymous. Cosette and Lucien Vogel, c. 1929

Edward Steichen. Lucien Vogel, 1925

LUCIEN VOGEL

1924–1927

Art Director, *Vogue Paris*

Lucien Vogel, born in Paris in 1886, started in publishing at Hachette at the age of seventeen. The son of Hermann Vogel, a well-known illustrator, he took up a career in publishing as a natural choice. He was soon entrusted with the design of the magazine *La Vie heureuse* before being appointed editor in chief of *Art et décoration* in 1908. That same year, he married Cosette de Brunhoff, and in 1912, launched—with her assistance—*Gazette du bon ton.* Vogel was particularly close to Michel de Brunhoff, his brother-in-law, with whom he collaborated for several years.

In 1920, shortly after the creation of *L'Illustration des modes,* Vogel was contacted by Condé Nast to assist with the launch of the French edition of *Vogue.* The two

men had previously worked together, and Nast admired his work. In 1924, under the direction of Edna Woolman Chase, Vogel became art director of *Vogue Paris,* contributing his expertise to the magazine.

Although he officially left his post in 1927 to devote himself to other projects, including the launch of the news magazine *Vu* in 1928, he remained the link between Brunhoff and Nast until his death in 1954.

American-born Main Rousseau Bocher (known as Mainbocher) started at *Vogue Paris* in 1922 as a fashion editor. A former fashion illustrator for *Harper's Bazaar*, his first role was as a Paris correspondent for the New York office. In 1928 Edna Woolman Chase appointed him editor in chief of the magazine, allowing Condé Nast to supervise the French edition. In September 1929, after several years with the magazine, Mainbocher decided to open his own fashion house in Paris, which moved to New York in 1940, where it remained until closing permanently in 1971.

MAINBOCHER
1928–1929
Editor in chief, *Vogue Paris*

Man Ray. Mainbocher, c. 1928

Gjon Mili. Michel de Brunhoff, 1950

MICHEL
DE BRUNHOFF
1929–1954
Editor in chief, *Vogue Paris*

Michel de Brunhoff was born in Paris in 1892. The son of Maurice de Brunhoff, an art book publisher, he discovered an interest in publishing in 1910 alongside his brother-in-law Lucien Vogel, who offered him a position as copy editor at *Art et décoration*. In 1912 they created *Gazette du bon ton,* a magazine for which Brunhoff also held the position of copy editor. Eight years later, Vogel launched *L'Illustration des modes* (which would become *Le Jardin des modes* in 1922) for which Brunhoff served as editor in chief. In 1926 Condé Nast and Edna Woolman Chase called on Brunhoff to turn around British *Vogue.* For several months, Brunhoff traveled to London as acting editor in chief while continuing his work at *Le Jardin des modes* in Paris.

His editorial experience and knowledge of the fashion world led Nast to appoint him editor in chief of *Vogue Paris* in 1929, a position he held until 1954 before leaving the post to his successor, whom he trained for several few years, Edmonde Charles-Roux.

Brunhoff was appointed honorary director of *Vogue Paris* from 1954 to 1957. He died a year later in Paris.

Mehemed Fehmy Agha, born in Russia in 1896, studied economics in Kiev and Asian languages in Paris, and had a general interest in design, photography, and the arts. He worked in Berlin for the German edition of *Vogue*, which was printed in 1928 and 1929. At the same time, Condé Nast was searching for a new art director to replace Heyworth Campbell. Nast traveled to Berlin and met Agha, whom he brought to New York. In 1929 Agha was appointed art director for Condé Nast Publications, and worked for the French, British, and American editions of *Vogue,* as well as for *Vanity Fair* and *House & Garden* until 1943.

MEHEMED FEHMY AGHA

1929–1943

Art Director, Condé Nast Publications

Horst P. Horst. Mehemed Fehmy Agha

William Klein. Alexander Liberman, 1959

ALEXANDER LIBERMAN

1943–1962

Art Director, Condé Nast Publications

Alexander Liberman, born in Kiev in 1912, grew up between Russia, London, and Paris, where he enrolled in the École des Beaux-Arts to study architecture. In 1932 he met the artist Cassandre, who introduced him to Lucien Vogel. Impressed with Liberman's talent, Vogel hired him the following year to assist with the design of *Vu,* where he later took over as art director. During the war, Liberman moved to New York, where he met up with his mentor, Lucien Vogel, who introduced him to Condé Nast. He made his debut at Condé Nast Publications in 1941 and was appointed art director of its publications in 1943, after Nast's death and Agha's departure. At the end of the war, Liberman introduced changes to *Vogue*'s design and,

1963–1994

Director, Condé Nast Publications

through an emphasis on fashion photography, modernized the magazines. In 1963, after twenty years as art director, he was appointed director of Condé Nast Publications. Liberman left the group in 1994 but remained honorary vice president of publications until his death in 1999.

Edmonde Charles-Roux, born in 1920, joined *Vogue Paris* in 1947 as a theater correspondent after working at *Elle* and *France-soir*. She was quickly appointed to oversee the cultural pages as well as news reports. In September 1952 she became Michel de Brunhoff's right-hand woman before succeeding him in 1954.

Charles-Roux was forced to resign because of her political affinities with communist writers and artists. Her proposal to feature model Donyale Luna on the cover of an issue in 1966 was the pretext for her dismissal a few months later. She then began a career as a writer and published *Oublier Palerme*, a novel for which she won the Prix Goncourt, that same year. A member of the Goncourt Academy since 1983, she became its president in 2002, a position she held until 2014, two years before her death in Marseille, France.

EDMONDE CHARLES-ROUX

1954–1966

Editor in chief, *Vogue Paris*

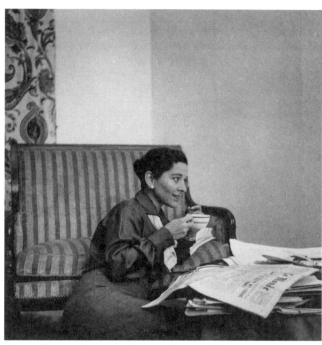

Henry Clarke. Edmonde Charles-Roux, 1966

Anonymous. Françoise de Langlade

FRANÇOISE DE LANGLADE

1966–1968

Editor in chief, *Vogue Paris*

Françoise de Langlade, born in Paris in 1921, started in the world of couture working for Schiaparelli. She then joined the editorial board of *Harper's Bazaar*, followed by *Vogue Paris* in 1951. She became fashion editor and was credited on the masthead under the name Françoise Bajenow, the family name of her second husband. Accustomed to social circles and the fashion world, she became the assistant editor in chief in 1963 under Edmonde Charles-Roux, whom she replaced in 1966 after Charles-Roux's departure.

Langlade ran *Vogue Paris* for two years before leaving her post to move to the United States with her husband, fashion designer Oscar de la Renta. From across the Atlantic, she continued her publishing career, working for the Condé Nast group as an editor for American *Vogue*, as well as *House & Garden,* until her death in 1983 at the age of sixty-two.

Françoise Mohrt was first credited on the masthead of *Vogue Paris* in 1964 as a member of the editorial staff. In 1966 she was appointed assistant editor in chief, becoming Françoise de Langlade's right-hand woman. After the departure of Langlade in 1968, Mohrt and Francine Crescent took over as editors in chief. This was the first time in the magazine's history the post was shared by two editors.

After a year, with their roles more clearly defined, Mohrt became editor in chief of beauty, news, and features. She transformed the beauty pages of the magazine and invited couturiers and other celebrities to collaborate within the section. In particular, she was credited with introducing special Christmas issues from 1969 onward.

Mohrt remained with *Vogue Paris* until 1977 and later published several books on designers including Marcel Rochas and Hubert de Givenchy.

FRANÇOISE MOHRT

1969–1977
Editor of Beauty, News, and Features, *Vogue Paris*

Martine Franck. Françoise Mohrt, c. 1972

Jean-Luce Huré. Francine Crescent, 1984

FRANCINE CRESCENT

1969–1977
Fashion Editor in chief, *Vogue Paris*

Francine Crescent, born in 1932, started at *Vogue Paris* in the late 1950s and became a member of the editorial staff in 1961. Specializing in fashion, during the mid-1960s she oversaw the "Fabrics, Leather, and Accessories" section, then became fashion editor after the departure of Edmonde Charles-Roux. When Françoise de Langlade left *Vogue Paris* in 1968, Crescent was appointed editor in chief alongside Françoise Mohrt. Both were responsible for managing the publication and divided their responsibilities from 1969 onward, with Crescent becoming editor in chief for fashion. She then took over the position of editor in chief on her own in 1977 after the departure of Mohrt.

1977–1986
Editor in chief, *Vogue Paris*

Crescent stepped down from her position after almost thirty years with the magazine.

Colombe Pringle, born in 1948, started as a runner on the TV series *Dim Dam Dom* (1965) at the age of seventeen. She then joined the agency MAFIA, where she trained for three years, worked for *Le Jardin des Modes,* and joined the fashion department of *Elle* magazine. With an interest in cultural subjects, she became a successful journalist and was appointed assistant editor in chief in 1982.

In 1986 Jean Poniatowski, then director of *Vogue Paris,* offered her a position with the team. She accepted and became editor in chief for the magazine section, soon in tandem with Irène Silvagni, who headed the fashion sections. After Silvagni's departure in 1991, Pringle became the sole editor in chief of *Vogue Paris.*

Pringle left the magazine in 1994 and, two years later, joined *L'Express,* followed by *Maison Française,* before becoming editorial director of *Point de Vue* from 2004 to 2013.

293

COLOMBE PRINGLE

1986–1991
Magazine Editor in chief, *Vogue Paris*

1991–1994
Editor in chief, *Vogue Paris*

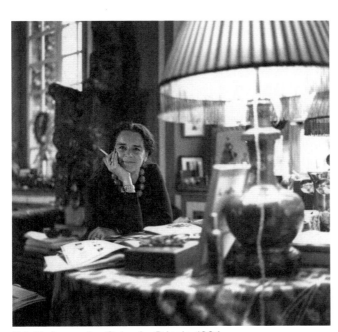

Brigitte Lacombe. Colombe Pringle, 1994

Peter Lindbergh. Irène Silvagni, 1993

IRÈNE SILVAGNI

1987–1991
Fashion Editor in chief, *Vogue Paris*

Irène Silvagni, born in 1941 in Cannes, started as a correspondent in Paris for the Italian magazine *Annabella,* then for *Mademoiselle.* She joined *Elle* as a fashion editor before becoming a European correspondent for American *Vogue* in 1982.

In 1987 she was appointed fashion editor of *Vogue Paris* alongside Colombe Pringle. She approached fashion in a new way in the pages of the magazine. To give impact to the images, she granted young photographers enormous creative freedom. Often criticized for not focusing enough on the actual clothes, she eventually left *Vogue Paris* in 1991. Soon after, she befriended the designer Yohji

Yamamoto and worked with him as art director for more than twenty years.

Joan Juliet Buck, born in 1948 in Los Angeles, spent most of her childhood in Paris and then in London. She dropped out of drama studies in New York to work at *Glamour* as a literary critic and assistant stylist. At twenty-three years old, she became features editor for British *Vogue,* then joined *Women's Wear Daily* as a correspondent in London and Italy. In 1980 she signed a contract with American *Vogue,* for which she wrote film reviews from 1991 to 1994 while continuing her collaborations with other magazines of the Condé Nast group, including *Vanity Fair, The New Yorker,* and *Traveler.*

In 1994, she accepted the position of editor in chief of *Vogue Paris.* Although she left her post in 2001, she continued to write for several magazines, including American *Vogue, Vanity Fair, W,* and *Harper's Bazaar.*

JOAN JULIET BUCK

1994–2001
Editor in chief, *Vogue Paris*

Brigitte Lacombe. Joan Juliet Buck, c. 1994

Inez & Vinoodh. Carine Roitfeld, 2006

CARINE ROITFELD

2001–2011
Editor in chief, *Vogue Paris*

Carine Roitfeld, born in Paris in 1954, began her career as a model at eighteen years old. She soon became interested in other fashion professions and joined *Elle* magazine in the late 1970s, first as a freelancer and then as a stylist. Freelancing for several years, she met leading figures with whom she collaborated throughout her career, such as photographer Mario Testino and designers Tom Ford and Karl Lagerfeld.

She was a freelance editor for *Vogue Paris* until the late 1990s, when she was approached by the president of the Condé Nast group in 2001 for the position of editor in chief. After ten years at the helm of *Vogue Paris,* Roitfeld launched her own semi-annual fashion magazine, *CR Fashion Book,* and continues to lead several independent projects alongside the publication.

Emmanuelle Alt, born in Paris in 1967, was seventeen years old when she made her debut at *Elle* magazine as an assistant fashion and beauty editor. In 1986 she joined the magazine *20 ans* as a fashion editor, and seven years later became fashion editor in chief.

While fashion editor in chief for *Mixte* magazine starting in 1998, she continued her career as a freelance consultant with major fashion houses.

In 2000 she joined *Vogue Paris* as fashion editor, and in 2011, was appointed editor in chief of the magazine.

EMMANUELLE ALT

2011–2021

Editor in chief, *Vogue Paris*

Patrick Demarchelier. Emmanuelle Alt, 2011

DOCUMENTS

ART DIRECTORS

HEYWORTH CAMPBELL
June 15, 1920–October 1924

LUCIEN VOGEL
October 1924– August 1927

MEHEMED FEHMY AGHA
1929–1943

ALEXANDER LIBERMAN
1943–December 1962

JACQUES FAURE
October 1960–August 1964

ANTOINE KIEFFER
September 1964–August 1967

JEAN CAU
September 1967–May 1969

PAUL WAGNER
June–July 1969–April 1970

JOCELYN KARGÈRE
May 1970–March 1984

PAUL WAGNER
April 1984–July 1988

MARY SHANAHAN
August 1988–October 1990

ANTOINE KIEFFER
November 1990–January 1994

PHILIPPE MORILLON
February 1994–July 1994

KAREN LOMBARD / WILLIAM STODDART
August 1994–October 1994

DONALD SCHNEIDER
November 1994–January 2002

M/M (PARIS)
February 2002–October 2003

FABIEN BARON
December 2003–April 2008

JOSEPH LOGAN
December 2003–October 2005

DAVID HÄGGLUND
November 2005–July 2007

JOHAN SVENSSON
August 2007–January 2012

GERMAIN CHAUVEAU
March 2012–February 2015

OHLMAN CONSORTI
February 2015–

OFFICES

1920–1928
2, rue Édouard-VII, Paris 9th

1928–1940
65, avenue des Champs-Élysées, Paris 8th

1945
11, rue Saint-Florentin, Paris 8th. *Le Jardin des Modes* shared its offices with *Vogue Paris*.

1946
65, avenue des Champs-Élysées, Paris 8th

1947–1994
4, place du Palais-Bourbon, Paris 7th

1994–1996
73, rue de Vaugirard, Paris 6th

1996–2014
56A, rue du Faubourg Saint-Honoré, Paris 8th

2014–2021
3, avenue Hoche, Paris 8th

PHOTOGRAPHER HOYNINGEN-HUENÉ

DATE 3 Sept 1931

WHERE Vogue - Studio , Parid

SUBJECT Combinaison "Simplette" de Cadolle

MODEL Miss Helen Wedderburn (à ne pas mentionner)

DATE OF ISSUE

4869

C.2. c) Cadolle "Simplette" A double-pointed yoke of cream-colour
Alençon is encrusted to give a moulded
line through the waist and hips. This
pink crêpe de Chine step-in has adequate
skirt fulness and very tiny shoulder
straps

cat. 50 George Hoyningen-Huene. Back of an image taken in the *Vogue Paris* studio on September 3,
1931. American *Vogue*, November 15, 1931, p. 75 and *Vogue Paris*, January 1932, p. 47

Documents

298

Téléph. { Elysées 64-72, 73, 74 / Elysées 15-41, 42, 43

Adresse Télégraphique:
Vopar – Paris

· V O G U E ·

LES EDITIONS CONDÉ NAST

SOCIÉTÉ ANONYME AU CAPITAL DE 1.300.000 FRANCS

REGISTRE DU COMMERCE: SEINE Nº 168.791

65, AVENUE DES CHAMPS-ELYSÉES

PARIS

January 18th 1935.

Mr. Christian Berard,
2 Boulevard Garibaldi,
Paris.

Dear Mr. Berard,

Confirming our various conversations, I am setting forth the terms of the contract between ourselves which we have agreed upon.

We employ you as an artist to execute and deliver Covers, Fashion drawings, Illustrations, etc..., to be published in the magazines of the Condé Nast Group and as may be ordered by our Editors.

This contract comes into force immediately and will terminate on the 31st of December 1935.

During the life of this contract, we agree to guarantee you minimum earnings on the annual basis of $6,600 (Six Thousand Six Hundred Dollars), part of which guaranty will be paid to you in monthly installments as mentioned hereunder, irrespective of any volume of work that you may deliver in the course of a given month.

This regular monthly payment will consist of Francs: 1500.- that will be paid to you by our Paris Office at the end of each calendar month, and a cheque for $200.- which will be sent to you by our New York Office on a boat which should bring this cheque to you also by the end of each calendar month.

During the life of this contract, we agree to pay you the following prices for the work that may be accepted by us:

$200. : per cover (x)
$175. : for black-&-white or color pages.

(The above prices include Reproduction rights in all our editions.)

.....

Mr. Christian Berard.) -2- (January 18, 1935.

 Francs: 1,500.- per black-&-white page intended for publication exclusively in our French edition.

 Any work accepted by us in the course of a month will be first credited against the regular monthly payment specified above and, if the value of such work exceeds this minimum monthly payment, we shall pay you the difference as soon as practicable (a reasonable time being allowed for the exchange of correspondence between our Paris and New York Offices).

 Under this arrangement, should the value of your work accepted by us during the life of this contract exceed the amount of the minimum annual guaranty, you will be compensated automatically through the above provision of monthly adjustments.

 Should we, however, be unable to fulfill this minimum guaranty through failure on our part to give you sufficient volume of work, we shall nevertheless pay you at the end of this contract whatever difference will be due you in order to bring up your earnings to the total minimum guaranty specified above.

 If, however, during the life of this contract, due to protracted illness on your part, or due to some other factors entirely dependent upon you which may prevent us from fulfilling the minimum guaranty above specified, you agree that in such a case an adjustment shall be made in the amount of such guaranty, in accordance with an agreement to be reached between us at the time.

 You agree to give us the first option for the renewal of this contract for a further period of one year or years, notice for such renewal to be mutually given not later than October 31st, 1935.

 In consideration of the above provisions, you agree to do no work whatsoever for any competitive publications and specifically for any magazines or newspapers owned or controlled directly or indirectly by W.R. Hearst or any of his representatives.

 If you are in accord with the above provisions, kindly sign the enclosed copy of this letter, which will thus constitute a binding agreement between us.

 Yours very truly

Lu & Accepté *Christian Biard*

Christian Berard
ISVP/SD

 I.S.V. Patcevitch
 Administrateur Délégué.

(x): It is further understood that the price of $200. per cover may be augmented to $250. per cover upon the publication of the first cover submitted by you to us. At that time we shall exchange letters amending the present contract to give effect to this change in prices per cover.

D1078

AGHA to CHASE

............No............

To be noted by
.............................

Referring to

Date Feb. 26, 1930No..............

Subject: American Vogue compared with Frog

I liked the February issue of French Vogue very much.
The general impression is still a little bit weak and
colourless, but on the whole, the magazine makes a
clean, dignified, and well-planned impression. I think
that that well-organized criticism begins at home. And
I intend to take this opportunity to compare the French
issue with our own March 1st issue of American Vogue.

I find it simply dreadful, and feel that several of our
recent issues have been bad. My opinion is confirmed
by 2 different sources: Mr. de Brunhoff, in his letter,
said he noticed that the pages of American Vogue are
getting more and more crowded; Benito in his letter to
Mrs. Snow says he finds that after the first 6 months
since the introduction of the new make-up, the develop-
ment of American Vogue stopped, and that now we are go-
ing backwards. This is more or less true and we must do
something about it.

I think that the bad appearance of the last issues is
partly due to the fact that our strict critical attitude
in regard to the editorial material is relaxed, and,
quite often, we arrange pages with things that are not
at all suitable to be used together, or, even that should
not be used at all. This concerns especially: (1) Paris
material. (2) Stage Pages. (3) Interior Decoration
Pages. (4) Snapshots.

The reason for this is that we have less control over
the creation of the material mentioned above than, for
instance, over fashion pages created in America, or over
illustrated articles which we can plan beforehand.

On the contrary, Paris material is often not planned at

............to............

D1078

AGHA to CHASE

............No............

To be noted by
.............................

Referring to

Date Feb. 26, 1930No..............

-2-

Subject: American Vogue compared with Frog (Cont.)

all, or planned in an entirely different manner from
that which we are obliged to use in American Vogue.
One case of Paris material not planned (Details by
Woodruff) is described in the attached memorandum.

Another case is found on pages 70 and 71 of February
Frog - which are very nice. We were obliged, however,
to use the same drawings with an article, and our
pages are too crowded, and the charm of light drawings
is lost. (see A. Vogue Feb. 15, pp. 86 & 87)

My suggestions for the improvement of the stage and
snapshot pages are given in the attached criticism of
our March 1st issue.

The interior decoration pages in the last issues were
often composed from unsatisfactory photographs. It is
a good policy to give large space to a beautiful photo-
graph; but, in the case of ordinary photographs, I
think it advisable to put several on one page and have
plenty of information at least. Often we can not do
that, however, because the choice of photographs is not
large enough.

Copy to: Mrs. Snow
 Mr. Nast

MFA/rn

cat. 56 February 26, 1930. "American *Vogue* compared with *Frog*": memo from Dr. Mehemed
Fehmy Agha to Edna Woolman Chase, copies to Carmel Snow and Condé Nast

· V O G U E ·

LES ÉDITIONS CONDÉ NAST

SOCIÉTÉ ANONYME AU CAPITAL DE 1.300.000 FRANCS

RÉPERTOIRE DES PRODUCTEURS N° 33.798 SEINE C.A.

REGISTRE DU COMMERCE SEINE N° 168.791

65, AVENUE DES CHAMPS-ELYSÉES

PARIS

Le 31 Mai 1940

My dear Condé,

First of all, thank you _so_ much for all your friendly
messages in the abominable moment we are going through.

We held up the June Frog issue, which was ready to go
to press three weeks ago, exactly on the day of the German invasion,
till yesterday when Kernan and I went to see Lelong; we then finally
decided it not to publish the number. I am so sorry about it
because I think it certainly was one of the most brilliant issues
realized in Paris. It contained seventy advertising pages including
a Couturier Portfolio of twelve splendid two-colour pages by Eric, and
four Jewellers pages in duotone and gold.

Financially, it should have been a success, as the
Government seemed ready to give us a subvention of Frs: 150.000.-
to acknowledge our efforts to help the Exportation; the advertising
subscriptions came in beautifully in spite of the war, and the
sale results was sure to be important since Femina has disappeared
since the beginning of the war.

If we finally decided to stop the publication in spite
of the involved costs of editorial contents, blocks, composition, etc.,
that is because it would have now given us no benefit, either financial
nor moral: We risked not to be paid for most of the announcements,
it would have been silly to use up a large portion of the small
paper stock we still have and, from the moral point of view, the time
has gone past the moment when we had to defend our de-luxe trade.
All the efforts of the nation tend solely towards armament, the clothing
of our soldiers, and the charity work that has become a gigantic task
since the horrible exodus of the Belgium and North of France populations.

In spite of the smashing sequence of disastrous news during
this month of May, the country is extraordinarily calm and fully
determined to fight on the Somme and the Aisne, even on the Seine and
the Marne if necessary. The news seem better since the last 48 hours about
the Northern English and French armies which the Belgian treason put
in a dramatic situation. I must say that all Paris only thought of the
horrible position of these armies which found themselves between fire
and water.

*If the front
stabilizes itself
this situation will
be straightened.*

— 2 —

I am leaving to-night to take new dispositions for my
wife and children which were in my villa near Deauville. Once this
problem solved, I will come back to see what is possible to arrange
to maintain a regular connection and try to send you from time to
time features and illustrations that might interest your readers.
But the subjects become more and more difficult, because the
dramatic things are really too much so, and the futile things are
impossible, at least for some time.

By same mail, I am writing to Edna to advise her of the
dispositions the Couture intends to make to face the events. Of course,
we shall do the necessary to be on the spot if these projects are
realized.

Croyez, mon cher Condé, à tout mon dévouement.

Michel

Condé Nast, Esq.,
VOGUE
NEW YORK OFFICE
N.Y.

VOGUE

LES ÉDITIONS CONDÉ NAST S.A.

4 PLACE DU PALAIS BOURBON PARIS 7

TÉLÉPHONE : INV. 64-65 • TÉLÉGR. VOPAR-PARIS

Monsieur Yves Mathieu St. Laurent
11, rue de Stora, Le 19 Août 1954
ORAN, Algérie

Mon cher Yves,

 Je m'excuse de ne répondre qu'aujourd'hui à votre
lettre qui est arrivée au moment de la folie des collections.

 Si vraiment vous voulez apprendre la couture, il
serait très intéressant que vous passiez un an à l'école professionnelle
du Syndicat de la Couture dont je vous envoie un programme.

 Si vous décidez d'y entrer, prévenez-moi de façon que
je vous recommande chaudement à la directrice. Je sais en effet que
les places sont assez limitées et peut-être qu'un mot de moi vous
facilitera votre entrée.

 Il vous serait possible, je crois, d'essayer de vendre
un certain nombre de croquis au couturiers, tout en suivant les
cours de l'école, ceci pour vous faire un peu d'argent de poche.
De toute façon, vous ne perdrez pas votre temps: que vous fassiez
de la couture, du décor de théâtre, etc, il vous sera très utile,
sinon indispensable de connaître la coupe.

 Je vous serre les mains,

Michel de Brunhoff,

Société Anonyme au Capital de 1.300.000 fr. - R. Prod. 23728 Seine C. A. - Reg. du Commerce 169791

Le 31 Août 1954.

Cher monsieur

Je viens de recevoir votre lettre et vous en remercie vivement. Ainsi donc, comme vous me l'aviez conseillé à Paris, je vais m'inscrire à l'École de Coupe et de couture et je vous demanderai, si nécessaire, de bien vouloir appuyer mon inscription.

Mon père qui doit se rendre à Paris dans la deuxième semaine de Septembre se permettra de vous rendre visite et pourra se renseigner sur les formalités d'Inscription

Je m'excuse encore de vous mettre ainsi à contribution et en vous remerciant encore je vous prie de croire, cher monsieur à mes meilleurs sentiments. et de présenter mes respectueux hommages à madame de Brunhoff.

Yves Mathieu Saint Laurent

EXHIBITED WORKS

PART I

PHOTOGRAPHS AND ILLUSTRATIONS

cat. 1

Helen Dryden
(1882–1972)
[Untitled]
Watercolor and ink on paper,
59.7 × 48.3 cm
New York, Condé Nast Archives

American *Vogue*,
June 1, 1920, cover
and *Vogue Paris*,
June 15, 1920, cover

cat. 2

Wladimir Rehbinder
(1878–1953)
Jane Renouardt in *Une sacrée
petite blonde* by Pierre Wolff
and André Birabeau.
Jeanne Lanvin dress
Gelatin silver print, 27.9 × 22.9 cm
New York, Condé Nast Archives

Vogue Paris,
February 1, 1922, p. 17
Repr. p. 25

cat. 3

Wladimir Rehbinder
(1878–1953)
Madame Stoïcesco
(née Simone de Caillavet).
Lucien Lelong dress
Gelatin silver print mounted
on cardboard, 39 × 29.5 cm
Lille, Librairie Diktats

Vogue Paris,
August 1922, p. 2
and American *Vogue*,
September 1, 1922,
p. 51

cat. 4

Adolphe de Meyer
(1868–1946)
Elsie Ferguson.
Callot Sisters dress
Gelatin silver print, 24.1 × 19 cm
New York, Condé Nast Archives

American *Vogue*,
February 1, 1921, p. 40
and *Vogue Paris*,
February 15, 1921, p. 16
Repr. p. 26

cat. 5

Adolphe de Meyer
(1868–1946)
Jeanne Eagels.
Chéruit evening cape
Gelatin silver print, 19 × 24.1 cm
New York, Condé Nast Archives

American *Vogue*,
February 1, 1921, p. 33
and *Vogue Paris*,
February 15, 1921, p. 9
Repr. p. 27

cat. 6

Adolphe de Meyer
(1868–1946)
Jeanne Eagels.
Chéruit dress
Gelatin silver print, 19 × 22.9 cm
New York, Condé Nast Archives

American *Vogue*,
February 1, 1921, p. 33
and *Vogue Paris*,
February 15, 1921, p. 9
Repr. p. 27

cat. 7

Georges Lepape
(1887–1971)
Evening coat
India ink and watercolor on paper,
40.6 × 31.8 cm
New York, Condé Nast Archives

American *Vogue*,
October 15, 1920,
cover and *Vogue Paris*,
November 1, 1920,
cover
Repr. p. 21

cat. 8

Georges Lepape
(1887–1971)
Hunting gear
Watercolor, ink and gouache
on paper, 40.6 × 32.4 cm
New York, Condé Nast Archives

American *Vogue*,
January 15, 1923,
cover and *Vogue Paris*,
February 1923, cover

cat. 9

Georges Lepape
(1887–1971)
"La loge de Françoise."
Chéruit dress
Watercolor and ink on paper,
41.9 × 33 cm
New York, Condé Nast Archives

Vogue Paris,
November 1922, p. 16
and American *Vogue*,
January 1, 1923, p. 82
Repr. p. 24

cat. 10

Edward Steichen
(1879–1973)
Madame Lucien Lelong
(née Princess Natalie Paley).
Lucien Lelong dress, Maria Guy hat
Gelatin silver print, 22.9 × 17.8 cm
New York, Condé Nast Archives

American *Vogue*,
January 15, 1928, p. 58
and *Vogue Paris*,
March 1928, p. 22

cat. 11

Edward Steichen
(1879–1973)
Marion Morehouse.
Madeleine Vionnet coat,
Cartier jewelry
Gelatin silver print, 25.4 × 20.3 cm
New York, Condé Nast Archives

American *Vogue*,
October 27, 1930, p. 42
and *Vogue Paris*,
January 1931, p. 44
Repr. p. 30

cat. 12

**George Hoyningen-
Huene** (1900–1968)
Brigitte Helm in *L'Argent*
by Marcel L'Herbier (1929).
Louise Boulanger dress
Gelatin silver print, 22.5 × 15.6 cm
Vogue Paris Archives

Vogue Paris,
October 1928, p. 39
and American *Vogue*,
February 16, 1929, p. 70
Repr. p. 32

cat. 13

**George Hoyningen-
Huene** (1900–1968)
Toto Koopman.
Augustabernard dress
Gelatin silver print, 24.1 × 17.8 cm
New York, Condé Nast Archives

American *Vogue*,
September 15, 1933,
p. 31 and *Vogue Paris*,
October 1933, p. 22
Repr. p. 33

cat. 14

Benito (1891–1981)
Mainbocher evening dress
Gouache and watercolor on paper,
41.3 × 27.3 cm
New York, Condé Nast Archives

Vogue Paris,
January 1932, p. 28
and American *Vogue*,
January 15, 1932, p. 56

cat. 15

**George Hoyningen-
Huene** (1900–1968)
Sonia Colmer.
Madeleine Vionnet dress
Gelatin silver print, 17.8 × 24.1 cm
New York, Condé Nast Archives

Vogue Paris,
November 1931, p. 24
and American *Vogue*,
November 15, 1931,
p. 44
Repr. p. 34

cat. 16

**George Hoyningen-
Huene** (1900–1968)
Sonia Colmer.
Madeleine Vionnet dress
Gelatin silver print, 17.8 × 24.1 cm
New York, Condé Nast Archives

Vogue Paris,
November 1931, p. 25
and American *Vogue*,
November 15, 1931,
p. 45
Repr. p. 35

cat. 17

Christian Bérard
(1902–1949)
Alix dress
Gouache and India ink on paper,
34 × 25 cm
Paris, Palais Galliera

Vogue Paris,
October 1937, p. 113
Repr. p. 37

cat. 18

Horst P. Horst
(1906–1999)
"Le point de vue de Vogue."
Décor Emilio Terry
Gelatin silver print mounted
on paper, 27 × 16.5 cm
Vogue Paris Archives

American *Vogue*,
March 15, 1936, p. 66
and *Vogue Paris*,
April 1936, p. 31
Repr. p. 36 bottom

cat. 19

André Durst
(1907–1949)
Agneta Fischer.
Maggy Rouff dress
Gelatin silver print, 24.1 × 17.8 cm
New York, Condé Nast Archives

Vogue Paris,
January 1937, p. 19
and American *Vogue*,
January 1, 1937, p. 52.

cat. 20

Horst P. Horst
(1906–1999)
Cora Hemmet.
Worth dress
Gelatin silver print mounted
on paper, 25.9 × 16.5 cm
Vogue Paris Archives

Vogue Paris,
October 1935, p. 32
Repr. p. 38

cat. 21

Horst P. Horst
(1906–1999)
Sheldon, Louise.
Mainbocher dress
Gelatin silver print mounted
on paper, 25.5 × 16.5 cm
Vogue Paris Archives

Vogue Paris,
March 1936, p. 46
and American *Vogue*,
March 1, 1936, p. 55
Repr. p. 39

cat. 22

Horst P. Horst
(1906–1999)
Comtesse de la Falaise. Creed suit,
Reboux hat
Gelatin silver print, 22.1 × 16.3 cm
Vogue Paris Archives

Vogue Paris,
August 1934, p. 20
Repr. p. 40 left

cat. 23

Horst P. Horst
(1906–1999)
Worth dress and coat, bronze
statue by Baguès
Gelatin silver print, 22.4 × 16.4 cm
Vogue Paris Archives

Vogue Paris,
August 1934, p. 44
Repr. p. 40 right

cat. 24

René Bouët-Willaumez
(1900–1979)
Suzanne Talbot scarf and hat
Watercolor and India ink on paper,
46 × 36.5 cm
Paris, Palais Galliera

Vogue Paris,
February 1935, p. 39
Repr. p. 41

cat. 25

Pierre Mourgue
(1890–1969)
"L'automne à Paris"
Gouache and watercolor on paper,
36.2 × 27.9 cm
New York, Condé Nast Archives

Vogue Paris,
November 1932, cover
and American *Vogue*,
November 1, 1932,
cover
Repr. p. 43

cat. 26

René Bouët-Willaumez
(1900–1979)
Mainbocher ensembles
India ink on paper, 49.5 × 39 cm
Paris, Palais Galliera

Vogue Paris,
October 1935, p. 60

cat. 27

**Carl Erickson, known
as Eric** (1891–1958)
Maria Guy hat, Worth scarf (left).
Agnès hat, Schiaparelli scarf (right)
Pencil, India ink and watercolor
on paper. 29.2 × 29.2 cm
New York, Condé Nast Archives

Vogue Paris,
March 1932, p. 27
and American *Vogue*,
March 15, 1932, p. 59
Repr. p. 42 top

cat. 28

**George Hoyningen-
Huene** (1900–1968)
Augustabernard and O'Rossen
suits
Gelatin silver print, 17.8 × 24.1 cm
New York, Condé Nast Archives

Vogue Paris, April 1929,
p. 6 and American
Vogue, May 11, 1929,
p. 109

cat. 29

**George Hoyningen-
Huene** (1900–1968)
Beer beach ensemble
Gelatin silver print, 17.8 × 24.1 cm
New York, Condé Nast Archives

Vogue Paris, July 1928,
p. 17 and American
Vogue, July 1, 1928,
p. 41
Repr. p. 45 top

cat. 30

**George Hoyningen-
Huene** (1900–1968)
Jean Patou swimwear
Gelatin silver print, 24.1 × 17.8 cm
New York, Condé Nast Archives

Vogue Paris, July 1929,
p. 52 and American
Vogue, July 6, 1929,
p. 43
Repr. p. 45 left

cat. 31

**George Hoyningen-
Huene** (1900–1968)
Hermès swimwear
Gelatin silver print, 22.9 × 19 cm
New York, Condé Nast Archives

Vogue Paris, July 1929,
p. 53 and American
Vogue, July 6, 1929,
p. 43
Repr. p. 45 right

cat. 32

Raymond Bret-Koch
(1902–1996)
Au Grand Frédéric swimwear,
Irande beach pajamas, Schiaparelli
ensemble, Hermès accessories.
India ink and wash drawing,
28.6 × 31.8 cm
New York, Condé Nast Archives

Vogue Paris, July 1929,
p. 54 and American
Vogue, July 6, 1929,
p. 45
Repr. p. 44

cat. 33

Vogue Studio
Cora Hemmet.
Klytia Beauty Institute
Gelatin silver print mounted
on paper, 27.6 × 16.5 cm
Vogue Paris Archives

Vogue Paris, July 1935,
p. 7

cat. 34

**George Hoyningen-
Huene** (1900–1968)
Marguerite Jay slip
Gelatin silver print, 26.7 × 21 cm
New York, Condé Nast Archives

American *Vogue*,
November 15, 1931,
p. 74 and *Vogue Paris*,
January 1932, p. 46
Repr. p. 46 top

cat. 35

George Hoyningen-Huene (1900–1968)

Siégel mannequin, Marie Alphonsine beret, Jean Patou coat
Gelatin silver print, 22.9 × 16.5 cm
New York, Condé Nast Archives

Vogue Paris, September 1928, p. 11 and American *Vogue*, September 15, 1928, p. 73

Repr. p. 47

cat. 36

Léopold "Alix" Zeilinger (1897–1990)

Gouache and India ink, 43.2 × 33 cm
New York, Condé Nast Archives

American *Vogue*, November 1, 1934, cover and *Vogue Paris*, January 1935, cover

Repr. p. 49

cat. 37

George Hoyningen-Huene (1900–1968)

René Clair
Gelatin silver print mounted on paper, 26.3 × 16.5 cm
Vogue Paris Archives

Vogue Paris, June 1929, p. 35

cat. 38

Horst P. Horst (1906–1999)

Jean Marais in *Les Chevaliers de la Table ronde* by Jean Cocteau
Gelatin silver print mounted on paper, 26.9 × 17 cm
Vogue Paris Archives

Vogue Paris, December 1937, p. 49

cat. 39

Man Ray (1890–1976)

Self-portrait with Meret Oppenheim, 1930
Gelatin silver print, 15.6 × 13 cm
Vogue Paris Archives

Repr. p. 53

cat. 40

George Hoyningen-Huene (1900–1968)

Max Jacob, November 25, 1931
Gelatin silver print, 23.5 × 16.2 cm
Vogue Paris Archives

cat. 41

Studio Lipnitzki (Boris Lipnitzki, 1887–1971)

Jean Cocteau (1934)
Gelatin silver print, 26.9 × 20.9 cm
Vogue Paris Archives

Repr. p. 56

cat. 42

Horst P. Horst (1906–1999)

Vicomtesse de Noailles. Schiaparelli ensemble, Suzy hat
Gelatin silver print mounted on paper, 27 × 16.5 cm
Vogue Paris Archives

Vogue Paris, July 1935, p. 28 and American *Vogue*, July 1, 1935, p. 28

Repr. p. 50 right

cat. 43

Horst P. Horst (1906–1999)

Countess Alexandre de Castéja. Georgette Rénal ensemble, Suzanne Talbot hat
Gelatin silver print mounted on paper, 25.7 × 16.5 cm
Vogue Paris Archives

Vogue Paris, July 1935, p. 29 and American *Vogue*, July 1, 1935, p. 26 (variation)

Repr. p. 50 left

cat. 44

Horst P. Horst (1906–1999)

Madame Max Ernst (Marie-Berthe Aurenche). Herz jewelry
Gelatin silver print mounted on paper, 27 × 16.5 cm
Vogue Paris Archives

American *Vogue*, July 1, 1935, p. 51 and *Vogue Paris*, September 1935, p. 41

Repr. p. 51

cat. 45

André Kertész (1894–1985)

Paris, c. 1925
Gelatin silver print, 23.9 × 18 cm
Vogue Paris Archives

cat. 46

Horst P. Horst (1906–1999)

Doris Lyla Zelensky. Robert Piguet ensemble Suzanne Talbot hat
Gelatin silver print mounted on paper, 25.5 × 16.5 cm
Vogue Paris Archives

Vogue Paris, March 1936, p. 54

Repr. p. 18 top

cat. 47

Horst P. Horst (1906–1999)

Doris Lyla Zelensky. Robert Piguet ensemble, Suzanne Talbot hat
Gelatin silver print mounted on paper, 25.6 × 16.5 cm
Vogue Paris Archives

American *Vogue*, March 1, 1936, p. 67

Repr. p. 18 bottom

cat. 48

Horst P. Horst (1906–1999)

Countess of Beauchamp. Vionnet dress, Reboux hat
Gelatin silver print, 22.5 × 16 cm
Vogue Paris Archives

Vogue Paris, March 1935, p. 56

cat. 49

Roger Schall (1904–1995)

Report published in *Life*, September 6, 1937
Vogue's teams following the Fall/Winter 1937 Haute Couture collections.
From left to right:
1. Countess Bouët-Willaumez, Duchesse d'Ayen, Michel de Brunhoff
2. Horst P. Horst photographing a dress by Molyneux
3. Christian Bérard
4. André Durst
Gelatin silver prints, 2021, 15 × 15 cm each
Roger Schall collections

Repr. cover sheets

cat. 50

George Hoyningen-Huene (1900–1968)

Back of an image taken in the *Vogue Paris* studio on September 3, 1931
Gelatin silver print, 26.6 × 21 cm
New York, Condé Nast Archives

American *Vogue*, November 15, 1931, p. 75 and *Vogue Paris*, January 1932, p. 47

Repr. p. 297

DOCUMENTS

cat. 51

January 27, 1930

Memo from Edna Woolman Chase to Michel de Brunhoff and Lucien Vogel
Facsimile, 21 × 14.8 cm
New York, Condé Nast Archives

cat. 52

January 15, 1930

Memo from Dr. Mehemed Fehmy Agha to Edna Woolman Chase
Facsimile, 29.7 × 21 cm
New York, Condé Nast Archives

cat. 53

April 4, 1938

Letter from Michel de Brunhoff to Condé Nast
Facsimile, 29.7 × 21 cm
New York, Condé Nast Archives

cat. 54

April 13, 1938

Letter from Edna Woolman Chase and Dr. Mehemed Fehmy Agha to Michel de Brunhoff
Facsimile, 29.7 × 21 cm
New York, Condé Nast Archives

cat. 55

January 18, 1935

Christian Bérard's first contract with Condé Nast Publications
Ink on paper, 27.1 × 21 cm
Paris, Bibliothèque Nationale de France

Repr. pp. 298–299

cat. 56

February 26, 1930

"American *Vogue* compared with *Frog*": memo from Dr. Mehemed Fehmy Agha to Edna Woolman Chase, copies to Carmel Snow and Condé Nast
Facsimile, 29.7 × 21 cm
New York, Condé Nast Archives

Repr. p. 300

CLOTHING

cat. 57

Schiaparelli, Fall/Winter 1927

Front of wool sweater
Paris, Palais Galliera

Vogue Paris, December 1927, p. 9

cat. 58

Schiaparelli, Fall/Winter 1938

"Phoebus" evening cape crêpe de Chine, silk, lamé, sequins, gold threads
Paris, Palais Galliera

Vogue Paris, November 1938, p. 41

cat. 59

Schiaparelli, Fall/Winter 1938

Evening jacket
Crêpe de soie
Paris, Palais Galliera

Vogue Paris, November 1938, p. 41

MAGAZINES

cat. 60

Helen Dryden (1882–1972)

American *Vogue*, June 1, 1920, cover
Paris, Palais Galliera

Repr. p. 22

cat. 61

Helen Dryden (1882–1972)

Vogue Paris, June 15, 1920, cover
Paris, Palais Galliera

Repr. p. 23

cat. 62

Adolphe de Meyer (1868–1946)

Vogue Paris, December 1, 1920, pp. 6–7

Paris, Palais Galliera

cat. 63

Man Ray (1890–1976) and Colette (1873–1954)

Vogue Paris, May 1925, pp. 30–31

Vogue Paris Archives

Repr. p. 52 bottom

cat. 64

Man Ray (1890–1976)

Vogue Paris, May 1926, pp. 36–37

Paris, Palais Galliera

Repr. p. 55

cat. 65

Douglas Pollard (dates unknown)

Vogue Paris, July 1926, pp. 26–27

Paris, Palais Galliera

Repr. p. 29 top

cat. 66

Douglas Pollard (dates unknown)

Vogue Paris, December 1927, pp. 8–9

Vogue Paris Archives

cat. 67

George Hoyningen-Huene (1900–1968)

Vogue Paris, May 1928, pp. 24–25

Vogue Paris Archives

Repr. p. 42 bottom

cat. 68

André Durst (1907–1949)

Vogue Paris, September 1933, pp. 26–27

Paris, Palais Galliera

Repr. p. 52 top

cat. 69

Edward Steichen (1879–1973)

Vogue Paris, July 1934, pp. 16–17

Paris, Palais Galliera

Repr. p. 46 bottom

cat. 70

Roger Schall (1904–1995)

Vogue Paris, December 1936, pp. 30–31

Paris, Palais Galliera

Repr. p. 150 bottom

cat. 71

Cecil Beaton (1904–1980)

Vogue Paris, December 1936, pp. 58–59

Vogue Paris Archives

Repr. p. 36 top

cat. 72

Christian Bérard (1902–1949)

Vogue Paris, November 1938, pp. 40–41

Paris, Palais Galliera

PART II

PHOTOGRAPHS AND ILLUSTRATIONS

cat. 73

**André Durst
(1907–1949)**

Arletty. Schiaparelli ensemble, Reboux hat
Gelatin silver print, 22.8 × 16.9 cm
Vogue Paris Archives

Vogue Paris, May 1939, p. 36

Repr. p. 77

cat. 74

**Christian Bérard
(1902–1949)**

Schiaparelli dress
India ink, gouache, graphite pencil on Canson vellum paper, 51.8 × 36.2 cm
Michel de Brunhoff Collection

Vogue Paris, April 1939, p. 61

Repr. p. 76

cat. 75

**André Durst
(1907–1949)**

Lisa Fonssagrives (left). Jean Patou dresses
Gelatin silver print, 22.1 × 16.1 cm
Vogue Paris Archives

Vogue Paris, March 1939, p. 39

cat. 76

**André Durst
(1907–1949)**

Ludmila Feodoseyevna. Jacques Heim dress
Gelatin silver print mounted on paper, 25.9 × 16.8 cm
Vogue Paris Archives

Vogue Paris, April 1939, p. 53

Repr. p. 75 right

cat. 77

**André Durst
(1907–1949)**

Andrée Lorain, Marcelle Dormoy dress. Mme Chauvière, Lucien Lelong dress
Gelatin silver print, 22.8 × 16.7 cm
Vogue Paris Archives

Vogue Paris, April 1939, p. 59

Repr. p. 75 left

cat. 78

**André Durst
(1907–1949)**

Lisa Fonssagrives. Vincent hairstyle
Gelatin silver print mounted on paper, 25.4 × 16.5 cm
Vogue Paris Archives

Vogue Paris, March 1939, p. 47

Repr. p. 80

cat. 79

**René Bouët-Willaumez
(1900–1979)**

Lanvin dress
Gouache, India ink, and graphite pencil on paper, 50 × 40 cm
Paris, Palais Galliera

Vogue Paris, October 1939, unpublished issue and American *Vogue*, October 1, 1939, p. 50

cat. 80

**Christian Bérard
(1902–1949)**

[Untitled]
Gouache and India ink on paper, 33 × 26 cm
Paris, Palais Galliera

Vogue Paris, December 1939, cover

Repr. p. 67

cat. 81

**Émile Savitry
(1903–1967)**

Marcel Dhorme trench coat
Gelatin silver print, 21 × 17.2 cm
Vogue Paris Archives

Vogue Paris, winter 1945–1946, p. 133 and American *Vogue*, December 1, 1945, p. 174

Repr. p. 90

cat. 82

**Cecil Beaton
(1904–1980)**

Pierre Balmain jacket and trousers
Gelatin silver print, 23.2 × 17 cm
Vogue Paris Archives

Vogue Paris, Winter 1945–1946, p. 156 and American *Vogue*, December 15, 1945, p. 59 (variation)

Repr. p. 91

cat. 83

**John Rawlings
(1912–1970)**

Molyneux frock coat
Inkjet pigment print on Hahnemühle Baryta paper, 2021, 25 × 20 cm
New York, Condé Nast Archives

American *Vogue*, October 15, 1946, p. 181 and *Vogue Paris*, January/February 1947, p. 83

Repr. p. 92 left

cat. 84

**John Rawlings
(1912–1970)**

Schiaparelli ensemble
Inkjet pigment print on Hahnemühle Baryta paper, 2021, 25 × 20 cm
New York, Condé Nast Archives

American *Vogue*, October 15, 1946, p. 1 and *Vogue Paris*, January/February 1947, p. 82

cat. 85

**John Rawlings
(1912–1970)**

Wenda Rogerson Parkinson. Robert Piguet jacket
Inkjet pigment print on Hahnemühle Baryta paper, 2021, 25 × 20 cm
New York, Condé Nast Archives

American *Vogue*, October 15, 1946, p. 183 and *Vogue Paris*, January/February 1947, p. 82

Repr. p. 92 right

cat. 86

**Serge Balkin
(1905–1990)**

Pierre Balmain suit, Albouy hat
Gelatin silver print, 25.5 × 20.8 cm
Vogue Paris Archives

Vogue Paris, May/June 1947, p. 113

Repr. p. 90

cat. 87

**Clifford Coffin
(1913–1972)**

Wenda Rogerson Parkinson. Jacques Griffe coat, Legroux Sisters hat
Gelatin silver print, 24.5 × 20.7 cm
Vogue Paris Archives

Vogue Paris, October/November 1948, p. 84

cat. 88

**Clifford Coffin
(1913–1972)**

Régine Debrise. Schiaparelli evening coat
Gelatin silver print, 30 × 24 cm
Vogue Paris Archives

Vogue Paris, May 1948, p. 34

cat. 89

**Clifford Coffin
(1913–1972)**

Wenda Rogerson Parkinson. Christian Dior evening dress and coat. Grand staircase of the Opera Garnier
Gelatin silver print, 30 × 23.9 cm
Vogue Paris Archives

Vogue Paris, May 1948, p. 28

Repr. p. 97

cat. 90

**Robert Randall
(1918–1984)**

Bettina and Marie-Claire Lafaurie. Jeanne Lafaurie ensembles (left) and Madeleine de Rauch (right)
Gelatin silver print, 25.7 × 20.2 cm
Vogue Paris Archives

Vogue Paris, May 1950, p. 77

Repr. p. 95

cat. 91

**Robert Randall
(1918–1984)**

Raphael suit
Gelatin silver print, 28 × 35.5 cm
Vogue Paris Archives

Vogue Paris, June 1951, p. 48

cat. 92

**Robert Randall
(1918–1984)**

Marie-Claire Lafaurie. Jeanne Lafaurie suit
Gelatin silver print, 27.9 × 35.3 cm
Vogue Paris Archives

Vogue Paris, June 1951, p. 47

cat. 93

Arik Nepo (1913–1961)

Marie-Christiane hat
Gelatin silver print, 27.8 × 35.3 cm
Vogue Paris Archives

Vogue Paris, September 1951, p. 108

Repr. p. 94 bottom

cat. 94

Arik Nepo (1913–1961)

Bettina. Achilles hat
Gelatin silver print, 17.7 × 28 cm
Vogue Paris Archives

Vogue Paris, September 1951, p. 109

Repr. p. 94 top

cat. 95

**Irving Penn
(1917–2009)**

Régine Debrise. Molyneux ensemble
Gelatin silver print, 35.4 × 27.9 cm
Vogue Paris Archives

American *Vogue*, September 1, 1950, p. 135 and *Vogue Paris*, October 1950, p. 91

cat. 96

**Irving Penn
(1917–2009)**

Lisa Fonssagrives. Balenciaga coat
Gelatin silver print, 35.4 × 27.9 cm
Vogue Paris Archives

Vogue Paris, December 1950, p. 120

Repr. p. 99

cat. 97

**Irving Penn
(1917–2009)**

Bettina. Jacques Claw coat
Gelatin silver print, 35.4 × 27.8 cm
Vogue Paris Archives

Vogue Paris, September 1950, p. 45

cat. 98

**Tom Keogh
(1922–1980)**

[Untitled]
Watercolor, gouache, India ink, graphite pencil, colored pencil on paper, 45.6 × 30 cm
Vogue Paris Archives

Vogue Paris, March 1949, cover

cat. 99

**Tom Keogh
(1922–1980)**

[Untitled]
Watercolor, India ink, graphite pencil, colored pencil on paper, 32.5 × 25 cm
Vogue Paris Archives

Cover project, April 1948

Repr. p. 96

cat. 100

**Tom Keogh
(1922–1980)**

[Untitled]
Watercolor, India ink, graphite pencil, colored pencil on paper, 32.8 × 25 cm
Vogue Paris Archives

Cover project, April 1948

Repr. p. 96

cat. 101

**Tom Keogh
(1922–1980)**

Jacques Griffe evening dresses
Watercolor, India ink, graphite pencil, colored pencil on paper, 39.5 × 27.5 cm
Vogue Paris Archives

Vogue Paris, April 1949, p. 82

cat. 102

**Tom Keogh
(1922–1980)**

"Pantalonnades," Christian Dior and Madeleine de Rauch ensembles
Watercolor, India ink, graphite pencil, pencil on paper, 36.3 × 20 cm
Vogue Paris Archives

Vogue Paris, December 1949, pp. 112–113

cat. 103

**Tom Keogh
(1922–1980)**

Robert Piguet evening dress
Watercolor, India ink, graphite pencil, colored pencil on paper, 38.3 × 28.2 cm
Vogue Paris Archives

Vogue Paris, February 1950, p. 54

cat. 104

Sabine Weiss (b. 1924)

Oriano jersey shorts for Les Galeries Lafayette, Robert Pitte jumpsuit
Gelatin silver print, 20 × 24 cm
Lausanne, Musée de l'Élysée, Sabine Weiss collections

Vogue Paris, July 1953, p. 72

Repr. p. 102 top

cat. 105

Sabine Weiss (b. 1924)

M.-R. Lebigot swimwear, Boutique Jacques Fath hat
Gelatin silver print, 26 × 20.5 cm
Lausanne, Musée de l'Élysée, Sabine Weiss collections

Vogue Paris, June 1954, p. 21

Repr. p. 102 bottom

cat. 106

**Henry Clarke
(1918–1996)**

Bettina. Lanvin-Castillo-Boutique Dress, Paulette hat. Monte Carlo
Gelatin silver print, 35.4 × 28.2 cm
Paris, Palais Galliera

Vogue Paris, February 1954, p. 40

Repr. p. 103 top

cat. 107

**Henry Clarke
(1918–1996)**

Régine Debrise. Maggy Rouff-Boutique blouse and skirt. Roquebrune
Inkjet pigment print on Hahnemühle Baryta paper, 2021, 30 × 40 cm
Paris, Palais Galliera

Vogue Paris, June 1951, p. 69

Repr. p. 103 bottom

cat. 108

**Henry Clarke
(1918–1996)**

Suzy Parker. Chanel coat
Gelatin silver print, 35.6 × 28.2 cm
Paris, Palais Galliera

Vogue Paris, July/August 1954, p. 55

cat. 109

**Irving Penn
(1917–2009)**

Lisa Fonssagrives
Inkjet pigment print on Hahnemühle Baryta paper, 2021, 40 × 30 cm
New York, Condé Nast Archives

American *Vogue*, May 1, 1950, p. 84 and *Vogue Paris*, July/August 1952, cover

Repr. p. 101

cat. 110

Carl Erickson, known as Eric (1891–1958)

Grès dress
Watercolor on paper, 87 × 69 cm
Michel de Brunhoff Collection

Vogue Paris,
July/August 1950,
cover

Repr. p. 100

cat. 111

Lee Miller (1907–1977)

From left to right: Model, Michel de Brunhoff, Madame de Séréville, Bernard Blossac, Nicole Lelong and her father Lucien Lelong, in Lucien Lelong's salons, 1944
Gelatin silver print, 2021,
16.5 × 15.2 cm
New York, Condé Nast Archives

American *Vogue*,
December 15, 1944,
p. 29

Repr. cover sheets

cat. 112

Pierre Boulat (1924–1998)

From left to right: Josette Merle d'Aubigné, Edmonde Charles-Roux, Michel de Brunhoff, Arik Nepo, Nina Leclercq, 1948
Gelatin silver print, 22.3 × 25.8 cm
Vogue Paris Archives

Repr. p. 65

cat. 113

Anonymous

Henry Clarke shooting at the Adam studio, rue Boissy-d'Anglas in Paris, for the Fall/Winter 1951 collections, for the French, English, and American editions of *Vogue*. On the left, his assistant Maurice, August 1951
Gelatin silver print, 2021,
20 × 20 cm
Paris, Palais Galliera

Repr. cover sheets

cat. 114

Anonymous

Henry Clarke shooting at the Adam studio, rue Boissy-d'Anglas in Paris, for the Fall/Winter 1951 collections, for the French, English, and American editions of *Vogue*, August 1951
Gelatin silver print, 2021,
20 × 20 cm
Paris, Palais Galliera

cat. 115

John Rawlings (1912–1970)

Gigi Twerlagne. Schiaparelli evening dress
Retouching, 25.7 × 20.2 cm
Vogue Paris Archives

Vogue Paris, April 1951,
p. 75

DOCUMENTS

cat. 116

December 1, 1939

Letter from Michel de Brunhoff to Condé Nast
Facsimile, 29.7 × 21 cm
New York, Condé Nast Archives

cat. 117

May 31, 1940

Letter from Michel de Brunhoff to Condé Nast
Facsimile, 29.7 × 21 cm
New York, Condé Nast Archives

Repr. p. 301

cat. 118

January 8, 1952

Letter from Monsieur Driancourt, Georges Lang printing, to the attention of Monsieur de Croisset, General Director of Condé Nast France; accompanied by a note dated January 11, 1952 from Monsieur de Croisset
Inks on paper, 27.1 × 21 cm
Vogue Paris Archives

cat. 119

November 3, 1953

Sabine Weiss's contract with Condé Nast Publications
Ink on paper, 27 × 21 cm
Sabine Weiss

CLOTHING

cat. 120

Christian Dior, Spring/ Summer 1947

"Bar" ensemble
Jacket in natural shantung, skirt in wool
Replica 1987
Dior Héritage

Vogue Paris,
May/June 1947, p. 96

MAGAZINES

cat. 121

Erwin Blumenfeld (1897–1969)

Vogue Paris, May 1939,
pp. 60–61

Jérôme Gautier Collection

Repr. pp. 78–79

cat. 122

Erwin Blumenfeld (1897–1969)

Vogue Paris, May 1939,
pp. 88–89

Lille, Librairie Diktats

cat. 123

Vogue Paris,
December 1939,
pp. 34–35

Paris, Palais Galliera

cat. 124

Brassaï (1899–1984)

Vogue Paris,
March 1940, pp. 20–21

Paris, Palais Galliera

cat. 125

Christian Bérard (1902–1949)

Vogue Paris,
January 1945, cover

Paris, Palais Galliera

Repr. p. 81

cat. 126

Émile Savitry (1903–1967)

Vogue Paris,
March 1947,
pp. 106–107

Paris, Palais Galliera

cat. 127

Christian Bérard (1902–1949)

Vogue Paris,
May/June 1947,
pp. 96–97

Vogue Paris Archives

Repr. p. 70

cat. 128

Giulio Coltellacci (1916–1983)

Vogue Paris,
May/June 1947, cover

Paris, Palais Galliera

Repr. p. 8

cat. 129

Robert Doisneau (1912–1994)

Vogue Paris, June 1951,
cover

Vogue Paris Archives

Repr. p. 93

cat. 130

Robert Randall (1918–1984)

Vogue Paris,
March 1952, pp. 116–117

Vogue Paris Archives

Repr. p. 104

AUDIO EXTRACT

Michel de Brunhoff (1892–1958)

On the evolution of French fashion since 1945
RTF, August 4, 1954
1 min 40 sec
Institut National de l'Audiovisuel

CULTURAL LIFE

PHOTOGRAPHS

cat. 131

Keystone Agency

Victory of Marcel Cerdan over Tony Zale, final of the World Middleweight Championships, Jersey City, September 21, 1948
Gelatin silver print, 15.3 × 21 cm
Vogue Paris Archives

Vogue Paris,
December 1948/
January 1949,
pp. 110–111

cat. 132

Robert Doisneau (1912–1994)

Alfortville
Gelatin silver print, 24.2 × 18.2 cm
Vogue Paris Archives

Vogue Paris,
November 1949, p. 38

cat. 133

Robert Doisneau (1912–1994)

"La banlieue de Paris"
Gelatin silver print, 23 × 24.5 cm
Vogue Paris Archives

Vogue Paris,
November 1949, p. 35

Repr. p. 73

cat. 134

André Ostier (1906–1994)

Léonor Fini during the Nuit du Pré Catelan, June 1946
Gelatin silver print, 40.4 × 30.4 cm
Vogue Paris Archives

Vogue Paris,
Winter 1946, p. 119

Repr. p. 87

cat. 135

Serge Lido (1906–1984)

Simone de Beauvoir at the Café de Flore
Gelatin silver print, 19.2 × 17 cm
Vogue Paris Archives

Vogue Paris,
July/August 1947, p. 75

Repr. p. 84 top

cat. 136

Lee Miller (1907–1977)

Dylan Thomas, December 1946
Gelatin silver print, 11.4 × 15.7 cm
Vogue Paris Archives

American *Vogue*,
July 15, 1947, p. 36
and *Vogue Paris*,
November 1947, p. 151

cat. 137

B.M. Bernand (dates unknown)

Jean-Louis Barrault in *Hamlet* at the Théâtre Marigny
Gelatin silver print, 36.5 × 30.5 cm
Vogue Paris Archives

American *Vogue*,
January 1, 1947, p. 117
and *Vogue Paris*,
January/February 1947,
p. 89

cat. 138

Robert Randall (1918–1984)

Maria Casarès, Serge Reggiani, and Michel Bouquet in *Les Justes* by Albert Camus, at the Théâtre Hébertot
Gelatin silver print, 35.7 × 26.9 cm
Vogue Paris Archives

Vogue Paris,
March 1950, p. 36

cat. 139

Robert Doisneau (1912–1994)

Juliette Gréco at La Rose Rouge
Gelatin silver print, 24 × 18 cm
Vogue Paris Archives

Vogue Paris,
December 1950/
January 1951, p. 66

Repr. p. 84 bottom

cat. 140

Arik Nepo (1913–1961)

Bernard Buffet at the Salon d'Automne in 1948
Gelatin silver print, 26 × 20.4 cm
Vogue Paris Archives

American *Vogue*,
November 15, 1948,
p. 137 (variation)
and *Vogue Paris*,
December 1948/
January 1949, p. 112

Repr. p. 89

cat. 141

André Ostier (1906–1994)

Marc Chagall in front of his painting *Moi et le Village* at the Musée d'Art Moderne de la Ville de Paris
Gelatin silver print, 25.5 × 20.6 cm
Vogue Paris Archives

Vogue Paris,
December 1947/
January 1948,
pp. 88–89

cat. 142

Robert Doisneau (1912–1994)

Jean Dubuffet in his studio
Gelatin silver print, 25.5 × 24 cm
Vogue Paris Archives

Vogue Paris,
November 1954, p. 55

cat. 143

Sabine Weiss (b. 1924)

George Braque at the Maeght Gallery
Gelatin silver print, 40 × 30 cm
Vogue Paris Archives

Vogue Paris,
October 1958, p. 132

cat. 144

Alexander Liberman (1912–1999)

Pablo Picasso, summer 1965
Gelatin silver print, 39.8 × 30 cm
Vogue Paris Archives

Vogue Paris,
November 1966, p. 102

cat. 145

Robert Doisneau (1912–1994)

Youly Algaroff and Jean Babilée at the Paris Opera
Gelatin silver print, 24.2 × 18.3 cm
Vogue Paris Archives

Vogue Paris,
March 1953, p. 116
and American *Vogue*,
March 15, 1953, p. 72

Repr. p. 88

cat. 146

Robert Doisneau (1912–1994)

Maurice Béjart
Gelatin silver print, 30 × 24.3 cm
Vogue Paris Archives

Vogue Paris, May 1961,
p. 102

cat. 147

Robert Doisneau (1912–1994)

Orson Welles
Gelatin silver print, 24.5 × 18.2 cm
Vogue Paris Archives

Vogue Paris,
February 1950, p. 51

cat. 148

MGM Studio

Marlon Brando in *Julius Caesar* by Joseph L. Mankiewicz
Gelatin silver print, 35.5 × 28.2 cm
Vogue Paris Archives

Vogue Paris,
November 1953, p. 47

cat. 149

William Klein (b. 1928)

Brigitte Bardot
Gelatin silver print, 30.5 × 40.3 cm
Vogue Paris Archives

Vogue Paris,
March 1958,
pp. 182–183

Repr. p. 146 top

cat. 150

Robert Doisneau (1912–1994)

Jean-Paul Belmondo
Gelatin silver print, 30 × 24.2 cm
Vogue Paris Archives

Vogue Paris, May 1960,
p. 94

PART III

PHOTOGRAPHS
AND ILLUSTRATIONS

cat. 189

Hervé Dubly
(1935–2005)

"Un style qui fait la loi"
Watercolor, gouache, ink,
pencils on paper, 44.3 × 32.7 cm
Vogue Paris Archives

Vogue Paris,
August 1963, p. 51

cat. 190

Hervé Dubly
(1935–2005)

"Un style qui fait la loi"
Watercolor, gouache, ink, pencils
on paper, 43.5 × 32.3 cm
Vogue Paris Archives

Vogue Paris,
August 1963, p. 49

Repr. p. 134

cat. 191

Chadwick Hall (b. 1926)

Jill Kennington. Haas & Lambert
and Eric Schäffer ensembles.
Café Kempinski, Berlin
Gelatin silver prints mounted
on cardboard, 38.4 × 48.6 cm
Vogue Paris Archives

Vogue Paris,
October 1966,
pp. 178–179

Repr. p. 145

cat. 192

Helmut Newton
(1920–2004)

Denise Bonan. Gérard Pipart
ensemble. Rio de Janeiro
Gelatin silver print, 29.9 × 19.9 cm
Vogue Paris Archives

Vogue Paris, May 1962,
p. 63

Repr. p. 129

cat. 193

Helmut Newton
(1920–2004)

V de V ensemble
Gelatin silver prints and prints
mounted on cardboard,
retouching, 34.1 × 50.7 cm
Vogue Paris Archives

Vogue Paris,
February 1965,
pp. 38–39

Repr. p. 128 bottom

cat. 194

Roman Cieślewicz
(1930–1996)

"Les Double Face"
Color printing mounted
on cardboard, 33 × 24.8 cm
Roman Cieślewicz/Imec Archives

Vogue Paris,
February 1966, p. 51

Repr. p. 139

cat. 195

Henry Clarke
(1918–1996)

Twiggy. Dorothée Bis dress,
Cartier jewelry
Gelatin silver print mounted
on cardboard, 43.3 × 35.6 cm
Vogue Paris Archives

Vogue Paris, May 1967,
cover

cat. 196

Helmut Newton
(1920–2004)

Jean Seberg. Jacques Dessange
hairstyle
Gelatin silver print, retouching,
32.7 × 24.5 cm
Vogue Paris Archives

Vogue Paris,
March 1967, p. 241

Repr. p. 141

cat. 197

François Giudicelli
(dates unknown)

"Bulletin beauté," hairstyles
India ink on paper, 50 × 32.5 cm
Vogue Paris Archives

Vogue Paris, July 1967,
p. 56

cat. 198

Barney Wan
(dates unknown)

Simonetta and Fabiani dress,
Jeanne Lanvin scarf
Ink, gouache, black pencil
on paper, and ink, black pencil,
red pencil on tracing paper,
49 × 27.5 cm
Vogue Paris Archives

Vogue Paris,
June 1965, p. 49

cat. 199

Helmut Newton
(1920–2004)

Christa Fiedler. Yoyo dress
from Madd, and Cathal ensemble
from Corolles
Gelatin silver prints and prints
mounted on card, 35.5 × 52 cm
Vogue Paris Archives

Vogue Paris,
August 1965,
pp. 34–35

Repr. p. 128 top

cat. 200

Roman Cieślewicz
(1930–1996)

Layout of the *Vogue Paris*
logotype,1966
Cut papers, glued to paper,
29.9 × 21 cm
Roman Cieślewicz Archives/Imec

cat. 201

Guy Bourdin
(1928–1991)

"Chaussures: Mat ou Brillant"
Karl Lagerfeld for Charles Jourdan
shoes
Gelatin silver print mounted
on cardboard, layer, 44 × 32.5 cm
The Guy Bourdin Estate

Vogue Paris,
February 1967, p. 64

Repr. p. 138

cat. 202

Helmut Newton
(1920–2004)

Maggi Eckardt.
Courrèges ensemble
Gelatin silver print and prints
mounted on cardboard,
40.9 × 32.5 cm
Vogue Paris Archives

Vogue Paris,
March 1965, cover

cat. 203

Guy Bourdin
(1928–1991)

Anne Gunning. Svend cap
Gelatin silver print, 34.5 × 23.7 cm
The Guy Bourdin Estate

Vogue Paris,
September 1956, p. 137

cat. 204

Sabine Weiss (b. 1924)

Guy Bourdin at work in the
courtyard of *Vogue Paris*,
4, place du Palais-Bourbon, 1956
Gelatin silver print, 23.9 × 18.1 cm
The Guy Bourdin Estate

Repr. p. 194

cat. 205

Sabine Weiss (b. 1924)

Guy Bourdin at work in the
courtyard of *Vogue Paris*,
4, place du Palais-Bourbon, 1956
Contact board, 21 × 29.7 cm
Sabine Weiss

DOCUMENTS

cat. 206

April 6, 1956

Note from Edmonde Charles-Roux
to William Klein
Inks on paper, 20.9 × 13.6 cm
Private collection

CLOTHING

cat. 207

Courrèges, Spring/
Summer 1965

Double-sided wool satin jacket,
wool and cotton dress, braided hat,
shoes
Groupe Courrèges

Vogue Paris,
March 1965,
pp. 138–139

MAGAZINES

cat. 208

Guy Bourdin
(1928–1991)

Vogue Paris,
February 1955,
pp. 62–63

Vogue Paris Archives

Repr. p. 151 bottom

cat. 209

Sabine Weiss (b. 1924)

Vogue Paris, April 1958,
pp. 144–145

Vogue Paris Archives

cat. 210

Françoise Sagan
(1935–2004)

Vogue Paris,
August 1963, pp. 70–71

Vogue Paris Archives

Repr. p. 144 top

cat. 211

William Klein (b. 1928)

Vogue Paris, March
1965, pp. 138–139

Vogue Paris Archives

Repr. pp. 130–131

cat. 212

Violette Leduc
(1907–1972), Guy
Bourdin (1928–1991)

Vogue Paris,
March 1965,
pp. 152–153

Paris, Palais Galliera

Repr. p. 144 bottom

cat. 213

Guy Bourdin
(1928–1991)

Vogue Paris,
March 1966, cover

Vogue Paris Archives

Repr. p. 136

cat. 214

Guy Bourdin
(1928–1991)

Vogue Paris,
June 1966, pp. 62–63

Vogue Paris Archives

Repr. p. 140

cat. 215

Peter Knapp (b. 1931)

Artistic direction
Roman Cieślewicz

Vogue Paris, July 1966,
pp. 32–33

Paris, Palais Galliera

Repr. p. 152 (top)

cat. 216

Bruno Barbey
(1941–2020)

Vogue Paris, October
1966, pp. 168–169

Vogue Paris Archives

cat. 217

Bob Richardson
(1928–2005)

Vogue Paris, April 1967,
pp. 112–113

Paris, Palais Galliera

CATHERINE DENEUVE

PHOTOGRAPHS

cat. 218

David Bailey (b. 1938)

"Deneuve et David"
Gelatin silver prints mounted
on cardboard, 36 × 49.1 cm
Vogue Paris Archives

Vogue Paris,
September 1966,
pp. 262–263

Repr. p. 142

cat. 219

David Bailey (b. 1938)

Newmarket overcoat
Gelatin silver print, 32.8 × 24.6 cm
Vogue Paris Archives

Vogue Paris, May 1966,
p. 113

Repr. cover and p. 143

cat. 220

Bert Stern (1929–2013)

Carita hairstyle
Gelatin silver print, 43 × 35.8 cm
Vogue Paris Archives

Vogue Paris, May 1964,
p. 73

cat. 221

David Bailey (b. 1938)

Yves Saint Laurent ensemble
Gelatin silver print mounted
on cardboard, 21.2 × 23.6 cm
Vogue Paris Archives

Vogue Paris,
December 1966/
January 1967, p. 3

MAGAZINES

cat. 222

Helmut Newton
(1920–2004)

Vogue Paris, April 1962,
cover

Christian Dior
Vogue Paris Archives

Repr. p. 57

cat. 223

David Bailey (b. 1938)

Vogue Paris,
October 1965, cover

Christian Dior
Paris, Palais Galliera

cat. 224

David Bailey (b. 1938)

Vogue Paris,
December 1966/
January 1967, cover

Yves Saint Laurent
Vogue Paris Archives

cat. 225

David Bailey (b. 1938)

Vogue Paris,
February 1968, cover

Rodier
Paris, Palais Galliera

cat. 226

David Bailey (b. 1938)

Vogue Paris,
February 1969, cover

Yves Saint Laurent
Vogue Paris Archives

cat. 227

Jeanloup Sieff
(1933–2000)

Vogue Paris,
August 1969, cover

Yves Saint Laurent
Vogue Paris Archives

cat. 228

Helmut Newton
(1920–2004)

Vogue Paris,
September 1970, cover

Revillon Boutique, Van Cleef
& Arpels
Vogue Paris Archives

cat. 229

Helmut Newton
(1920–2004)

Vogue Paris,
February 1972, cover

Saint Laurent Rive Gauche
Vogue Paris Archives

cat. 230

Tony Kent
(dates unknown)

Vogue Paris,
November 1972, cover

Yves Saint Laurent
Vogue Paris Archives

cat. 231

Guy Bourdin
(1928–1991)

Vogue Paris,
October 1973, cover

Yves Saint Laurent
Vogue Paris Archives

cat. 232

Helmut Newton
(1920–2004)

Vogue Paris,
October 1974, cover

Yves Saint Laurent
Vogue Paris Archives

cat. 233

Helmut Newton
(1920–2004)

Vogue Paris,
March 1976, cover

Yves Saint Laurent
Vogue Paris Archives

cat. 234

Henry Clarke
(1918–1996)

Vogue Paris,
November 1977, cover

Yves Saint Laurent
Vogue Paris Archives

cat. 235

Albert Watson (b. 1942)

Vogue Paris,
March 1984, cover

Yves Saint Laurent
Vogue Paris Archives

cat. 236

Peter Lindbergh
(1944–2019)

Vogue Paris, May 1991,
cover

Yves Saint Laurent
Vogue Paris Archives

cat. 237

Mario Testino (b. 1954)

Vogue Paris,
December 2003/
January 2004, cover

Lanvin
Vogue Paris Archives

YVES SAINT LAURENT

PHOTOGRAPHS
AND ILLUSTRATIONS

cat. 238

Kammermann-Dalmas

Yves Saint Laurent succeeds
Christian Dior
Gelatin silver print, 21.4 × 33 cm
Vogue Paris Archives

Vogue Paris, March
1958, p. 117

Repr. p. 10

cat. 239

Yves Saint Laurent
(1936–2008)

Hairstyle of the "Les Espagnoles"
Collection (Spring/Summer 1977),
for Alexandre, hairstyle
Graphite pencil and felt on paper,
32 × 12.5 cm
Paris, Yves Saint Laurent Museum

Vogue Paris, April 1977,
p. 120

cat. 240

Yves Saint Laurent
(1936–2008)

Hairstyle of the "Les Espagnoles"
Collection (Spring/Summer 1977),
for Alexandre, hairstyle
Graphite pencil and felt on paper,
32 × 12.5 cm
Paris, Yves Saint Laurent Museum

Vogue Paris, April 1977,
p. 120

cat. 241

Yves Saint Laurent
(1936–2008)

Hairstyle of the "Les Espagnoles"
Collection (Spring/Summer 1977),
for Alexandre, hairstyle
Graphite pencil and felt on paper,
19 × 12.5 cm
Paris, Yves Saint Laurent Museum

Vogue Paris, April 1977,
p. 120

DOCUMENTS

cat. 242

August 19, 1954

Letter from Michel de Brunhoff
to Yves Saint Laurent
Ink on paper, 26.8 × 20.8 cm
Paris, Yves Saint Laurent Museum

Repr. p. 302

cat. 243

August 31, 1954

Letter from Yves Saint Laurent
to Michel de Brunhoff
Ink on paper, 25.7 × 19.6 cm
Paris, Yves Saint Laurent Museum

Repr. p. 303

cat. 244

March 12, 1962

Letter from Françoise Mohrt
to Pierre Bergé
Ink on paper, 27 × 21.1 cm
Paris, Yves Saint Laurent Museum

cat. 245

June 7, 1963

Letter from Jacques Faure
to Gabrielle Busschaert
Ink on paper, 26.8 × 20.8 cm
Paris, Yves Saint Laurent Museum

cat. 246

February 12, 1977

Letter from Françoise Mohrt
to Yves Saint Laurent
Ink on paper, 22.9 × 14.7 cm
Paris, Yves Saint Laurent Museum

CLOTHING

cat. 247

Yves Saint Laurent,
Spring/Summer 1962

Dress in white silk organdy
from Brivet
Paris, Palais Galliera

Vogue Paris,
March 1962, p. 221

cat. 248

Yves Saint Laurent,
Fall/Winter 1965

Mondrian dress in wool jersey
(replica from 2002)
Paris, Yves Saint Laurent Museum

Vogue Paris,
September 1965, cover

Repr. p. 60 bottom right

cat. 249

Yves Saint Laurent,
Spring/Summer 1978

Black gabardine jacket, black
gabardine pants, red satin crêpe
blouse, red straw boater
Paris, Yves Saint Laurent Museum

Vogue Paris,
March 1978, cover

MAGAZINES

cat. 250

William Klein (b. 1928)

Vogue Paris,
March 1962,
pp. 220–221

Paris, Palais Galliera

cat. 251

William Klein (b. 1928)

Vogue Paris, May 1962,
cover

Vogue Paris Archives

cat. 252

David Bailey (b. 1938)

Vogue Paris,
September 1965, cover

Paris, Palais Galliera

Repr. p. 60 bottom right

cat. 253

Helmut Newton
(1920–2004)

Vogue Paris,
March 1978, cover

Vogue Paris Archives

Repr. p. 11

PART IV

PHOTOGRAPHS
AND ILLUSTRATIONS

cat. 254

Urs Landis
(dates unknown)

"Votre passeport couleur."
Makeup Charcoal, gouache
on paper mounted on cardboard,
59.5 × 47.5 cm
Vogue Paris Archives

Vogue Paris,
February 1970, p. 91

Repr. p. 162

cat. 255

Urs Landis
(dates unknown)

"Votre passeport couleur."
Makeup Charcoal, gouache on
paper mounted on cardboard,
61 × 48.5 cm
Vogue Paris Archives

Vogue Paris,
February 1970, p. 93

Repr. p. 162

cat. 256

Guy Bourdin
(1928–1991)

Jane Birkin. Vager Nastat Réal
dress and Karl Lagerfeld
for Chloé ensemble
Gelatin silver prints mounted
on cardboard, 36 × 51.2 cm
The Guy Bourdin Estate

Vogue Paris, May 1969,
pp. 90–91

Repr. p. 163

cat. 257

Jeanloup Sieff
(1933–2000)

Georges Rech suit
Gelatin silver print mounted
on cardboard, 37.9 × 28.3 cm
Vogue Paris Archives

Vogue Paris, April 1971,
p. 68

Repr. p. 164

cat. 258

Jean-Jacques Bugat
(b. 1938)

Dominique Sanda. Claude de Coux
dresses, Louis Féraud and Goutille
knitwear
Gelatin silver prints mounted
on cardboard, 39 × 50.5 cm
Vogue Paris Archives

Vogue Paris, April 1969,
pp. 48–49

cat. 259

Helmut Newton
(1920–2004)

Ulla Danielsen. Vikt Körper
and André Sauzaie coats
Gelatin silver prints mounted
on cardboard, 41.8 × 57.5 cm
Vogue Paris Archives

Vogue Paris,
December 1969/
January 1970,
pp. 110–111

Repr. pp. 166–167

cat. 260

Helmut Newton
(1920–2004)

Gilles Dufour for Marie-Martine
dress
Gelatin silver print mounted
on cardboard, 39.5 × 28.9 cm
Vogue Paris Archives

Vogue Paris,
December 1975/
January 1976, p. 166

Repr. p. 171

cat. 261

Helmut Newton
(1920–2004)

Hanae Mori ensemble.
Place du Palais-Bourbon, Paris
Gelatin silver print mounted
on cardboard, 25.6 × 30.1 cm
Vogue Paris Archives

Vogue Paris,
March 1978, p. 221

Repr. p. 170

cat. 262

Gian Paolo Barbieri
(b. 1938)

Liselotte Zinglersen. Grosvenor
Canada coat
Gelatin silver print mounted
on cardboard, 35 × 50 cm
Vogue Paris Archives

Vogue Paris,
September 1977, p. 432

Repr. p. 165 bottom

cat. 263

Gian Paolo Barbieri
(b. 1938)

Tree Allen. Grosvenor Canada coat
Gelatin silver print mounted
on cardboard, 35 × 50.5 cm
Vogue Paris Archives

Vogue Paris,
September 1977,
p. 433

Repr. p. 165 top

cat. 264

Hans Feurer (b. 1939)

Vonni (left). Emmanuelle
Khanh-Troisa and Vera Finbert
ensembles
Gelatin silver print, 39.6 × 27 cm
Vogue Paris Archives

Vogue Paris, April 1975,
p. 85

cat. 265

Arthur Elgort (b. 1940)

Kathy Ireland. Armani ensemble
Gelatin silver print, 20 × 29.4 cm
Vogue Paris Archives

Vogue Paris,
February 1982, p. 358

cat. 266

Bill King (1939–1987)

Porizkova, Paulina.
Azzedine Alaïa dress
Gelatin silver print, retouching,
37.6 × 29.7 cm
Vogue Paris Archives

Vogue Paris,
February 1986, p. 270

Repr. p. 173

cat. 267

**Franco Rubartelli
(b. 1937)**

Veruschka. Emo swimwear.
Rio de Janeiro
Inkjet pigment print on
Hahnemühle Baryta paper, 2021,
50 × 50 cm
Rubartelli Archives

Vogue Paris, April 1969,
p. 76

Repr. p. 177

cat. 268

**Antonio Lopez
(1943–1987)**

"Et pourquoi pas St Trop."
Cacharel ensemble, Tan Guidicelli
for Micmac dress
India ink, Pentel pens, colored film
on paper, 61 × 45.7 cm
Paris, Palais Galliera

Vogue Paris,
June/July 1970, p. 75

Repr. p. 176

cat. 269

**Jeanloup Sieff
(1933–2000)**

Talitha Getty
Gelatin silver print mounted on
cardboard, 39.9 × 29.7 cm
Vogue Paris Archives

Vogue Paris, April 1970,
p. 51

cat. 270

**Alex Chatelain (dates
unknown)**

Ingrid Boulting "Bulletin beauté.
Pronostics cheveux
printemps 1970"
Gelatin silver print mounted
on cardboard, retouching,
48.2 × 35.2 cm
Vogue Paris Archives

Vogue Paris,
February 1970, p. 88

cat. 271

Sarah Moon (b. 1941)

Susan Moncur (center),
Carole Singleton (right). Lancaster
by Heidi Morawetz makeup,
draped veils by Jeannine Montel
with the advice of Karl Lagerfeld
Digital pigment print on matte fine
art paper, 2021, 40 × 60 cm
Paris, Palais Galliera, gift from
Sarah Moon

Vogue Paris,
February 1973,
pp. 114–115

Repr. p. 192

cat. 272

**Guy Bourdin
(1928–1991)**

"Point de vue sur une nouvelle
beauté." Christian Dior makeup
Modern print on Fujiflex paper,
60 × 59.5 cm
The Guy Bourdin Estate

Vogue Paris,
March 1972, p. 155

Repr. p. 182

cat. 273

**Guy Bourdin
(1928–1991)**

Kathy Quirk. Nuits d'Élodie
breeches
Modern print on Fujiflex paper,
80 × 60.1 cm
The Guy Bourdin Estate

Vogue Paris,
December 1976/
January 1977, p. 262

Repr. p. 183

cat. 274

**Guy Bourdin
(1928–1991)**

"Bulletin beauté spécial jeunes.
Rush sur le rouge."
Harriet Hubbard Ayer makeup
Modern print on Fujiflex paper,
60 × 71 cm
The Guy Bourdin Estate

Vogue Paris, May 1970,
pp. 76–77

Repr. pp. 180–181

cat. 275

**Daniel Jouanneau
(dates unknown)**

"Essayons LEUR cuisine."
Cooking pages
Inkjet pigment print on
Hahnemühle Baryta paper, 2021,
50 × 40 cm
Vogue Paris Archives

Vogue Paris,
November 1979, p. 166

cat. 276

Hans Feurer (b. 1939)

"Dix remèdes nouveaux contre
le mal de dos." Beauty section
Inkjet pigment print on
Hahnemühle Baryta paper, 2021,
50 × 40 cm
Vogue Paris Archives

Vogue Paris,
March 1975, p. 184

Repr. p. 179

cat. 277

**Mike Reinhardt
(b. 1938)**

"La beauté efficace." Janice
Dickinson. Beauty pages
Gelatin silver print, 39.6 × 26.8 cm
Vogue Paris Archives

Vogue Paris, April 1979,
p. 226

Repr. p. 178

cat. 278

**Daniel Jouanneau
(dates unknown)**

"Aujourd'hui comme demain."
Cooking pages
Inkjet pigment print on
Hahnemühle Baryta paper, 2021,
50 × 40 cm
Vogue Paris Archives

Vogue Paris,
March 1977, p. 261

cat. 279

**Daniel Jouanneau
(dates unknown)**

"Des plumes mais en casserole."
Cooking pages
Inkjet pigment print on
Hahnemühle Baryta paper, 2021,
50 × 40 cm
Vogue Paris Archives

Vogue Paris,
September 1977, p. 472

Repr. p. 185 top

cat. 280

**Alexis Waldeck
(b. 1943)**

Jim Morrison and Donna Mitchell.
Beauty section for men
Gelatin silver print mounted
on cardboard, 48.2 × 36.7 cm
Vogue Paris Archives

American *Vogue*,
November 15, 1967,
p. 84 and *Vogue Paris*,
March 1968, p. 242

Repr. p. 191

cat. 281

**Helmut Newton
(1920–2004)**

Charlotte Rampling. Van Cleef
& Arpels accessories
Gelatin silver print mounted
on cardboard, 32.6 × 29.4 cm
Vogue Paris Archives

Vogue Paris,
November 1977, p. 89

cat. 282

**Jeanloup Sieff
(1933–2000)**

Marina Schiano.
Yves Saint Laurent dress
Gelatin silver print mounted
on cardboard, 39.7 × 29.7 cm
Vogue Paris Archives

Vogue Paris,
September 1970,
p. 257

Repr. p. 161

cat. 283

**Mike Reinhardt
(b. 1938)**

Janice Dickinson
Dye Transfer print mounted
on cardboard, 52.2 × 37 cm
Vogue Paris Archives

Vogue Paris, Beauty
Supplement Spring/
Summer 1978, cover

cat. 284

**Salvador Dalí
(1904–1989), Henry
Clarke (1918–1996)**

"Assez bonne imitation de Dalí."
Van Cleef & Arpels clips
Color print on barium paper
enhanced with ink, 49.5 × 39.9 cm
Vogue Paris Archives

Vogue Paris,
December 1971/
January 1972, p. 193

cat. 285

**Salvador Dalí
(1904–1989), Henry
Clarke (1918–1996)**

"Cravate du bon chasseur."
Yves Saint Laurent tie
Color print on barium paper
enhanced with ink, 40 × 30 cm
Vogue Paris Archives

Vogue Paris,
December 1971/
January 1972, p. 199

Repr. p. 189

cat. 286

**Salvador Dalí
(1904–1989), David
Bailey (b. 1938)**

"Giambattista Della Porta
(1536–1615)"
Gelatin silver prints mounted
on cardboard, gouache, ink,
retouching, 41.3 × 50.6 cm
Vogue Paris Archives

Vogue Paris,
December 1971/
January 1972,
pp. 186–187

Repr. p. 188

cat. 287

**Jeanloup Sieff
(1933–2000)**

Barbara Barnard. Lacoste shirt
and Dorothée Bis pants
Gelatin silver print and
felt-enhanced prints, mounted
on cardboard, 31.4 × 24.1 cm
Paris Archives

Vogue Paris, May 1970,
cover

Repr. p. 158

cat. 288

**Guy Bourdin
(1928–1991)**

Layout for "Le point de vue
de Vogue."
Maudie James. Saint Laurent–
Rive Gauche ensemble
Gelatin silver print and prints
mounted on cardboard,
42.5 × 27.5 cm
The Guy Bourdin Estate

Vogue Paris,
February 1969, p. 81

Repr. p. 105

cat. 289

**Helmut Newton
(1920–2004)**

Nina Klepp (left). "Une-pièce
à succès." Yves Saint Laurent,
Ted Lapidus and Scherrer
Boutique swimwear
Gelatin silver print mounted
on cardboard, reproduction,
27.3 × 45.6 cm
Vogue Paris Archives

Vogue Paris, April 1979,
pp. 206–207

CLOTHING

cat. 290

**Grès, Spring/
Summer 1975**

Blanc de Racine dress
in silk jersey and rayon
Paris, Palais Galliera

Vogue Paris,
March 1975, p. 142

MAGAZINES

cat. 291

**Jeanloup Sieff
(1933–2000),
Jacques Robert
(dates unknown),
Anonymous**

Vogue Paris,
December 1968/
January 1969,
pp. 118–119

Paris, Palais Galliera

Repr. p. 159

cat. 292

**Guy Bourdin
(1928–1991)**

Vogue Paris,
December 1969/
January 1970,
pp. 128–129

Vogue Paris Archives

Repr. p. 190

cat. 293

**Helmut Newton
(1920–2004)**

Vogue Paris,
September 1975,
pp. 146–147

Paris, Palais Galliera

Repr. p. 168

cat. 294

**Helmut Newton
(1920–2004)**

Vogue Paris,
March 1975,
pp. 142–143

Paris, Palais Galliera

cat. 295

**Guy Bourdin
(1928–1991)**

Vogue Paris,
March 1975,
pp. 180–181

Vogue Paris Archives

cat. 296

Albert Watson (b. 1942)

Vogue Paris, May 1979,
pp. 152–153

Paris, Palais Galliera

Repr. p. 175 top

cat. 297

**Gunter Sachs
(1932–2011)**

Vogue Paris, April 1981,
pp. 156–157

Vogue Paris Archives

cat. 298

**Steve Hiett
(1940–2019)**

Vogue Paris, May 1981,
pp. 162–163

Vogue Paris Archives

Repr. p. 175 bottom

cat. 299

**Helmut Newton
(1920–2004)**

Vogue Paris,
November 1981,
pp. 164–165

Paris, Palais Galliera

Repr. p. 169

cat. 300

**Andy Warhol
(1928–1987)**

Vogue Paris,
December 1983/
January 1984, cover

Vogue Paris Archives

Repr. p. 187

cat. 301

**Patrick Demarchelier
(b. 1943)**

Vogue Paris,
September 1984,
pp. 456–457

Paris, Palais Galliera

Repr. p. 172

FILMS

**Guy Bourdin shooting
for *Vogue Paris***

"Effraction," France 3, Paris
September 30, 1986
1 min 1 sec
Institut National de l'Audiovisuel

**Jeanloup Sieff
shooting with Jane
Birkin for the May 1969
cover of *Vogue Paris***

"Chambre noire," ORTF
Television 2
April 28, 1969
1 min 36 sec
Institut National de l'Audiovisuel

**Helmut Newton
shooting
for *Vogue Paris***

"Fenêtre sur"/*Les métiers d'art
et de création*, Antenne 2
May 25, 1976
2 min 6 sec
Institut National de l'Audiovisuel

Patrick Demarchelier
shooting with Brooke
Shields for the
September 1983 cover
of *Vogue Paris*

"13 heures le Journal," TF1
August 1, 1983
1 min 21 sec
Institut National de l'Audiovisuel

PART V

PHOTOGRAPHS
AND ILLUSTRATIONS

cat. 302

Steven Meisel (b. 1954)

"Le diable au corps." Linda
Evangelista. Azzedine Alaïa gloves,
Nicoletta Santoro styling
Inkjet pigment print on Hahnemühle
Baryta paper, 2021, 80 × 60 cm
Steven Meisel

Vogue Paris,
June/July 1989, p. 117

Repr. p. 207

cat. 303

Peter Lindbergh
(1944–2019)

"Désir d'ailes." Philippe.
School Rag coat, Agnès b.
suit and shirt Le Touquet.
Nicoletta Santoro styling
Gelatin silver print, 37.7 × 47.3 cm
Paris, Peter Lindbergh Foundation

Vogue Paris, May 1989,
pp. 160–161

Repr. p. 210 top

cat. 304

Peter Lindbergh
(1944–2019)

"Désir d'ailes." Cordula Reyer.
Alaïa dress. Le Touquet.
Nicoletta Santoro styling
Gelatin silver print, 30 × 40 cm
Paris, Peter Lindbergh Foundation

Vogue Paris, May 1989,
pp. 162–163

Repr. pp. 210–211 top

cat. 305

Peter Lindbergh
(1944–2019)

"Désir d'ailes." Cordula Reyer.
Alaïa dress. Le Touquet.
Nicoletta Santoro styling
Gelatin silver print, 40 × 30 cm
Paris, Peter Lindbergh Foundation

Vogue Paris, May 1989,
p. 164

Repr. p. 211 top

cat. 306

Peter Lindbergh
(1944–2019)

"Désir d'ailes." Cordula Reyer, Tanel
Bedrossiantz, Philippe. Martine
Sitbon ensemble, School Rag coat,
Agnès b. costume Le Touquet.
Nicoletta Santoro styling
Gelatin silver print, 40 × 30 cm
Paris, Peter Lindbergh Foundation

Vogue Paris, May 1989,
p. 165

Repr. p. 211 top

cat. 307

Peter Lindbergh
(1944–2019)

"Désir d'ailes." Cordula Reyer,
Tanel Bedrossiantz, Philippe.
Comme des Garçons ensemble,
School Rag coat, Agnès b. suit
Le Touquet. Nicoletta Santoro
styling
Gelatin silver print, 30 × 40 cm
Paris, Peter Lindbergh Foundation

Vogue Paris, May 1989,
pp. 166–167

Repr. p. 210 bottom

cat. 308

Peter Lindbergh
(1944–2019)

"Désir d'ailes." Cordula Reyer,
Tanel Bedrossiantz, Philippe.
Comme des Garçons ensemble,
School Rag coat, Agnès b. suit
Le Touquet. Nicoletta Santoro
styling
Gelatin silver print, 40 × 30 cm
Paris, Peter Lindbergh Foundation

Vogue Paris, May 1989,
p. 168

Repr. p. 210 bottom

cat. 309

Peter Lindbergh
(1944–2019)

"Désir d'ailes." Cordula Reyer.
Jean-Paul Gaultier ensemble.
Le Touquet. Nicoletta Santoro
styling
Gelatin silver print, 40 × 30 cm
Paris, Peter Lindbergh Foundation

Vogue Paris, May 1989,
p. 169

Repr. pp. 210–211 bottom

cat. 310

Peter Lindbergh
(1944–2019)

"Désir d'ailes." Tanel Bedrossiantz
and Philippe. Agnès b. ensemble
Le Touquet. Nicoletta Santoro
styling
Gelatin silver print, 40 × 30 cm
Paris, Peter Lindbergh Foundation

Vogue Paris, May 1989,
p. 170

Repr. p. 211 bottom

cat. 311

Peter Lindbergh
(1944–2019)

"Désir d'ailes." Cordula Reyer.
Jean-Paul Gaultier ensemble.
Le Touquet. Nicoletta Santoro
styling
Gelatin silver print, 40 × 30 cm
Paris, Peter Lindbergh Foundation

Vogue Paris, May 1989,
p. 171

Repr. p. 211 bottom

cat. 312

Peter Lindbergh
(1944–2019)

"Nomades Land." Kristen
McMenamy. Helmut Lang dress.
Beauduc. Elisabeth Djian styling
Inkjet pigment print on
Hahnemühle Baryta paper, 2021,
120 × 80 cm
Paris, Peter Lindbergh Foundation

Vogue Paris,
October 1990, p. 247

cat. 313

Max Vadukul (b. 1961)

"Fric-Frac." Leslie Navajas.
Versace Atelier dress
Gelatin silver print, 39.9 × 49.2 cm
Vogue Paris Archives

Vogue Paris,
September 1989,
pp. 268–269

cat. 314

Max Vadukul (b. 1961)

"La Dolce Vita 89." Vanessa Duve.
Giorgio Armani smoking jacket.
Nicoletta Santoro styling
Gelatin silver print, 49.3 × 35.4 cm
Vogue Paris Archives

Vogue Paris,
February 1989, p. 221

Repr. p. 215

cat. 315

Max Vadukul (b. 1961)

"Ça cartoone." Linda Evangelista.
Jean-Paul Gaultier chinstrap.
Nicoletta Santoro styling
Gelatin silver print, 49.2 × 37.7 cm
Vogue Paris Archives

Vogue Paris,
August 1989, p. 153

cat. 316

Dominique Issermann
(b. 1947)

"À la légère." Heather
Stewart-Whyte. Christian Lacroix
dress
Inkjet pigment print on Rag
Hahnemühle paper, 2021,
50 × 40 cm
Paris, Dominique Issermann

Vogue Paris,
September 1991, cover

Repr. p. 212

cat. 317

Helmut Newton
(1920–2004)

"Spécial bijoux." Cartier bracelet
Inkjet print, 50 × 43 cm
Berlin, Helmut Newton Foundation

Vogue Paris,
June/July 1994, p. 107

cat. 318

Helmut Newton
(1920–2004)

"Tranches de vie." Bulgari jewelry
Chromogenic print, 57 × 34 cm
Berlin, Helmut Newton Foundation

Vogue Paris,
June/July 1994, p. 109

Repr. p. 236

cat. 319

Arthur Elgort (b. 1940)

Beatrice Dalle. Marc Bohan for Dior
dress. Hotel Lancaster, Paris
Gelatin silver print, 30.6 × 24 cm
Vogue Paris Archives

Vogue Paris,
March 1989, p. 189

Repr. p. 216

cat. 320

Mats Gustafson
(b. 1951)

"Verts libres." Thierry Mugler
dress and accessories
Glued papers, 43.4 × 32.6 cm
Vogue Paris Archives

Vogue Paris,
November 1989, p. 225

Repr. p. 218

cat. 321

Mats Gustafson (b. 1951)

"Verts libres." Jean-Paul Gaultier
dress and accessories
Glued papers, 43.4 × 32.6 cm
Vogue Paris Archives

Vogue Paris,
November 1989, p. 222

cat. 322

Herb Ritts (1952–2002)

"La vie." Esther Cañadas. Viktor
& Rolf Haute Couture ensemble.
Directed by Marcus von Ackermann
Gelatin silver print, 35.4 × 27.8 cm
Vogue Paris Archives

Vogue Paris,
December 1998/
January 1999, p. 195

Repr. p. 233

cat. 323

Mario Testino (b. 1954)

"Boogie Days." Liisa Winkler.
Missoni coat, Tomas Maier bikini.
Directed by Carine Roitfeld
Cibachrome print, 39.9 × 30.5 cm
Vogue Paris Archives

Vogue Paris,
August 1999, p. 85

Repr. p. 231

cat. 324

David LaChapelle
(b. 1963)

"Si la couture m'était contée."
Angelica Boss. Nina Ricci dress.
Directed by Jenny Capitain
Chromogenic print, 35.6 × 27.8 cm
Vogue Paris Archives

Vogue Paris,
September 1995,
p. 140

cat. 325

Enrique Badulescu
(b. 1961)

"Je video." Ewa Witkowska.
Issey Miyake dress.
Directed by Delphine Tréanton
Chromogenic print, 27.8 × 35.4 cm
Vogue Paris Archives

Vogue Paris,
October 1998,
pp. 210–211

cat. 326

Jean-Baptiste
Mondino (b. 1949)

Karen Elson. Versace dress.
Directed by Debra Scherer
Inkjet pigment print on Hahnemühle
Baryta paper, 2021, 60 × 50 cm
Jean-Baptiste Mondino

Vogue Paris,
December 1997/
January 1998, cover

Repr. p. 226

cat. 327

Jean-Baptiste
Mondino (b. 1949)

Linda Nyvltova. Cartier bracelet
Inkjet pigment print on Hahnemühle
Baryta paper, 2021, 60 × 50 cm
Jean-Baptiste Mondino

Vogue Paris,
December 1999/
January 2000, cover

Repr. p. 227

cat. 328

Jean-Philippe
Delhomme (b. 1959)

"L'éducation sentimentale"
Gouache on paper, 38 × 28.5 cm
Jean-Philippe Delhomme
Collection

Vogue Paris,
November 1997, p. 147

Repr. p. 223

cat. 329

Jean-Philippe
Delhomme (b. 1959)

"Mon shopping couture."
Givenchy fashion show
Gouache on paper, 28.5 × 38 cm
Jean-Philippe Delhomme
Collection

Vogue Paris,
March 1997, p. 172

Repr. p. 222 top

cat. 330

Jean-Philippe
Delhomme (b. 1959)

"Mon shopping couture."
Mugler fashion show
Gouache on paper, 28.5 × 38 cm
Jean-Philippe Delhomme
Collection

Vogue Paris,
March 1997, p. 175

cat. 331

Christian Lacroix
(b. 1951)

"Couleurs de créateurs."
Beauty pages
Colored pencils, India ink,
gouache on paper, 30 × 21.1 cm
Vogue Paris Archives

Vogue Paris,
August 1995, p. 82

cat. 332

Stefano Canulli
for Thierry Mugler
(b. 1948)

"Couleurs de créateurs."
Beauty pages
Watercolor, India ink, graphite
pencil, gouache on paper,
31.1 × 23.1 cm
Vogue Paris Archives

Vogue Paris,
August 1995, p. 81

cat. 333

Éric Traoré (dates
unknown)

"Les ailes du plaisir."
Audrey Marnay. Keita Maruyama
headpiece and dress.
Directed by Delphine Tréanton
Cibachrome print, 46.4 × 31.4 cm
Vogue Paris Archives

Vogue Paris, May 1999,
p. 120

Repr. p. 221

cat. 334

Satoru Makimura
(b. 1956)

"Rencontre interstellaire."
Krizia dress
India ink, gouache, watercolor,
printed Letraset film, color film
on paper, 37.7 × 27.3 cm
Vogue Paris Archives

Vogue Paris, July 1995,
p. 98

cat. 335

Satoru Makimura
(b. 1956)

"Rencontre interstellaire."
Krizia dress
India ink, gouache, watercolor,
printed Letraset film, color film
on paper, 37.4 × 27 cm
Vogue Paris Archives

Vogue Paris, July 1995,
p. 99

cat. 336

Pierre Le-Tan
(1950–2019)

"Variétés. Mélodies du bonheur."
Pull Marine. Lyrics Isabelle Adjani
and Serge Gainsbourg.
Music Serge Gainsbourg
Watercolor, India ink on paper,
29.8 × 22.7 cm
Vogue Paris Archives

Vogue Paris,
December 1996/
January 1997, p. 82

Repr. p. 219

cat. 337

Pierre Le-Tan
(1950–2019)

"Variétés. Mélodies du bonheur."
Pourquoi un Pajama? by Serge
Gainsbourg, performed by Régine
Watercolor, India ink on paper,
29.8 × 22.7 cm
Vogue Paris Archives

Vogue Paris,
December 1996/
January 1997, p. 84

cat. 338

Pierre Le-Tan
(1950–2019)

Patrick Modiano
India ink on paper, 29.7 × 21 cm
Vogue Paris Archives

Vogue Paris,
March 1989, p. 40 and
October 2012, p. 251

cat. 339

Mats Gustafson (b. 1951)

Barbara
India ink on paper, 35.6 × 28 cm
Vogue Paris Archives

Vogue Paris,
December 1996/
January 1997, p. 159

cat. 340

Brigitte Lacombe
(b. 1950)

Daniel Day-Lewis
Gelatin silver print, 35.5 × 27.8 cm
Vogue Paris Archives

Vogue Paris,
December 1994/
January 1995, p. 221

cat. 341

Brigitte Lacombe
(b. 1950)

Gérard Depardieu
Gelatin silver print, 40.4 × 30.7 cm
Vogue Paris Archives

Vogue Paris,
December 1994/
January 1995, p. 223

cat. 342

Brigitte Lacombe
(b. 1950)

Jay McInerney
Gelatin silver print, 35.3 × 27.9 cm
Vogue Paris Archives

Vogue Paris,
June/July 1999, p. 149

Repr. p. 229 bottom

cat. 343

Brigitte Lacombe
(b. 1950)

Mick Jagger and Jerry Hall
Gelatin silver print, 35.3 × 27.7 cm
Vogue Paris Archives

Vogue Paris,
December 1996/
January 1997,
pp. 222–223

cat. 344

Brigitte Lacombe
(b. 1950)

Isabella Rossellini and
her daughter Elettra, Moscow
Gelatin silver print, 35.4 × 25.9 cm
Vogue Paris Archives

Vogue Paris,
October 1990, cover

cat. 345

Brigitte Lacombe
(b. 1950)

Jean-Paul Gaultier
and Gilbert & George
Gelatin silver print, 30.5 × 40.4 cm
Vogue Paris Archives

Vogue Paris,
December 1997/
January 1998, p. 190

cat. 346

David LaChapelle
(b. 1963)

Carven Haute Couture dress
Color reversal film, 25.2 × 20.1 cm
Vogue Paris Archives

Vogue Paris,
September 1995, p. 12

cat. 347

Steve Hiett
(1940–2019)

"Le chic en cavale."
Joseph ensemble.
Directed by Isabelle Peyrut
Color reversal film, 20.2 × 24 cm
Vogue Paris Archives

Vogue Paris,
September 1995,
p. 206

cat. 348

Peter Lindbergh
(1944–2019)

"Nomades Land." Helmut Lang
dress. Beauduc. Elisabeth Djian
styling, 1990
Contact board, 30 × 24 cm
Paris, Peter Lindbergh Foundation

cat. 349

Anonymous

Peter Lindbergh and Kristen
McMenamy shooting at Beauduc
for the October 1990 issue, 1990
Gelatin silver print, 13 × 18 cm
Paris, Peter Lindbergh Foundation

cat. 350

Jean-Luce Huré
(b. 1942)

Colombe Pringle, Nelson Mandela,
and Jean Poniatowski, Paris, 1993
Gelatin silver print, 8.8 × 12.7 cm
Colombe Pringle

Repr. p. 197

DOCUMENTS

cat. 351

Nelson Mandela
(1918–2013)

Model with ANC logo and message
from October 14, 1993 to *Vogue Paris*
Felt on paper, reproduction,
37.4 × 26.9 cm
Vogue Paris Archives

cat. 352

Peter Lindbergh
(1944–2019)

Notes on shootings at Beauduc
for the October 1990 issue, 1990
Manuscript, 16 × 18 cm
Paris, Peter Lindbergh Foundation

CLOTHING

cat. 353

John Galliano,
Spring/Summer 1995

Houndstooth wool suit
John Galliano SA

Vogue Paris,
February 1995, p. 125

Repr. p. 61 middle right

MAGAZINES

cat. 354

Anonymous

Vogue Paris,
December 1989/
January 1990,
pp. 234–235

Vogue Paris Archives

cat. 355

Bruce Weber (b. 1946)

Vogue Paris, December
1989/January 1990,
pp. 292–293

Vogue Paris Archives

Repr. pp. 208–209

cat. 356

Herb Ritts (1952–2002)

Vogue Paris,
June 1993, pp. 144–145

Vogue Paris Archives

cat. 357

Juergen Teller (b. 1964)

Vogue Paris,
August 1993,
pp. 138–139

Vogue Paris Archives

Repr. p. 228 bottom

cat. 358

Tommy Motswai
(b. 1963)

Vogue Paris,
December 1993/
January 1994, cover

Vogue Paris Archives

Repr. p. 225

cat. 359

Mario Testino (b. 1954)

Vogue Paris,
February 1995,
pp. 124–125

Vogue Paris Archives

cat. 360

Brigitte Lacombe
(b. 1950)

Vogue Paris,
December 1996/
January 1997,
pp. 196–197

Vogue Paris Archives

Repr. p. 227

cat. 361

Éric Traoré
(dates unknown)

Vogue Paris,
March 1997,
pp. 206–207

Vogue Paris Archives

Repr. p. 220

cat. 362

Mario Testino (b. 1954)

Vogue Paris, April 1998,
pp. 116–117

Vogue Paris Archives

Repr. p. 232

cat. 363

Raymond Meier (b. 1957)

Vogue Paris,
October 1999,
pp. 256–257

Vogue Paris Archives

Repr. pp. 234–235

PHOTOGRAPHS AND ILLUSTRATIONS

cat. 364

Helmut Newton
(1920–2004)

Karl Lagerfeld
Gelatin silver print, 30.3 × 40.4 cm
Vogue Paris Archives

Vogue Paris,
November 1973, p. 67

Repr. p. 156

DOCUMENTS

cat. 365

July 1973

Letter from Karl Lagerfeld
to Robert F. Caillé
India ink on paper, 29.8 × 21.1 cm
Vogue Paris Archives

cat. 366

July 2, 1973

Letter from Robert F. Caillé
to Marlene Dietrich
Ink and felt on paper,
26.2 × 21.2 cm
Vogue Paris Archives

CLOTHING

cat. 367

Karl Lagerfeld
for Chloé,
Fall/Winter 1983

"Bugatti" dress in embroidered
black viscose jersey
Paris, Palais Galliera

Repr. p. 61 middle right

cat. 368

Karl Lagerfeld
for Chanel

Métiers d'art "Paris-Hamburg"
2017/2018
Jacket and skirt in off-white
fantasy tweed with red trim
on all the borders, cap in white
tweed and red trim
Karl Lagerfeld for Chanel
Pair of earrings, quilted gold metal
cuff bracelet, link bracelet,
four-row pearl cuff bracelet,
interlocking-C gilded metal brooch
Paris, Chanel Heritage

Vogue Paris, April 2018,
cover

MAGAZINES

cat. 369

Vogue Paris,
December 1973/
January 1974, cover

Vogue Paris Archives

Repr. p. 186 top left

cat. 370

Guy Bourdin
(1928–1991)

Vogue Paris,
August 1977,
pp. 122–123

Paris, Palais Galliera

cat. 371

Albert Watson (b. 1942)

Vogue Paris,
October 1983, cover

Vogue Paris Archives

Repr. p. 61 middle right

cat. 372

Guy Bourdin
(1928–1991)

Vogue Paris,
August 1984,
pp. 258–259

Vogue Paris Archives

cat. 373

Karl Lagerfeld
(1933–2019)

Vogue Paris,
June/July 2004,
pp. 170–171

Vogue Paris Archives

cat. 374

Inez & Vinoodh
(b. 1963 and 1961)

Vogue Paris, April 2018,
cover

Paris, Palais Galliera

PART VI

PHOTOGRAPHS AND ILLUSTRATIONS

cat. 375

Inez & Vinoodh (b. 1963 and 1961)

Tasha Tilberg. Miu Miu jacket, pants, and shirt; Charvet sweater. Directed by Marie-Amélie Sauvé. Evian
Inkjet pigment print on Hahnemühle Baryta paper, 2021, 80 × 60 cm
Inez & Vinoodh

Vogue Paris, September 2001, p. 286

Repr. p. 250

cat. 376

Inez & Vinoodh (b. 1963 and 1961)

"Fantasmes." Anja Rubik. Roberto Cavalli dress, Pierre Hardy sandals. Directed by Emmanuelle Alt
Inkjet pigment print on watercolor paper, 101.3 × 69.2 cm
Paris, Palais Galliera

Vogue Paris, February 2005, p. 169

cat. 377

Mario Sorrenti (b. 1971)

"Série noire." Guinevere van Seenus, La Perla Mare jersey, Camille Fournet choker, Jil Sander cuff, Chrome Hearts bracelet, Dolce & Gabbana Eyewear glasses (bottom). Enikő Mihalik, Versace jersey, Max Mara pants, Furla bag, Cartier and Hermès jewelry (top). Directed by Carine Roitfeld
Inkjet pigment print on Rag Hahnemühle paper, 2021, 63.5 × 46.6 cm
Mario Sorrenti

Vogue Paris, June/July 2009, p. 171

Repr. p. 256

cat. 378

Mario Testino (b. 1954)

"Réjouissances." Patricia Schmid. Chanel perfume and makeup, Dolce & Gabbana belt. Directed by Carine Roitfeld
Color print from a digital file, 180 × 135.7 cm
Mario Testino

Vogue Paris, February 2007, p. 259

Repr. p. 261

cat. 379

Inez & Vinoodh (b. 1963 and 1961)

"L'escarpin." Christy Turlington. Giuseppe Zanotti and Brian Atwood shoes. Directed by Carine Roitfeld
Pigment inkjet print on Hahnemühle Baryta paper, 2021, 80 × 60 cm
Inez & Vinoodh

Vogue Paris, October 2008, p. 296

Repr. p. 251

cat. 380

Mario Sorrenti (b. 1971)

"Cil icône." Natasha Poly. Frank B makeup, Recine hairstyle, Anny Errandonea nails, Tom Ford anti-UV goggles, faux theater eyelashes. Directed by Carine Roitfeld
Inkjet pigment print on Rag Hahnemühle paper, 2021, 63.5 × 52.2 cm
Mario Sorrenti

Vogue Paris, September 2009, p. 327

Repr. p. 259

cat. 381

Mert & Marcus (b. 1971)

"Néoclassiques." Lara Stone. Chanel cardigan, Balenciaga by Nicolas Ghesquière jacket, Maison Martin Margiela Ligne 1 leotard, Boucheron hoop earrings. Directed by Carine Roitfeld
Pigment inkjet print on watercolor paper, 100 × 76 cm
Paris, Palais Galliera

Vogue Paris, March 2008, p. 333

Repr. p. 265

cat. 382

Mert & Marcus (b. 1971)

"Le Noir, partie 4." Daria Werbowy. Viktor & Rolf coat, Carine Gilson camisole, Chantal Thomas panties, Falke bottoms, Valentino Garavani shoes, Henri J. Sillam earrings. Directed by Emmanuelle Alt
Pigment inkjet print on watercolor paper, 101 × 76.2 cm
Paris, Palais Galliera

Vogue Paris, September 2012, p. 343

Repr. p. 275

cat. 383

David Sims (b. 1966)

"Commando." Iselin Steiro. Balmain ensemble. Directed by Emmanuelle Alt
Pigment inkjet print on Rag Hahnemühle paper, 101.7 × 76.7 cm
Paris, Palais Galliera

Vogue Paris, March 2010, p. 299

Repr. p. 271

cat. 384

Mario Sorrenti (b. 1971)

"Paris mon amour." Aymeline Valade. Alexander McQueen dress. Grand Palais, Paris. Directed by Emmanuelle Alt
Pigment inkjet print, 35.5 × 28 cm
Paris, Palais Galliera

Vogue Paris, August 2012, p. 193

Repr. p. 4

cat. 385

M/M (Paris)

Carine (2003)
Screenprint 2 colors, 176 × 120 cm
M/M (Paris)

Repr. p. 149

cat. 386

Mario Sorrenti (b. 1971)

Daria Werbowy. Beauty pages. Recine hairstyle, Peter Philips makeup
Pigment inkjet print on watercolor paper, 101.6 × 76.2 cm
Paris, Palais Galliera

Vogue Paris, September 2004, p. 292

cat. 387

Mario Sorrenti (b. 1971)

"Jeu de paumes." Beauty pages. Enikő Mihalik. Repossi ring, Bulgari solitaire. Directed by Carine Roitfeld
Inkjet pigment print on Rag Hahnemühle paper, 2021, 58.4 × 48.9 cm
Mario Sorrenti

Vogue Paris, August 2010, p. 185

Repr. p. 257

cat. 388

Terry Richardson (b. 1965)

"Festin." Crystal Renn Buccellati buckles; Bulgari necklace; Chopard, Chanel Joaillerie, Buccellati, Adler, and Piaget rings; Prada cardigan; DeLaneau watch. Directed by Carine Roitfeld
Pigment inkjet print on Hahnemühle Baryta paper, 2021, 80 × 60 cm
Terry Richardson

Vogue Paris, October 2010, p. 602

Repr. p. 258

cat. 389

Mario Sorrenti (b. 1971)

"Think punk." Freja Beha Erichsen. Dior Haute Couture dress. Directed by Emmanuelle Alt
Inkjet pigment print on Rag Hahnemühle paper, 2021. 48.2 × 48.2 cm
Mario Sorrenti

Vogue Paris, October 2010, p. 534

cat. 390

David Sims (b. 1966)

"Pull Lover." Edie Campbell. Balenciaga sweater. Directed by Emmanuelle Alt
Inkjet print on Dibond, 2021, 150 × 120 cm
David Sims

Vogue Paris, September 2017, p. 260

Repr. p. 270

cat. 391

David Sims (b. 1966)

"Androgyne." Iselin Steiro. Bottega Veneta jacket, Lanvin waistcoat, Charvet shirt, Brioni bow tie, Maison Martin Margiela pants, Chapellerie Traclet hat. Directed by Emmanuelle Alt
Pigment inkjet print, 2021, 120 × 80 cm
David Sims

Vogue Paris, October 2010, p. 567

Repr. p. 273 bottom

cat. 392

Mario Sorrenti (b. 1971)

"Sauvage." Anja Rubik. Dolce & Gabbana swimwear top; Lost Art mini-cape, skirt, and necklace. Directed by Emmanuelle Alt
Inkjet pigment print on Rag Hahnemühle paper, 2021, 63.5 × 50.6 cm
Mario Sorrenti

Vogue Paris, June/July 2013, p. 137

cat. 393

Inez & Vinoodh (b. 1963 and 1961)

"Eau de rose." Sasha Pivovarova. Diesel dress, Yves Saint Laurent earrings. Directed by Emmanuelle Alt
Pigment inkjet print on Hahnemühle Baryta paper, 2021, 60 ´80 cm
Inez & Vinoodh

Vogue Paris, March 2008, p. 363

cat. 394

Inez & Vinoodh (b. in 1963 and 1961)

"L'hippie trendy d'Etro." Daria Werbowy. Etro ensemble, Jill Heller hoop earrings. Directed by Emmanuelle Alt
Pigment inkjet print on Hahnemühle Baryta paper, 2021, 80 × 60 cm
Inez & Vinoodh

Vogue Paris, February 2010, p. 170

Repr. p. 278

cat. 395

Inez & Vinoodh (b. 1963 and 1961)

Gisele Bündchen. Directed by Emmanuelle Alt
Pigment inkjet print on watercolor paper, 2021, 90.5 × 75.4 cm
Paris, Palais Galliera

Vogue Paris, June/July 2012, cover

Repr. p. 280

cat. 396

Patrick Demarchelier (b. 1943)

"Au Charme, etc." Natasha Poly. Dries Van Noten linen top, Antiflirt panties, Falke knee sock. Directed by Emmanuelle Alt
Pigment inkjet print on Hahnemühle Baryta paper, 2021, 60 × 50 cm
Patrick Demarchelier

Vogue Paris, February 2005, p. 236

cat. 397

Mikael Jansson (b. 1958)

"Un été pas comme les autres." Rianne Van Rompaey. Chloé dress, Jessie Western earrings. Directed by Emmanuelle Alt
Inkjet pigment print on Rag Hahnemühle paper, 2021, 80 × 60 cm
Mikael Jansson

Vogue Paris, May 2019, p. 121

Repr. pp. 276–277

cat. 398

Inez & Vinoodh (b. 1963 and 1961)

"Haute Couture." Raquel Zimmermann. Dior Haute Couture dress, Dior necklace, Sergio Rossi boots. Directed by Emmanuelle Alt
Inkjet pigment print on Dibond, 2021, 150 × 120 cm
Inez & Vinoodh

Vogue Paris, November 2011, p. 161

cat. 399

David Sims (b. 1966)

"Wanted!" Isabeli Fontana. Emilio Pucci jacket, Haider Ackermann pants, Laurence Doligé blouse, John Galliano suspenders, Kiliwatch belt, Sommier & Fils hat, Eglé Bespoke bandana. Directed by Emmanuelle Alt
Inkjet print on Dibond, 2021, 150 × 120 cm
David Sims

Vogue Paris, April 2011, p. 181

cat. 400

Inez & Vinoodh (b. 1963 and 1961)

Kate Moss. Ralph Lauren jacket. Directed by Emmanuelle Alt
Inkjet print on Dibond, 2021, 150 × 120 cm
Inez & Vinoodh

Vogue Paris, October 2009, cover

cat. 401

Inez & Vinoodh (b. 1963 and 1961)

"Parlez-vous français?" Edie Campbell, Valentino Haute Couture dress. Rianne ten Haken, What Goes Around Comes Around jacket, American Apparel armband and leggings. Directed by Emmanuelle Alt
Inkjet print on Dibond, 2021, 150 × 120 cm
Inez & Vinoodh

Vogue Paris, May 2015, p. 162

Repr. p. 279

cat. 402

Mert & Marcus (b. 1971)

"Haute Couture, Été 2011." Kate Moss. Zuhair Murad Couture jacket, Wolford tights, Giorgio Armani Privé necklace. Directed by Emmanuelle Alt
Inkjet print on Dibond, 2021, 150 × 120 cm
Mert Alas et Marcus Piggott

Vogue Paris, May 2011, p. 144

cat. 403

Craig McDean (b. 1964)

"À la folie." Sasha Pivovarova. Chanel Haute Couture dress, Manolo Blahnik shoes, Peter Philips veil. Directed by Carine Roitfeld
Pigment inkjet print on Hahnemühle Baryta paper, 2021, 50 × 40 cm
Craig McDean

Vogue Paris, April 2006, p. 245

Repr. p. 255

cat. 403 bis

Juergen Teller (b. 1964)

"Strip-Jean." Raquel Zimmermann. Diesel Black Gold shirt, Dior skirt, Liza Bruce swimwear, Atsuko Kudo necklace, Hermès and Dior bracelets, Yves Saint Laurent cuff, Cartier medallion, Hermès necklace, Jimmy Choo pocket. Directed by Carine Roitfeld.
Pigment inkjet print on Hahnemühle Baryta paper, 2021, 60.9 × 50.8 cm
Juergen Teller

Vogue Paris, mai 2009, p. 125

CLOTHING

cat. 404

Anthony Vaccarello for Saint Laurent, Spring/Summer 2018

Dress in satin and black velvet
Paris, Palais Galliera
"Smoking" ear clips, "V" cuff, "Yeti" boots in velvet and feathers
Saint Lawrence

Vogue Paris, February 2018, cover

MAGAZINES

cat. 405

Inez & Vinoodh (b. 1963 and 1961)

Artistic direction M/M (Paris)

Vogue Paris, October 2002, pp. 222–223
Vogue Paris Archives

Repr. pp. 252–253

cat. 406

Mario Testino (b. 1954)

Artistic Direction M/M (Paris)

Vogue Paris, December 2002/ January 2003, pp. 204–205
Vogue Paris Archives

Repr. p. 152

cat. 407

Mert & Marcus (b. 1971)

Vogue Paris, September 2008, pp. 324–325
Paris, Palais Galliera

Repr. p. 263

cat. 408

Mert & Marcus (b. 1971)

Vogue Paris, December 2010/ January 2011, pp. 184–185
Paris, Palais Galliera

Repr. p. 262

cat. 409

Josh Olins (b. 1980)

Vogue Paris,
February 2011,
pp. 148–149

Vogue Paris Archives

cat. 410

Alasdair McLellan
(b. 1974)

Vogue Paris,
February 2017,
pp. 190–191

Vogue Paris Archives

Repr. p. 272 top

cat. 411

David Sims (b. 1966)

Vogue Paris,
February 2018, cover

Vogue Paris Archives

cat. 412

Sam Rock

Vogue Paris, May 2019,
pp. 170–171

Vogue Paris Archives

Repr. p. 272 bottom

FILM

Inez & Vinoodh
(b. 1963 and 1961)

Girls on Film, September 2010

KATE MOSS

PHOTOGRAPHS

cat. 413

David Sims (b. 1966)

Gucci bolero. Directed by Joe
McKenna
Pigment inkjet print, 61 × 50.8 cm
Paris, Palais Galliera

Vogue Paris,
March 2004, cover

Repr. p. 266

cat. 414

Alasdair McLellan
(b. 1974)

"Kate sur la peau." Isabel Marant
dress, Kate Moss for Fred jewelry.
Director Capucine Safyurtlu
Pigment inkjet print on
Hahnemühle paper (Rag Pearl),
59 × 46 cm
Alasdair McLellan

Vogue Paris,
October 2011, p. 391

cat. 415

Max Vadukul (b. 1961)

"La nouvelle allure"
Gelatin silver print, 40.6 × 30.2 cm
Vogue Paris Archives

Vogue Paris,
March 1993, p. 142

Repr. p. 217

cat. 416

Jean-Baptiste
Mondino (b. 1949)

"Brut de brut." Corinne Cobson
ensemble
Gelatin silver print, 40.4 × 30.2 cm
Vogue Paris Archives

Vogue Paris,
November 1993, p. 149

cat. 417

Inez & Vinoodh (b. 1963
and 1961)

Gucci leather jacket, Replay
shorts, Kiliwatch belt. Directed
by Emmanuelle Alt
Pigment inkjet print on
Hahnemühle Baryta paper, 2021,
80 × 60 cm
Inez & Vinoodh

Vogue Paris,
April 2008, cover

cat. 418

Inez & Vinoodh (b. 1963
and 1961)

"Kate." Isabel Marant coat.
Directed by Emmanuelle Alt
Pigment inkjet print on
Hahnemühle Baryta paper, 2021,
80 × 60 cm
Inez & Vinoodh

Vogue Paris,
October 2009, p. 235

Repr. p. 269 bottom

cat. 419

Mert & Marcus (b. 1971)

Balmain jumpsuit. Directed
by Emmanuelle Alt
Chromogenic print, 2021,
107.8 × 80 cm
Mert Alas et Marcus Piggott

Vogue Paris,
December 2011/
January 2012, cover

Repr. p. 267

cat. 420

Mert & Marcus (b. 1971)

Prada ensemble, Wolford bottom.
Directed by Emmanuelle Alt
Chromogenic print, 2021,
105.6 × 80 cm
Mert Alas et Marcus Piggott

Vogue Paris,
March 2015, cover

cat. 421

Craig McDean (b. 1964)

"Ultimate Kate." Dior Haute
Couture by John Galliano crown.
Directed by Carine Roitfeld
Pigment inkjet print on
Hahnemühle Baryta paper, 2021,
50 × 40 cm
Craig McDean

Vogue Paris,
December 2005/
January 2006, p. 194

Repr. p. 268

MAGAZINES

cat. 422

Corinne Day
(1965–2010)

Vogue Paris,
April 2001,
pp. 248–249

Vogue Paris Archives

cat. 423

Mario Testino (b. 1954)

Vogue Paris,
December 2005/
January 2006,
pp. 206–207

Vogue Paris Archives

Repr. p. 269 top

ACKNOWLEDGMENTS

This exhibition would not have been possible without the collaboration and generous loans from:

Condé Nast Publications, Paris
Javier Pascual del Olmo, Emmanuelle Alt, Delphine Royant, Caroline Berton, Laure Fourni, Carole Dumoulin, Georgia Bedel

Condé Nast New York
Chris Donnellan, Ivan Shaw, Marianne Brown, Gretchen Fenston, Miranda Muscente

The Palais Galliera would like to thank the following for lending to this exhibition:

Bibliothèque Nationale de France
Delphine Minotti, Chiara Pagliettini, Sylvie Ferreira

Nadia Blumenfeld Charbit

Michel de Brunhoff Collection
Éric Sorrel Dejerine, Nicolas Sorrel Dejerine

Jean-Philippe Delhomme
Galerie Martine Gossieaux

Patrick Demarchelier
Victor Demarchelier

Dior Héritage
Soizic Pfaff, Solène Auréal, Justine Lasgi, Barbara Jeauffroy-Mairet

Fonds Roger Schall
Jean-Frédéric Schall

Jérôme Gautier

Groupe Courrèges
Xavier Landrit

Helmut Newton Estate
Tiggy Maconochie, Pandora Lavender

Helmut Newton Foundation
Matthias Harder

Jean-Luce Huré

IMEC
Claire Giraudeau, Allison Demailly

INA
Dominique Thiercelin

Inez & Vinoodh
Kim Pollock (VLM Studio)

Dominique Issermann
Vincent (L'Office)

Mikael Jansson
Hervé Szerman

William Klein Studio
William Klein, Pierre-Louis Denis

Librairie Diktats
Antoine Bucher, Nicolas Montagne

M/M (Paris)
Michael Amzallag, Mathias Augustyniak, Jane Schwengbeck

Craig McDean
Michael Van Horne (Art + Commerce)

Alasdair McLellan
Jeremy Abott

Steven Meisel
Michael Van Horne (Art + Commerce)

Mert Alas & Marcus Piggott
Stefanie Breslin (artpartner)

Jean-Baptiste Mondino
Félix Mondino, Juliette David (Iconoclast Image)

Sarah Moon
Guillaume Fabiani

Musée de l'Élysée, Lausanne
Nora Mathys, Mélanie Bétrisey

Musée National Picasso, Paris
Juliette Pozzo, Sarah Lagrevol, Sophie Daynes-Diallo

Musée Yves Saint Laurent, Paris
Madison Cox, Olivier Flaviano, Marie-Andrée Corcuff, Aurélie Samuel, Lola Fournier, Joséphine Imbault, Domitille Eblé

Chanel Estate
Odile Prémel, Julie Deydier, Sarah Piettre, Anne-Charlotte Beaussant, Rosa Ampudia

John Galliano Estate
Brigitte Pellereau

Peter Lindbergh Foundation
Benjamin Lindbergh, Thoaï Niradeth

Colombe Pringle

Terry Richardson
Stefanie Breslin (artpartner)

Franco Rubartelli

David Sims
Eve Dawoud, Giorgina Jolly (artpartner)

Mario Sorrenti
Katie Fash, Stefanie Breslin (artpartner)

Juergen Teller
Josselin Merazguia

Mario Testino
Gabriela Antunes

The Guy Bourdin Estate
Samuel Bourdin, Élise Patry, Frédéric Arnal

Anthony Vaccarello and the Maison Saint Laurent

Sabine Weiss
Laure Augustins

As well as the authors of the catalog:

Jérôme Gautier,
Director of Publishing, Christian Dior Couture

Sophie Kurkdjian,
PhD, Assistant Professor, The American University of Paris

Shonagh Marshall,
Curator and Writer

Alice Morin,
Media History Researcher

Alexis Romano,
PhD, Curatorial Fellow, Costume Institute, Metropolitan Museum of Art

Marlène Van de Casteele,
Contemporary Art Historian

The Palais Galliera would also like to thank exhibition partners for their support:

Picto Foundation
Philippe Gassmann,
President and CEO
Vincent Marcilhacy, *Director*
Sylvie Besnard,
Photographers' Relations

American Express
Jean Diacono,
VP & General Manager, Head of Continental Europe, American Express Global Merchant Services

Sylvie Lécallier would especially like to thank for their advice and invaluable help: Laurent Cotta, in charge of the Graphic Arts department; Sylvie Roy, Library Manager; and Alexandre Samson, in charge of the Haute Couture and Contemporary Creations, at the Palais Galliera.

And for sharing their memories, Emmanuelle Alt, Patrick Hourcade, Colombe Pringle, Irène and Alexia Silvagni, Marc Soussan, Hélène Tran, and Sabine Weiss. Additionally, Jérôme Gautier, for his knowledge about the modeling world.

PHOTO CREDITS

Translated from the French
Vogue Paris: 1920-2020
by Zach Townsend

Graphic design by Lisa Sturacci

Published in 2022 by Abrams,
an imprint of ABRAMS. All rights
reserved. No portion of this book
may be reproduced, stored in
a retrieval system, or transmitted
in any form or by any means,
mechanical, electronic,
photocopying, recording,
or otherwise, without written
permission from the publisher.

Original edition © 2021 Paris
Musées, les musées de la Ville
de Paris
This edition © 2021 Abrams,
New York

Abrams books are available at
special discounts when purchased
in quantity for premiums and
promotions as well as fundraising
or educational use. Special
editions can also be created to
specification. For details, contact
specialsales@abramsbooks.com
or the address below.

Library of Congress Control
Number: 2021943156

ISBN: 978-1-4197-6148-5

Photoengraving :
Key Graphic, Paris, France
Printed and bound in Italy
by D'Auria Printing SPA
10 9 8 7 6 5 4 3 2 1

Abrams® is a registered trademark
of Harry N. Abrams, Inc.

ABRAMS
The Art of Books

195 Broadway
New York, NY 10007
abramsbooks.com

Front endpapers
cat. 49 Roger Schall. Report
published in *Life*, September 6, 1937.
Vogue's teams following the Fall/
Winter 1937 Haute Couture
collections. André Durst.
Christian Bérard

cat. 113 Henry Clarke shooting
at the Adam studio, rue Boissy-
d'Anglas in Paris, for the Fall/
Winter 1951 collections,
for the French, English, and American
editions of *Vogue.* On the left,
his assistant Maurice, August 1951

Back endpapers
cat. 111 Lee Miller. From left
to right: Model, Michel de Brunhoff,
Madame de Séréville,
Bernard Blossac, Nicole Lelong
and her father Lucien Lelong,
in Lucien Lelong's salons, 1944.
American *Vogue*, December 15,
1944, p. 29

ill. 1 Donald Honeyman.
Alexander Liberman, Nina Leclercq,
Michel de Brunhoff, Edna Woolman
Chase, Iva S. V. Patcévitch,
Thomas Kernan, Despina Messinesi,
Peggy Riley, c. 1947

ill. 2 Saskia Lawaks.
Vogue Paris team on September 16,
2014, at *Vogue* Fashion Night.
Vogue Paris, November 2014, p. 242

ill. 3 Donald Honeyman.
In front of the offices of *Vogue Paris,*
4, place du Palais-Bourbon, c. 1947

On the cover
cat. 219 David Bailey.
Catherine Deneuve. Newmarket
overcoat. *Vogue Paris*, May 1966,
p. 113

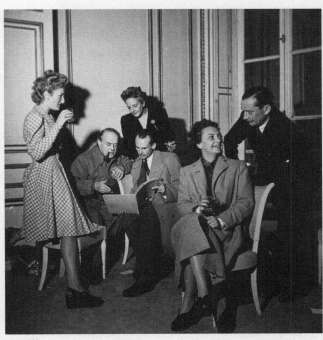
cat. 111

ill. 1

ill. 2